T0355594

On the Animation of the Inorganic

On the Animation of the Inorganic

Art, Architecture, and the Extension of Life

Spyros Papapetros

University of Chicago Press : Chicago and London

The University of Chicago Press, Chicago 60637
The University of Chicago Press, Ltd., London
© 2012 by The University of Chicago
All rights reserved. Published 2012.
Paperback edition 2016
Printed and bound by CPI Group (UK) Ltd, Croydon, CR0 4YY

25 24 23 22 21 20 19 18 3 4 5 6

ISBN-13: 978-0-226-64568-1 (cloth)
ISBN-13: 978-0-226-38019-3 (paper)
ISBN-13: 978-0-226-64567-4 (e-book)
DOI: 10.7208/chicago/9780226645674.001.0001

Library of Congress Cataloging-in-Publication Data

Papapetros, Spyros.
 On the animation of the inorganic : art, architecture, and the extension of life / Spyros
Papapetros.
 p. cm.
 Includes bibliographical references and index.
 ISBN-13: 978-0-226-64568-1 (cloth : alkaline paper)
 ISBN-10: 0-226-64568-1 (cloth : alkaline paper) 1. Nature (Aesthetics) 2. Animation
(Cinematography) 3. Art—Philosophy—20th century. I. Title.
 BH301.N3P36 2012
 700.1—dc23
 2011040993

♾ This paper meets the requirements of ANSI/NISO Z39.48-1992 (Permanence of
Paper).

Contents

Preface

From television cartoons to virtual architectures and from 2-D imaging technologies to 3-D logos floating in space, we evolve and dissolve in a computer (re)generated culture that is increasingly possessed by the spirit of animation. This book attempts to locate the origins of contemporary animated culture by inquiring into discourses of simulated movement and inorganic life that evolved from the analogously vivified terrain of the preceding fin de siècle.

Founded upon the "enslaved" columns of Vitruvius, incorporated in Renaissance doctrines of proportion, echoed in classical theories of physiognomy and *caractère*, and subjectified in formulations of empathy theory in nineteenth-century psychological aesthetics, discussions of pneumatism, spiritism, or the animism of forms have been implicitly central in art and architectural discourses via the analogical relation to the human body and, increasingly, its inner agency, the soul. Starting, however, with the physiological conception of the sublime in the eighteenth century, such bodily metaphors mutated from external morphological correspondences to inner pathological symptoms afflicting the organisms of statues, buildings, and modern metropolises. It is within this shifting ground of fin-de-siècle Europe that the artistic drive, Alois Riegl's all-encompassing *Kunstwollen*, presented an ambiguous inflection that marks the shift from empathy theory to what Wilhelm Worringer in his 1907 dissertation, *Abstraction and Empathy*, prophetically calls "the uncanny pathos which attaches to the animation of the inorganic." The main argument presented in my own account is that empathy, the ability to identify with the objects of the external world, was not erased but repressed by modernist subjects; thus, it had to return metamorphically projected, objectified, and finally reified in the inorganic form of the animistic artifacts of twentieth-century modernity.

This research was provoked by an abiding contradiction: while our relationship to objects has evidently changed, the way we talk about them has not. Fetishism, the uncanny, and now animation disclose an affinity with objects that is always contested. Objects and subjects appear as the epigones of an *unfamiliar* kinship: they may now be closer than ever, yet their communication is stalled in the same typified roles of artifacts and users, images and spectators, or buildings and occupants. Without inventing new terms, this book shows how our renewed deployment of older ones, such as animation, may have in fact created new communicative possibilities that essentially undermine the subject-object divide. The ultimate objective of this study, then, is to identify a vital epistemological shift in the status of objects that occurred during the turn of the previous century and has remained with us ever since.

One could indeed describe the fin de siècle as the time when artifacts start having cataclysmic effects on people. Real and textual subjects collapse at the sight of these new mesmerizing objects. Although glacial and inorganic, modern artifacts are radiant and electric; they emanate magnetic powers and vibrate with energy, life, and desire of their own. In all their metallic coldness and austere sublimity, the industrial artifacts of the early twentieth century do not lack either pathos or sexual appeal. Fueling this erotic capacity is what Worringer describes as "the intensification of a resistance," a traumatic reaction provoked by the hostility of the external world, which the threatened modernist ego feels compelled to fetishistically displace upon inanimate objects. On the other hand, by constantly investing objects with psychic powers, modern subjects gradually renounce their own subjectivity. As in the awakening of infantile sexuality, the issue of agency becomes mysterious and inexplicable: "Things are happening to us, and we don't know where they're coming from!" Actions and objects or causes and effects are liquidated into abstract stuff, flowing and swelling. Such is the "landscape effect" of animation created by leveling the verticality of the human subject onto the horizontal plane of material effects—a thick tapestry of intertwined associations with no essential distinction between points of action and forces of motivation behind an event.

The animation of the inorganic promoted by Worringer is then essentially an act of transgression; it heralds the infusion of life in a domain to which the animate did not formerly belong. Turn-of-the-century monists, such as Ernst Haeckel, discovered that inorganic materials, including crystals and other mineral substances, possess sensation and memory, and thus ought to be granted a soul. At the same time art historians like Aby Warburg probed painted accessories and ornaments that display a codified behavior based on a repertory of memory patterns. The covert imposition of agency on inorganic

matter ultimately subverts the epistemological framing of both objects and subjects, as well as the forms of analogy, sympathy, or antipathy that hitherto governed the relationships between them.

Such radical change in the status of objects stirs a wave of reciprocal ambivalence. Whereas in pantheistic theories of empathy, external objects appear friendly and amenable to human desires, the animated artifacts of twentieth-century modernism appear fundamentally hostile. From Freud's agoraphobic Vienna and the primitive jungle of his *Totem and Taboo*, to Warburg's animistic Renaissance and the serpentine links between America and Hamburg, the basic presupposition that the fin de siècle has bequeathed to us is that we are living in a "hostile external world," that any relation of human subjects to external objects can only be either in terms of mastery or mutual destruction. The animism of tribal societies described in nineteenth-century anthropological accounts turns into animosity—a malevolent air permeating houses, commodities, and images in contemporary metropolitan milieus. The invention of empathy theory and the revival of anthropomorphism and the physiognomy of objects portray the failed attempt of turn-of-the-century aesthetics to subjectify (and partly neutralize) the radical power of artifacts in both archaic and modern societies. From Freud to Durkheim and from Marx to Lukács, terms such as "objectivity" (*Sachlichkeit*), "reification," as well as "fetishism" and its former occult synonym "animism" cast a symbolic web upon concepts, institutions, artworks, and commodities. Binary oppositions—such as animate and inanimate, organic and inorganic, vital and mechanical—uncannily intermingle to create new hybrid forms. Fernand Léger's cubo-futurist *Nudes in the Forest* of 1911, for example, amalgamates pneumatic technology with the animistic rites described by social anthropologists such as Durkheim. But while for Durkheim animistic rites express the belief in a collective soul— the impersonal *anima* of the tribe—modern rituals of animation presage the ultimate isolation within a personal space—the animated universe of private fiction.

By juxtaposing the concepts of cultural anthropology and psychoanalysis with those of art, architectural, and cultural history, my aim is to demonstrate that empathy and animation are something more than aesthetic theories; they are attitudes in art and life with profound social and political consequences. Although posing as bright symbols of modernity, the ubiquitous crystals, vegetal ornaments, and geometric curves of early twentieth-century design act rather as dark allegories of turbulent geoformations—social, political, economic, and racial. Individualism and collectivism, capitalism and bolshevism, patriarchy and feminism are all preparing for battle by glazing themselves with

the angular surfaces of crystals or by becoming armed with the swelling pseudopodia of amoebas. In a few decades, however, both the empathetic curvatures of the fin de siècle and the agitated angles of the Great War would be flattened by the political *inanimate* of the late 1930s in which the story of this book reaches its ostensible conclusion.

. . .

While animation revives the ancient correspondences of analogical thinking between the microcosm of human artifacts and the macrocosm of universal affairs, it also reenergizes the world of polarities, the splitting of both natural and conceptual entities into oppositional pairs. Animated objects (such as Warburg's snake symbols) not only represent but at times embody these polarities in their dynamically ambivalent behavior.

Based on this twofold attitude, all variable forms of animation could be summarized into two different yet interconnected modes. The first animated type is material: it represents changes and transformations in the substance of objects, transitions from the organic to the inorganic, from animal to vegetal to mineral, and so on. The second form of animation is temporal: it describes rebirths, survivals, renewals, and anachronisms—the temporal reanimation of archaic themes within the chronological collage of modernism. Like Nosferatu, animated characters are essentially vampires: they carry on in a perpetual afterlife because they never live a *proper* life. Several of the objects of this narrative embody both the material and temporal aspects of animation. For example, following Alberti's instructions in *Della Pittura*, the windswept locks of Botticelli's Venus transform from human hair to snakes and to flames, but following Warburg's reading in his 1892 dissertation, the same undulating tresses also act as chronodiagrams of psychological expression from antiquity to the Italian Renaissance, and then implicitly to the art historian's own period of turn-of-the-century Europe.

These modes of animation are represented by two seemingly opposite iconographic themes. On the one hand, this is a story populated by accessories, snakes, forests, and women who turn into trees: the clandestine mythological stream of the survival of paganism in modernity analyzed by Warburg and later on by the surrealists. However, it also includes an excess of abstract shapes, vegetal ornaments, and crystalline patterns, such as the visual geometries that crisscross Riegl's analysis of late Roman artifacts and Worringer's reanimation of the Gothic.

Following these iconographic currents, German art history provides us with two distinct forms of animation. One is the *external* simulation of move-

ment (*äussere Beweglichkeit*) in inanimate objects detected by Warburg in fluttering hair, billowing draperies, and meandering snake motifs. The second is the static or inner liveliness (*innere Lebendigkeit*) of geometric forms in abstract ornamentation, as examined by Riegl and Worringer. This inorganic form of animation has less to do with movement than with a form of energy intensified by immobility and stillness. It is an imperceptible vibration, more "spiritual" (*geistig*) than sensory (*sinnlich*). My argument is that much of modernist art has espoused that second inorganic type of animation, while some clings anachronistically to the figurative first.

It is important to represent both of these modes and forms of animation in this narrative. Most of the episodes in this account are illustrated by transitional images that combine empathy *and* abstraction, curves *and* rectangles, nymphs *and* crystals. Such hybrid figures disclose a sense of change in the making; they describe animal and vegetal metamorphoses that have not yet reached a crystallized state. This explains why Léger's *Nudes in the Forest*, an organic morphology in the process of crystallization, is central in this story. Léger's mineral figures manifest the new inorganic human—or the new *inhuman*, as T. E. Hulme would call it—that modernism substituted for (or, in fact, extended) the models of nineteenth-century organicism. While between 1905 and 1911 (when Worringer's dissertation was first written and Léger's painting was first exhibited, respectively) there was a definite movement from empathy to abstraction, or from curves to crystals, the myriad contradictions in Worringer's text presage that this inorganic phase was coming to a close. Soon enough, the petrified nymphs and fossilized snakes of early twentieth-century modernism would reawaken from their crystalline narcosis. This is the half-somnolent moment of surrealism introduced in the final episode of this narrative. Daphne, Ovid's forest nymph concurrently resuscitated by art historians of the Warburg Library in Hamburg and by surrealist authors in France and the United States, presents the grave moment when the vertiginous excitement of animation turns into a petrifying paralysis. Half woman and half tree, half myth and half history, Daphne's metamorphosis in fact never ends: it is the sign that the story of this book remains open ended and can be infinitely protracted by a number of possible postscripts.

. . .

While seemingly encyclopedic in scope, this book does not aspire to be either a chronological survey or a compendium of theories of animism or animation. The final product is a chronological collage of certain fragments of a history of objects that are historically and conceptually intertwined. While my point

of departure is turn-of-the-century German art history—mainly Warburg, but also Worringer and Riegl—I extend historical theorizations of animation into early twentieth-century art and architectural avant-gardes: Léger, Mies van der Rohe, and Dalí. One has to underscore the fact that the visual and textual materials of this narrative are deliberately chosen from a variety of historiographic schools, modernist movements, and national contexts. One of the main arguments of this account is that the "animation of the inorganic" is an elusively abstract concept that implicitly migrates from one area to another. The wide-ranging content of this book retraces that covert migration.

To organize these disparate fragments, one has to use a clear geometric frame. The book is organized into six chapters that are symmetrically divided in two parts: "Animated History" and "Inorganic Culture," two sections that split the animation of the inorganic into its constituent terms. The first part traces a number of interlinked narratives from late nineteenth-century historiography, while the second represents certain episodes from early twentieth-century art and architectural practices. However, the overall line of the plot is meant to be continuous, even if noticeably circuitous in contour. The two sections do not simply follow but rather confront one another, producing a thematological mise-en-abîme. Warburg's peripheral animation of accessories will eventually become interleaved with the vegetal extensions of Daphne as illustrated by the surrealists. Worringer's animate crystals in his 1907 dissertation will resurface in the mineralogical landscape painted by Léger in 1910.

Following the logic of accessories described in the first chapter, most of the animated objects that appear in this narrative are equally "peripheral" or "eccentric" in nature: snakes, vampires, old houses, running nymphs, and deflated car tires are marginal specimens of phenomenal endurance that, like Freud's "overdeteremined elements," reappear in several scenes of a dream narrative. This is the substratum of archaeological fossils pushed under modernism's bar of repression—the very limit that allows modern culture's depository of "enigmatic signifiers" to flourish. Whatever manages to break the surface disintegrates into a cluster of hairy extensions, such as Venus's serpentine tresses or Daphne's arboreal appendages. The objects being explored in this narrative are water spirals, vegetal tendrils, hair locks, or fabric folds, and the methodological devices being used to analyze such objects are equally bifurcating and circuitous in their patterns. Following a similar *peripheral logic*, the chapters of this book are not articulated by a central narrative but by a sequence of "additions," a series of accessory appendages stitched together in the form of a mosaic. Such is the legacy (and perhaps the *curse*) of Warburg's "accessory" working method: creating fragmentary compilations of philologi-

cal "addenda" whose perpetual accumulation maintains the textual fabric in a perennial form of incompletion, yet constantly in motion, and anxiously alive.

In empathy with its subject matter, the book's method could then be viewed as properly animistic. Early ethnographers describe the archaic belief in the extensive power of "contagious" and "imitative" magic in which the same animating principle passes from one object to another simply as the effect of physical proximity or superficial resemblance, thus making it possible to obtain the same results from two substantially different objects. The sympathetic influence embedded within the principle of contagion allows us to bring together the heterogeneous specimens of several historiographical and artistic currents to establish new, diagonal relationships. The unformed legs of a tadpole sketched by Warburg next to the upright arm of Nosferatu or the raised hand of a metallic figure by Léger become familial parts of a totemic arrangement. The simulating metaphors of life and movement (*Lebendigkeit, Beweglichkeit*) help diagram affinities between faculties and practices that seem prohibitively distant, such as art history, natural history, ethnography, and psychoanalysis. While trying to establish affinities and similarities, differences and discontinuities also become important. The "animation of the inorganic" portrayed by Riegl and then Worringer is different from the life and mobility of inorganic accessories envisioned by Warburg. Furthermore, Worringer's "inorganic" is different from that of Nietzsche, Bataille, and Deleuze. Both *animation* and the *inorganic* are pliable terms and always remain unstable, which is why it is impossible to write a linear history of these two protean ideas.

. . .

Method is not the only element of this work that is in empathy with its animated subject. The book is not meant to be an external critique of animation; its primary task is not to judge or condemn animation for its suspicious motives, its numbing effects on human subjects, or the economic agencies that it tends to conceal. The aim is rather to propose a view from inside: to work *with* and even *like* animation in order to discover how animation works, how it disseminates, how it perpetually revives itself, and how it continues to captivate its unsuspecting victims. Moreover, by transposing the focus from the psychological responses of the perceiving subject to the communicative properties of the object itself, this narrative strives to reaffirm alternative social potentialities on animation that have often been overlooked by its critics. Turn-of-the-century social anthropologists, such as Durkheim, describe the unique capacity of the animated artifact to transcend distinctions between human, animal, and natural agents, and to unite all diachronic members of a tribe, whether living,

departed, or unborn. Perhaps these projective social properties of animation, its promise of an expanded form of sociability across natural and manmade objects, may be the secret core that continues to be masked by the vivified commodities and the lively images that overwhelm our computer screens.

This continuing displacement gives us an idea of the unfulfilled desire that keeps discourses of animation in perpetual motion. The constant warping and digression from their original aim illuminate the phenomenal eccentricity ascribed to animated objects and expands to the methods of this study. One might describe both these subjects and these methods as *peripheral* in nature, yet that may best approximate the nature of animation and how it operates. We may continue to fail in deciphering the mysteries of modern animist menagerie and its unfailing power over contemporary consumers if we refuse to read closely the world of its marginal specimens. Perhaps one can only address the large spherical questions posed by animation by circling around them, rather than addressing their core, which, in fact, does not exist. There is no substance or depth in current animated environments. In spite of the latest 3-D imaging technologies, animation will always remain a two-dimensional system.

Such an impossibility of in-depth analysis invokes earlier epistemological modes of inquiry. Inadvertently, this study has the paratactic structure of a medieval book of wonders, partially updated for the requirements of the modern age. All of its chapters are interspersed by descriptions of one miraculous event after another, with little or at times no attempt toward a rational explanation. As in the aberrantly flying fabrics and hair in Renaissance painting examined by Warburg, the absence of logical justification becomes part of the animated event.

■ ■ ■

This book, then, is not only about the animation of objects, but also the reanimation of an earlier form of scholarship. Such methodological recurrence addresses not only the animistic structure of the project in its totemic exploration of adjacencies across disciplines, but also the vast scale of the narrative paired with the allegorical detail of the description. Part of the subtext of allegorical accounts (whether in their Baroque or early twentieth-century guise) is the enormity of the task undertaken; such incommensurable effort unavoidably leads not to a comprehensive compendium, but to a vast collection of fragments. Animation is everywhere, yet in spite of the books and conferences on animation in the last decade, very few of the existing accounts attempt to view art and architectural animation in their larger epistemological implications. The expansive character of this book (in which each of its six chapters threat-

ens to turn into a book of its own) is part of that allegorical strategy, but also a response to previous partial critiques of or tributes to animation.

Perhaps it is not mere accident that the main works analyzed in this book, which originated as a doctoral dissertation, are either other doctoral dissertations, such as Warburg's 1892 thesis on Botticelli and Worringer's 1907 *Abstraction and Empathy*, or "firstborn" essays and "breakthrough" projects, such as Léger's *Nudes in the Forest* of 1911 and Mies's glass tower model of 1922. All of these inaugural efforts are characterized by an omnivorous, encyclopedic scope: they strive to say everything with a single gesture as if the first text, painting, or building could also be the last. What makes these modernist epics allegorically successful is their inadvertent capacity to turn into landmarks of their own failure. Each piece of these vast mosaics hypothetically condenses the author's personal trajectory into the microscopic fragment of a cosmic whole.

From Daphne's tree to Léger's forest, the growth of this endlessly bifurcating narrative is predicated upon the process of branching—the split between and recombination of heterogeneous practices. In its dual structure between historiography and practice, the book polemically argues that studies of art, architecture, and historiography should not be viewed separately, and that such divisions can potentially impoverish the study of all of them. Such research is based on the belief that scholars should not be obliged to commit to any compulsory repertory, but be free to participate in diagonal alliances between discursive terrains and to invent their own composite practices. One cannot stop aspiring of being either ignorant enough, like the twelve-year-old (memory) author of Proust's *Recherche*, or more than adequately learned, like the cosmically erudite Aby Warburg, in order to bypass what the German art historian once called the "border police"—the designated team of academic patrol officers who demand to examine our papers and check our credentials whenever we attempt an exit from our assigned area of research. The passing or trespassing of such perennial checkpoints could also gradually become the work of scholarly reanimation.

. . .

Acknowledgments

Given the length and complexity of this project, I am deeply grateful to the institutions that supported it over the years. I am most indebted to the University of California at Berkeley, for allowing me to create an ad hoc interdisciplinary doctoral program in the theory and historiography of art and

architecture, sponsored by the Departments of Architecture, Art History, Rhetoric, History, German, and Film Studies; for facilitating a year of study at the University of California at Los Angeles; and for granting me the Townsend Center for the Humanities and Chancellor's Dissertation fellowships. I would also like to acknowledge the Getty Research Institute for a nonresident post-doctoral fellowship that funded an additional year of research at the Archive of the Warburg Institute in London, and for two residential grants as a Visiting Fellow and Getty Scholar, during which the manuscript of this book was completed. Six additional months of research were made possible as a Visiting Scholar at the Canadian Centre for Architecture. The University Committee on Research in the Humanities and Social Sciences at Princeton University offered a number of summer research grants. The publication of this book was also made possible by a generous grant by the Barr Ferree Publication Fund, administered by the Princeton University Art and Archaeology Department. Finally I would like to thank the University of Chicago Press for its ongoing support of interdisciplinary projects and innovative scholarly research—a commitment particularly valiant during these financially hard times.

Sincere thanks are also due to a number of individuals. First, the members of my dissertation committee: T. J. Clark, Kathleen James-Chakraborty, Martin Jay, Anton Kaes, Kaja Silverman, and Anthony Vidler, as well as the rest of my professors at Berkeley, Leo Bersani, Whitney Davis, and the late Michael Baxandall; and at UCLA: Carlo Ginzburg, Sylvia Lavin, and Donald Preziosi. At the Getty Research Institute: Thomas Crow, Gail Feigenbaum, Thomas Gaehtgens, Sabine Schlosser, and my research assistants Priyanka Basu and Sandra Zalman. At the Canadian Centre for Architecture: Phyllis Lambert, Nicholas Olsberg, Mario Carpo, Mirko Zardini, and Alexis Sornin. At the Warburg Institute: archivists Dorothea McEwan, Claudia Wedepohl, and Eckart Marchard. At Princeton: Dean Stan Allen, Beatriz Colomina, Christine Boyer, Ed Eigen, Hal Foster, Rena Rigos, and my research assistants Irene Sunwoo, Brandon Clifford, and Daniela Fabricius. I am grateful to the library staff of the Warburg Institute, Getty Research Institute, the Canadian Centre for Architecture, and the Princeton School of Architecture. Leo Bersani, Anne Cheng, Leonard Folgarait, and Angus Fletcher read parts of the manuscript and made valuable suggestions. Two anonymous readers offered extraordinarily insightful reports solicited by my indefatigable editor, Susan Bielstein, who endorsed this project and who, with the help of the team at the University of Chicago Press, "babied" it to publication. My friends Ron and Bill offered encouragement during some difficult moments in the initial phases of this project, and the members of my family in Greece stoically with-

stood months of my writing-in-isolation during a number of summers before its completion.

Parts of the manuscript, significantly rewritten and revised in this book, were earlier published in *Grey Room*, as well as edited anthologies including *Surrealism and Architecture* (Routledge, 2004), *Biocentrism and Modernism* (Ashgate, 2011), and Aby Warburg's *Schlangenritual* (Akademie Verlag, 2007). Material from the book was presented in lectures at UC Berkeley, University College London, the History of Scholarship seminar at the Warburg Institute, the doctoral program in architecture at Harvard University, the program in Hellenic studies at Princeton University, the Henry Moore Institute in Leeds, the Zentrum für Literaturforschung in Berlin, the College Art Association, and the Society of Architectural Historians annual conferences. Finally, material from the book was taught a number of times at a graduate seminar in the School of Architecture, cosponsored by the program in media and modernity at Princeton University; I am grateful to all students who attended.

The book is dedicated to all of the people who have taught me in the past. Being a teacher myself during the past eight years makes me appreciate even more their uncompromising attitude toward scholarly standards. Particular acknowledgments are included among the endnotes of each chapter; here, however, I would like to single out three individual *gestures* that proved definitive for the orientation of this project in its early stages. The first is by Michael Baxandall, who in one of his last seminars at Berkeley on *Della Pittura* pointed with his finger at a paragraph of Alberti's text that offered instructions for the pictorial representation of "inanimate objects in movement." The second is by T. J. Clark, who, during a tutorial following one of his legendary class lectures on "abstraction and figuration," looked at a reproduction of Léger's *Nudes in the Forest* and, while scratching his beard, asked: "But don't you think there is something mineralogical about this painting?" And finally the third memorable gesture is by Anthony Vidler. While he offered his hand to say goodbye at the end of our very first meeting in his office at UCLA, he inquired as to what topic I would like to pursue for my dissertation. "Something on the *inanimate*," I replied. "And next to the inanimate there is *animation*," responded Tony with his typical (Mephisto-played-by-Emil-Jannings) smile. It took me several years to fully realize that the inanimate indeed lies next to animation, even if signs of this uncanny adjacency became apparent to me early on. The day after that meeting in Los Angeles, I visited Disneyland for the first time, where I collapsed during one of the so-called fun-rides. This was my personal introduction to the inanimate, or *inorganic*, mode of animation, whose petrifying effects have since grown roots within my writing and continue to branch out.

Introduction

Animation Victims

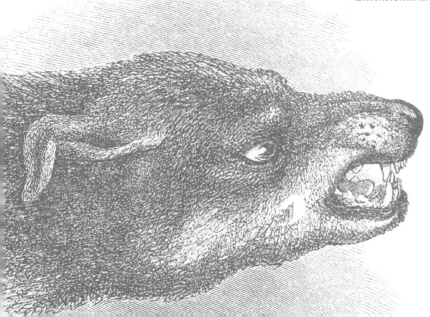

An Abridged History of Animated Response

"You live and do nothing to me": a statement in which a subject, specifically an art historian, addresses an object as if it were a living being. But how much confidence can we bestow upon this "nothing"? Does not the object's status as a living entity enable it to do something? And does not the very act of talking to an inert thing empower it with the agency of hearing? Could the subject's denial then be a form of exorcism against all the things that objects *can* do, the harm that they are capable of inflicting? And would not this refutation ultimately provoke a response by that interlocutor that is condemned to say or do "nothing"? The series of examples that follow describe the outcome of this outwardly self-assured, yet inwardly anxious statement. They form an episodic history of response to the vivification of objects. Because there is no other way of experiencing the life of an object than through its subjective affect—the often paralyzing reaction it provokes on the body. Indeed, such instantaneous paralysis is the proper point for introducing animation.

The child and the (television) spells

"Her eyes rolled back and she went into convulsions . . . she didn't come round for more than ten minutes," reported a mother. "The lights seemed to encom-

pass me . . . next thing I knew my mom was telling me I had lost consciousness," added her nine-year-old daughter. Morning newspapers would offer an animated account of similar incidents: "One moment they were happily munching on their dinner and watching their favorite cartoon show on television; the next moment, hundreds of children across the country were shaking and convulsing and being rushed to hospital."[1] The event occurred in Japan on the night of December 16, 1997, during the televised broadcast of an episode of the popular animation series *Pokémon* (short for "pocket monsters").

Physical symptoms included mild reactions, such as "dizziness, headaches, and nausea," which subsided in one or two hours. But there were also more severe effects, such as "convulsions, fainting, seizures or difficulty in breathing that lasted for more than twenty four hours" and caused approximately seven hundred of the afflicted youngsters to be hospitalized. Medical experts diagnosed the phenomenon as "optically stimulated epilepsy": epileptic fits caused by rapidly moving images, which are experienced primarily by individuals between the ages of five and nineteen, when the body has a lower threshold to seizure. While "mass suffering from photo stimulation" was the official diagnosis, there were also suggestions of "mass hypnosis" or "mass hysteria" provoked by a combination of the "increased stress and anxiety" of Japan's competitive technological society and the harmful effects of "children sitting too close to the television screen."[2]

But while most of these explanations address the psychopathological history of the afflicted subjects, the idiosyncratic properties of the object itself—specifically, the scene of the infamous cartoon episode—are also particularly telling.[3] The action takes place inside the hard drive of a computer where teenage warriors aided by friendly Pokémon have converged to battle computer viruses (see plate 1). The enemy viruses fire missiles and the Pokémon Pikachu responds by ejecting from its serpentine tail a vaccine bomb that produces a thunderous explosion. The blast fills the entire screen. A white gust is followed by rapid flashes of blue, red, and violet colors. Then a bigger explosion covers the frame with a cloud of black smoke. In the final scene, the teenage warriors emerge dumbfounded, along with the victorious Pokémon, from the burned ruins of a building. However, by that point, many of the young viewers were anesthetized and were unable to witness the jovial conclusion.

As animation experts explained, similar visual techniques—called "paka-paka"—had been repeatedly used in Japanese cartoons to cause a sense of tension. But in that particular segment the flashes, alternating in every second, were double the normal number, and combined with the intensity of the colors, the photostimulation became overbearing. Following the initial

"*Pokémon* hysteria" in Japan, the incident sparked an international debate in newspapers and the Internet between the enraged parents who criticized television executives and the enthusiastic teenagers who defended their favorite show. After a four-month suspension, the program was back on air in Japan and soon around the world, followed by *Pokémon* videogames, toy stores, and safari theme parks sponsored by the Nintendo corporation, which was producing the cartoon. While the television series was officially "killed" in 2001, the *Pokémon* saga enjoys a vibrant afterlife not only in popular, but also academic circles, including a reference in a newspaper article by Umberto Eco and an anthology of critical essays devoted exclusively to the "rise and fall" of the short-lived animation empire.[4] But what can we ultimately learn about animation from the *Pokémon* incident?

First, that we can never *know* much about animation—at least not from firsthand experience. In fact, the very idea of knowledge becomes obsolete the moment animation occurs. Think of the young victim's testimony: "The lights seemed to encompass me . . . next thing *I knew* my mother was telling me I lost consciousness" (my emphasis). Animation is experienced as an epistemological and spatiotemporal seizure; body and mind shut down and surrender entirely to the effervescence of the image. The image, in this case, is animated not because it is a cartoon, but because of the overwhelming power that it has upon the subject, who, in contrast, appears defenseless and is in a state of total disarray.

Second, despite the contrast in effectiveness between subject and object, animation also induces a complimentarity between the two. Think for example of the bewildering reciprocity between the representations on the screen and the events happening in real space. The white blasts and flashing lights on the television screen were replicated by the "whitening out" and "hot and cold flashes" on the spectators' faces. The spiraling explosions and loud screams in the cartoon's "computer interior" echoed the veering convulsions of the afflicted juveniles and the screaming reactions of their mothers in the interiors of the Japanese homes. Finally the clouds of black smoke covering the screen just before the end of the episode duplicated the "blackout" of the anesthetized spectators and practically eliminated all spatial distinctions between the real and the virtual domain: what started as a mise-en-abîme of colorful explosions ends up as a black-on-black general effect.

One might perceive this sequence of sensorial reverberations as an extreme case of *empathy* between the image and the viewing subject. But animation proper has very little to do with empathy. In the *Pokémon* incident all effects originate in the image and act involuntarily upon the spectator. "The

lights seemed to encompass me," said the young viewer. The subject does nothing other than become the object of the active advances of the image—an abstract agency that leaps from the opposite side of the screen to enfold the unsuspecting subject with its impact. Yet ultimately the reciprocity of these recoiling effects shows that agency in animation is less important; what matters is the effect, which demonstrates a puzzling resemblance with the cause. As internal and external forms replicate one another, it becomes increasingly unclear who is doing what to whom. The body deceptively disappears and then returns in the uncanny state of a disaster, a post-explosion landscape of effects—much like the carpet on which the arabesque convulsions of the juvenile spectators were embroidered.

The *Pokémon* mishap makes clear that the animation of the image comes at the expense of the human subject. Every instance of animation is complemented by an equivalent occurrence of paralysis. As in the myth of Daphne, who appears at the other end of this narrative, excitation rises to such levels that the subject instantly freezes and is unable to react. Similar to the abrupt freezing of an overloaded computer screen (the interface of the interior in which the *Pokémon* characters descended), the only way that the subject can recover is by shutting down its entire apparatus and then waiting to restart again.

Catherine and the boat

The next episode describes a similar instance of paralysis that happened six hundred years earlier. Once again we know the exact time of the event: January 29, 1380, Sunday evening, the hour of the vespers. That was the moment when Saint Catherine of Sienna suddenly collapsed while praying in the old basilica of Saint Peter's in Rome. As we learn from her disciples, the female saint had been praying for hours in front of Giotto's famous mosaic of the *Navicella* and its tempestuous boat scene, when suddenly she felt that "the boat had fallen off and landed on her shoulders." Crushed by the vessel's "unbearable weight," Catherine, too, fell on the floor. As if it had turned into stone, the saint's frail body became so heavy that her companions could not lift her from the pavement.[5] Catherine apparently never walked or appeared again in public after that event. Paralyzed from the waist down, she fell gravely ill and died three months later. Unlike the *Pokémon* victims, the female saint did not survive her spell of (in)animation.

I refer to this historical incident because it is included in a review of Wilhelm Worringer's *Abstraction and Empathy* authored by the Gestalt psycholo-

gist Rudolf Arnheim and first published in a psychiatric journal in 1967. In his review, Arnheim mentions Catherine's collapse at Saint Peter's as an example of the differences between empathy and animation. As an objective Gestaltist, Arnheim denounces the concept of empathy as overly subjective because this type of psychological experience transforms everything into a "projection" of the self. On the contrary, asks Arnheim, "is not any genuine encounter with a work of art the exact opposite, namely animation flowing from the work of art and imposing the impact of its life upon the beholder?"[6]

According to Arnheim, Catherine's "extreme" experience was not an instance of empathy, but of animation: "Undeniably, the substance of this encounter is not in what Catherine did to the boat, but what the boat did to Catherine."[7] Of course, here, Arnheim chooses not to take into account the idiopathic reciprocity between the female saint and Giotto's tempestuous representation. After all, we know that Catherine would repeatedly collapse in front of sacred images and have heartrending ecstatic visions, such as receiving the stigmata or marrying Christ. We also know from her biographers that when the particular incident occurred, *la dolce venerabile Mamma* ("the sweet venerable mother") was very distressed with the pope's ecclesiastical politics, and therefore had not slept or eaten for weeks, sustaining herself with only a few sips of water.[8] But Catherine's idiosyncrasies and poor health conditions do not necessarily invalidate Arnheim's assessment. They simply show that animation has a predilection for a specific type of subject that is predisposed for its effects. As in the case of the *Pokémon* viewers, the human agent is already pre-exhausted, and therefore more vulnerable to the (in)animating stimulus of the image.

As becomes clear in the examples of both Catherine and the *Pokémon*, it is not "life" that "imposes its impact upon the beholder," as Arnheim would describe the experience of animation, but paralysis. Furthermore, if there is a trace of psychological empathy between the viewer and the image enacted in Catherine's collapse, that correspondence is not subject-centered, but subject-*decentered*: the human figure is broken and dislocated by the massive presence of the powerful artwork. Catherine felt Giotto's boat "on her shoulders," where her head should have been; her body acted before her mind ever had time to react.

Although both empathy and animation might have had a reciprocal effect in Catherine's encounter, I would like to maintain Arnheim's basic distinction between the two concepts. That is, while empathy pertains to subjects doing things to inanimate objects, animation is about objects doing things to human subjects. *Things doing things*: causes and effects are homogenized on a level of

blunt linguistic generality (reminiscent of the epigram "you live and can do nothing to me," in which a thing supposedly causes no-*thing*). Once again, what ultimately matters is not the agency, but the effect: who is doing *more* to whom. Catherine did not voluntarily jump into Giotto's sea. The boat allegedly fell from the wall and landed on her shoulders. Giotto's mosaic did not become livelier because of the saint's extreme physiological response. Catherine herself turned into a mosaic, as her body turned into stone and refused to be extracted from the pavement.

But let us once again turn away from the afflicted subject and focus our attention on the image. What were the elements of the original mosaic that might have triggered such response from Catherine? Following the iconographic precepts of the story in the New Testament, the *Navicella* depicts a vessel with the twelve apostles watching in agony as Christ saves Peter from the turbulent sea waves. But as is well known, Giotto's mosaic was eventually destroyed and is today known only through a number of contemporary drawings that differ from one another (fig. 0.1).[9] However, there are a number of

Figure 0.1 Parri Spinelli, study after Giotto's *Navicella*. Pen on paper (c. 1410). Cleveland Art Museum.

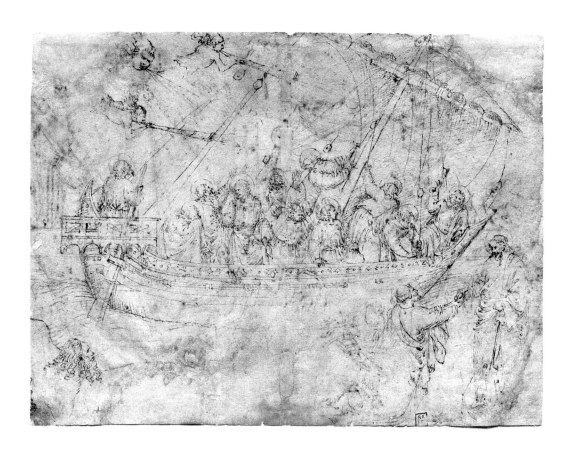

iconographic elements that are common in most of these accounts and that corroborate the affinity of Giotto's representation with narratives of animation. First, there are the archaic wind-gods, the representatives of the Greek *anemos* or wind behind the *anima* or soul of animation, who blow at the sails. Sometimes whole bodies floating on air, sometimes mere faces or masks emerging from the water, sometimes angels and sometimes demons, these airy figures represent daemonic agencies that blend ancient pagan archetypes with medieval allegorical devices. Then there are also the highly expressive gestures of the apostles—a pictorial innovation praised in Alberti's treatise *On Painting*.[10] Along with the apostles' agonizing facial expressions, these dramatic gestures externalize internal movement and provoke empathetic responses in the spectator. The body here becomes an agitated fabric in harmony with the rest of the turbulent ambience. But to return to Arnheim's distinctions, if these are the figurative representatives of empathy in Giotto's image, what would then be the more abstract signifiers of the "flowing" animation proposed by the psychologist?

Figure 0.2 Style of Pisanello, study after Giotto's *Navicella* (c. 1420–30). Pen and silverpoint on paper. Milan, Biblioteca Ambrosiana, MS. F. 214 inf., fol. 10 recto.

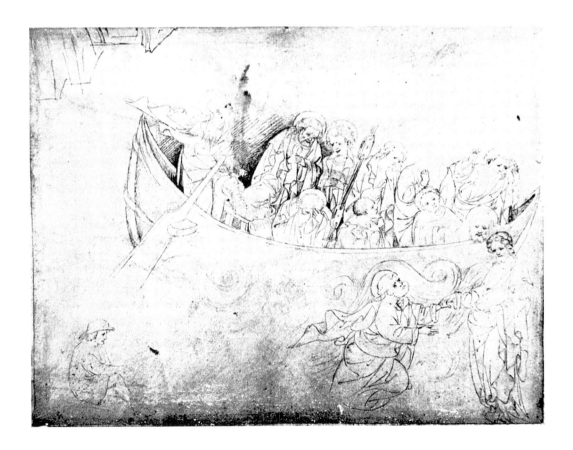

Animation Victims

One of the pictorial elements that varies the most in the numerous copies made after Giotto's mosaic is the depiction of water. In a drawing in the style of Pisanello (fig. 0.2), the sea waves are shown in the form of large spirals, reminiscent of an ancient Near Eastern iconographic convention for representing water that continued to be employed by Byzantine and early Renaissance artists.[11] In the fifteenth-century drawing by the school of Pisanello, the head of Saint Peter appears entirely engulfed by these swirling meanders.[12] The spirals simultaneously arrest and elongate the movement of the human body and its flowing garments. Moreover, the same winding lines appear to extend the gestures of the apostles and to connect with the agencies of the wind as signifiers of pictorial agitation. The spirals then represent both the cause and the effect of animation; at once they visualize the external threat of the natural elements and also diagram the psychological unrest of the defenseless subject.

Perhaps, then, it was not only the boat that caused these grave effects on Catherine. As in the spiraling explosions in the *Pokémon* cartoon, it is again an abstract pattern that unwinds (or rewinds) the animated episode that is about to follow. The image *anticipates* the event. External and internal tribulation are crystallized in a rhythmic wave pattern that drags the subject into its irresistible orbit. It is therefore for a variety of reasons that Giotto's *Navicella* constitutes a mythic origin of animation in Western representation, and like the origin of every myth (following Levi-Strauss), the material object that supports such an invention is "necessarily" lost.[13]

To be sure, between the episodes of *Pokémon* and Saint Catherine there are extensive differences not only in terms of chronology and cultural circumstances, but also in the historical reception of the two events. While the *Pokémon* incident was fully medicalized by authorities and demonized by the popular press, Catherine's collapse was *not* considered calamitous by her contemporaries. On the contrary, this extraordinary occurrence was revered as additional proof of the saint's divinity and became a constitutive part of her legend.

For centuries the halo over Catherine's figure would freeze into a venerable arch. Even her early nineteenth-century biographers would describe her collapse in Saint Peter's as a divine apparition of grace. It was only during the fin de siècle that Catherine's ecstatic encounters would be stripped of their supernatural aura and become pathologized, if not directly demonized. It is remarkable that in J.-M. Charcot and Paul Richer's *Les Démoniaques dans l'art* (*The Demoniacs in Art*) of 1887—a well-known account of the diachronic relations between art and hysteria—Catherine is the only historical personage, appearing three times in both image and text: in the first two instances as

the serene healer of possessed victims, and then as a delusional ecstatic. The authors compare her visions to "the passionate attitude" (*les attitudes passionelles*) of turn-of-the-century hysterico-epileptic females.[14]

Here, it is as if Giotto's redeeming *Navicella* turns into a *Stultifera Navis*, the medieval "ship of fools" that Foucault invokes in the first chapter of *Madness and Civilization*.[15] The spirals of divine communication break down into the illegible scrolls of the insane. The age of reason draws a line between ecstatic revelers and pathological victims possessed or unexpectedly attacked by animation.

The dog and the parasol

Following the overstimulation of contemporary preteens and the collapse of medieval ecstatics, the third example of this episodic history comes closer to the proper temporal frame of this book, which issues from the second half of the nineteenth century. The victim, here, is not a human being but an animal, specifically a domestic animal that during that particular period appeared to frequent, even more hauntingly, the territory of the human:

> [M]y dog, a full grown and very sensible animal, was lying on the lawn during a hot and still day; but at a little distance a slight breeze occasionally moved an open parasol, which would have been wholly disregarded by the dog, had any one stood near it. As it was, every time that the parasol slightly moved, the dog growled fiercely and barked. He must I think, have reasoned to himself in a rapid and unconscious manner, that movement without any apparent cause indicated the presence of some strange living agent, and no stranger had a right to be on his territory.[16]

Picture an English garden on a hot summer day in the early 1870s. Charles Darwin, the owner of the dog and author of that autobiographical description, is resting on a bamboo armchair set on the backyard of his Down House at Kent, with his dog beside him.[17] One or more women must have been strolling around, leaving an open parasol behind. Suddenly a slight breeze blows, the parasol moves, and the dog starts growling. The stillness of the picturesque landscape is instantly shattered and from the English countryside we are suddenly thrown into the jungle. "The tendency in savages to imagine that natural objects and agencies are animated by spiritual or living essences, is perhaps illustrated by a little fact which I once noticed," was Darwin's preface to the description of his dog's reaction to the parasol in his 1871 *The Descent*

of Man.[18]

While sitting in his garden, Darwin might have been ruminating on his recent reading of descriptions of animist religions in "primitive societies" by nineteenth-century British anthropologists, such as Edward Tylor, Herbert Spencer, and John Lubbock, all of whom are cited in the scientist's footnotes in the same section as the story of the dog.[19] In the ethnographic accounts collected in such narratives, it is not parasols, but trees, bamboo shoots, and seashells that sway, hiss, or whistle, eliciting the defensive reactions of the fearful "savages." Such auditory illusions were considered by Covent Garden anthropologists the very origins of animistic beliefs—a perfect aural supplement to Darwin's own anthropological observation in his garden.[20]

It is as if the dog's growl crossed a line between different topographies: animal and human, "savage" and civilized, textual and real. Darwin himself attempts to anthropomorphize his dog: "full grown and very sensible" as well as capable of rationalizing the agency of movement. The dog, in turn, momentarily animalizes Darwin's mind, causing his thoughts to swerve and forcing him to identify reason as, essentially, an animal defense. The dog no longer represents a domestic animal but a radically disruptive form of animality. Its growling is similar to a prelinguistic sign, such as mumbling, trying (and failing) to fully articulate a reaction.

Following Darwin, the absence of human agency in the production of movement causes the dog to "unconsciously" bestow a living power on the parasol. The animation of the object is predicated on the momentary suspension of human presence. But here the human factor is essentially elided in more than one register. The "living agent" intuited by the dog behind (or inside) the parasol is evidently not human; it is rather another animal—or even something fundamentally unknowable, which triggers the hostile reaction. Animation is then not only about the uninvited "intrusion" of the object into the territory of the animal, but also the sudden reappearance of the animal within the territory of the human. Animism becomes animalism, and animation provokes animalization. The back-and-forth swaying of the parasol redraws these anthropological perspectives.

Darwin's brief animal example must have made quite an impression on his contemporaries. The growling of his dog not only echoes earlier anthropological descriptions, but also provokes new ones from the very class of anthropologists cited by the scientist. For example, in a chapter on "The Ideas of the Animate and the Inanimate" from the first volume of his *Principles of Sociology* (1876), Herbert Spencer would add his own reactions to the epi-

sode described by Darwin. Spencer in general rejects Tylor's doctrine of animism as the belief in "life" attributed to movement because, as the sociologist claims, both men and "superior animals" are able to distinguish "living" from "merely moving" things by evaluating the "spontaneity of motion."[21] While birds or cattle browsing in the field were once alarmed by the presence of the railway, in contemporary times, claims Spencer, whenever a train passes, the same animals continue to graze, unruffled.

> Converse evidence is yielded by the behaviour of a dog mentioned by Mr. Darwin. Like others of his kind, and like superior animals generally, he was regardless of the swaying flowers and the leaves occasionally rustled by the summer breeze. But there happened to be on the lawn an opened parasol. From time to time the breeze stirred this; and when it did so, the dog growled fiercely and barked. Conscious, as his experiences had made him, that the familiar agency which he felt raising his own hair, sufficed also to move the leaves about, and that consequently their motion was not self-produced, he had not observed so large a thing as a parasol thus moved. Hence arose the idea of some living power—an intruder.[22]

Spencer's dog is even more rational than Darwin's (even if both authors refer to the same animal). The philosopher's canine is fully capable of deciphering the agency of movement and distinguishing the animate from the inanimate based on empirical observation. For the mental evolutionist, the parasol incident was simply a momentary "error," and even humans can temporarily err. Animation is then presented as an occasional lapse of our rational faculties; it signifies the reanimation of a primitive mentality, into which only under extraordinary circumstances can civilized subjects occasionally relapse.

While Spencer refutes the animation of objects, his own description becomes more animated by the implementation of contextual details. The "flowers," the "leaves," the dog's "own hair"—none of which were present in Darwin's original description—here emerge, fusing reality with imagination. As Aby Warburg would later prove in his dissertation on Botticelli's representation of "accessories-in-motion," animation thrives by the flourishing of peripheral details following a state of epistemological suspension.

Darwin's animal example becomes further embellished in the interpretation offered by Tito Vignoli, the animal psychologist whose book *Myth and Science* (1880) was an influential source for the young Warburg.[23] Vignoli had apparently read about the dog and the parasol in Spencer, yet he enhances the biologist's description with new insights:

For if the dog were frightened and agitated by the movement of the umbrella, or ran away, as Herbert Spencer tells us, from the stick which had hurt him while he was playing with it, it was because an unusual movement of pain produced by an object to which habit had rendered him indifferent, aroused in the animal the congenital sense of the intentional subjectivity of phenomena, and this is really the first stage of myth, and of its subsequent form of fetishism.[24]

For Vignoli animism is not an instantaneous lapse into the animal, as it was for Darwin; nor is it a momentary suspension of rational faculties, as it was for Spencer. Animism for the animal psychologist is an ongoing "mythmaking" impetus, deeply imbedded in the organic memory of the living being. For Vignoli, it is primarily pain that revives the experience of animation. While pricking the animal skin, the formerly unseen "stick" (the material signifier of the parasol) stirs the concentric circles of disquiet that engulf the organism from within.[25]

As an animal psychologist, Vignoli was particularly interested in the response of animals to inanimate objects in movement, which he investigated in a series of experiments that he describes in detail in *Myth and Science*. The scientist would, for example, insert an "unfamiliar object" that he would then move by a "simple arrangements of strings" inside the cages of "birds, rabbits, moles, and other animals," or he would also instruct one of his assistants to hide among the hedges and interrupt the path of a running horse by brandishing "a white handkerchief" attached on a stick to test how the animals would react.[26] Vignoli concluded that the animals' responses to the movement of objects correspond in two modes of animation or "Belebung"—the experience of infusing life into an object. The first animation Vignoli called *static*, and the second *dynamic*. In static animation "the sentient animal subject remains tranquil." While the act of vivification has a tremendous impact on the animal's mind, the living creature shows no "external signs" of it. While extraordinarily intense, psychological response remains physically muted. In dynamic animation, Vignoli observes the reverse behavior: the animal expresses the overwhelming effect of the object "with violent gestures, cries, and other animated signs . . . as if the inanimate object were another real animal."[27] Such would evidently be the case of the violent reaction of Darwin's dog to the swaying parasol. In the static mode, animation is an imperceptible trembling, while in the dynamic one, a violently arrested form. Unlike all previous authors, Vignoli makes clear that animation is not necessarily associated with external

movement, but it can also be intensely present in inertia.

In his working notes and in his copy of the German translation of Vignoli's book, Aby Warburg underlines precisely the scientist's two types of animation (fig. 0.3).[28] Warburg essentially combined the static and dynamic aspects of animation in the singular gesture of the "pathos formula" or *Pathosformel*— an ancient pictorial device that transforms a vital bodily reaction provoked by an impending mortal danger into a stylized pattern of expression. In Warburg,

Figure 0.3 Top, Aby Warburg, note on "static" and "dynamic" (*statische-dynamische*) "animation" (*Belebung*) from Tito Vignoli's *Mythus und Wissenschaft*. Warburg Institute Archive (WIA), Zettelkästen (ZK) 41, "Aesthetik," 041/021131. *Bottom*, the same passage and terms underlined in Warburg's personal copy of Tito Vignoli's *Mythus und Wissenschaft* (Leipzig: Brockhaus, 1880). Library of the Warburg Institute. Photographs: Warburg Institute, London.

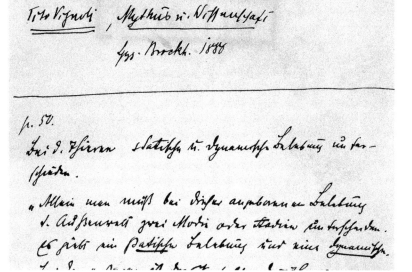

dynamic animation becomes essentially static by its form of expenditure. And it is in fact in a similarly expressive gesture—albeit a textual one—performed by Warburg himself that we may witness the poignant conclusion to the episode of Darwin's growling dog and the parasol.

During his student days in Florence in the late 1880s, Warburg had extensively read Darwin, as well as Vignoli. Among his lengthy notes on Darwin's *The Expression of Emotions in Man and Animals* there is one page on dogs (*Hunde*) that refers to a page of the English edition of Darwin's book that includes the engraving of "a snarling dog" (fig. 0.4). The same cluster of transcriptions and comments includes references to Darwin's *Descent of Man* and Spencer's *Principles of Sociology*.[29]

Nearly thirty-five years later, in March 1923, while receiving treatment at

Figure 0.4 Drawing of "Head of snarling dog. From life by Mr. Wood," in Charles Darwin, *The Expression of the Emotions in Man and Animals* (London: J. Murray, 1872), fig. 14.

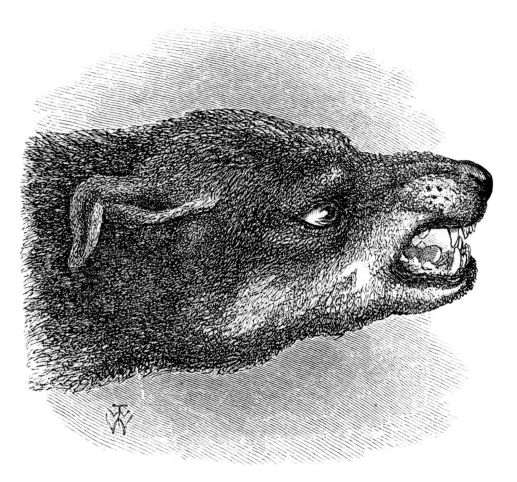

Fig. 14. Head of snarling Dog. From life, by Mr. Wood.

Ludwig Binswanger's sanatorium in Kreuzlingen for his mental breakdown, Warburg composed an autobiographical fragment in preparation for his well-known lecture on Pueblo dance rituals. In a passage from this text that refers to mythical conceptions of causality Warburg notes: "When a door screeches because of an air current, this excitation provokes in the savage or in the infant a sentiment of anxiety." And here, in a spontaneous association, the art historian exclaims: "The dog growls!" (*Der Hund knurrt!*)[30]

Three and a half decades after the art historian first read Darwin and Vignoli, the dog's growl reverberates as a mental reflex—just as Darwin originally perceived it in his own autobiographical memoir. As in Vignoli, animation for Warburg represents the reanimation of a phobic memory *engram*. As opposed to the liberating protraction experienced by the Pueblo dancers in their identification with nature, animation for Warburg and Vignoli is transformed into a phobic contraction, the memory of which is as painful as the original event.

From Warburg to Vignoli to Spencer and back to Darwin the same animal cry ricochets from one text to the next. The animated event becomes part of a historiographic legend that amplifies the original incident. All four of the previous authors associate the dog's growl with the idea of causality. But contrary to all of them, one might argue that the spasmodic reaction of the dog is motivated by the very inability to find a cause. The moving artifact can offer no answer to the question of agency, but it can further procreate this and other questions. The dog would have to attack and destroy the parasol, only to discover there is nothing behind its beckoning surface.

I would then finally argue that Darwin's dog is *not* barking at the parasol; instead, it is barking at itself out of frustration. The dog's hostile reaction stems from its inability to decipher the enigmatic object treading on its territory. The response of late nineteenth-century European thinkers to the phenomenon of animation is perhaps not much different. The reason why anthropologists and mental evolutionists, like Spencer and Darwin, appear so puzzled by the dog's cry is because they themselves are fundamentally perturbed by the enigmatic intrusion of animated artifacts within their own cultural ground. The dog's growl resonates with their own ambivalence toward a strangely familiar animistic mentality that, while omnipresent in both archaic and technologically advanced societies, they dismiss as irrational and animal-like.

Invented as an apparatus of climatic temperance, the parasol serves now as an ideogram of cultural intemperance. It oscillates not only by the breeze, but also by the psychological ambivalence of its users—no wonder that its slight swaying would end up causing such a stir.

Animism

As made evident in Darwin's references to contemporary anthropological literature, the strange object (or strange animal) that had intruded into Western territory was the idea of *animism*, which was introduced by ethnographic descriptions in the second half of the nineteenth century to describe the religious attitudes of "primitive" people. Perhaps in an attempt to make that idea less strange, anthropologists would compare it with earlier Western philosophical discourses on the soul, such as Aristotle's *De Anima*, Leibniz's *Monadology*,[31] the animistic theories of the seventeenth-century medical philosopher G. E. Stahl,[32] or the *panpsychist* theories of mid-nineteenth-century multiscientists such as Gustav Theodor Fechner, whose works regained popularity during the fin de siècle.[33] Though *animation*, *animism*, *animatism*, and *animosity* are independent concepts, they share the same etymological root in the Latin *anima*, or soul, based on the Greek *ἄνεμος*, meaning wind, breeze, or, simply, air. But this ethereal linguistic origin also discloses the enigmatic plasticity of these concepts and their ability to illusively fuse with one another. Air appeared to suffuse everything with an enigmatic buoyancy; it made words and things move when they were not supposed to be swaying. Darwin's dog might as well have been barking at the breeze.

Perhaps the first systematic attempt to organize non-Western ideas about the soul into a religious and philosophical doctrine is in Edward Tylor's voluminous anthropological study *Primitive Culture* (1871), whose second section is entirely devoted to the principle of *animism*.[34] "Savages," according to Tylor, perceive "souls" everywhere: "rivers, stones, trees, weapons and so forth, are treated as living intelligent beings, talked to, propitiated, punished for the harm they do."[35] The very idea of the *anima* is thus associated with a type of menacing behavior on the part of objects ("the *harm* they do"), which is reciprocated by an ambivalent performance ("punished," "propitiated," "talked to") by the afflicted subject. As Tylor observes, this habit of animated exchange had been already invoked in the studies on fetishism by De Brosses, as well as in Hume's *Natural History of Religion* and Comte's *Philosophie Positive*.[36] However, Tylor insists on a distinction between animism and fetishism. Unlike fetishism, animism does not refer to a singular object; instead, the anima is a property common to all natural bodies. It is an indistinct substance evolving from the body like the scent from the flower; like a permanently migrating "no-body," the soul traverses the physical and the metaphysical world.

> It is a thin insubstantial human image, its nature a sort of vapour, film or
> shadow; the cause of life and thought in the individual it animates; indepen-

dently possessing the personal consciousness and volition of its corporeal owner, past or present; capable of leaving the body far behind to flash swiftly from place to place; mostly impalpable and yet also manifesting physical power and especially appearing to men walking or asleep as a phantasm separate from the body of which it bears the likeness; continuing to exist and appear to men after the death of that body; able to enter in, possess and act in the bodies of other men, of animals and even of things.[37]

Such form of animation is more often heard than seen. As mentioned earlier in relation to Darwin's example, early ethnologists would situate the origin of animistic beliefs in auditory effects of inanimate objects in nature, such as the rustling and crackling of tree leaves or the wailing of bamboo shoots.[38] When the spirits appear in the dark room of the shaman, voices are heard from everywhere; there is "rattling and drumming" on "the dry reindeer," "bears growl, snakes hiss and squirrels leap about in the room." No doubt "it was the spirits who were drumming, growling, and hissing."[39] This "hissing" sound might explain why "kettles" and "locomotives" are the most frequent technological artifacts to be included in these animistic descriptions.[40] The anima has many objects working in its service, for the soul itself is always migrating, moving, shifting.

According to Tylor, movement is key for the perception of the anima. Everything in motion—"the rivers, the stars, the sea, the sun, the moon, light itself"—is animated. Contemporary natural philosophy would in fact agree with the "primitive" belief that movement is an essential vital force and therefore coincides with life: "We advance by placing one foot in front of the other; other creatures, like the leech, by drawing the body together; others, like the infusoria, slither along by the aid of cilia; and all of these movements are dependent upon totally different principles. Yet the ideal aim of attaining what is necessary for life by a change of place is in all cases the same."[41] Everything remains living by changing place. It does not matter whether the organism uses its feet, like bipeds and quadrupeds, or its entire body, like the snake, or whether it advances quickly, like the hare, or slowly, like the snail. It does not even matter whether the organism is in fact an automated mechanism, whose movement is without consciousness. The anima is a mobile energy that is independent from the bodies it infuses. Ethnographers like Wundt, Durkheim, and Mauss in fact describe the belief in such a mobile force as the intrinsic principle of the *preanimistic* stage, or *animatism*, also mentioned by Freud in *Totem and Taboo*. Animatism describes the animation of all objects by a universal force; it is, however, "a diffused state of force equally spread into

all objects, preceding the individual souls."[42] If there is indeed a survival of animistic beliefs in technologically advanced civilizations, it is not animism that persists, but rather the abstract condition of animatism—the belief in a perpetually circulating energy located outside of individual bodies.

In spite of its energetic influence, the turn-of-the-century revival of animism had only a limited lifespan. Not long after it was invoked by Tylor, animistic thought was repudiated by mental evolutionists, such as Spencer, who refused to believe that "savages" were naïve enough to perceive souls in inanimate objects. Tylor himself had warned that the animism inherent in modern and primitive forms of "spiritualism" threatened to put "two hundred years of Enlightenment" in danger.[43] Yet the anthropologist had all the more "reason to be thankful for fools"—not only primitive "savages," but also modern ghost-seers, Boston mediums, and members of organized "spiritualist" societies—who showed "how large a share of stupidity, unpractical conservatism and dogged superstition" have had in preserving traces of ancient beliefs, thus serving as "witnesses against themselves" in the precipitous progress of modern science.[44]

Darwin's dog was then not alone in being tricked by the movement of an object. He is in the same company of characters, including the "spiritualist" believer, the female hysteric, and the "savage," who, according to nineteenth-century science, were most likely to be "fooled" by animation. But none of these representatives of "lower stages of humanity" was more privileged and prone to such deception than the child.

The baby and the chair

Trying to move beyond the animistic beliefs of tribal and spiritualist societies and to illustrate the animistic practices of everyday life, Tylor would invoke a number of familiar incidents involving "fully grown Europeans" who in the face of an accident regress into infantile behavior. For example, after bumping their head into furniture or a wall, otherwise sensible adults would "instinctively" blame the object, curse it, and even hit it back. "The force of momentary passion will often suffice to supersede the acquired habit," Tylor explains, "and even an intelligent man may be impelled in a moment of agonizing pain to kick or beat the lifeless object from which he has suffered."[45] As in the case of the dog and the stick described by Vignoli, pain is the primary catalyst for the vivification of objects and the reflexive regression into animist mentality.

As Tylor would remark, children—and especially when irritated by pain—are highly susceptible to such behavior. "The first beings that children learn to understand something of are human beings, and especially their own selves; and the first explanation of all events will be the human explanation, as though chairs and sticks and wooden horses were actuated by the same sort of personal will as nurses and children and kittens."[46] While denigrating animism as "infantile," Tylor inadvertently elevates it into an innate element of human behavior. It is as if the child, according to Tylor, sees an object as another infant—a lively yet not fully grown human individual. Animism is once more *masked* by an infantile aspect of anthropomorphism, which was a much more familiar idea for Western audiences.

Spencer again would disagree. Invoking another painful interaction between a child and a piece of furniture, the sociologist would argue that animistic behavior is not innate but acquired—in fact taught by certain ill-behaving adults: "But on remembering that trying to pacify a child that has hurt itself against some inanimate object, a mother or nurse will affect to take the child's part against this object, perhaps saying, 'Naughty chair to hurt baby—beat it!' we shall suspect that the notion does not originate with the child but is given to it."[47] What is "given" to the baby, then, is not only the belief that the object is animate and responsible for his or her pain, but also the impetus to reciprocate the injury: "Naughty chair to hurt baby—*beat it!*" Mother and child spontaneously unite in lively camaraderie against the indefensible object. The prelinguistic signal of Darwin's growling dog now transforms into the mother's full-fledged instruction to attack, as an attempt to counteract the infant's verbal insufficiency. The mother not only humanizes the object by telling the baby to strike it, but also objectifies the baby by canceling its own subjectivity. The alleged "humanization" of the object provokes the most inhumane behavior in the subject. It is as if the only way humans and objects can communicate is through reciprocal punches. That is the gestural language of animation taught by a subject to another subject and bestowed, only by *accident*, upon the object.

Forty years after Spencer's study, Émile Durkheim would further the English sociologist's refutation of animism by elaborating on the same accident:

If [a child] lays the blame on the table which has hurt him, it is not because he supposes it animated and intelligent, but because it has hurt him. His anger once aroused by the pain, must overflow; so it looks for something upon to discharge itself, and naturally turns toward the thing which has

provoked it, even though this has no effect. The action of an adult in similar circumstances is often as slightly reasonable. When we are violently irritated, we feel the need of inveighing, of destroying, though we attribute no ill will to the objects upon which we vent our anger.[48]

Durkheim demonstrates that animation does not, as Tylor would claim, concern the "personification" of causes. The cause at this point is irrelevant. What matters is to discharge the effect that has been caused by *any* agent, even if such reaction has no impact. Once again, animation does not concern specific objects, effects, or directions; rather, it is an indiscriminate *furor* that unites subjects and objects through a mutual process of destruction. Like "sneezing" in primitive beliefs, souls and spirits pass from one body to another with malevolent effects. Animism regresses into the preanimistic abstract force of animatism by turning into pure animosity.

Unlike the parasol that moved toward the dog, here the baby advances toward the table. In this case the object stays still, while the subject bumps into it accidentally. And yet the encounter is still described as if the child was hit *by* the table. The occurrence of an accident conflates the idea of causality with the very inability to find a cause. In many of these cases, the expiation of guilt is habitually transferred upon the object, which is the most convenient entity to blame. Historians would describe how in ancient Athens inanimate artifacts were put on trial and cast out beyond the city's border when an accident happened to their users.[49] The eviction of incriminated tools from the civic territory of ancient Greece echoes the expulsion of animistic artifacts from the limits of the civilized world in turn-of-the-century modernity. Reading the descriptions of "the maliciousness of the object" in the fictional narratives of the philosopher Friedrich Theodor Vischer, one might be lead to believe that objects are guilty for all the misfortunes that plagued late nineteenth-century Europe.[50] While revered and overvalued on a material level, artifacts are criminalized within Western epistemological discourses; perhaps then objects and not subjects are the most unfortunate *victims* of animation.

Phobic animation

From the animated encounters between Darwin's dog and parasol, to Spencer's child and nursery furniture, it is as if we only remember to attribute agency to objects when something *bad* is happening to us. Animation appears to happen only as an *accident*—a disruptive event that destabilizes normative procedures. In order to acknowledge that objects have a life, they have to

knock us on the head and anaesthetize us; when we recover (if we do), we *have* to hit them back in return, following the example of our nineteenth-century predecessors.

What we experience in these spiteful encounters is a form of animation we could describe as *phobic*. As in Vignoli's animal experiments, the idea of vivification follows the fearful reactions caused by objects intruding into the territory of the living. Either expressed in bodily collapse (*Pokémon*) or violently asserted as a "punch on the table" (Durkheim), *phobic* animation discloses a relationship that always oscillates between the inexplicable revolt perpetrated by objects and the dumb role we insist on assigning to them.

This ambivalent attitude is a product of what Freud, Vignoli, and Darwin would describe as the "hostile external environment" (*die feindliche Umwelt*). However dynamically expressed, phobic animation remains static. It is a process in which external and internal painful stimuli replicate each other endlessly, but in a limited space. Such phobic experiences are trapped inside the immobilizing spaces of the uncanny and lost among the endless deflections of the psychoanalytic screens that mediate between projection and introjection. This belligerent environment is the invention of turn-of-the-century psychoanalysis, anthropology, and natural science; yet it is also a product of the historical, political, and socioeconomic conditions of the fin de siècle, which bequeathed that malevolent milieu to us. Recall how Tylor described animism: "rivers, stones, trees, weapons and so forth . . . talked to, propitiated, punished for the *harm* they do." Things, at the turn of the century, are not primarily considered for the good they may produce, but rather for the harm they are capable of inflicting.

Not only the objects, but also the subjects victimized by such animated environments are integral parts of that phobic cycle. The child, the female hysteric, the "savage," and the (domestic) animal are the frail victims of a perpetual assault by their surroundings. Such bodies have a "lower threshold" in their defense mechanism, yet a higher degree of sensitivity in their lively exchange with objects and spaces. The "hostile external world" is made *for*, and in some cases, *by* them. As much as this study bestows agency on objects, it also tries to restore the traumatic subjectivity of these ailing characters—sometimes through the very objects that have hurt them.

You live and (yet) do nothing?

Here we can revisit the epigram with which this introduction began: "You live and do nothing to me" (*Du lebst und thust mir nichts*). The phrase was used as

a motto by Aby Warburg on the first page of his unpublished manuscript on aesthetics, originally titled *Foundational Fragments for a Monistic Psychology of Art* and written between 1888 and 1903. In this highly disparate collection of over 430 aphorisms, one of the overarching themes is the shifting relation between the experiencing subject and the object through the mediation of the image.[51]

Warburg's intellectual biographer Ernst Gombrich translates the epigram as "you live and do me no harm," which presupposes that the only thing that an object can do is harm and not something good (which, most likely, was also Warburg's presupposition).[52] However, the phrase itself creates more ambiguities than this unequivocal assertion. And, first, who is the person that speaks: a subject, an art historian, or the unconscious? Why does it appear only as the recipient—"to me" (*mir*)—of the object's tentative action? But then does the "you" (*du*) refer to another subject or an object, and if it is an object, is it a physical artifact or a two-dimensional image? Or could it simply be anything that could eventually be perceived as "living"—a general perception of aliveness? But the most ambiguous word in this small sentence is the "*und*" in the middle of the original phrase, which can entirely change the meaning of the statement: are we to understand it as a merely paratactic "and" or as an apposite conjunction, such as "yet," "but," or "even though"?

Either "you live and (because you live) you can do nothing to me," or "you live, yet (despite the fact that you live) you can do me nothing." In the first case, the phrase demonstrates our empathetic attachment to things that give a general semblance of life by appearing lifelike. Following empathy theorists such as Friedrich Theodor and Robert Vischer, whom Warburg was avidly reading at the time,[53] humans have a tendency to empathize with things that look like them, such as objects with curved shapes that give a semblance of organic life. And yet, the object of organic form is merely lively but not actually living; therefore, even if it appears capable of doing things, it can essentially do nothing.

Following Vignoli, Warburg considers that in real life animals and humans perceive everything that looks alive or merely moving as "hostile" and potentially harmful.[54] *But not in art.* Art (or at least Western art) allows us to have representations of "life-in-motion" (*Bewegtes Leben*) that are not threatening. The subject is pacified by encountering "living" things that are essentially harmless. The lively images of turn-of-the-century Western representations exorcise the animistic power that artifacts have in tribal cultures. The "you" (or *du*) of Warburg's motto could then entail all three possibilities of being a

subject, an object, and an image; but it is ultimately the image that absorbs, inflects, or nullifies all previous agencies and mediates our communication with both subjects and objects.[55]

"Here," adds Warburg in a note scribbled underneath his motto, "lies the idea of Distancing" (*Entfernung*).[56] By turning the "living" object into a lively image, our once empathetic identification with it transitions into a seemingly safe abstraction. Like most of his contemporary theories of empathy, Warburg's motto is a defensive response against the animistic properties of the object—a reassuring assertion that seeks to pacify the terror of agency in a category of being that is radically different from our own. Instead of being confronted with real life (*das Leben*), the subject rejoices in the graceful liveliness (*Lebendigkeit*) of animated images. Cartoons then could be the antipode of Darwin's parasol; however, the grave consequences that we observed earlier in the *Pokémon* mishap prove that even seemingly innocuous cartoons can do much more than "nothing."

But we could also read Warburg's phrase in reverse. What happens when an object does *not* live or does not seem to be living? What is the impact of images or artifacts that do not appear lively, but dead? Perhaps the art historian's statement demonstrates not only our sympathy with things that are seemingly alive, but also our fundamental dread of things that appear lifeless or inorganic. Western art knew for centuries that in order to obliterate the enigmatic power of an object, the trick was to infuse it with life, to strip the *thing* of all its deathly connotations. That is exactly the task that modern art and architecture, having absorbed the lesson of the primitive fetish, have forsaken. Modern art-industry (Riegl's *Kunstindustrie*) discovered that in order to keep the human subject under its spell it had to unleash the auratic power of death that the artifact innately carries with it.[57] In their illusive inertia and animated inorganicism, modern artifacts whisper vindictively in Warburg's ear: "I may not live, yet I can do *anything* I want to you!" "*I* can—*you* can:" the object now does the talking.

Extensional animation

Of course this daemonic retort is not part of a communicative exchange and does not really give a voice to the muted object. In their enigmatic silence, objects can pose a multitude of questions, but can never give answers or make positive and negative claims.[58] Warburg's motto and its legacy in twentieth-century aesthetics do not break but complete the cycle of mastery and oblit-

eration that characterizes a mode of animation based on fear. Almost all of the animated responses we have witnessed so far appear as instances of *phobic* animation. But could we ultimately be allowed to communicate with an object instead of fearfully retracting or reciprocating the attack? In other words, could there be another form of animation, in which we could survive the life of objects without suspending our own?

As opposed to the contraction characterizing fearful experiences, we could envision an animated occurrence based on formal *extension*. The animated form protracts instead of forestalling modes of relationality between a subject and a thing. Such extensional encounters would consist of an exchange based on a willing and not coerced reciprocity between different species of animate and inorganic life. Unlike the immobilizing effect of the uncanny and of fetishism, such extensional forms of animation facilitate an uninterrupted flow, a continuous use without possession. The anima becomes a borrowed substance, a gift that no one possesses and that continuously returns to its original source for others to use, too.

While pronouncing the death of earlier anthropological theories of animism, in the conclusion of his *Elementary Forms of the Religious Life*, Durkheim proposes a way that the idea of the anima could continue living. What inspired the idea of the immortality of the soul was not the belief in an individual psyche that would hover in some faraway ethereal region after death, but "the perpetuity of the life of the group" right here on earth. The anima was an immaterial bond, a "germinative plasm" representing a type of "spiritual unity" that connects the members of the social organism in the course of life and death. Human bodies act as material heuristics, while the anima is the permanent factor in the social equation. Durkheim applies the same sociological scheme to totemic systems, in which the impact of the soul expands from human bodies to things:

> No one possesses it entirely and all participate in it. It is so completely independent of the particular subjects in whom it incarnates itself, that it precedes them and survives them. Individuals die, generations pass and are replaced by others; but this force always remains actual, living and the same. It animates the generations of today as it animated those of yesterday and as it will animate those of tomorrow. Taking the words in a large sense, we may say that it is the god adored in each totemic cult. Yet it is an impersonal god, without name or history, immanent in the world and diffused in an innumerable multitude of things.[59]

Not only the life of the tribe, but also the survival of animation as a collective practice depends upon this "impersonal" nucleus described by the ethnographer. Animation is in the core of every social movement. The desire for a collective point of reference unites bodies and things in perpetual circulation. The object that houses that soul can be anything: a twig, a bird feather, a live animal, a manmade artifact, or a building structure. The subject grants power to the object as an active gift. Properties, qualities, and social relations are all incorporated in this object whose circumference of energy far exceeds its actual dimensions. This form of collective movement centered upon objects is certainly not absent in modern terrains, but it is displaced and stalled in a static yet extremely potent form of vibration. The vision of that omnipotent soul might be the agent that propels the contradictory responses of what Vignoli (and then Warburg) recognized as *static* animation.

Taking account of the differences between archaic and modern animistic practices, we can elucidate the distinctions between Durkheim's model of social animation and its fossilized remnants in modernity. While the ethnographer's collective soul was supposed to unite the members of a social group, the spirited economy of capital separates them. Not all members have equal access to the animating force, leading to a substantial difference in the mode of social organization. Durkheim's principles were based on the *organic* theories of Saint-Simon and his followers, for whom the social organism was a unified bodily entity of external limbs and internal organs activated by the same animating force.[60] Yet during the transformation of this organism from nineteenth- to twentieth-century discourses, its mode of organization shifted from an organic to an inorganic—or even *superorganic*—model. Modern plateaus are animated by the social friction they produce and the reaction force they generate.

What we recognize today as animation is rather the *reanimation* of the memory of Durkheim's lost collective soul. While distributed in a multitude of spaces and scattered in a mass of artifacts, contemporary animistic practice fails to fulfill its social promise.[61] As ethnographers recount, when the divine fetish did not produce the goods it had promised, the previously reverent faithful would revolt and start beating and abusing the object of their earlier exaltation as punishment for its "deceit." Unlike the altercation between the child and the furniture, here the object is punched back not for the injury it unexpectedly triggered, but for the anticipated benefit it fell short of producing. The spirit of the depreciated object would wander belligerently in the air as a side product of the energy that was "wasted" in it.[62] In a similar way,

commodified artifacts fail to fulfill the promise of communication that they advertise on their surface. When their conceit wears out, they will inevitably provoke the contempt and aggression of their former users, and in turn appear daemonic or malicious, thereby perpetuating the "hostility" of the external world.

"Animism spiritualized the object, whereas industrialism objectifies the spirits of men," claim Horkheimer and Adorno. Commodity fetishism has an "arthritic influence over all aspects of social life," which gradually transmogrifies individuals into things.[63] The symptoms of "arthritis" diagnosed by the two dialecticians of Enlightenment disclose that the bodily effect triggered by the overstimulating environments of modern life is not the instant paralysis that afflicted the *Pokémon* victims or Saint Catherine. Rather, an imperceptibly slow process of calcification takes hold of the body, gradually mineralizing its substance and arresting its mobile soul.

This introductory history thus concludes with an instance of paralysis similar to the one with which it started. Petrification is the starting point and endpoint of animation. The very structure of the *Pokémon* episode serves as an ideogram for the transformation of modernity's animated response. However we try to historicize it, animation lives in a temporal void that resembles the spatiotemporal blackout experienced by the chromoepileptic teenagers. Suddenly the human action stops, and the screen is filled with a series of revolving spirals that transport the narrative back in time, while the audience gasps in a state of suspended animation. If the growl of Darwin's dog expressed the hostile reaction of Western subjects to the territorial intrusion of non-Western animistic mentalities, then the instant seizure experienced by the contemporary juveniles signals that the lively gestures of the previous century have abruptly ended. We have moved from the dynamic animation of the 1900s to the stultifying anesthesia of *Fantasia 2000*.

Warburg's verbal exorcism against the object, the growling of Darwin's dog at the parasol, the instruction of Durkheim's nurse to beat the chair that had allegedly hurt the baby, all are instances not of a facilitative exchange between subjects and objects, but a barrage of miscommunication. Turn-of-the-century histories of art and anthropologies of culture provide us with a record of failed responses to the appearance of animistic artifacts by which Western audiences are both enlivened and mortified. There are no truly animated objects in modernity, yet we are inundated by cartoons—mere semblances of animation that conform to Warburg's "you live and do me nothing." Perhaps then the paralysis or the "arthritic" effect of modern culture diagnosed by

Horkheimer and Adorno is in the epistemological divisions that disallow all forms of being other than the human to *live* and have a language of their own. Ultimately, Darwin's dog might have been barking neither at the parasol nor at the breeze, but at its master for failing to make sense of its animate responses.

1

The Movement of Accessories

Fabric Extensions and Textual Supplements from
Modern and Antique Fragments

Animation starts with little things: accessories, supplements, fabric extensions. It is as if the members of that inorganic periphery of matter compose a pliable threshold of the animated field. Accessories are less than regular objects, yet they are able to do more. Oscillating between surface and volume, they act as mediators between the sentient subject and the space that lies beyond her. While their folds record the carrier's movement, accessories also trace a form of agency, which is far removed from the subject's own. These semiautonomous extensions appear to leap from one area of knowledge to the next. The following three chapters on accessories, snake motifs, and vegetal or crystal patterns track this peripheral commotion by reconstructing the scholarship that trails behind it. Accessories form another introduction to a history of animation—a foreword that starts from the object's and the subject's very ends, the mobile edges of their common contours. It is within this interactive space that one may reformulate the foundations for an animated epistemology of the surface.

An epigram from the Bible

And now you, Daniel, bring words into a close,

and seal the Book until the Time of the End;

until many a people are taught,

and knowledge is increased.

The Messianic epigram from the Book of Daniel (12:4) appears twice among the manuscript notes of Aby Warburg. First, in Warburg's personal copy of a German translation of Thomas Carlyle's *Sartor Resartus*. "Many shall run to and fro and knowledge shall be increased," quotes Carlyle from an English version of the Bible, and Warburg cites a larger excerpt from the same passage in German, Latin, and in Greek (but not in Hebrew, the passage's original language) (fig. 1.1, *top*).[1] Carlyle's *Resartus* is a book about another book that would be a philosophy and universal history of clothing. Aprons, cloaks, belts, shawls, and "even the Kilmarnock nightcap is not forgotten"[2]: most of the items piled up in this "irregular treasury of learning" are less clothing per se than clothing accessories, or redressings of the original cloth. The novel's only chapter dedicated to a clothing article is an account of aprons, "screens" worn on top of regular dress as a "safety" defense.[3] The tailoring of the world under the guise of additional layers has no end. From the microcosm of fabric accessories, Carlyle transitions to the macrocosm of the fabric of the earth, the stars, and the sky. Because if "nature is the living garment of God," as Goethe had said,[4] then what else are religion, laws, or even words and thoughts, asks Carlyle, than the manmade appendages of the divine garment?

Predictably, this universal history is never finished, as its hypothetical author, the highly erudite German professor Teufelsdröckh ("devil's excrement") from the university of Weissnichtwo ("don't-know-where"), is unable to bring his chaotic drafts to a close. From early on, Warburg appears to have developed an empathy with that idiosyncratic German scholar. We know that the young Warburg had been reading Carlyle's *Resartus* since his teenage years; it was the first book he recommended to his future wife and a number of his relatives, as if this incomplete history of clothing and its strange author were an accessorized portrait of himself.[5]

It might then not be an accident that the same epigram from Daniel quoted in *Resartus* appears a second time among the manuscript addenda in the *Handexemplar*—the bound printed proofs—of Warburg's dissertation, whose sartorial subject matter was equally multilayered (fig. 1.1, *bottom*). The main objects of the dissertation were Botticelli's two well-known paintings,

Figure 1.1 Top, Aby Warburg, manuscript notes. Quotation from the book of Daniel (12:4) in German, Latin, and Greek. Personal copy of Thomas Carlyle, *Sartor Resartus*, interleaved with notes. The Library of Warburg Institute. Photograph: Warburg Institute, London. *Bottom*, Aby Warburg, manuscript notes. Excerpt from Thomas Carlyle, *Sartus Resartus*, and quotation from the book of Daniel in Greek dated October 12, 1924. WIA, III.40.1.1.1, "Sandro Botticellis 'Geburt der Venus' und 'Frühling,' 1893. *Handexemplar* (personal copy interleaved with notes)." Photographs: Warburg Institute, London.

" Und nun Daniel, verbirg die Worte und versiegle die
Schrift, bis auf die letzte Zeit, so werden Viele darüber
kommen und großen Verstand finden " (?!)

"Tu autem, Daniel, claude sermones & signa librum,
usque ad tempus statutum : plurimi pertransibunt,
& multiplex erit scientia."

Καὶ σὺ Δανιὴλ ἔμφραξον τοὺς
λόγους, καὶ σφράγισον τὸν βιβλίον
ἕως καιροῦ συντελείας, ἕως διδαχ-
θῶσι πολλὰ καὶ πληθυνθῇ ἡ γνῶσις.

Th. Carlyle, Sartor Resartus, p. 6:

".. many shall run to and fro, and knowledge shall be increased .."
[Dan. XII,4] Surely the plain rule is, Let each considerate person
have his way, and see what it will lead to. For not this man
and that man, but all men make up mankind, and their
united tasks the task of mankind."

..... Καὶ σφράγισον τὸ βιβλίον ἕως καιροῦ συντελείας,
ἕως διδαχθῶσι πολλοὶ καὶ πληθυνθῇ ἡ γνῶσις
12. Oct 92?.

The Birth of Venus and *Spring*, while the overall subject was the depiction of fabrics and hair fluttering in the wind, which Warburg called "accessories-in-motion" (*Bewegtes Beiwerk*).[6] Even though completed by the end of 1891 and published by the end of 1892, the dissertation remained open ended until the end of Warburg's life through the continuous supplementation of scholarly addenda, one of which was the biblical epigram (fig. 1.2).

Figure 1.2 Sandro Botticelli, *Birth of Venus* and *Spring*. Illustrations from Aby Warburg, *Sandro Botticellis Geburt der Venus und Frühling* (Hamburg and Leipzig: Leopolod Voss, 1893).

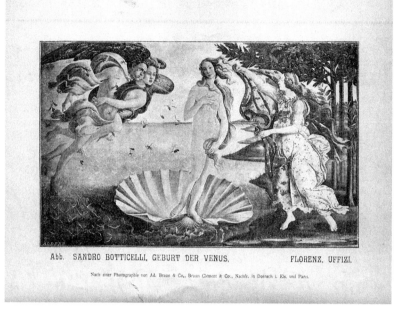

Abb. SANDRO BOTTICELLI, GEBURT DER VENUS. FLORENZ. UFFIZI.

Nach einer Photographie von Ad. Braun & Co., Braun Clément & Co., Nachfr. in Dornach i. Els. und Paris.

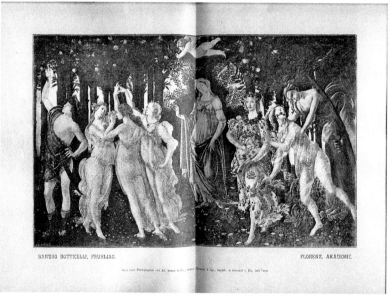

SANDRO BOTTICELLI, FRÜHLING. FLORENZ. AKADEMIE.

Nach einer Photographie von Ad. Braun & Co., Braun Clément & Co., Nachfr. in Dornach i. Els. und Paris.

Looking closer at Warburg's two handwritten additions from Daniel and Carlyle, one notices obvious differences in letter size, penmanship, and ink thickness, which suggest that the citations in Greek, both in the copy of the German *Resartus* and the printed exemplar of the dissertation, were probably added much later. Often Warburg would return to one of his texts, many years after it was published, and add the original source of a particular quotation. The second quotation is then a sartorial redressing of the first, in different languages and different fabrics, yet never in the original one. The scholar uses Carlyle's biblical quotation as an essential accessory, a rhythmically repeated variation that punctuates the evolution of his life and work.

Both in the early drafts and later appendixes to the dissertation, Warburg often substitutes the term "accessories-in-motion" with the phrase "extensive dynamic additions" (*Zusätze*).[7] Interestingly, the same term (*Zusätze*) was used by Warburg's editors to describe the addenda published in the posthumous edition of the scholar's collected writings (including the epigram from Daniel).[8] Such coincidence implies that pictorial and textual appendages are part of the same "extensible" fabric.

For nearly forty years, Warburg continued to redress the main body of his dissertation by adding more of these multilingual accessories. The fabric of this "inaugural" text is kept constantly in motion by the use of philological and iconographic supplements (fig. 1.3). The addendum from Daniel to the hand-exemplar of the dissertation is dated October 12, 1924—approximately two months after the scholar returned to Hamburg from the mental sanatorium in Kreuzlingen. But Warburg continued adding notes even later; one of the dissertation's latest addenda was written on Christmas 1928 during Warburg's last trip to Rome.[9] Inserted less than a year before the scholar died, the note refers to the myth of Daphne—the nymph that turned into a tree—who was one of Warburg's original subjects in the iconographic mosaic of his dissertation (fig. 1.4). His small sketch of the petrified figure may act as a reminder that at times this mass of erudite "accessorizing" can also lead to a scholarly paralysis, as notes start to multiply in ramifying pathways, all of which seem equally alluring.

Why, then, is the biblical epigram placed at the very origin of this ornamented philological treasury? It might seem that by adding more notes, Warburg essentially disobeys God's instruction to Daniel, asking the prophet to put an end to words and "seal the Book" forever. But Messianic statements have no deadlines; the "time of the end" can be infinitely extended. For Warburg, the epigram from Daniel is perhaps a signal that a time *will* come when

Figure 1.3 Aby Warburg, manuscript addenda and inserted illustration. WIA, III.40.1.1.1, "*Sandro Botticellis 'Geburt der Venus' und 'Frühling,'* 1893. *Handexemplar* (personal copy interleaved with notes)." 31. Photograph: Warburg Institute, London.

Figure 1.4 Aby Warburg, manuscript addenda and sketch of Daphne and Apollo *a la franzese* copied from an illuminated manuscript by Christine de Pisan and dated December 25, 1928, Rome. WIA, III.40.1.1.1, "*Sandro Botticellis 'Geburt der Venus' und 'Frühling,'* 1893. *Handexemplar* (personal copy interleaved with notes)." 27. Photograph: Warburg Institute, London.

the book will close, compelling others to pick up the pieces of his erudite clothing. Until then, the historian keeps adding more knots to be unraveled by a community of scholars. "For not this man or that man but all men make up mankind, and their united tasks the task of mankind" is Carlyle's didactic conclusion following his rendition of Daniel. Carlyle's phrase (included in Warburg's notes in English) portrays knowledge as a collective fabric that stays animated by the progressive movement of its threads.[10] Let us now follow one of these textual threads to its hypothetical origin.

A professor smiles

As in a painting of religious iconography, the annunciation of Aby Warburg's dissertation topic was greeted by a smile. Consider this excerpt from a letter by the art historian to August Schmarsow, Warburg's former professor in Florence, written on July 24, 1907, approximately fifteen years after his dissertation was completed:

> [P]erhaps you still recall a winter evening, when we were sitting together at Pauli's (worried about our dear, poor friend Ernst Burmeister) and I confided to you my great secret, that I wanted to write about Filippino Lippi's

fluttering garments and the Antique. How right you were to smile about it then [*Sie hatten damals Recht, darüber zu lächeln*]. Now after eighteen hard years of service I attempt this anew; it would truly please me, if you would find some of these attempts of mine worthy of the effort that the Florentine Exodus once demanded of you. I have you to thank for the inner call of commitment to the Florentine demons as among the 8 [students in your seminar] I remain the solitary combatant (with the exception of Semrau) on the Italian field; [therefore] I thought I should not be absent from this festive tribute [in your honor].[11]

Smiles are inherently enigmatic. We shall never know whether Schmarsow's beaming response was meant to be a sign of recognition or a condescending sneer. The smile itself is a twofold drapery: on the front side, the annunciation of a future revelation, but on the underside, the ill-omened symbolism of a Mephistophelian grin. The "fluttering garments" of Filippino Lippi invest the Florentine interlude with an equally multivalent scenery. Like waving flags, Filippino's fabrics brandish the call to the battlefield against the feisty "demons" that hide inside the same enigmatic pleats. With each of his anxious efforts, the Renaissance scholar renews the pledge to his solitary battle. And now, after eighteen years, and while the younger art historian was finally starting to garner some scholarly attention, he too might have a few reasons to smile in return.

But why would the disclosure of Warburg's dissertation topic provoke such ambivalent responses? After all, throughout the 1880s several art historians in France and Germany, including Schmarsow, were writing about the representation of movement in Renaissance art, with an emphasis on the depiction of fabrics and gestures and their relation to the antique.[12] The subject of "fluttering garments" was neither original nor eccentric. But perhaps an entire dissertation on such fabric appendages, as well as an attempt to reconstruct the culture of an era based on such flimsy items, was, if not original, then rather eccentric, and would justifiably provoke certain smiles. This eccentricity derives not from the *object* but rather from the *method*, the transfer of the accessory from the periphery to the center of representation—a stratagem that implies a major epistemological reversal. In his critique of the "comic" element in literature and theater, Friedrich Theodor Vischer would remark that inverting or turning things upside down represents a change that is against the laws of both physical and intellectual gravity; therefore such irreverent reversals are inherently laughable.[13] No wonder, then, that the young scholar's methodological *sartarelos* would give his professors reasons to be coyly cheerful.

The science of curlicues

As the pleading tone of Warburg's letter discloses, the memory of that first "smile" is tainted by a number of painful experiences. In a newspaper article of 1893, Schmarsow referred to his former student's published dissertation as an "archaeological study of curlicues" (*archaeologische Schnörkelkunde*) and as a "philological absurdity" (*philologischer Aberwitz*). Schmarsow castigated the author of that text (without mentioning Warburg by name) for "denigrating" the painter of the *Primavera* and other Italian artists to the level of "superficial imitators of antique garment tails" (*Gewandzipfel*).[14]

Figure 1.5 Aby Warburg, lecture notes and sketches of volute ornament and "fluttering garments" from the "Battle against the Philistines" from Ghiberti's reliefs on the life of David, *Gates of Paradise*, Baptistry, Florence. WIA, III.33.2.8, "Von Nicolo Pisano bis Michelangelo. Vorlesung von Prof. A. Schmarsow gehalten im Kunsthistorischen Institut zu Florenz, W-S [18]88/89," 67. Photograph: Warburg Institute, London.

Warburg's preoccupation with hair and fabric extensions, however, originates precisely in his early art historical training under Schmarsow in Florence. The phrase "fluttering garments" mentioned in Warburg's letter, apropos Filippino Lippi, appears among his notes from a lecture course on Italian art, taught by Schmarsow at the Florence Art Historical Institute in 1888–89. In a manuscript page from December 1888, Warburg accompanies his written notes on Ghiberti's reliefs for "the gates of paradise" in the Baptistery in Florence with a few fragmentary sketches of the "battle against the Philistines" from the *Life of David*; specifically, the "fluttering garments" (*flatternde Gewänder*) worn by two warriors, and which fly in "opposite directions" (*entgegengesetzte Richtungen*) (fig. 1.5).[15] Warburg also draws the "volute" ornament

attached to the helmet of one of the warriors, suggesting perhaps a formal affinity between the billowing garment and the ornamental pattern. But the mobile accessory lacks the crystalline regularity of the motif. Steered by the warrior's gestures as well as the dynamic space of Ghiberti's battlefield, the garment dissipates the regular geometries of ornamentation.

Another *corruption* of ornament appears in two other pages of Warburg's notes from student exercises following the same lectures, which mention the compositional principles employed by Raphael in his murals for the Vatican's

Figure 1.6 Aby Warburg, manuscript notes and sketches: "A hair of my mustache [*Ein Haar meines Schnurrbartes*]." WIA, III.33.2.7, "Masolino und Masaccio. *Übungen*, KHIF," fol. 91 verso. Photograph: Warburg Institute, London.

Figure 1.7 Aby Warburg, notes on "Camera della Segnatura" and sketches of ornamental motifs. WIA, III.33.2.7, "Masolino und Masaccio. *Übungen*, KHIF," fol. 92. Photograph: Warburg Institute, London.

Camera della Segnatura (fig. 1.7). Here, Warburg notes the contrast between the "definite axes" running through Raphael's composition for the Disputá (Disputation over the Sacrament) and the indefinite axes of The School of Athens.[16] It is as if the rhetorical disputations represented in Raphael's mural are reflected on the ornamental composition of his space. Warburg illustrates his notes with his own sketches of abstract spiral, polygonal, and vegetal motifs, including a symmetrical diamond pattern rendered in the form of a medallion. While a few of these ornaments may vaguely resemble the patterns

of the decorative bands in Raphael's murals, they seem to be Warburg's own self-fashioned embellishments. The scholar appears entirely absorbed by the ornament itself, translating Schmarsow's abstract "compositional principles" into a diamond jewel.[17]

On an adjacent page, there are more sketches filled with ornamental patterns that demonstrate a similar seduction by or abandonment in ornament (fig. 1.6).[18] Bored or amused, the young student accessorizes his notes with a flourish of doodles, including a grotesque human figure emerging from a cocoon that is suspended from a stick (and that eventually transforms into a geometric ruler). On the left side there are two friezes with meandering motifs. The manuscript caption under the spiral patterns reads: "A hair of my moustache" (*ein Haar meines Schnurrbartes*). Like most German men in his social class, Aby wore a mustache since his student days, but it is highly unlikely that he had actually seen one of his own facial hairs under the microscope. Nevertheless, if we examine a series of microscopic cross-sections of male and female hair published in late nineteenth-century studies of forensic science, we may conclude that Warburg's simile between meandering ornaments and hair dissections is both acute and accurate (fig. 1.8).[19] Perhaps initially the young student was copying ornamental motifs, but gradually he started seeing hair curlicues in them. It is as if the hair grew organically out of the geometric patterns, once the ostensibly abstract ornaments began to flourish with manifold associations. Ornament is a device of continuous seduction for the young art historian, who is just emerging from his scholarly cocoon. Decoration represents a pattern whose constant growth is synonymous with the deviation from an original trajectory or aim, provoking a split between illustration and abstraction, and an oscillation between the preservation of meaning and the proliferation of nonsense.

"Uns geometrisch auf ein Haar, beweist wie gross der Biertopf war": this is how Warburg's German edition of *Sartor Resartus* renders Samuel Butler's maxim "by geometric scale, doth take the size of pots of ale." The humorous proverb is quoted by Carlyle in the "preliminary" section of his book (close to the epigram from Daniel) in order to expose the excessive exactitude of German scholars.[20] The German translator has added "one hair" (*ein Haar*) to the English original to make his version rhyme. This added strand presents further proof that hair serves as evidence of microscopic precision. The geometric ruler appearing in Warburg's scribbles is ostensibly a sign of such pseudoscientific accuracy. The same proverb from Carlyle, however, also serves as warning that one can often get lost in such "hairsplitting" investigations. Perhaps the abstract tangle of lines underneath Warburg's ornamental friezes signals how

Figure 1.8 Drawing of "Microscopical appearance of hairs from various sources, and vegetable and other fibers," in A. McLane-Hamilton et al., eds., *A System of Legal Medicine* (New York: E. B. Treat, 1894).

Microscopical Appearance of Hairs from Various Sources, and Vegetable and other Fibers

Figs. 22 to 35.—22, horse (back); 23, mouse; 24, cat; 25, chinchilla; 26, large hair from head; 27, hair from head of female, age, eighteen; 28, hair from head of man after treatment with caustic soda; 29, fine hair from back of hand; 30, from head of child; 31, cross-sections of hair from the head; 32, silk; 33, cotton; 34, flax; 35, wool.

J. F. Babcock

easily such microscopic details can turn into a forest of disheveled knots that can never cohere into a regular pattern.

Notes on ornament are rare among Warburg's research drafts on Renaissance art. Throughout his career Warburg was less interested in two-dimensional ornamental motifs (as was Riegl in *Stilfragen*) than in accessory artifacts, such as fabric accessories, hair, and headgear—objects that adorn the human figure and have physical and symbolic *weight*, including a number of iconographic associations.[21] A number of index cards with notes from Schmarsow's course on Masolino and Masaccio contain Warburg's sketches depicting the hairstyle of Saint Peter as an iconographic type as painted by Trecento artists, from Giotto onward. According to Warburg, Italian painters habitually render Peter "with a type of [stylized] dandy-wig with three hair-rolls." Warburg also sketches the eyelashes of the same figure and takes note of the semiclosed shape of the eye and the brown color of the iris.[22] These minute records demonstrate Warburg's skills in techniques of connoisseurship—an essential component of art historical training at that time. During the last quarter of the nineteenth century, such practices achieved new levels of rigorous precision by adopting forensic techniques used in criminological investigations. The decisive clue in locating an identity was always hidden inside microscopic accessory details—either on the body itself or the clothing and adornments that covered it.

Figure 1.9 Drawing "[f]rom a photograph of an insane woman, to show the condition of her hair," in Charles Darwin, *The Expression of the Emotions in Man and Animals* (London: J. Murray, 1872), fig. 19.

FIG. 19.—From a photograph of an insane woman, to show the condition of her hair.

It is, however, remarkable how Warburg managed to convert such scientific clues into components of a psychological theory. Contemporary with the young scholar's studies under Schmarsow in Florence was his first reading (in the national library of the same city) of Darwin's *The Expression of the Emotions in Man and Animals*.[23] This is how the rising of hair in apes, cats, and dogs, illustrated in graphic detail in the evolutionist's book, were intertwined with the agitated hair of Renaissance iconography—both serving as involuntary expressions of excitement. To illustrate the permanent effect caused by the repetition of these transient manifestations, Darwin offers the drawing of "an insane woman" whose bristling hair condition was typical in patients suffering from a "recurrent state of paroxysm" (fig. 1.9). Expanding on psychiatric opinion that "a lunatic is a lunatic to his finger's ends," Darwin suggests that the same consensus could be extended "to the extremity of each particular hair."[24] As in art historical connoisseurship, hair is once again used for the purposes of visual identification—the optical isolation of a human type. But here a new depth is added within these miniscule fibers, as hair becomes a medium for the study of psychological expression. Oscillating between the organic and the inorganic state, hair threads extend hard data into malleable hypotheses. What Schmarsow had classified as a "study of curlicues" was, rather, an investigation of the resilient strands that constitute the genetic fibers of art history.

Fluttering fabrics

A comparable psychological shift occurs in the art historical treatment of drapery. Like hair, the shapes and texture of garments were used for purposes of identification. The hand of a specific artist or member of a school could be distinguished by the idiosyncratic manner in which he drew fabric pleats. Listen to Robert Vischer (the art historian and empathy theorist, whose work was highly influential for the young Warburg): "Signorelli treats garments in a manner strongly reminiscent of Verrocchio. To be sure, Signorelli does drapery more simply, but the hard breaks and the particular agitation of the fabrics caused by the wind enforce such a connection. . . . Signorelli loves, for example, to give some air to the lower part of the clothing of angels as if they were twirling, similar to Perugino, but with a lesser degree of mannerism."[25]

Once again Vischer uses fabrics to mark differences and similarities among individual painters. But here, following the pattern of Alberti, the theorist infuses draperies with a psychological movement.[26] "Garments and hair are the critical means of the subjective in painting," writes Vischer.[27] To be externalized, subjective emotion has to be mediated by an object. The windswept fab-

rics of Signorelli's angels—lighter than Verrochio's, but less mannered than Perugino's—could be heralding a transition from empathy theory to animation, from the "subjective" to the independently objective. The "air" of Signorelli's garments acts as a buffer element that grants fabrics a relative autonomy from the body of the human carrier, as well as the will of the individual artist.

This symbolic transition becomes more apparent in the work of Vischer's father, the philosopher and aesthetician Friedrich Theodor Vischer, whose late essay on "the Symbol" was another influential text for the young Warburg.[28] Vischer's much-discussed essay is a dense theoretical text with only a few examples, mostly from rhetoric and poetics.[29] However, there are two consecutive examples from the visual arts, specifically Renaissance painting, both of which refer to the representation of the Holy Mother as the "embodiment of unlimited being" (*Verkörperung schrankenlosen Daseins*). In his manuscript notes from Vischer's essay, Warburg copies precisely those two passages, both of which include references to the treatment of drapery.[30] The first excerpt is an animated description of Titian's *Assunta* (*The Assumption of the Virgin*). "Everything that strives towards a free psychic existence," writes Vischer, "breaths and gazes" through the female appearance. Warburg underlines the following phrase: "a buoyancy of joyousness floating from the qualm of life travels through the moving limbs and the folds of the drapery."[31] Vischer's second reference to painting is an equally airy musing on Raphael's *Sistine Madonna* (a reproduction of which, as documented in photographs of Vischer's residence, hung on a wall in his study):[32] "Every feature of this countenance seems to say: no word, no tongue can name the delights of the spiritual world, from which I arrive floating; the youth in her embrace dreams intently of such heavenly bliss; a soft breeze from above plays with his little locks; with the movement of the floating draperies descending from above, one believes that he hears the rustling of the [holy] mother's garment [*glaubt man das Gewand der Mutter rauschen zu hören*]."[33]

The Virgin's mantle mediates between the earthly world that we cannot see in the painting (and yet which Saint Sixtus points to us with his finger) and the "spiritual world" from which the Virgin "arrives floating" and that (as the Holy Mother, via Vischer's voice annunciates) we cannot even imagine. Raphael's drapery, then, becomes the material threshold between two invisible domains. The agency of movement (wind) remains hidden, therefore it is symbolically transferred to the drapery. This inorganic piece of fabric is the most alive and palpable feature of the representation—a transient body, whose rustling movement activates the synaesthetic interface between two remote worlds.

I would further argue that Vischer's drapery also becomes the threshold to a *third* ethereal world, which is the world of animation. The verb "rustling" (*rauschen*), used by Vischer to describe the palpable effect of the Virgin's mantle, is reminiscent of the narratives of nineteenth-century ethnographers and comparative anthropologists, who describe the "rustling" and "crackling" sounds of tree leaves or the wailing voices of bamboo tubes as auditory signals associated with the origin of animistic beliefs in tribal cultures. The sound produced by the oscillating object becomes the signifier of another form of consciousness that may have common traits with, yet is radically different from, human subjectivity. Vischer's description of Raphael's drapery, then, represents the transition from empathy to animation, a world in which the inorganic object has an agency that appears autonomous within the picture frame. In the eyes and minds of turn-of-the-century art historians such as Warburg, Renaissance fabrics move less because of the wind, but rather, they flutter because of their oscillation between two different epistemological systems, represented by empathetic psychology and animistic mentality.

Warburg's notes from Vischer date from his student days, but certainly the synaesthetic "rustling" of the Virgin's drapery continued to reverberate in his work. This extraordinary sequence of the two Vischers' treatment of drapery marks the transition from the fact-driven science of connoisseurship to a philosophically (and implicitly anthropologically) informed version of art history. Even though Warburg inherited the preoccupation with accessory details from connoisseurship, he transformed these hard facts into a pliable science by using the writings of the two empathy theorists (both whom he duly acknowledges in a footnote in the first page of his dissertation).[34]

Key to this transition is the psychological understanding of the garment and the relation of both fabrics and hair to physical excitation. Here the experiments on animal psychology by Tito Vignoli come to mind:

One day I and a friend went out driving with this horse, and I directed a man, while we were passing at moderate pace, to wave the same handkerchief, attached to a stick, in such a way that his person on the other side of the hedge was invisible. The horse was scared and shied violently, and even in the stable he could not see the handkerchief without trembling, and it was difficult to reconcile him to the sight of it. I repeated the experiment with slight variations on other horses, and the issue was always more or less the same.[35]

The movement of the fabric can become both cause and effect of excitation. As shown in the introductory example of the dog and the parasol, for the

event of animation to take place, no external agency should be visible. In Vignoli's illustrative example, the human agent temporarily withdraws from the picture; he becomes a "stick," a mere extension of the hand, which registers as an object—masked like the author's own hand—behind the screen of the fabric that beckons, enigmatically, to the spectator.

The psychological affect of the drapery is then twofold. On the one hand, it externalizes the mental and bodily excitation of the human or animal subject, operating as a seismographic device that registers internal excitation;[36] on the other hand, the agitated fabric acts as a memory image that provokes further excitation whenever the spectator sees similar images in art or real life. Even though associated with the mental reflexes of subjective psychology, the animated accessory has the capacity to extend beyond the body and its personal psyche, and to acquire a *shrouded* subjectivity of its own.

Knitting the strands of hair from Schmarsow's art historical lectures with the scientific threads from Darwin's and Vignoli's pathognomic studies, the young Warburg weaves his own art historical fabric. Oscillating between the psychological excitation of the subject and the overwhelming affect of the object, fabrics and hair herald an animated form of scholarly inquiry—a pliable science whose edges flutter by a mysterious air deemed "antique" or "pagan."

Mosaic

Warburg's fabrics have many sides, yet perhaps the most manifold of all was his dissertation. Most contemporary reviewers of the original 1893 edition seemed to miss the main point about the centrality of accessories, and instead grumbled about Warburg's treatment of iconographic problems.[37] In later years, even Warburg's most sympathetic commentators would ostensibly apologize for the scholar's "first-born-work." [38] Too many examples, too many quotes, too many theses, and (perhaps the most criminal of all) too many *ideas*, stated the critical consensus. But comments like these miss the main methodological impetus behind Warburg's doctoral research, which was to reconstruct an entire network of relations around a general category of objects, and not simply to analyze two paintings by the same artist.

Referring to the dissertation's overabundance of "references and quotations," Ernst Gombrich calls it a "mosaic."[39] Gombrich's characterization inadvertently illuminates the brilliance of the essay's lavishly decorated surface, as well as the empathy between the object and the research method. How else could a composite narrative on accessories be better represented than *as* a mosaic made out of fragments artfully pieced together within a textual frame?

Yet the same metaphor also implies the distance that the viewer (or the reader) needs for the mosaic's patterns to take shape; without that distance, one may get lost inside the myriads of tiles embedded within the intricate surface, without being able to grasp the overall design. Like a resplendent ornament, Warburg's dissertation is filled to the brim with precious material; the bits that spill over the rim become the "foundational fragments" (*grundlegende Bruchstücke*) for future investigations, as the young student eventually realizes that it is impossible to contain such a treasury within the limits of a single project.[40]

The ornamentative outlook extends to the dissertation's structure. What would traditionally be the main object (*Hauptwerk*) of doctoral research, such as a specific artist or an artwork, becomes secondary and is subject to change, while the mobile accessory (*Beiwerk*) is the most stable point of reference throughout the scholar's meandering investigations. Warburg's letter to Schmarsow shows that Filippino Lippi was the first of these changeable main objects (fig. 1.10). The painter of the "adoration of the Golden Calf," with its

Figure 1.10 Aby Warburg, "Flora-Filippino Typus," manuscript notes on the clothing of Neapolitan women and sketch from Cesare Veccelio, *Habiti Antichi* (ed. 1664). WIA, ZK 7, "Ikonologie-Literatur," 007/002899.

dancing female figures clad in windswept fabrics, might have been an ideal choice for Warburg. In a preliminary exercise on Filippino composed in Florence, Warburg quotes Vasari, who wrote that Filippino was the first "to show the moderns the new method of giving variety to vestments, and embellished and adorned his figures with the girt up garments of antiquity."[41] Filippino was a colleague of Botticelli and also the son of Botticelli's teacher Fra Filippo Lippi. In fact, one of Warburg's colleagues, Hermann Ulmann (who was also a student of Schmarsow in Florence), completed a dissertation on Fra Filippo as a teacher of Botticelli under Schmarsow in Breslau in 1890 (another reason why the young student wanted to keep his dissertation subject "secret.")[42] While hardly traceable in origin, accessories appear to be part of an artistic and scholarly genealogy.

At the top of an almost blank page among Warburg's early dissertation drafts another name of that genealogy appears: "Ag.[ostino] di Duccio."[43] Even if finally Warburg decided to focus on another artist, the dissertation's published text does contain a page on Agostino's lively reliefs in the Tempio Malatestiano and their association with Alberti, who was commissioned to redesign the temple. With their planetary symbolism and intensely windswept movement, Agostino's reliefs might have been a most appropriate subject for Warburg. [44] But here another of Warburg's close friends and student colleagues in Florence, Ernst Burmeister, whose health problems are mentioned in Warburg's letter to Schmarsow and who died in the following years, wrote a dissertation on the "sculptural decoration" of the Rimini church from an iconographic point of view.[45] Almost forty years later, Warburg would dedicate an entire panel in his *Mnemosyne Atlas* to the same reliefs under the title: "Rimini: Pneumatic Representation of the Spheres in Opposition with Fetishistic. Antique Form"—a description that hints at the potential antagonism between different epistemological systems energizing Agostino's "pneumatic" representations (fig. 1.11).[46]

Figure 1.11 Aby Warburg, *Mnemosyne Atlas* (1927–29), panel no. 25, *Rimini.*

Filippino (via Schmarsow and Ulmann) or Agostino (via Burmeister) represent only two of the earlier stages in the evolution of Warburg's research. Looking closer at the early dissertation drafts, it seems that initially the young scholar had a much larger plan in mind, only a fragment of which ultimately surfaced in the published dissertation. The final work is a memorial to prematurely aborted subjects. A title page from another dissertation draft shows only Botticelli's *Primavera* as the main subject,[47] yet in later investigations it is joined by what was at the time considered to be its sister painting, *The Birth of Venus.* Finally, another title page from yet another discarded draft shows that the general subject was the "treatment of fabric" (*Gewandbehandlung*) in the

Florentine art of the Quattrocento.[48] What is usually referred to as "the dissertation on Botticelli," then, is in fact a composite fabric with multiple layers that defy a definite chronological order. Hair and fabrics are part of a mobile art historical enquiry in which the *main* subject (or object) stays perpetually in motion.

Tables and grids

To track diachronic relations between Renaissance and antique representations, Warburg composed numerous diagrams and tables in which he cross-references a large list of painters and sculptors who employ similar motifs of fabrics and hair in motion, such as Ghirladaio, Agostino, Mantegna, Leonardo, Botticelli, and even Raphael and Titian (both of whom were mentioned in F. T. Vischer's essay on the symbol for their use of drapery).[49] Warburg's investigation is essentially a process of *mapping*: the art historian tries to recreate the geographic trajectory of these windswept motifs from one artist or artistic circle to the next, as well as their temporal migration from antiquity to the Renaissance. In fact, among Warburg's notes, one can find a number of actual maps drawn by the art historian, in which he marks the exact places, cities, or family circles that owned Renaissance or antique artworks that incorporated representations of accessories-in-motion.[50]

From the macro scale of the map to the micro scale of the classificatory table, the art historian scans for movement. The map is like a compass, a tool for orientation in geographic space, while the table delineates the coordinates of mental space. The diagrams sketched by Warburg during the same period designate a third instrument for orientation, one that mediates between the table and the map. If the table is mainly an analytic tool, the diagram is a more synthetic apparatus: it not only traces previous movements, but also supplements their correspondences with new ones. It is the most suitable scholarly device to retrace the pathways of accessories-in-motion.[51]

Even when Botticelli's two paintings became the central objects of the dissertation, the processes of canvassing and diagramming did not end. On the contrary, Warburg used the two well-known paintings as frames to create new tables based on the several themes depicted in their mythological landscapes. The transition to Botticelli, then, does not necessarily represent what we would call the "focus" of the historian's research, but yet another screening device that opens up new areas for the investigation of movement.

In a vertical table on iconographic themes from *The Birth of Venus*, for example, Warburg compares the representation of the winds and the Hours

in Botticelli's painting, as opposed to how the same mythological figures are represented in the "Homeric Hymn" to Aphrodite, and Poliziano's poetry (fig. 1.12). The table shows the number of mythological personages who are present in each text or painted scene, as well as their exact names, manner of clothing, and hairstyle.[52] In a much larger chart spread over a series of pages, Warburg repeats the same mapping process for all the figures of the *Primavera*.[53] We learn, for example, that in Horace and Boccaccio, Mercury wears an antique "chlamys," just as he does in Botticelli's painting. Zephyrus and Flora appear in both Ovid and in Poliziano, but in the latter the running nymph appears "without a girdle" similar to the representation of the Graces, who are omnipresent.

It is remarkable that clothing is set precisely at the center of this comparative system. Accessories—fluttering or fixed (such as girdles)—function as the fulcrum of all analogies between the vertical and horizontal features of the table. The scholar's chart is like a grid laid over the fabric to trace its knots and seams and map its peaks and recesses. The linear matrix also suggests the transference of the methods of chronophotography to the historiography of art. Like the contemporary photographic experiments by Marey and Muybridge, the table is an attempt to track movement by analyzing it in a series of sections. In this way the scholar can pin down the elusive motion of accessories and retrace the origin of their proliferating progress: where they come from, how they circulate, and how they may eventually stop gyrating. The art historian's tracking system exchanges movement with arrest.

It seems that the overall subject of Warburg's dissertation is not simply the movement of accessories in Renaissance painting, but movement in general as a historiographic problem. This is clearly stated in the concluding paragraph of Warburg's introduction, which after a series of revisions appeared in the published text in the following form: "It is possible to trace, step by step [*Schritt für Schritt*], how the artists and their advisers saw in 'the antique' a required model [*Vorbild*] for an intensified external movement and how they followed the ancient models when the case was the representation of accessories-in-motion, garments and hair."[54]

There are at least two different types of movement described in this passage. First is the virtual movement of accessories inside the frame of either antique or Renaissance artworks. The second movement is that of the Renaissance artists and authors as they look back to the artworks of antiquity for ways to represent these mobile objects. The one movement is spatial, the other chronological; the first evolves inside the painting, the second extends beyond the frame. Yet there is a third movement involved here, which is the

Cpt. n.d. Stanzen (I, 99–100)

Nb. Sg.	Polizian	Bottic.	Polz. kr. Zus.
Zephyros	Zefiri	Zefiri	
—	vero il vecchio	vecchio	vero il vecchio
—	Soffiar d. venti	soffiar	ver Soffiar di venti
die Horen	die Horen	vien Hor	
	in braccio verti	vien de...	
—	die lieft krönfes d. kleid	gl. kleid	Das gewand vest
	meerspart		n. d. saum
	n. saum	n. saum	
	distes u. lenti		
—	n.d. V. der see	n.d. 2 s.h.	gl. Bagn. Polvz. Epigr. gr. LIV.
	e.... n.d.	n.d. L. s.h.	Velkens p. 119
	d. bucht del...		
n.d. 3 N. ca	v.d. drei Nymph	n. vier	
klenden	Balzbach	betel	
Schmückung	Shm. m. Feldblumen Mymfen		
in Völlisch-kl.	d. jahresem		
	m. sternen-mantel	m. e. Mantel	
Schmückg. mit Junu		mit Blumen	
harit			
	in d. Wolken und		die zitternd luft scheint
	Nymphen		wehen

Polb. schilderd b. d. Kolbesspr. zwei Scenen in Pal. d. Venus
die erste enthält in: 1.) d. Castration d. Saturn 2.) die Geburt d. Giganten, furien n. Nymphen
3.) die Geburt d. Venus u. ihr Empfang 4.) ihr Empfang
u. Schmückung
4.) 5.) ihr Entschweben zum Himmel 101, 6. Poi
6.) Vulcano Peller

Kosmogonische Allegorie

Figure 1.12 Aby Warburg, table describing the iconographic treatment of the *Birth of Venus* in literature and painting (*The Homeric Hymn*, Poliziano, Botticelli). WIA, III.38.2, "Botticelli, 1888–1891. 'Geburt der Venus,' Notes and Drafts," 10. Photograph: Warburg Institute, London.

movement of the historian himself, who follows both of the former movements "step by step" as he tries to reconstruct their historical trajectory. This rhythmic process is again reminiscent of chronophotography's sequential sectioning of movement.

But the researcher's *synchronized* investigation often fails, since the movement of accessories hardly follows a common rhythmic pattern. In his word-by-word comparison of ancient and Renaissance descriptions of accessories by authors such as Homer, Ovid, Claudian, and Poliziano, Warburg remarked that the modern Italian authors have a tendency not simply to replicate, but also to embellish further these already ornate objects:

> *Ovid*: Europa . . . her golden hair.
> *Poliziano*: Europa . . . her *lovely* golden hair [a "be'[n]" is added by the
> Italian poet]

> *Claudian*: Proserpina is born away by the swift chariot / Her hair spread
> out to the wind
> *Poliziano*: Proserpina appears in a great chariot; her unfastened hair the
> amorous zephyrs waft from side to side.[55]

By adding or varying words or phrases in these windswept details, the Italian authors do nothing more than to *accessorize* the accessory, creating a second decorative extension around the ornamented contour. But this is perhaps the only formal *law* of the accessory's movement—the principle of its quasi-*organic* growth. Accessories proliferate by addition: like tendril ornaments, they bifurcate by adding another word, another squiggle, another *fioritura* in the already decorated fabric. Such augmentation seems almost animistic in its self-motivated growth. While seemingly whimsical or totally arbitrary, the "science of curlicues" is animated by an autonomous formal logic whose processes are impossible to chart via either grids or tables.

The face of the wind

Intrinsic to Warburg's initial investigation was the discovery of an origin—a departure point in which the increased circulation of accessories in Renaissance culture might originate. But is there a single agent—whether an artist, author, or a school—whom one can credit or blame for such generalized commotion? In spite of his use of grids and diagrams, finding such a starting point proved to be an impossible task for Warburg. And yet even before the young

student launched his investigation, historians were pointing their finger at one particular source: Alberti and his treatise *On Painting*. Early in his dissertation, Warburg cites the entire paragraph from the second book of Alberti's *Della Pittura* in which the Italian author, following a description of movements of the body and movements of the soul, speaks with remarkable enthusiasm about the depiction of movement in so-called inanimate objects.[56]

It is pleasing to see some movement in hair, locks, boughs, leafy fronds, and garments. I myself take pleasure in seeing hair in seven different movements, as I said earlier: hair should twist as if trying to break loose from its ties and rippling in the air like flames, some of it weaving in and out like serpents some swelling here, some there. Branches should twist upward, then downward, outward and then inward, contorting like ropes. Folds should do the same: folds should grow like branches from the trunk of the tree. They should follow every movement, rippling, so that no part of the garment is still. These should be gentle, moderate movements, as I frequently remind you, appearing to the onlooker as something pleasurable rather than an effort to be marveled at. Where it is required to depict billowing garments, and where these are heavy and hang down to the feet, it will be a good idea to portray in that painting the face of the winds, Zephyrus or Auster, among the clouds blowing the garments, on the side struck by the wind, to reveal its nude form; on the other side the garments will fly in the air, blown by the gentle wind; and, in this billowing, the painter must take care not to show any drapery as moving against the wind and that they are neither too irregular nor excessive in their extent. So, all we have said about the movements of animate and inanimate things should be rigorously observed by the painter.[57]

Not only the accessories, but the author's own voice sounds highly animated throughout this passage. "I certainly like to see hair" (*certo ad me piace nei capelli vedere*) performing such movements, writes the Renaissance scholar. In this sentence, the Italian text speaks of pleasure (*piacere*) and the Latin of desire (*cupio*). There is, then, a strong personal impetus behind the movement of these agitated objects. Alberti's desire is almost authorial; Warburg calls it a "painting rule" (*Malerregel*) that artists were obliged to follow.[58]

Earlier in his text, Alberti states that every mobile body has seven directions of movement: "either up or down or to right or left, or going away in the distance or coming towards us; and the seventh is going around in a circle" (*in girum*).[59] Alberti instructs painters that the limbs of human figures should move along these spatial coordinates. In the case of inanimate objects,

however, these abstract forms of movement are taken to a much higher level of intensity. Hair, branches, and fabrics "twist," "weave," "slither," "contort," "grow," and "bifurcate." In his manuscript, Warburg has underlined Alberti's metaphor in the Italian text *"come serpe*—like serpents" that renders the Latin *"serpant,"*[60] a verb that connotes a "slithering" movement reminiscent of the snake hair of the Medusa.

The limbs of human bodies, however, do not possess the same serpentine agility, and therefore their degree of pictorial freedom is lower. Alberti had admonished painters that their human figures should not move so violently as to show "both chest and buttocks" because such contortion is both "physically impossible and indecent to look at."[61] Though human bodies should not twist, accessories are exempt from such physical (and cultural) limitations. By being allowed to rotate, hair and draperies can show all of their physical and metaphorical aspects; therefore accessories are more versatile than their human carrier.

Movement facilitates a transformation that goes beyond the visible surface. Through the use of verbal and pictorial figures, Alberti's text implies a material change that penetrates the very substance of the object. Hair and fabrics move, and while they move their matter appears to transform into animal (snakes), vegetal (tree branches), and even the aerial substances (flames). From their inorganic foundation, these gyrating bodies communicate with all degrees of animate and inanimate existence.

Warburg remarks on the polarity between Alberti's delight in the almost hallucinatory "play-space" (*Spielraum*) of his "fantasy" and the author's "reflection" and self-imposed "restraint" (*Besonnenheit*) commanding that hair and fabrics should not move *too* much. The accessories are inadvertently associated with a certain danger of excess. What if these seemingly aberrant extensions were to overpower all norms of decorum? What if they covered the entire visual plane, which appears to occur in some of Agostino's mannered reliefs in the Rimini temple?

Warburg notes that nothing of this visual play would be possible without an "imaginative concession." The pictorial convention commonly accepted by Renaissance artists and spectators is the presence of the winds as a face or a mask among the clouds. Warburg recognizes this mythological form of explanation as an epistemological "compromise between anthropomorphic imagination and analogical reflection" (*vergleichender Reflexion*).[62] Here, Warburg's reference, as mentioned in one of the footnotes in his earlier drafts, is the work of the aesthetic philosopher Alfred Biese on the role of association and anthropomorphism in the perception of nature.[63] According to Biese, anthropo-

morphism is a species of empathetic response that attributes causes, agency, and humanlike will to inanimate objects, and that differs from other forms of associative thinking. The audible utterances of the inorganic objects of nature—such as the sounds of the wind or water—are primary causes of such reflexive form of thinking among the ancient Greeks, as well as "the people of nature" (an implicit reference to contemporary anthropological literature on animism).[64] "Man never knows how anthropomorphic he is," Biese quotes from Goethe. The same maxim is repeated by Warburg in several of his later notes and writings.[65] Goethe's motto implies that man, too, and not only the wind, has to wear a "human" mask in order to become the carrier of cultural representation.

But did the Italian artists of the Quattrocento possess the anthropomorphic imagination theorized by Biese? Michael Baxandall characterizes Alberti's addition of the wind-gods as "eccentric" even for Alberti's time. The wind-gods might have been acceptable in Giotto's *Navicella* made during the Trecento, but, as Baxandall argues, fifteenth-century painters employed more "subtle" pictorial devices to suggest the movement of air, including the tips of clouds used as "weathercocks" connoting the direction of the wind.[66] Given the quasi-scientific impetus in the rest of Alberti's treatise, one might agree with Baxandall that such overtly mythological references might indeed seem "eccentric." But does not the very "eccentricity" of these ostensibly superfluous additions point precisely to their schematic agency in the painting?

If we look more closely at Alberti's original text we see that the presence of the winds is not compulsory. "*Stará bene*—it will be good," writes Alberti in Italian. The same phrase is rendered as "*pulchre*" in the Latin text, indicating that the addition of the winds' faces will have a beautiful effect. Both renditions connote that the presence of the wind-gods is appropriate, but not entirely necessary. Alberti's tone is much less imperative when he suggests the presence of the wind's face than when he speaks about the movement of accessories. The accessories-in-motion *have* to be in the picture, the wind-gods not necessarily so. Ultimately, the accessories do not move because the winds are blowing; the winds arrive *after* the accessories had already moved. Cause and effect are inverted. The wind-god is the accessory of the accessory—an accessory of the second degree.

This textual nuance in Alberti's text and the corresponding commentary by Warburg describe the hypothetical origin of the animated condition of space: a state in which causes and effects are obliterated in a landscape of seemingly autonomous visual effects. All agencies in the picture have to be either expunged or disguised so that all objects appear to float with no obvious

motivation. The author's desire may enter the painting as long as he or she is wearing a "mask," which is appropriately antique in countenance.

Alternating from angels to demons, the antique wind-gods gradually begin to disappear.[67] In a few decades, the wind-gods' faces will eventually vanish from the picture. The accessories-in-motion will survive, and they will be revived again and again. What we witness here is the removal of the wind—the Greek *anemos*—out of the anima, or soul of animation. The air is now pocketed inside the self-inflated folds of the fabric. It is as if mobile accessories are the "pocket monsters" of the Renaissance. In his 1907 letter to Schmarsow, Warburg presciently called Filippino's fabrics "demons," conflating the agent and the medium in one spirited body.[68] While represented as anthropomorphic projections, demons gradually extract agency from the human subject and redirect it toward the objects of her surroundings. "Demonism" is the malevolent anthropomorphic mask imposed upon animistic mentality. External agency is now internalized within the mobile artifact, which brandishes its "demonic" independence by floating aimlessly across the visual plane.

The mannerism of movement

One of the most prominent, but also paradoxical properties of these animated calligraphies is indeed their apparent *autonomy*, not only from the movement of the wind, but also the body of their carrier. While analyzing one of Botticelli's female portraits, Warburg writes: "A lock of hair flies out behind, unmotivated by any bodily movement."[69] The same "unmotivated" fluttering extends from hair to human garments. In one of his aesthetic aphorisms written during the period of his dissertation research, Warburg remarks that in pictorial representations of the first half of the Quattrocento, the movement of drapery is not dictated by the movement of the body: the garments move, while the human bodies underneath them remain relatively static. Only in the second half of the Quattrocento do the bodies underneath the fabric start moving too. In both periods the movement of drapery proceeds "against natural conditions."[70] If this general observation is correct, then the bodies *follow* the movement of accessories, and not the other way around. As in the presence of the winds, cause and effect are once again inverted. Objects become animated not because they imitate life, but because they have a tendency to move against nature and disrupt all living conventions.

A similar formulation appears in one of the preliminary versions of the "Theses" that Warburg appended to his dissertation after it was published: "The pleasure in movement becomes balanced through intensified additional

forms [*Zusatzformen*] taken from the memory images of the artist, which are abstracted from many possible movement positions seen in real life. Through this abstraction the image becomes animated [*belebt*] and idealized at the same time against reality. To achieve this animation [*Belebung*] an intensification or exaggeration [*Übertreibung*] and not a frugality of means (as in nature) is necessary."[71] Animation, then, subsists on "exaggeration" and hyperbole, as well as an increasing "abstraction" from real life: it thrives in its denunciation of "frugality" and celebrates the *excess* of imagination and its luxurious use of visual means. By employing economic terms, Warburg (the greatest capitalist in the history of art history) foregrounds animation as a composite venture. Similar to Freud's economic processes of condensation and displacement, animation is essentially a "dream-work" operation that intensifies and further distorts memory images while superimposing them with ideal mental patterns. Mythological contexts, such as the landscapes in Botticelli's two paintings, facilitate such formal transpositions.

Even though it was present in Vignoli, Warburg does not use the term "Belebung" (animation) either in the earlier or the published version of the dissertation. Instead to describe the autonomous movement of hair and fabrics in Quattrocento painting, he uses the term *Bewegungsmanierismus*, a mannerism that was located not only in the individual artists or the figures represented in a painting, but in the movement *itself*—an idea that Warburg apparently conceived during his apprenticeship under Schmarsow in Florence.[72] In addition to autonomy from external agency or other rational justification, this form of mannerism also signifies an independence from any previous model or prototype—including the authority of antiquity.

Here the historian had to partially revise his original hypothesis vis-à-vis Renaissance artists' reliance on antique models. Whenever they wanted to represent accessories-in-motion, Warburg argues, Italian painters would look *back*. But what would they see? Apparently, not much. Looking at the fluttering fabrics of Botticelli and other Quattrocento artists, one can easily discern that Renaissance painters follow neither nature (fabrics do not move like that in real life) nor antiquity (moving draperies do not look like that in ancient sculptures). Accessories-in-motion create a relatively abstract and diversified notion of mobility that bears only a faint similitude to either natural circumstances or antique precedents.

And even when the Italian artists do copy antique sarcophagi—as in the Chantilly drawing that is analyzed in Warburg's dissertation—they ignore the main elements of the antique composition, including the painting's *historia*, and focus only on the depiction of accessory details (fig. 1.13).[73] The artist of

Figure 1.13 Aby Warburg, Hand corrections on the printed proof pages of his dissertation with illustrations of the Chantilly drawing by the school of Botticelli and a drawing of *Achilles in Skyros* from an antique sarcophagus. The arrow drawn by Warburg indicates that a paragraph containing part of his description of the drawing should move above the reproduction. WIA, III.39.6.5, "Botticelli, 1888–1906," 14–15.

the school of Botticelli irreverently rearranges all fabric items like mobile ornaments among the individual figures, altering their position on each body. Yet it is precisely this emptying out of physical gravity and functional significance that ultimately grants the accessory its phenomenal autonomy and movement. The accessory acts as a free-floating signifier of "antiquity." The mobility attributed by Alberti to inanimate things extends to their signification.

Nevertheless, this mobile signifier is also fixed in terms of form. As Warburg suggests, to be instantly recognized as "antique," the flying hair lock and the billowing scarf of the Chantilly drawing must replicate a certain shape. Movement is now signified by a visual pattern or decorative motif, such as the

Die anderen drei Gestalten scheinen einer antiken friesartigen Composition entnommen. Eine Frau mit Leyer in der L. im Chiton und aussen gegürteten Ueberschlag, daneben der behelmte Kopf eines Jünglings und als Abschluss ein Jüngling in starker Schrittstellung nach R., den Kopf im Profil zurückgewendet.

Es ergab sich, dass diese drei Figuren in der That einer Sarkophag-Darstellung des „Achill auf Skyros" entnommen sind; die Frau mit der Leyer ist eine der Töchter des Lykomedes und der stark ausschreitende Jüngling der entfliehende Achilles.[1]

Abb. 3. Zeichnung Botticellis (?) in Chantilly.
Nach einer Photographie von Ad. Braun & Cy., Braun, Clément & Co. in Dornach i. Els. und Paris.

Abb. 4. Darstellung aus der Achilleis.
Nach Robert, die antiken Sarkophag-Reliefs.

Die nackte Frauenfigur neben ihr — ungefähr in der Pose der Mediceeischen Venus, hält den r. Arm rechtwinklig vor die Brust (ohne dieselbe zu verhüllen), mit dem l. Arm den Unterkörper bedeckend.

Die Beine sind kreuzweise verschränkt und die Füsse stehen in rechtem Winkel zu einander, eine Stellung, die nicht fest genug erscheint, um den etwas zurückgebogenen Oberkörper zu tragen.

Ihr Haar ist in der Mitte gescheitelt, dann zusammengenommen und als Flechte um den Hinterkopf gelegt, in einen frei flatternden Schopf auslaufend. Dieselbe „brise imaginaire" verursacht auch die Schwellung eines shawlartigen Gewandstückes, das auf der l. Schulter aufliegt.

Da die Verstümmelungen auf der Zeichnung nicht willkürlich ergänzt sind, so lässt sich das vorbildliche Exemplar genau bestimmen: Es ist der heute in Woburn-Abbey aufbewahrte Sarkophag, welcher sich ursprünglich unter den Reliefs befand, die seit der Mitte des 14. Jahrh. an der Treppe von St. Maria Araceli in Rom eingemauert waren.[2]

Michaelis[3] beschreibt ihn folgendermassen: „To the l. of Achilleus are visible four daughters of Lykomedes: one in chiton and a chlamys

[1] Statius, Achilleis, v. 835 ff.:
„Nec servare vices nec brachia jungere curat
Tunc molles gressus, tunc aspernatur amictus
Plus solito rumpitque choros et plurima turbat."
[2] Vgl. Beschreibung Rom's, III, I, p. 543, u. Dessau, Sitzungsber. d. Berl. Akad. 1883. II, p. 1075 ff.
[3] Ancient Marbles in Great Britain, p. 730.

volute-spiral that Warburg had compared to the billowing cape of Ghiberti's warrior. In this way, the mobile accessory stands for the ornamentalization of movement—its permanent arrest or ambient crystallization in the rhythmic pattern of an ornament.

Life-in-movement

"The most difficult problem in all art," writes Warburg toward the conclusion of his dissertation, "is that of capturing images of life-in-movement."[74] Recent commentators have stressed the role of late nineteenth-century technologies of visual culture in Warburg's research on the depiction of movement in Quattrocento painting. Chronophotography and early cinema appeared to offer new solutions to artists and art historians, as well as natural scientists, for "capturing" life not only *in*, but also *by* movement, such as the movements of the camera shutter or the cinematic reel.[75]

In a chapter from his *Nature and Art* (*Natur und Kunst*) (1890) titled "Representations of Life-in-movement" (*Darstellungen des bewegten Lebens*), the natural philosopher and evolutionist Ernst Krause (writing under the pseudonym of Carus Sterne—a name that tellingly concocts astrology with eighteenth-century art criticism and natural science) came to a similar conclusion as Warburg: the representation of movement was an irresolvable problem for both Renaissance and contemporary artists.[76] Sterne borrows most of his examples (and some of his conclusions) from the contemporary study of movement in the visual arts by the renowned anatomist, physiologist, and teacher of Freud, Ernst Brücke.[77] For example, in his "Hunt of Diana," writes Sterne, Domenichino had to paint three different arrows to trace the trajectory of the shot from the goddess's bow. Sterne also describes how baroque and even rococo artists paint the wheels of Phoebus's carriage, midflight, as if they were inert, while the sun god's horses gallop away, their manes fluttering. Only Velasquez in his *Hilanderas* (*The Tapestry Weavers*) portrays the moving radii of the spinning wheel as they appear in the eye, that is, as a series of concentric circles connoting the revolution of the gleaming spikes attached to the revolving disc.[78]

Contemporary experiments in chronophotography by Muybridge and Ottomar Anschütz, argues Sterne, aided scientists toward the correct representation of men and animals in movement by providing a model for analyzing their progress step by step. However, Sterne concludes that such investigative analysis is not as helpful when applied to the more composite problems that painters face. Here Sterne cites an illustration from the journal the *Ameri-*

can Queen (fig. 1.14) in which the artist has pasted several still images from Muybridge's photographic experiments that record horses running. As the scientist comments, this "composite" picture is neither beautiful nor true to reality, leading Sterne to conclude that the painter can learn a great deal from but should not copy photographic images.[79] Chronophotography cannot solve the problem of "life-in-motion" for the artist, but perhaps the art historian who deals with the same problem could benefit from its techniques.

Figure 1.14 Carus Sterne, illustrations from "Darstellungen des bewegten Lebens," *Natur und Kunst* (1890), figs. 58–59. *Top, The Running Horse Gallie Garner in 12 Phases (after Muybridge); bottom, Competition Horses and Jockeys Composed by Instantaneous Images (after Eders* Momentphotographie).

Fig. 58. Das Rennpferd Sallie Gardner in 12 Phasen.
(Nach einer Aufnahme von Muybridge.)

Fig. 59. Wettrennen aus Augenblicksbildern componirt.
(Nach Eders „Momentphotographie".)

For Sterne, as well as Marey and Muybridge, "life-in-motion" is primarily connected to the movement of bodies, animal or human. Even when certain inanimate objects, such as an axe or rifle, appear in chronophotographic experiments, they closely follow the movement of the living carrier, as if they were organic extensions of his or her limbs. On the contrary, Warburg focuses almost exclusively on the movement of inorganic accessories that move independently from the living body. "Bewegtes Leben" has thus been substituted by "Bewegtes Beiwerk": the accessory has absorbed both "movement" and "life." Every vital sign must be screened through an inorganic medium.

Accessory logic

Warburg's accessory (*Beiwerk*) is then something *less*, but also something *more* than a normative object. *Beiwerk* is literally a side-work, or *parergon* in Greek (yet not a *paralipomenon*, or leftover). Such an intermediary object transcends distinctions between the accessory and the necessary, the organic body and the inorganic thing imposed in earlier philosophical discourses. In his *Critique of Judgment*, for example, Kant famously writes that the "decorative artifact" (*Zierath*) or "Parergon" may "augment delight by its form," but is "only an addition [*Zuthat*] and not an intrinsic constituent in the complete representation of the object." Kant's examples of such superfluous objects include "the frames in pictures, the draperies in statues, or the colonnades in palaces."[80] In his *Aesthetics*, Hegel associated accessories (*Nebensachen*) such as "laboriously elaborated draperies and surroundings generally" with the "artificiality and awkwardness" of an earlier style, in contrast to the "simplicity" of more mature classical styles. The philosopher also criticizes the excessive attention to "externals, such as clothes, hair, weapons, and trappings of other sorts," including the "folds of the dress" that are "not adapted to the movement of the limbs."[81]

Warburg appears equally critical of such decorative calligraphies that were proliferating in artistic circles during the late nineteenth century. In his dissertation drafts, the scholar associates Botticelli with an "ornamental decline" in the art of the "High-Renaissance."[82] Yet implicitly, as Gombrich has described, Warburg's dissertation on Botticelli was written as a defense against the growing "ornamentalization" of the art of his period, exemplified by the Pre-Raphaelites and other decorative movements preceding art nouveau.[83] Like animism, ornamentalism was considered the byproduct of a "primitive" mentality, which was mysteriously revived. The earth was increasingly saturat-

ed with peripheral artifacts that were eventually wrenched from their organic origins, proliferating *inorganically* within disparate cultural milieus. Warburg's projection of the origin of such deviant calligraphies into the Quattrocento, as well as his scholarly effort to analyze their movement through the framework of grids and tables, is another frantic attempt to retroactively control the seemingly irrational progress of these demonically animistic curlicues. Yet the scholar gradually realized that the accessory is *not* an isolated object, but rather, it is the representative of an entire mentality or thought process whose rudiments proliferated in his own era.

Perhaps the most appropriate analytic model for interpreting the function of accessories is the theory of "overdetermined elements" exposed by Freud in his *Interpretation of Dreams*. Like the "small dried plant specimen" in the psychoanalyst's "dream of the botanical monograph" or the "droplet earring" in Dora's first dream, accessories exemplify these small and seemingly marginal objects that dominate the dream narrative by capitalizing on their capacity to act as visual indexes of various psychic regions.[84] Akin to "parliamentative representatives" (to use Freud's political metaphor), such composite elements are elected by popular vote because their ornamental imagery is embedded in so many memory compartments of the subject's psyche.[85]

One of the common visual characteristics of the elements deemed "overdetermined" by Freud is their relative inconspicuousness. These are items that in real life may not immediately absorb our attention, yet eventually end up dominating our psychic life. Perhaps their relatively minor size and thin substance allows such elements to slip into so many psychic compartments and become omnipresent. While initially the increasing presence of such elements appears to overwhelm the existence of more important events, the same images of objects are also the singular visual signifiers of repressed occurrences. Like screen memories, overdetermined elements both disclose and conceal the psychic regions that they represent. They are the clues that the analyst, and the art historian, has to work with in order to recover the patient's (or the artwork's) "great secrets," which otherwise have no access to the visual realm.

Perhaps Warburg's analysis of the accessory in his dissertation is the prelude to such *peripheral* modes of art historical interpretation. Like Freud, Warburg understands the accessory-in-motion as the representative of different regions—from literature to relief sculpture to painting, and from the Renaissance to the "antique," as well as to the animated visual culture, painting, photography, and early cinematography of the fin de siècle. On a historiographic

level, the accessory also functions as the common element between art history and natural history, aesthetics, anthropology, and cultural ethnography—the manifold areas of knowledge that the art historian has to deploy in order to analyze such composite representations. From Darwin to Vignoli, and from Schmarsow to Carlyle, the accessory is the pliable apparatus that allows historical and epistemological transpositions to take place.

Mobile subjects

Could we then advance this "law" of the accessory into a more general art historical method beyond the mere study of fabrics and hair? And could such epistemological principle in fact affect not only the behavior of the inanimate objects portrayed in a painting, but also the decorum of the living subjects that are immured on the same composition? As Freud's dream interpretation makes clear, the process of overdetermination, in addition to the so-called minor objects of the dream (such as the dried flower or the drop-form earring), also addresses the major representational elements, including the identity of the human figures (such as Freud's patients, family members, or colleagues) that are attached to these marginal specimens. Could we then envision a form of iconography in which the living subjects represented in a painting also transform by the accessory's pliable logic? Listen to Poliziano's description of a (deceased) Florentine beauty cited in one of Warburg's addenda: "Whenever she let her hair tumble loose without restraint, she seemed Diana, a terror of wild beasts, or, if she gathered her tresses again in tawny gold, she seemed a Venus (her hair dressed with the Cytherean's comb)."[86]

The young lady in this poem changes her mythological likeness, and eventually her identity, with a single movement of her hair. This transformation reveals the volatility and transience of correspondences between human figures and mythological personae. Human identities can shift in one movement, while the mobile accessory, coiffure, type of dress, and emblems linked to a specific god or goddess remain fixed. The accessory is a medium that facilitates a certain *mobility* of identity, even if that identity remains limited to the level of likeness or appearance.

Is it a mere accident that the iconographic subject of the Chantilly drawing analyzed in Warburg's dissertation portrays Achilles in Skyros—one of the earliest depictions of cross-dressing in Western culture? In the antique sarcophagus, the male demigod's bicep, thigh, and calf muscles prominently bulge from beneath the pleats of the female *chiton*. The gender difference is much less discernible in the drawing of the artist from the school of Botticelli,

who seems less interested in the fact that the main figure in the antique ensemble is a man. It is as if the decentering of attention from the living subject to the accessory has rendered the carrier's gender irrelevant.

Notably, Warburg's accessories-in-motion are almost always female and associated with the "Ninfa" type, while, as Gombrich has remarked, similar windblown draperies appeared on both male warriors and angels (regardless of these heavenly creatures' genders).[87] On the one hand, the accessory appears to blur sexual differences by facilitating shifts in the identity of the carrier: nymph or angel, Venus or Diana. But on the other hand, it also consolidates visual identifications by creating a fixed "type" masked by a particular set of decorative insignia.

In the antique and Renaissance literary fragments selected by Warburg, female figures continually transform into a mobile mass of fabrics and hair. Daphne, Proserpina, Europa, and Flora are all reduced to an essential "type," that of a running nymph with flying veils and waving hair (Warburg tentatively recognized the origin of this figure in Ovid's description of Daphne fleeing from Apollo).[88] The male suitors Apollo, Pluto, Jupiter, and Zephyrus, respectively, play the role of *force-motrice* in related scenes of *amor fugitivus*, or "amorous pursuit"; while masked as living agencies, they are essentially another accessory setting the female fabrics and hair in motion.

If indeed the mobile accessory can promote an "identity-in-motion," Warburg's fixation with the identification of the figure of Spring in the *Primavera* as the legendary Florentine beauty Simonetta Vespucci (an association that most contemporary art historians rejected) might appear puzzling.[89] For readers of the dissertation who are not Renaissance specialists, it might be difficult to understand why the author devotes so much time to iconographic problems if his original task was to decipher the presence of accessories-in-motion. But perhaps in such composite research, there is no difference between these two sets of problems. Inside the reorganized space of Renaissance imagery, even the human figures can have an *accessory* value. For example, Warburg and a number of art historians before and after him had great difficulty in deciphering Mercury's presence in Botticelli's *Primavera*. Finally the art historian had to concur with Seneca that Mercury appears there "because that was how the painter saw it."[90] According to Warburg's iconographic interpretation, Mercury, Zephyr, Flora, and the Graces are all part of the company of Venus. As the constituents of her transferable dominion (*Reich*), they move with her wherever she goes. Such mythological figures are, in a way, Venus's own portable accessories that, like her, are copied, yet not always faithfully from antique sources. As illustrated in Warburg's large iconographic table for the

Primavera, in some sources these allegorical figures appear close to Venus, but in others some of them, such as Mercury, do not. These human quotations, then, are neither totally necessary nor entirely arbitrary; they are *appropriate* to Venus's presence.

Warburg's analysis of accessories-in-motion leads us to a more elastic understanding of human iconography. The pictorial analysis of the accessorized human figure is closer to a typology in which identities have a *heuristic*—less imposing—presence.[91] The animation of accessories, then, stands not only for the mobility of objects, but also for a peculiar *mobility of the human subject* beyond the limits of a particular iconographic problem. This is perhaps the most eccentric effect enacted by the accessory's gyrations.

But ostensibly such sharp divisions between accessory and necessary elements in a representation did not exist in the Renaissance. As shown in Kant's and Hegel's aesthetics, the polarity between *Beiwerk* and *Hauptwerk* or *parergon* and *protergon* is the product of a later distinction. During the Renaissance, all elements of a pictorial representation—both animate and inanimate—might have enjoyed a greater equanimity of being. Visual attention was equally distributed across the periphery and the center, to small details and larger figures or objects. Botticelli's *Primavera*, with its multiple centers of visual attention—including the subtly "marginal" character of the figure of Venus and the enigmatic eccentricity of Mercury, intertwined with the veils, hair, jewels, trees, and little flowers spread throughout the landscape—might be the quintessential example of such ontological equanimity.

What we are witnessing then is not only the origin of a modern visual culture, but also the relic of an anterior mode of analogical thinking about images and relationships between things. Warburg's imposition of a line between the main work and the accessory does not annihilate such vestigial mentality. On the contrary, it sets it into motion and makes it anxiously appealing for cultures beyond the Renaissance. By foregrounding the agency of marginal clothing articles and treating their living carriers as equally excitable fabrics, the historian essentially constructs a *monist* interpretation of painting. His analysis grants equal space to objects and subjects, and intimates that minor beings such as accessories can be granted a mobile soul. Inadvertently, his interpretation projects a confluence of turn-of-the-century philosophical monism and the animism described by contemporary ethnographic literature.

In sum, Warburg's dissertation brings forward animation's two *modes*. First, the material animation of fabrics and hair, which unfolds as these pieces of matter transmogrify into foreign substances and (following Alberti) begin to emulate aerial, vegetal, and animal shapes, such as flames, branches, and

serpents. The second form of animation enacted in this "inaugural" work is temporal. The accessory's movement propels the resurgence of an anthropomorphic (and implicitly animistic) mentality into the modern era of the Renaissance and its *revival* in the fin de siècle. Like many of Warburg's subjects, Botticelli's two paintings combine both the material and temporal side of animation. Venus's surging tresses that (following Alberti) seem to materially transubstantiate from hair to flames also transform into undulating chrono-diagrams, which (following Warburg) extend their pseudopodia into our own time (see plate 2).

Though rooted in the study of the Renaissance, Warburg's dissertation investigates a seminal change in the epistemology of his contemporary culture. The accessory-in-motion introduces a novel understanding of the object as a more powerful category of being. It is a dynamic entity that mobilizes itself across temporal planes and areas of knowledge—an artifact with agency, movement, and life (*as if*) of its own.

. . .

"After eighteen years I am still researching this anew," wrote Warburg in his 1907 letter to Schmarsow. It is as if his mentor's smile had opened up a fabric sack of "demons"—a veritable pandemonium of spirited fabrics from which the art historian tried to keep his distance, but only with intermittent success. Based on his reading of Carlyle, the young scholar constructed an accessorized image of the world as a succession of animate layers. Following the publication of his dissertation, Warburg would continue to write about accessories and other similar artifacts, such as the theatrical costumes for the Italian *Intermedi*, the small *tondini* (roundel) engravings of *Impresse Amorose*, as well as Pueblo ornament and bodily adornment. And after these tellurian fabrics came the rhythmic patterns of cosmological decorations, in which the accessories' agitated motion was balanced by the ordered revolution of the stars.[92]

2

The Movement of Snakes

Pneumatic Impulses and Bygone Appendages
from Philo to Warburg

> We understand being a bird, being ant, being lizard: but to be serpent, to have no legs or arms, to move by wriggling, coiling up in spirals, slithering on your belly, that's something extraordinary! How can one be a serpent! Just thinking about it puts the imagination to torture.
>
> PAUL SOURIAU, *L'Esthétique du Mouvement*[1]

"How awful," then, "to be a snake!" concludes the English translator of Paul Souriau's *Aesthetics of Movement*, one of Warburg's textual sources concerning the psychology of motion.[2] Even the possibility of identifying with a legless animal—proposed and then immediately revoked by the turn-of-the-century aesthetician—becomes a source of *negative* empathy. It is as if the serpent's lack of external organs dislocates not only the representation of animal organisms, but also the very organization of human thinking. But then there are all these "movements"—also called "evolutions," "lines," or "attitudes"—such as, "wriggling," "coiling," and "slithering," which keep folding onto each other and reproduce themselves in the author's text despite his volition to arrest them. The limbless movement of the snake creates an involuntary pattern that signals the epistemological shift from empathy to animation—the unexpected

taking over of the subject by the incomprehensible signals of an unfathomable object-being.

Paper serpents

Number six of Aby Warburg's Zettelkästen, the collection of card-boxes that contain the scholar's "scientific notes," is labeled "Iconology-Synthesis" and is distinguished by the snakeskin texture of its paper cover (see plate 3). Appropriately perhaps, the box's first file of notes is titled "Snake, Tree," with the word "Myth" (*Sage*) written over the two other terms in pencil (fig. 2.1). The folder includes six index cards containing mainly bibliographic references to serpent and tree worship in the religious history of ancient Greece and the Near East.[3] In the middle of the fifth page, and over some Greek and Yiddish terms, we read (fig. 2.2):

Figure 2.1 Aby Warburg, Zettelkasten no. 6 ("Ikonologie-Synthese"). WIA. Photograph: Ian Jones for the Warburg Institute, London.

> Philo of Byblos, Phoenician History . . .
> Snakes: Swiftness [*Geschwindigkeit*] with no feet or hands
> or any other member with which
> other animals move forward.[4]

Figure 2.2 Aby Warburg, bibliographic notes (Baudissin–Philo). WIA, ZK 6 , "Ikonologie-Synthese," 006/002160. Photograph: Warburg Institute, London.

From a bibliographic reference we understand that Warburg copied these lines from the book *Studies on the History of Semitic Religion* by the renowned nineteenth-century philologist Wolf Wilhelm Graf Baudissin. A chapter titled "The Symbolism of the Snake" includes a section on "The Snake according to the Phoenicians," in which the author quotes at length from the *Phoenician History* by Philo of Byblos.[5] Baudissin's quotation from Philo is well over thirty lines long and lists several miraculous qualities attributed to serpents by the ancient Phoenicians. And yet Warburg transcribes only this one phrase praising the serpents' limbless locomotion. There was, then, something in this enigmatic movement that arrested the historian's attention and was related to the absence of organic agency in the reptile's bodily progression.

But it is precisely this *lack* of agency that itself turns into an agency and motivates a multitude of textual evolutions. For Warburg appears not to be alone in being seduced by Philo's description: a number of turn-of-the-century art and architectural historians, philologists, evolutionists, and ophiologists quote, knowingly or not, from the same antique source. It is as if the lack of feet gave new feet both to the snake and to this textual fragment that traversed historical boundaries, leaving behind it a number of *footprints* on a variety of epistemological terrains.

Snakes everywhere

Winckelmann's sublime description of Laocoön intertwines snakes with the origins of Western art history. And yet it seems that the same reptiles are also tangled with the origins of architectural history. Such a departure point is the work of architect, archaeologist, and comparative anthropologist James Fergusson, the author of the first *World History of Architecture* (at least in the English-speaking world). Fergusson's *Tree and Serpent Worship* (1868)—a detailed iconographic study of the sculptural ornamentation of the monumental gates in two Indian Buddhist *topes* in Sanchi and Amravati (first and fourth CE AD)—is also the first extensive monograph on an architectural monument of non-European origin (fig. 2.3).[6]

If excited by the serpents announced in the title, Fergusson's reader might soon be disappointed. Among the one hundred plates of the book there are relatively few snakes to be seen. The gestures of adoration performed by the faithful were addressed more frequently to the sacred tree than to the Nagas, the anthropomorphic deities with serpents' hoods growing from their spines. Fergusson interprets this paucity as a result of the decline in serpent worship following the rise of Buddhism, a religion whose "ascetic spirits" were incom-

Figure 2.3 James Fergusson, *Tree and Serpent Worship; or, Images from Mythology and Art in India in the First and Fourth Centuries after Christ from the Sculptures of the Buddhist Topes at Sanchi and Amravati* (London: India Museum, 1868), cover (*left*) and frontispiece (*right*). Photograph: Getty Research Institute.

patible with the "sensual enjoyment" of the indolent "Ophites."[7] However, the historian also cautions his readers to be vigilant by watching out for snake motifs that are not immediately visible:

> I spent a considerable time in exploring these caves, but my mind was full of architecture. I measured everything, drew every detail, and familiarized myself with every architectural affinity. But neither then nor subsequently did I note the presence of any Nagas. Now that my attention is turned to it, I find in drawings and photographs twelve or fifteen sculptured representations of the seven-headed Naga, and there may be many more. I now also recollect seeing Nagas in all the Jaina temples at Abu, at Sadree, and elsewhere, but then I passed them over. Now I cannot take up a photograph of any temple belonging to the group of religions which include the Buddhist, Jaina, or Vaishnava faiths, without seeing snakes everywhere, but in places where neither I nor anyone else detected them before.[8]

Figure 2.4 Drawing of snake *Hydrophis coronata* (from life) and details of head and skin texture. "Drawn by Hurrish Chunder Khan, student, Government School of Art, Calcutta. M & N Hanhart, chromo-lith.," in Joseph Fayrer, Sir, *The Thanatophidia of India, Being a Description of the Venomous Snakes of the Indian Peninsula with an Account of the Influence of Their Poison on Life; and a Series of Experiments* (London: Churchill, 1872), plate 26. Photograph: The British Library, London.

"Seeing snakes everywhere" while they initially appear nowhere: the abrupt transition from absence to omnipresence is staged by two factors— photography and architecture. It is only after studying photographs that Fergusson began to see the snakes hiding inside the Indian temples. But perhaps one of the reasons that the archaeologist could not initially distinguish these reptiles was that their outlines were obscured by the highly decorated background. Human and animal figures can get lost within the framework of sinuously undulating bands and ribbons, an architectural framework as serpentine as the lurking snake-gods themselves.

While Fergusson had difficulty recognizing the snakes hiding in the Indian temples, he was in fact encircled by them in the context of contemporary Indian scholarship. It appears as if every other book on India published during the latter half of the nineteenth century included some reference to snakes, snake bites, snake healers, or snake charmers.[9] Most of these herpetological studies were written by British physicians resident in India in response to the

tens of thousands of deaths reported every year due to snake bites. One of the most well known was James Fayer's *The Thanatophidia of India* (1872), which, in addition to an elaborate classification of all known deadly snakes in the area, included an extensive atlas with splendid color illustrations and drawings of anatomical details so that all venomous species could be accurately recognized (fig. 2.4).[10]

The orchestrated leap of these paper snakes in many different areas of knowledge is perhaps not accidental. Apart from their common context of late nineteenth-century India, Fergusson's archeological folio and Fayer's ophiological atlas have secret affinities in content and method. Perhaps herpetology and archaeology, the two disciplines indexed in this narrative, share such subterranean analogies; snake hunting, the pursuit of illusive objects of desire that have the power to displace our attention, represents only one thread of the two sciences' intertwined evolution.

Full of pneuma and fire

In the first pages of his introduction, Fergusson attempts to explain why the snake has been the object of religious adoration in so many archaic cultures throughout the world. The reason he proposes is peculiar: "As was well remarked by an ancient author, 'The serpent alone of all animals *without legs or arms, or any of the usual appliances of locomotion, still moves with singular celerity*'; and he might have added grace, for no one who has watched a serpent slowly progressing over the ground, with his head erect, and his body following apparently without exertion, can fail to be struck with the peculiar beauty of the motion. There is no jerk, no reflex motion, as in all other animals, even fishes, but a continuous progression in the most graceful curves."[11]

The "ancient author" noting the locomotion of the serpent "without legs or arms" is of course Philo of Byblos. Here Fergusson embellishes the archaic praise with his own mélange of nineteenth-century functionalist physiology and eighteenth-century Hogarthian aesthetics, applauding the "grace, beauty and elegance" of serpentine lines. Yet, the historian's fascination with this ancient description does not stop here. Later in his text, during his remarks on snake cults in Phoenicia, Fergusson again mentions this "curious passage," and while previously he only cited a single phrase from it, he now finds it "worth wile to quote it nearly entire":

Taautos attributed a certain divine nature to dragons and serpents, an opinion which was afterwards adopted by the Phoenicians and Egyptians. He

teaches that this genus of animals abounds in force and spirit more than any other reptiles; that there is something fiery in their nature; and though possessing neither feet nor any external members for motion common to other animals, they are yet more rapid in their motion than any others. Not only has it the power of renewing its youth, but in doing so receives an increase of size and strength, so that after having run through a certain term of years it is again absorbed within itself. For these reasons this class of animals were admitted into temples, and used in sacred mysteries. By the Phoenicians they were called the daemon, which was the term also applied by the Egyptians to Cneph, who added to him the head of a hawk to symbolize the vivacity of that bird.[12]

Philologists warn that the authorship of this passage is a complex matter: the author in this case is not one but at least four, for we are dealing with a quadruple quotation. Fergusson translates (not always correctly) from several Latin editions of the *Evangelical Preparations* of Eusebius of Caesaria, originally written in Greek after 313 AD.[13] In a passage from Book 1, section 9, of his *Preparations*, Eusebius quotes from the *Phoenician History*, attributed to Philo of Byblos and written during the first century AD. In turn, Philo claims to have translated his *Phoenician History* directly from the ancient Phoenician author Sanchuniathon, whose existence is rather dubious.[14] But in this particular passage, even this fabulous Sanchuniathon appears to disclaim the authorship of these statements, attributing them, rather, to the god Taautos or Thoth. Taautos/Thoth, the precursor of Hermes and Mercury, is the mythical inventor of the Phoenician alphabet, and according to Baudissin, a snake-god himself.[15] In short, this erudite confusion shows that we will never know who said or wrote this well-known eulogy of snakes. The lack of agency in snake movement is echoed by the lack of definitive authorship in the commentary that trails behind it.

In spite of several nuances lost in Fergusson's English translation, Philo's quotation retains the startling effect of Eusebius's Greek text. The serpent's "pneumatic" movement, performed with no hands or feet (*άνευ χειρών τε και ποδών*) or other external instruments to facilitate locomotion, could be defined as an *anorganic* movement (when one considers the origin of the term "organic" in the Greek "organon" or instrument). There is no visible agency or ground for the progression of the snake, thus the ancient author has to resort to metaphysics. "Abounding in spirit" and "fiery" correspond to the Greek words *πνευματικότατος και πυρώδες*, meaning full of pneuma and fire—two of the four elements that, in the cosmogony of the ancient Phoenicians, created

the world.[16] Yet, fire and pneuma are by no means organic or rational causes. The two ethereal elements do not explicate how snakes progress, but instead further enhance the *wonder* of their progression.

Philologists studying Philo's *Phoenician History* have remarked that his avowed quotation of Sanchuniathon's mythological cosmogony sounds too "rationalistic" to be as archaic as he claims. The scholarly consensus is that if Philo is indeed citing an ancient text, it is one that likely had already been filtered through other Hellenistic writers.[17] Something similar may have occurred in the passage on the movement of snakes, in which the manner of "Sanchuniathon's" inquiry into the snake's *anorganic* movement seems rather anachronistic in its Aristotelian overtones.[18] In his treatise on the "Progression of Animals," Aristotle provides a rational interpretation why feet would be entirely superfluous to snakes, and therefore such animals ought *not* to have them. Within the limits of such rational explanation, Philo's phrase marking the absence of external members in an organism would sound even more startling in a post-Aristotelian world.[19]

Snakes with feet

While Aristotle's scientific logic refuted the existence of feet in serpents, mythological imagination kept restoring them. For example, the well-known figure of Sito, the primeval serpent god of the Egyptians, is a snake traditionally shown walking upright on two human legs.[20] But could it be that what poses as the product of a myth is the trace of a prehistoric truth? In other words, could snakes with feet be the vestiges not of historically erroneous beliefs, but rather of the *engrams* of cultural (or biological) memory? Here one has to turn from Philo's *Phoenician History* to nineteenth-century natural history and its reconstruction of footed reptiles.

One of the major themes in turn-of-the-century evolutionary biology was the role played by the development of external organs, such as feet and hands, in the processes of natural selection. *Werden und Vergehen* (*Becoming and Passing Away*), a popular history of evolution by Carus Sterne (the late nineteenth-century multitheorist whom we earlier saw in relation to representations of "life-in-motion") focuses on the organs that animal species either preserve and develop or let perish, as if leaving them behind.[21] In a chapter titled "From Many-Feet to Six-Feet," Sterne points out that initially invertebrate organisms, especially certain crustaceans, as well as insects, spiders, and multilegged worms, had several dozens of feet, only a few of which were actually used for movement. Over a long period of time, some of these appendages

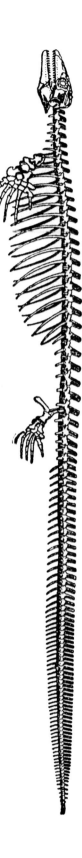

atrophied and transformed into quasi-vegetal extensions around the head or the tail that were used as sense organs, such as tentacles and antennae, or were totally discarded so that finally the most important of these species were left with only six feet distributed in three pairs across the trunk. Sterne argued that the elimination of these superfluous extensions marked a significant progression in the evolution of animal species. Animals could "move on" by leaving feet behind.[22]

Snakes were part of such devolution. In his chapter on serpents titled "The Uncanny" (*Die Unheimlichen*), Sterne engages in a detailed discussion of an extinct genus of amphibian reptiles from the group of the so-called protopythons (*Pythonomorphen* or *Riesenschlinger*) that had been reconstructed from fossils, and that had also attracted the attention of Cuvier at the end of the eighteenth century. These primeval reptiles, numerous remains of which were later found in North America, were approximately ten meters long. They had beaked heads similar to lizards, expanded thoraxes, and two pairs of quite size-

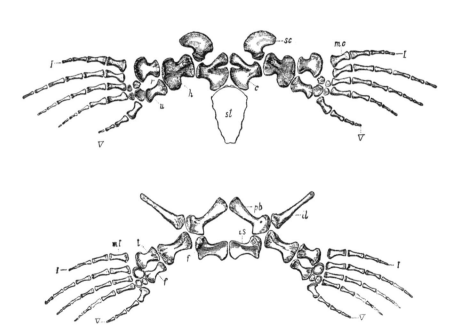

Figure 2.5 *Right*, restored skeleton of *Platecarpus* (after Merriam); *left*, pelvic area and lateral appendages in extinct snake-type sea saurian *Platecarpus* (*Lestosaurus*) *simus marsh* from the upper chalk beds of Kansas (one-twelfth of full size): *sc* shoulder blade, *c* coracoid, *st* sternum (breastbone) (supplemented), *h* humerus, *r* radius, *u* ulna, *il* ilium, *pb* pubic bone, *is* ischium, *f* femora, *t* tibia (shinbone), *f* fibula, *mc* and *mt* metacarpal and metatarsal bones of the first through fifth toes." Carus Sterne, *Werden und Vergehen*, 4th ed. (Berlin, 1900).

able, fully developed feet that were connected to the spine by two wide wrist bones (hence the species is also known as *Platecarpus*) (fig. 2.5). Since the feet were almost directly attached to the spine, these animals essentially had no legs. Therefore, while such appendages aided the movement of these animals in water, they must have made it very difficult for them to move on earth, explaining their eventual disappearance.[23]

This meant that millions of years ago the ancestors of modern serpents, like many other organisms when they left the ocean, had feet that they ultimately abandoned. Among existing species, only pythons preserve vestiges of them (and for that reason are called "stump-footed" [*Stummelfüssler*]). The python's single pair of feet are internal, yet the claws still protrude slightly in the lower part of the reptile's tail in the form of thin hornlike spurs (fig. 2.6). These hardly visible claw tips are the only external remains of the protopython's large hind appendages. Once again organic history is manifested as a rigid, almost inorganic trace that can both draw and erase lines between different evolutionary stages.

Figure 2.6 Spine structure and hornlike spurs in pythons. Carus Sterne, *Werden und Vergehen*, 4th ed. (Berlin, 1900).

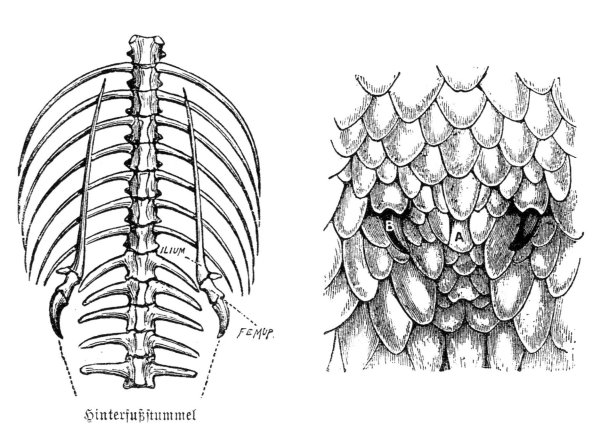

ILIUM

FEMUR.

B A

Hinterfußstummel

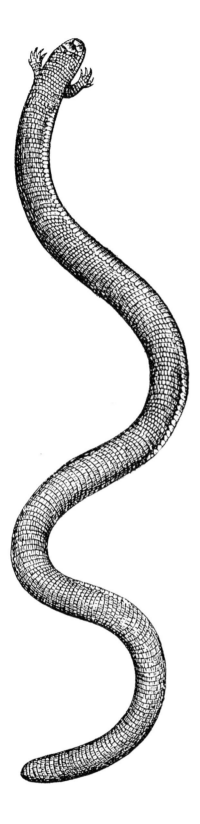

Apart from these bygone specimens, however, there were also some animal fossils that were still "living." One of Sterne's illustrations depicts a peculiar type of worm-lizard known as "hand-burrower" (*Handwühle* or [*bi*]*chirotes canaliculatus*), found in Southern California, which has only one pair of very small hands with five fingers and four claws used for digging and not for walking (fig. 2.7).[24] Other herpetological studies show similar species of lizards (skinks) with minuscule and virtually nonfunctional limbs even thinner than those of the hand-burrower, and with only three toes (*Hemicherotes*). When moving quickly, these lizards fold their feet against their sides (like airplane wheels during takeoff) in order to glide like snakes.[25]

We know that feet were not the only body parts that snakes eventually abandoned: they also lost their eyelids (and therefore seem to never sleep) and a lung. Snakes breathe very little—when inert or sleeping, as little as once every hour, bringing them close to the vegetal or the latently *inert* state.[26] Thus, the archaic author's assertion that snakes move solely by means of their "breath" cannot be verified by science.

Considering these major organic losses, Sterne concluded that "[r]eligious symbolism is therefore perhaps justified from the standpoint of natural history when it regarded this 'animal reduced completely to a tail' as an image of the falling away from the way of nature, as the enemy of all progress lurking in the dark."[27] Perhaps the reason for this unanimous condemnation of serpents is the whimsical will these animal usurpers manifest in having feet and willing them gone. Natural theorists such as Sterne proved that the "all-but-one-tail" state of the snake was not the product of a divine curse, as the Bible would have it, but of a *choice* made by the serpents themselves. In forsaking their feet, these reptilian atavists demonstrate their will to move differently than their quadruped counterparts: not only do they move

Figure 2.7 Two-legged lizard or hand-burrower ([*Bi*]*chirotes canaliculatus*) (after Hayet). Carus Sterne, *Werden und Vergehen*, 4th ed. (Berlin, 1900).

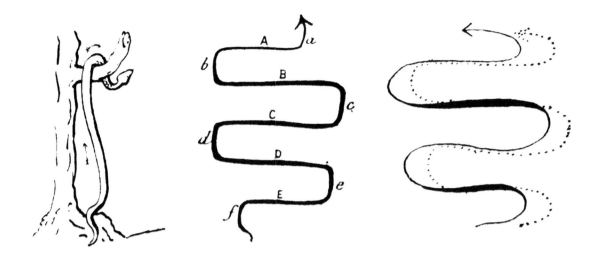

Figure 2.8 Depiction and diagrams of serpentine movement. Paul Souriau, *L'Esthétique du Mouvement* (Paris: Alcan, 1889), figs. 11–13.

without feet, but also they move backward in terms of evolution. Snakes were the progeny of *unnatural* selection.

However unnatural, such atrophy had significant advantages, the most extraordinary of which was the serpent's swiftness. Nineteenth-century anatomists were well aware that snakes do not move fast because of their fiery breath, but rather due to the unique structure of their spine consisting of two to four hundred highly versatile vertebrae, each of which (with the exception of those forming the tail) is joined to a pair of semicircular ribs that follow the spine's rotations. In order to move, the snake partly glides on the tips of these ribs.[28] Far from having no feet, we suddenly discover that snakes are potentially "all feet."

In his *Aesthetics of Movement*, Souriau described snake movement as the "progression of a wave moving from head to tail," combining progression in certain parts and regression in others.[29] Essentially the bodies of snakes never move in a singular direction: either in contact or by lifting parts of their body from the ground, they oscillate from right to left and then they roll backward and forward (what ophiologists characterize as the "concertina" movement of the snake). The serpent's progression is a complex form of perpetual displacement (fig. 2.8).[30]

Regressive evolution

The phenomenon of progress due to (a partial) regression was an example of what turn-of-the-century natural theorists came to recognize as "regres-

sive evolution"—a supplement (if not an alternative) to Darwin's theory of linear evolutionary progress. In their book *L'évolution régressive en biologie et en sociologie* (1897), Demoor, Massart, and Vandervelde—social and natural theorists from the Institute of Sociology at Brussels—examined the impact of regression in the evolution of individual animal organisms, but also in that of collective social organizations.[31] Employing examples from plants and certain species of crustaceans, the three Belgian scientists described the development and subsequent loss of vital extensions in vegetal and marine organisms. The final lesson was that in order to take two steps forward, an organism had to take at least one step back. Unlike Sterne, the Belgian scientists did not see regression as a deviation from the way of nature, but rather as a viable presupposition for progress. In order to gain something, an organism had to lose something else. There could be no evolution without devolution. Just like the "concertina" movement of the snake, no progress could be performed without recoil.

However, the scientists' most vivid examples come from the side of contemporary atrophying institutions—social organisms, such as the British monarchy or the system of sheriffs in England, that have become increasingly powerless or even entirely defunct and yet persist in the form of pageantry and festivals. In an era saturated by projections of major social changes, this was an extremely topical study: will such rudimentary vestiges survive in the future, and if they do, will they be conducive or hostile to broader changes?[32] The lost feet of the snake were now entangled in a multilegged political predicament.

Demoor, Massart, and Vandervelde's book is in the Warburg Library. Warburg himself used the phrase *evolution régressive* (in French) in his early drafts for the Kreuzlingen lecture to describe the regressive forms indigenous American cultures take in the Western literary unconscious.[33] Perhaps the snake's lost feet function as the missing links between Warburg's earlier work on fifteenth-century Florentine accessories-in-motion (the nonfunctional but vibrantly moving fabrics surrounding the oceanic organism of Botticelli's Venus) and his study of accessories worn by Pueblo Indians during their serpent rituals. Both the Florentine moving drapery and the Indian snake dance are "primitive survivals" that manifest the persistence of antiquity. Both are organs or implemental rituals that have lost their original functional value. Nevertheless, both "accessory forms" are more than merely ornamental relics.

What, then, is the role of these reduced but enduring vestiges of culture? Can such atrophied limbs or institutions be revived into a fully organic existence? With the exception of certain forms of teratomorphic atavisms, the answer of Demoor, Massart, and Vandervelde was *no*. Once an organ disappears

it cannot grow back again or regain its primitive function; however, if it does not cease to exist and is merely reduced, it may regain a new significance that goes beyond ornamental survival.[34] These rudimentary appendages become the living traces of a prior organic state that now continues to exist in a modified form. Organisms perish and cultures die, yet something remains of them that creates a link with further transformations. The remnant is not only a monument to the past, but also the link to a future development. Anticipating the results of a "regressive" form of cultural evolution, Warburg's main concern was not simply the preservation, but mainly the renewal (*Erneuerung*) and further development of archaic vestiges into agents of cultural change.

Finally, the subterranean revival of animism within late nineteenth- and twentieth-century modernity could be the product of regressive evolution—a necessary "stepping back" toward analogical mentalities that can promulgate new epistemological formations.

Pottery snakes

From the dozens of books dealing with snakes and snake symbolism in the Warburg Library, Erich Küster's *The Snake in Greek Art* (*Die Schlange in der griechischen Kunst*) stands out for its peculiar treatment of the snake figure.[35] Like most of the previous snake authors, Küster quotes a large excerpt from Eusebius's citation of Philo, this time in the original Greek.[36] Nevertheless, it is more interesting to follow the young archaeologist's visual translation of Philo's passage as he traces the evolution of serpentine motifs in Greek art and in archaic pottery in particular.

From the naturalistic representation of serpents on bone carvings of the prehistoric era to the zigzag serpentine motifs in the ornamented implements of tribes in Central America and Oceania, and from the curvilinear spiral motifs of Minoan and Mycenaean art to the rectilinear stylized patterns of the Doric style, Küster recognized the repetition of a movement from naturalism to geometric stylization. The serpent's flexible outline can accommodate any shape, adapting as easily to the organic curve as to the manmade right angle. Such geometric transformation could be seen in the development of the Greek meander from the simple spiral, the double spiral, the progressing spiral (also known as "running dog" [*laufender Hund*]), and the spiral meander, followed by the rectilinear versions of all previous motifs, all of which Küster arranged in a diagrammatic frieze (fig. 2.9, *top*).

Küster argues that several wavy lines (*Wellenlinien*, also known in German as *Schlangenlinien*) seen in Greek pottery, which initially appear to be total-

ly abstract or generic, in fact represent snakes. For example, many of these threads seem to thicken at their crescent, forming a large dot that indicates a head. The line might also bifurcate into an open mouth or terminate on a ring with a dot inside it, signifying an eye (fig. 2.9, *bottom left*). Following the same lines to their opposite ends, Küster observed that they grew thinner to-

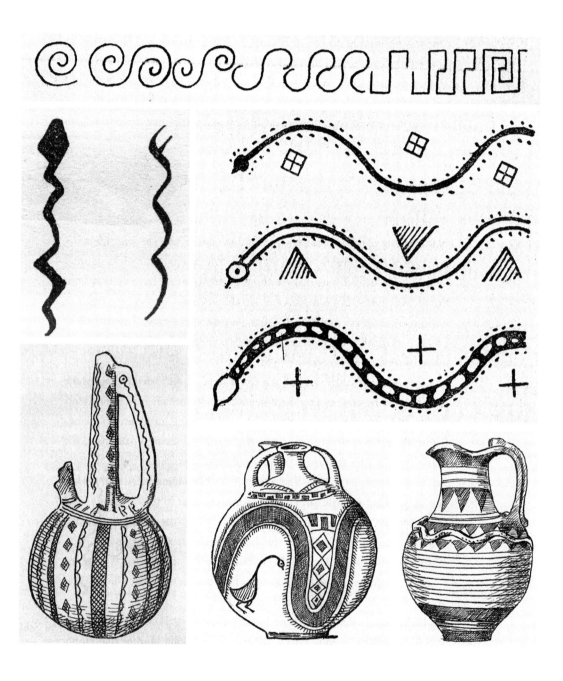

ward what could be construed as the snake's tail (fig. 2.9, *middle left*). In their advocacy of abstraction, contemporary art historians such as Alois Riegl and Wilhelm Worringer would decidedly undermine the naturalistic, vegetal, or animal origins of ornamental motifs.[37] Küster seems to gravitate toward the opposite side, that of figuration, by recovering the body of the animal inside the abstract pattern. In historiographic terms, this recoil into figuration might appear as a regression. It was as if the figurative unconscious of abstraction was showing its animal head, or in fact many heads—all of them (as Freud might envision them) *archaic*.

Figure 2.9 Snake motifs in archaic Greek pottery from Erich Küster, *Die Schlange in der griechischen Kunst und Religion* (Giessen: Töpelmann, 1913). *Top,* from spiral to meandering motifs; *middle left,* thinning lines indicating snake tails and bifurcating line representing snake mouth; *middle right,* three snake outlines and skin textures; *bottom left,* circle and dot as snake eye; *bottom center,* snake body as general decorative outline; *bottom right,* snake in full relief on the surface of archaic vase.

Küster further argues that in certain depictions of snakes in archaic pottery, purely geometric patterns (such as squares, triangles, and crosses) surrounding the serpentine line represent details of the snake's skin, which gradually become independent and function as abstract indexes of the reptile (fig. 2.9, *middle right*). It is as if the elastic tube of the snake's body carries within it an energy surpassing the capabilities of its diameter. The reptilian figure suddenly disperses in a constellation of satellite representations, reminiscent of the planetary iconography of Warburg's astrological studies.

In fact Küster traces a pictorial shift during which the snake transforms from figure to an all-encompassing quasi-cosmic background. At the height of their geometrization, snake patterns transformed into abstract wavy bands that provided the frame for whatever was represented inside the painted vase (fig. 2.9, *bottom center*). Instead of being a figure enclosed inside a frame, the snake itself became an expansive frame enclosing all other figures. This was Küster's most staggering argument. The serpent was no longer a concrete body, but a phobic *no-body* deceptively hibernating in the periphery. It could not be seen, but it was "all around." It could not be grasped because everything was inside it. Anywhere you stood, you could be stepping on a serpent's tail.

But perhaps such an abstraction was too overwhelming and needed some figurative safety pins. Küster shows that even in a state of maximum geometrization, certain elements in Greek archaic art remain thoroughly figurative. For example, while the snakes and other animal figures painted on the surfaces of archaic Attic vases are strongly geometric, the clay snakes sculpted on the periphery or the handles of the same vases are carved in full relief and in considerable detail (fig. 2.9, *bottom right*).[38] This meant that there was no uniform *Kunstwollen* governing the imaging of snakes in archaic art. Serpents continued to meander between abstraction and figuration, as well as symbolic function and decorative excess.

One might think that Küster exhibited a symptom similar to that manifested by Fergusson: he too was "seeing snakes everywhere," especially in plac-

es where no one had seen them before. And once again, the outlines of archaic snakes appeared imbedded inside a serpentine background that was uncannily contemporary. In accordance with the nineteenth-century "materialist" theories of the followers of Gottfried Semper, Küster credited the geometrization of snake and other animal motifs to the growth in the mass manufacturing of decorated artifacts, such as pottery, during the Bronze Age.[39] Snakes were popular because their undulating patterns fit the mass reproduction of objects. Küster's art historical analysis of Greek archaic motifs then perhaps reflects a similar debate in Germany prior to the Great War concerning the industrial standardization (*Typisierung*) of artifacts. In this sense, the flowing serpentine meanders of ancient Greek vases appear as dynamograms externalizing the forces of modern economic production—forces that in their lack of visible agency seem equally serpentine.

The transformation of the snake motif into a form of industry is perhaps the closest link between Küster's small treatise and Warburg's lecture on serpent ritual, in which again the snake transforms into a technological apparatus. Warburg had read at least part of Küster's dissertation. In his copy of the book in the Warburg Library, there is a line marking one of Küster's footnotes referring to the Moki snake dance; under the letter "M" in the index, between "*mykenischer Stil*" and "*Mysterien*," Warburg has handwritten "Moki" in reference to this note—another clue that the ancient Greeks and the Native Americans shared a mysterious "kinship."[40]

Bygone conclusions

But there are more snake threads tying Warburg's account of "serpent ritual" with the archaeological and ophiological texts by previous authors.[41] For example, both in the context of nineteenth-century India documented by Fergusson and the American Southwest visited by Warburg, the snake represents a relic of indigenous resistance—another fossil of regressive evolution, whose meandering movement needed to be arrested to be scientifically described. The two main types of researchers converging on Arizona and New Mexico at the turn of the century were, on the one hand, ethnographers and anthropologists coming to observe the Hopi and witness their snake dance, and, on the other, natural scientists and herpetologists studying the resilient fauna of the southern United States and northern Mexico, especially the various species of reptiles thriving in the desert.[42] Sometimes anthropology and natural history coincided: the surviving lizards were studied together with the remaining natives.[43] Warburg himself on his American trip seems to have toyed with

Figure 2.10 Aby Warburg, sketch of lizard from his "Indian vocabularies," WIA, III.46.1.7.3, "Pueblo Indians. 'Indianische Vocabulare, 1895–96,'" 78. Photograph: Warburg Institute, London.

similar excursions into natural history. His travel notebooks contain drawings of Pueblo costumes and implements, many of them decorated with animal symbols, but also sketches of real animals, such as the images of a spider and a lizard decorating two pages of the Pueblo Indian vocabulary Warburg compiled during his field research (fig. 2.10).

Several of Warburg's sketches drawn in situ and later collected in a Zettel-kasten under the title "Americana," refer to the subject of bodily accessories and prosthetic extensions.[44] In the philosophical fragments Warburg composed at that time, he refers to such objects as the "*Gerät*," the "apparatus" of functional implements used and clothing worn by the Moki, such as hunting tools, knives, axes, and arrows.[45] This form of technical equipment lies in a zone mediating between the organic and the inorganic: tools and other man-made accessories expand the organic body by adding a second inorganic layer on top of the human skin.

An aphorism from Warburg's "Monistic psychology" project, written during his American trip and dated August 21, 1896, reads: "How does primitive man lose the feeling of unity (identity) between his living self and his particular actual spatial bodily circumference: by means of the tool, ornament, traditional dress—painless body parts—by means of possession, ownership, gift." [46] In the aphorisms that follow, Warburg shows how man adapts (*angleicht*) his organic body to the inorganic condition of his clothing and implements. In so doing, he loses his unity with nature and with his living self, but expands the prevailing spatial outline of his body through the extension offered by the inanimate apparatus of his clothing and tools.

One of Warburg's drawings shows a Pueblo man wearing a short apron or a skirt decorated with a snake across the hips (fig. 2.11).[47] It looks as if the drawn serpent is the only trace of organic life in the dehumanized individual. Snake and clothing create a polarity: in the center lies the obsolete anorganic animal, while on the periphery stands the fully equipped man, a superorganic organism verging on the solidity of the inorganic.

The subject of bygone appendages resurfaces in Warburg's Kreuzlingen lecture. Just like the natural or cultural organisms it addressed, the lecture

Figure 2.11 Aby Warburg, drawing of Pueblo Indian costume with snake, WIA, ZK 40, "Americana," 040/020434, 44. Photograph: Warburg Institute, London.

originally had several textual appendages—including two alternative conclusions—some of which were finally cut either by the author himself or the subsequent editors of his essay. We can be positive that the "Uncle Sam" finale, which was published, was in fact *not* the conclusion that was presented on the night of April 21, 1923, at the Bellevue sanatorium.[48] In another section, also marked as "*Schluss*," which was written one day before the actual delivery of the lecture, Warburg returns to the subject of feet and their relation to bodily and cultural evolution. This passage begins with a condemnation of snake worship and makes references to the biblical theme of the "brazen serpent": "A tangible and graspable living animal, such as the snake, arrested with both hands, becomes a symbol (*Sinnbild*) that one worships in a bronze reproduction. Moreover, the snake becomes a symbol of sin, i.e. of the illicit

idolatrous cult of the lower poisonous reptiles."[49] Then, with Enlightenment fervor and the zeal of a modern Moses, Warburg emphatically concludes: "And so it should stay. Man, should not have to be a four-footed antelope during divine service, he should not have to be an animal, when he wants to approach the infinite. He should use only his two feet, go up the stairs, and lift his head up to the sky."[50] The markedly progressive tone of this last remark hailing salvation through cultural enlightenment is different from the gloriously pessimistic "Uncle Sam" ending for the published version of the essay. From the "many feet" of protozoa to the six feet of advanced organisms described by Sterne, and from the four feet of the antelope to the two feet of man observed by Warburg, we watch an orderly mathematical progression, whose irrational culmination is the snake's total absence of appendages. Is the snake then below or *above* man in the evolutionary *ladder,* and what can its lost feet signify for the ontological pathways that humans have chosen to abandon?

Without feet or footnotes

We would perhaps arrive at a very different critical conclusion if we were to grasp Warburg's lecture "by the feet," so to speak, particularly those that later editors either discarded or added. In addition to the alternate conclusions, one of these marginal entry points is the small group of footnotes that were later inserted to the published version of the essay, one of which in fact returns to the subject of the serpent's feet. There is a mysterious interplay between the subject of the absence of feet in snakes and the scarcity of footnotes in the scholar's text, a sign that, in this case, the historian had to learn how to crawl without his usual philological supplements.

Certainly Warburg was a historian of word and image and thus, even in a lecture initially titled "Images [*Bilder*] from the Region of Pueblo Indians," literary references abound. However, since the historian had little or no access to the specialized books of his library when preparing his lecture, he had to quote freely from memory. After the lecture was delivered, he did add a few bibliographic references in the manuscript addenda he inserted on the typescript of his text. But since the version of the lecture that was finally published appeared scarcely footnoted, these philological citations remain largely unacknowledged, sometimes even by the author himself.[51]

Such is the case with the quotation on the movement of snakes from Philo's *Phoenician History.* Winding its way from Warburg's scientific notes to the drafts of his 1923 Kreuzlingen lecture, it ended up in the printed edition of the essay based on a compilation of Warburg's lecture drafts published in the

Journal of the Warburg Institute (JWI) in 1938.[52] Yet, in a devilish coincidence, it appears not in the main text, but in a footnote added by the *JWI* editors. The latter inserted this footnote in a passage in which Warburg refers to the snake as "the most natural symbol of immortality and of rebirth from sickness and mortal anguish," preceding the passage on Asclepius and healing.[53] And while the whole article was translated into English by W. F. Mainland, the following passage alone appeared in the original German[54] (here in English from the recent American edition):

> Through which qualities does the serpent appear in literature and art as a usurping impostor?
> 1. It experiences through the course of a year the full life cycle from deepest, deathlike sleep to the outmost vitality.
> 2. It changes its slough and remains the same.
> 3. It is not capable of walking on feet and remains capable nonetheless of propelling itself [forward] with great speed [*Sie ist nicht imstande auf Füssen zu laufen und besitzt trotzdem ein Maximum von sich vorwärts bewegender Schnellkraft*], armed with the absolutely deadly weapon of its poisonous tooth.
> 4. It is minimally visible to the eye, especially when its colors act according to the desert's law of mimicry, or when it shoots out from its secret holes in the earth.
> 5. Phallus.[55]

The first half of quality number three—"speed" without feet—apparently refers to Philo's movement "with no feet or hands," as Warburg had read it in Baudissin. It is as if the ancient source has been camouflaged by all the other snake properties streaming inside the same formulation. But here Warburg connects the snake's enigmatic movement with the serpent's poison fang, as if this irrational manner of movement also had something poisonous about it. The snake for Warburg is a "phobic object," not a beautiful animal, as it was for Fergusson. Any sense of attraction has to be counterbalanced by repulsion, and the oscillation between the two creates an ambivalent decorum.

But in fact the pairing of the snake's movement with its poison was not new for Warburg. The majority of his working notes on the subject of snakes from the Zettelkasten mentioned earlier (including the passage from Philo) are bibliographic references about the therapeutic qualities of serpents, and some of these sources can be found in the relevant section of the Warburg Library on *pharmakopoieia*.[56] Although these notes cannot be dated pre-

cisely,[57] they are connected with themes that Warburg studied over a long period of time, such as snake antidotes and snake antidote vendors.[58] Why, then, did Warburg transcribe the quotation from Philo on the movement of snakes among these references that have mainly to do with healing? It may have been that the scholar was looking at Baudissin's references to the snake as *Agathodaemon* (good spirit) in Egyptian religion (coinciding with the origin of Asclepius in Semitic theology), and only by serendipity came across the passage on the snake's movement "with no feet or hands." But could it also be that in that limbless meandering, Warburg recognized something that was ostensibly *therapeutic*? Darwin would remind his readers that animals, when they are hurt, shake their limbs violently to dispel pain, and a few years later the aesthetician Souriau would describe movement as the "best anesthetic" against bodily discomfort.[59] But then why does Warburg combine the snake's palliative movement with the "weapon" of its poison fang that is "absolutely deadly"?

Within scholarly research, not all snake threads lead to a viable conclusion. The ones that remain unresolved keep an inquiry "in motion." One could argue that the Kreuzlingen lecture is less an essay about the snake, per se, than about Warburg's methodology of snake connections: Athens and Oraibi, Florence and San Francisco. Warburg himself regresses into an "animistic" form of associative thinking, even if he explicitly renounces such mental patterns. Similar to the Renaissance "accessory," the serpent functions as a Freudian "overdetermined element"—a marginal object that moves into the center of representation by connecting a great number of regions that appear distant, yet can be uncannily close. Not everyone could follow such a meandering and/or *peripheral* method.

If in 1888, the announcement of Warburg's dissertation topic made Schmarsow smile, later on the exposition of his "accessory" method would cause concern rather than amusement. After hearing his patient speak in the sanatorium hall, Warburg's psychiatrist Ludwig Binswanger would comment that: "the lecture itself . . . expanded on a large quantity of knowledge, but in a manner that was somewhat disordered: the principal facts [*Hauptsachen*] are too heavily covered by *accessory elements* [*Beiwerk*], and the important viewpoints are indicated only in passing by intimate archaeological allusions that only very few people in the audience can understand."[60] However critical (and implicitly envious) Binswanger's assessment might be, it is perhaps the most accurate diagnosis that the psychiatrist ever made of his patient. Even if Binswanger himself grumbles about details and misses the "principal fact" about the scholar's thinking process, he implicitly acknowledges that for War-

burg the accessory is not simply an object, but a *method*. Following Carlyle, Warburg clothes the "main facts" (*Hauptsachen* or *Hauptwerk*) by multiple layers of accessory elements (*Beiwerk*). His working procedure is in empathy with his peripheral object; this is his way of circumscribing the conceptual periphery (*Umfangsbestimmung*) of his subject. Perhaps the reason for Binswanger's concern was that he had already witnessed that bewildering process of composing images and narratives in too many of his patients' dreams or delusional accounts. But the psychiatrist overlooks the fact that here the subject is an art historian, and that a similar inverted logic was already ingrained in his patient's scholarly trade.

The renewal of Phoenician antiquity

One of the main properties of this accessory-animistic and/or snakelike scholarship is mimicry—the capacity to adapt in different contexts by clothing earlier statements by means of new words. One devilish detail in the wording of Warburg's unacknowledged reference to Philo offers us a hint about the new bewildering associations attached to the snake in early twentieth-century modernity. The quotation from Baudissin's 1872 translation of Philo, transcribed by Warburg, reads "swiftness [*Geschwindingkeit*] with no feet or hands." In his own formulation written in 1923 in Kreuzlingen, Warburg talks of the snake "propelling itself with great speed [*Schnellkraft*] with no feet."[61] Since Warburg was missing most of his notes and had access to very few books while at Kreuzlingen, he could write things only as they came to his mind; therefore it is understandable that references to texts he had read in the past would be imprecise. But this apparent misquotation has significant merit.

Warburg's *Schnellkraft* (speed power) is something different from the *Geschwindigkeit* (swiftness) of Baudissin. Both terms refer to Philo's Greek "τάχος," connoting the snake's celerity. But *Schnellkraft* does not have the flowing quality of *Geschwindigkeit*, as it refers to something less continuous and more mechanical, combustive, or jerky, and energized by pressure, like the firing of a bullet in a machine gun or a sprinter at the starting line.[62] *Schnellkraft* signifies a latent, potent form of energy about to discharge rather than an active, ongoing kinetic flow. Perhaps the reason behind this (re)energized rendition of Philo was simply that between the time that Warburg copied Philo's passage from Baudissin and 1923, when he wrote the drafts for his lecture, mechanical devices, such as machine guns and motorcars, had become ubiquitous. Since it "propels itself," the snake is essentially an *auto-mobile*—a body motivated by an autonomous agency of movement.[63]

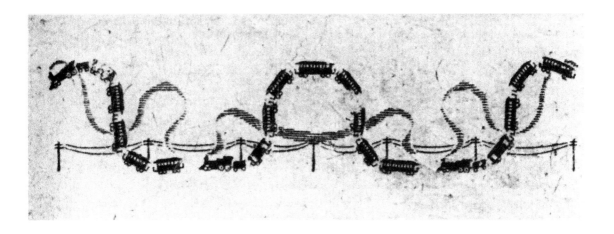

Figure 2.12 Gelett Burgess, locomotive, vignette, *The Lark*, San Francisco 1896.

Even though cars do not explicitly appear in any of the drafts of the Kreuzlingen essay, there is another mechanical mode of transportation that was almost omnipresent in that era. I refer to the train locomotive, which resurfaces several times in Warburg's descriptions of his Pueblo journey and figures prominently in his photographs from the American frontier. Most peculiar is the locomotive shown in the caricature by Gellet Burgess, selected by Warburg as an illustration to his short essay "American Chapbooks" (1897), written shortly after the scholar's return from America (fig. 2.12).[64] The vignette depicts a train leaping snakelike in the air in a symmetrical interlacing of train, wavy ribbons of smoke, and the wires of telegraph poles. In his reminiscences, Warburg refers to the comparison of the locomotive with the horse or the hippopotamus in the eyes of uninformed natives as an example of "objective biomorphism."[65] The snake-locomotive of the Californian vignette artist is an example of the animal biomorphism of machines.

The steam train occasions another link with Eusebius's Greek text, his reference to the serpent's *pneuma*. Around the turn of the century, the term *pneumatic* had a number of associations, the most prevalent of which referred either to telecommunications, such as postal or telegraphic apparatuses energized by air pressure,[66] or vehicular devices, most prominently bicycle and motorcar tires (known in France as *pneus* or *pneumatiques*). As we shall see later in the description of Léger's 1910 landscape, a number of multinational industries were then filling the globe with pneumatic accessories made out of Indian rubber, whose buoyancy was, however, limited. Perhaps the sight of pneumatic wastelands, such as the heap of deflated car tires depicted in a newspaper photograph used by Moholy-Nagy in his *von material zu architektur* as an illustration of modern "massing" (fig. 2.13),[67] may then share a

number of analogies, whose origins are not merely linguistic, with the mass of serpents brimming inside the Pueblo *kiva* shown in photographs from early twentieth-century anthropological studies of the Hopi (fig. 2.14).[68] In contrast with the bridling animation of the *kiva* snakes, the mound of motorcar tires is a solidified image of depression. The ancient author was perhaps right when he wrote that at the end of its life, the snake becomes "absorbed within itself" and "never dies a natural death": the modern snake (which is increasingly "self-absorbed") expires from deflation.

Figure 2.13 László Moholy-Nagy, *Massing (Surface Aspect) Old Motorcar Tires (häufung [faktur] alte autoreifen)*; photograph reprinted from the illustrated journal *Weltspiegel*. László Moholy-Nagy, *von material zu architektur*, Bauhausbücher, no. 14 (GmbH Köthen, 1929), fig. 32.

Figure 2.14 Detail of photograph of "snake washing" ceremony inside a Pueblo *kiva*. From George A. Dorsey and H. R. Voth, *The Mishongnovi Ceremonies of the Snake and Antelope Fraternities* (Chicago: Field Columbian Museum, 1902).

After this intercultural juxtaposition of images, Warburg's final detour from the deserts of New Mexico to the streets of San Francisco in the gloriously pessimistic "Uncle Sam" finale of his lecture appears less surprising. Here, the snake is anthropomorphized into a person—Franklin, the modern electricity snake-god—yet at the same time it effaces itself by turning into a circuitous network. Perhaps Warburg's understanding of the cyclical transformation of the snake is best reflected in his celebrated expression "the infinite waves," which refers to contemporary devices of wireless (*drahtlose*) communication,[69] and which is invoked in the conclusion of the published version of his lecture: "Natural forces are no longer seen in anthropomorphic or biomorphic guise, but rather as infinite waves [*als unendliche Wellen*] obedient to the human touch.[70]" In the annotated original typescript preserved in the archive, above the word "*Wellen*," Warburg has added a small, almost illegible phrase underlined by a scroll (fig. 2.15). With much effort one may decipher a few words whose meaning appears to be "in empathy" with the author's handwriting: "*kleinste unsichtbare Stücke*"—"smallest invisible particles"—is perhaps a reference to microphysics.[71] But there is also another illegible word written in the margin of this snakelike insertion that appears to begin with the prefix "*makro*." This could be "*makroskopisch*," although "*mikroskopisch*" seems to correspond better to the preceding annotation. Perhaps the unconscious juxtaposition traced here is a dynamic polarity between the microscopic texture and the macroscopic frame of modern telecommunication devices, for the correspondence between microcosm and macrocosm was one of the subjects preoccupying Warburg throughout the last two decades of his life.[72] But the polarity inscribed in this annotation is not only telling for Warburg's modernity, but also prophetic for our very own. Just like the clouds inside the Pueblo "world house," the "infinitesimal particles" transporting the "endless waves" of

Figure 2.15 Aby Warburg, manuscript addenda "as infinite waves [*als unendliche Wellen*]," typescrift drafts for the 1923 lecture "Images from the Region of Pueblo Indians of North America." WIA, III.93.1, "Bilder aus dem Gebiet der Pueblo-Indianer in Nord Amerika," 79. Photograph: Warburg Institute, London.

modern wireless (mis)communication embellish the world with a muddled substance of haze and static noise. The modern snake has no hands or feet, yet it has endless prosthetic extensions. It no longer undulates linearly, but moves in a radial manner. Pneumatic and electrical technologies are now almost entirely substituted by wireless devices, in which the agency of movement is ever more abstract. In such radical *anorganicism*, feet are a bygone subject.

If in Fergusson, the serpent was a figure hiding inside the background, and in Küster, a motif expanding into a framework, in Warburg, the snake is at once god and ornament, symbol and motif, frame and figure; yet in spite of its hybridity, the final transubstantiation of the snake is into a cluster of invisible particles that elude mental and physical perception. As in the snake patterns of archaic pottery, Warburg's serpent is no longer a singular animal, but a linear network framing all natural and artificial objects. Whether employed as fellow rainmakers in Pueblo rituals, or transformed into energy circuitries in modern metropolises, snakes in Warburg's "repaganized" modernity are part of an artful industry; in no case are they the "idle reptiles" of the Bible.

This, then, is the circuitous *fortuna* of Philo's archaic saying in modernity—further proof that the contemporary *Nachleben* of an image or a phrase can be similar to, but never the same as, the antique *Leben*. A history of fascination is something different from a history of reception. The latter focuses more on the critical, while the former records on the uncritical reception of a text or an image. The degree of fascination exercised by serpents has hitherto remained undiminished. The forms that have instigated this fascination have changed, and not always in a rational manner.

The decapitated frog

In empathy with Warburg, who had written at least three different endings for his essay, I would like to add three alternative conclusions in the form of postscripts describing a number of events following the delivery of his Kreuzlingen lecture.

On April 26, 1923, Warburg sent a letter to his collaborator Fritz Saxl, which accompanied the typescript of the lecture he had delivered five days earlier. In the letter, Warburg emphatically forbade the publication of this talk that was "so formless and philologically badly founded" (*so formlos und philologisch schlecht fundiert*). He further limited the circulation of his lecture to an intimate circle of acquaintances with the following instruction: "This gruesome convulsion of a decapitated frog [*diese gräuliche Zuckung eines enthaupteten Frosches*] should only be shown to my dear wife, selectively to Dr.

Embden and my brother Max, and to professor Cassirer."[73] The "decapitated frog" leaping out from Warburg's letter could in fact have several (lost) heads. Similar to the snake, the headless animal has a sporadic prehistory in Warburg's personal life as well as academic research, in which it acts as a link between the areas of ethnographic and natural science.

In Warburg's "Americana" Zettelkasten, there are three pocket-sized, leather-bound notebooks filled with the historian's sketches, several of them representing animals or insects. Two pages of one of these sketchbooks show a snakelike creature, drawn with an undulating zigzag line and a bulbous head (fig. 2.16).[74] As Warburg notes, this is not a snake, but a *"Wassertier"* or "water animal," and more specifically a *"Kaulquappe"* or "tadpole." With Philo in mind, one might recall that the tadpole is one of the rare animals to develop limbs after its birth and thus spends a considerable part of its early life in

Figure 2.16 *Left*, Aby Warburg sketch of dragonfly, frog, and tadpole from his pocket sketchbook during his trip to the American Southwest. WIA, ZK 40, "Americana," 040/020443–44, no. 4, 58 verso. *Right*, Aby Warburg, sketch of dragonfly and tadpole from his pocket sketchbook during his trip to the American Southwest. WIA, ZK 40, "Americana," 040/020443–44, no. 4, 57 recto. Photograph: Warburg Institute, London.

an anorganic condition "with no feet and hands." Tadpoles are also common specimens in elementary biology classes precisely because they are ideal models for teaching Western schoolchildren how arms and legs grow. Warburg's own children had the habit of collecting frogs (including tadpoles) and housing them in a terrarium in their summerhouse.[75]

In addition to tadpoles, other batrachians can be found in Warburg's sketches, including frogs, "horned" frogs, and toads (fig. 2.17, *left*).[76] In a totemic-like scheme that appears twice in Warburg's sketchbooks, a human figure is surrounded by three animals (a frog, an antelope, and an unknown mammal); the same figure stands beneath a Pueblo sun symbol flanked by two snakes (fig. 2.17, *right*).[77] This makes it even clearer that Warburg's sketches do not represent live animals, but rather religious symbols of animals that the scholar may have copied from Zuni artifacts, such as ritual vases or church walls, during his visits to the Pueblos. Some of these same symbols were recorded in ethnographic studies of the Pueblo Indians, such as the catalogs by Frank Hamilton Cushing and the studies by Adolph Bandelier.[78] An atlas-like color drawing by Bandelier of Tehua symbols such as the sun, the earth-house, and the snake-lightning, includes a group of four animal figures identified as frog, tadpole, trout, and dragonfly, which is also called *libella* or "water-nymph" (fig. 2.18).[79] These last animal symbols bear a striking resemblance to the animal and insect figures in one of Warburg's drawings. According to Bandelier, all four of these creatures are *intercessory* animals connected with

Figure 2.17 Left, Aby Warburg, drawing of horned frog and other symbols, WIA, ZK 40, "Americana," 040/020723. *Right,* Aby Warburg, drawing of Pueblo symbols with "frog," WIA, ZK 40, "Americana," 040/020742. Photos: Warburg Institute, London.

the element of water. Like the snake, they intervene between the earth and the sky in order to facilitate the production of rain: "The frog cries when rain approaches, therefore he prays to the sky for humidity."[80] As we learn from various ethnographic accounts, frogs, just like snakes, were believed to pos-

Figure 2.18 Adolph Bandelier, detail of color drawing of Tehua symbols (1885). Adolph Bandelier, *A History of the Southwest: A Study of the Civilization and Conversion of the Indians in Southwestern United States and Northwestern Mexico from the Earliest Times to 1700*, ed. Ernest J. Burrus (Vatican City: Biblioteca Apostolica Vaticana, 1987), vol. 1 supp., plate 2.

sess therapeutic properties. For the Hopi, medicine was the "seed of water," thus all animals associated with water had healing powers.[81] The association of both snakes and frogs with healing processes presents another common link in Warburg's researches into the medicinal properties of animals both in Pueblo culture and in ancient Greece.

In the short footnote on the Moki snake dance (underlined by Warburg) in Küster's book, there is a reference to two articles in the ethnographic journal *Globus* by the renowned anthropologist Konrad Preuss that mention the role of frogs, specifically decapitated frogs, in rainmaking rituals: "According to European folk beliefs, the croaking of frogs presages rain, and therefore when frogs are decapitated rain ensues."[82] Preuss further references Wilhelm Mannhardt, whose work on "animistic tree cults" and "harvest customs" Warburg mentions in the introductory pages of his Kreuzlinger lecture in reference to Native American tree rituals.[83] In his *Wald- und Feldkulte*, Mannhardt refers repeatedly to the ritual of the decapitation of the frog as a rainmaking and fertility ceremony during European harvest rituals, which precedes the well-known ritual of the decapitation of the king: "The king announces the death penalty for him [the frog] and then the executioner chops off the head of the frog and throws the jittering [*zappelnde*] bloody body to the bystanders."[84]

Even if this description is strikingly similar to the "gruesome convulsion of the decapitated frog" mentioned by Warburg in his letter to Saxl, there is in fact another reference that is even closer to Warburg's metaphor. I refer to an experiment with a decapitated frog mentioned in Charles Darwin's *The Expression of the Emotions in Man and Animals*, a book that Warburg had read when he was a student in Florence and that had a strong influence on him ever since.[85] In one of the introductory sections of his book on reflex movements, Darwin re-cites "the often quoted experiment of the decapitated frog which cannot feel or consciously perform any movement" from Henry Maudsley's well-known psychiatric treatise *Body and Mind* (1870).[86] In the passage selected by Darwin, Maudsley himself quotes from descriptions of experiments performed by Eduard Pflüger.[87] Such tests on frogs were commonly performed by scientists during the eighteenth century, such as Luigi Galvani's popular bioelectrical experiments.[88] These early experiments were relatively simple: a frog would be decapitated and its organs removed one by one until only a bare spine and two legs remained. Manual stimulation of the nerves of the spine caused the feet of the obsolete organism to contract and rise upward, proving that such "electric-biological" reactions were not dependent on the presence of a brain.

Maudsley's (and Pflüger's) experiment, which Warburg had encountered in Darwin's book, was more complex or, as Maudsley himself described it, "more striking and instructive": a drop of acid would be applied to the thigh of a decapitated frog and the headless creature would gradually manage to rub it off using the dorsal surface of the foot belonging to the same leg. This leg was then amputated at the knee and another drop of acid was applied to the remaining thigh. This caused the frog to attempt in vain to rub off the acid with its absent foot. Maudsley writes: "After some fruitless efforts, therefore, it gives up trying in that way, seems restless, as though . . . it was seeking some other way, and at last it makes use of the foot of the other leg and succeeds in rubbing off the acid." Darwin then remarks: "These are actions that have all the appearance of being guided by intelligence and instigated by will in an animal, the recognized organ of whose intelligence and will has been removed."[89] In other words, there is still something in the brainless animal that is capable not only of taking action, but also of making decisions. While headless, the frog is still thinking—not with the brain but with the feet, including those that are absent.

Warburg's extensive notes from his first reading of Darwin's book while in Florence in 1889 are preserved among the "scientific notes" of his first Zettelkasten on the "Study of Expression" (*Ausdruckskunde*).[90] In one of the cards from this file we find the description of Maudsley's experiment: "Reflex movements (with no consciousness). Decapitated frog [*Enthaupteter Frosch*] that tries to wash off drops of acid with its feet, Pflüger."[91]

While most of Warburg's notes from Darwin's book are in the original English, this last description is in German, which makes the identification between the *"enthaupteter Frosch"* copied in this early note and the same animal expression resurfacing in the Kreuzlingen letter of 1923 even more striking. During the thirty-four years that have passed, the image of the decapitated frog was converted from a literary reference into an autobiographical memory engram and at a point when the historian himself had become the object of medical experimentation.

Like Darwin's mutilated batrachian, Warburg was also "seeking some other way" to react to his affliction. Devoid of the essential organs of his library and notes, and with his mental powers in question, the scholar had to learn how to move "with no feet or hands" to carry out this arduous live performance. In the end, however, Warburg's lecture is not only the "gruesome convulsion" of Darwin's decapitated frog, but also the praying call of the therapeutic frog adored by the Zuni. And this time the frog's croaking *did* bring the rain: a veritable "healing wonder" staged as a tragedy, including the necessary scene of *Katharsis*.[92]

In Warburgian terms, the decapitated frog is staging its own *Pathosformel* not by raising its arm, like Orpheus, but by lifting its foot. One of Warburg's early aphorisms on the function of accessories reads: "The memory image [*Erinnerungsbild*] is felt as a bodily member."[93] Considering Philo's phrase on the legless movement of snakes, the reverse might also be valid: the *absence* of a bodily member is felt as a memory image, which is then carried on as a phantom limb. The absence of organs, such as the frog's cutoff limbs, constitute an alternative form of prosthesis.

Darwin's headless batrachian, struggling to move with no hands and only one leg, amounts to a caricature of the fiery serpent deified by the Phoenicians. But while the animal praised by the ancient author had no feet or hands by nature (or, as the evolutionists argued, because it *chose* not to), the decapitated frog reaches that anorganic condition after aggressive human intervention. The difference is clear: in the movement of the snake there is a continuous flow—*Geschwindigkeit*—while in the spasms of the jittery frog there is only a jerky erratic exertion—*Schnellkraft*. Unlike the Phoenician author who "unwinds" serpentine movement into fire and pneuma, the quest of nineteenth-century science is to dissect that elusive movement, to arrest it, and cut it in pieces until the pneumatic agency in question expires, before it is ever discovered.

In opposition to the unnaturally mutilated frog stands the naturally limbless tadpole venerated by the Moki. The marine movement of the tadpole represents an alternative form of healing—less painful than the electrotherapy administered to the decapitated frog. The tadpole is the representation of nonorganic possibility, a mere zigzag pattern with a head prolonging the freedom of intrauterine existence within the limitations of the real world.

Bronzino, Laocoön, and the brazen serpent

The second postscript of this narrative describes a similarly "convulsive" or even *headless* form of scholarship produced during Warburg's final years. This thread, too, originates in the scholar's study notes in his Zettelkästen. Inside one of the index-card boxes that Warburg assembled for his final trips to Rome in 1927 and 1928, there is a slim file marked *"Eherne Schlange"* (brazen serpent) following some notes on the theme of Laocoön. The folder contains three paper slips bearing some vague sketches suggesting human bodies (fig. 2.19). From the accompanying bibliographic references, we realize that two of these wobbly scrawls are Warburg's frustrated attempt to depict parts of Bronzino's fresco of the biblical theme of the adoration of the brazen ser-

Figure 2.19 Aby Warburg, manuscript notes and drawings of Bronzino's composition with the brazen serpent (*Eherne Schlange*), WIA, ZK [12], "Antike Vorprägung" 066/039061–62. Photographs: Warburg Institute, London.

pent (*Il serpente di bronzo*) in the chapel of Eleonora in the Palazzo Vecchio in Florence (fig. 2.20).[94] Before these two paper slips, there is another card with scrawls that appear to be from a scene similar to, yet different from, that of Bronzino's mural. The card bears a reference to a poem entitled "Geestelick Houwelijk" by the Dutch author Jacob Cats, published in an edition of his

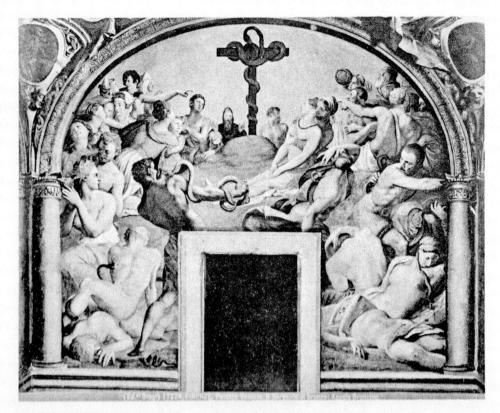

Bronzino, Die eherne Schlange
Fresko, Florenz, Palazzo Vecchio

Figure 2.20 Agnolo Bronzino, *The Brazen Serpent* (*Il serpento di bronzo*) (1542). Fresco at the entrance to the Chapel of Eleonora of Toledo, Palazzo Vecchio, Florence, Italy. From the copy of F. Goldschmidt's *Pontormo, Rosso und Bronzino*, with pencil mark, in the library of the Warburg Institute, London.

collected works from 1700, which initially seems unrelated. Yet on page 229 (as noted by Warburg) of the edition of Cats's works in the Warburg Library, there is a long description of the biblical story of the brazen serpent (fig. 2.21). On the same page, there is also an illustration of a scene similar to the one depicted by Bronzino, but with a different arrangement of the human figures that corresponds to some of Warburg's scrawls.[95]

But how did the snakes of Bronzino migrate so far north? Warburg's drawings apparently date from a period between 1925 and 1926, following his return from Kreuzlingen, when the historian, with the encouragement of the codirector of his library, Fritz Saxl, became increasingly interested in the masters of the Northern baroque and their links with the painters of the Italian

En stracks daar op soo volgt en pest, en harde strijt, (a)
En niet als slaag verderf, en niet als droeven tijt.
De stoute Korach muyt, en Dathan daar beneven, (b)
Door haat, door swarten nijt, door eersucht aangedreven
Abiram komt'er by en dringt geweldig aan,
Sy willen Priesters zijn, en voor den Heere staan.
Twee hondert vijstig man, al luyden van vermogen,
Zijn tegen Godes erf geweldig op-getogen;
Daar staat het gansche volck in wonder groot gevaar:
Maar 't wort in korten stont des Heeren macht gewaar.
Het aartrijck doet hem op tot aan de diepste gronden, (c)
En Korachs gansch gesin is in der haast verslonden,
Sijn huys leyt over-hoop, sijn tente neér-gedruckt,
En hy wort in der haast in 't duyster weg-geruckt.
Maar schoon of al het volck aansiet de sware plagen, (d)
Die Dathans grillig rot gedwongen is te dragen,
'tEn wort noch even-wel niet buygsaam in den geest,
Soo dat het even doen den Heere niet en vreest.
Het gaat op Moyses aan als met de gansche leden,
Het smaat op sijn beleyt met onbeschofte reden,
Het seyt met vollen mont, dat hy uyt wrangen aart
Het zaat van Abraham in geenen deel en spaart.
Godt siet den handel aan met gramschap aen-gesteken,
En gaat door seldsaam vier sijn dienaars onrecht wreken,
Daar rees een heete gloet die op het Leger quam,
En in een korten stont veel duysent menschen nam.
Godt seyt hem boven dat: Ontreckt u van de scharen,
Ick wil aan desen hoop mijn krachten openbaren,
En plagen al het heyr met druck en ongeval,
Soo dat 'er niet een mensch hun over-blijven sal.
Maar Aron, op den raet door Moses hem gegeven, (e)
Heeft met een soeten reuck de plagen weg-gedreven,

En Godt met een versoent. De kracht van haar gebedt
Die heeft het snel bederf en haestig vyer belet.
Den brant is uyt-geblust. Daar komen blijde dagen; (f)
Want Arad wort gevelt, en sijne macht geslagen,
Het vruchtbaer Canaän, dat in het zuyden lag,
Is in der haest verheert, en schier met eenen slag.
Daar trekt het Leger op, maar t'wijl de Lieden reysen;
En op haar eersten staat en op Ægypten peysen,
Beginnen nieu geklag en reden sonder slot,
Sy grollen op een nieu, en morren tegen Godt:
Siet wat een vreemt gewoel, en wat een seldsaem leven! (g)
Wy doen schier anders niet als gins en weder sweven,
Wy dolen even-staeg, al zijn wy bijster swack,
Wy spillen onse jeugt, in druck en ongemack.
Siet wat een slappe kost wy op den tocht gebruycken!
Wat kan een quackel zijn voor onse grage buycken?
Wat geest men aan het volck het labbe-soete Man,
Dat ons geen rechte kracht of herte geven kan?
O die eens wederom Ægypten mocht betreden,
Om daer van edel graan eens broot te mogen kneden,
Dat heeft eerst kruymen in, en pit, en rechte keest,
En kan in volle maat verquicken onsen geest.
Het was een groot vermaak aen onse jonge gasten,
Doen sy eens in het vet tot aan de kneuckels tasten,
En hadden vollen lust van Schaep- en Ossen-vleys,
En gaven even-staeg den buyck haar vollen eys.
Waer is die goede tijt en alle vreugt gevaren?
O dat wy noch een reys soo wel geseten waren!
Wel op dan, Abrams zaet, waer toe hier lang gedraelt?
't Is beter eens gekeert als even-staeg gedwaelt,
Godt hoort het nortsche volck, en send haer heete slangen,
Die met een dichten krol haar om de leden hangen,

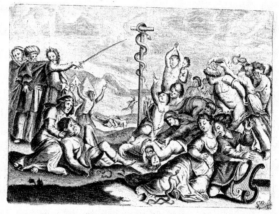

Die schieten haar vergif tot aan het innig bloet,
Soo dat in korten stont de ziele ruymen moet.
Hier komt een herders kint getreden aen der heyden,
En gaat met bly gemoet sijn teere schapen weyden,
En t'wijl het uyt de borst een aardig deuntjen singt,
Soo voelt het dat een slang hem om de leden springt.
Daar is een jeugdig paar in stille vreugt geseten,
En, eer het iemant weet, soo wort'er een gebeten.
Daer set een jonge maagt haer in het jeugdig kruyt;
En waerse bloemen soeckt daar komt een adder uyt.
De vrijsters zijn gequetst, de vrouwen krijgen wonden
Of in haer sachte borst, of aen haer teere monden,
En menig wacker man ontfangt een felle beet,
Terwijl hy ligt en slaept, of aen sijn tafel eet.

Daar hoort men droef gekerm door al het leger rijsen,
Een ieder soeckt den Heer sijn smerten aan te wijsen;
En Godt verhoort het volck, en, even met'er daet,
Vertoont haar sijne gunst, en schaft haar goeden raet.(h)
Hy laat, in korten stont, de siecken troost genieten,
Hy laat aan sijnen knecht een slang van koper gieten;
Die wort om hoog gerecht te midden op het velt,
Ten goede van het volck dat gift van adders quelt.
En wie het dier besag, hoe kranck hy mochte wesen,
Die was van sijn verdriet van stonden aen genesen;
Men nam geen menschen hulp, geen dranck of heylsaem
 kruyt,
De slang maer eens gesien die joeg het swadder uyt.
Wat dient'er meer verhaelt? geheele veertig jaren
Zijn aen des Heeren volck met doolen weg-gevaren,

(a) Num. 14. 35. (b) Num. 16. 5. (c) Num. 16. 31. (d) Num.
16. 41. (e) Num. 16. 47.

(f) Num. 21. 4. (g) Num. 21. 5. (h) Num. 21. 9.
H h 3 En

Figure 2.21 Illustration of the brazen serpent from Jacob Cats, "Geestelick Houwelijk," in *Alle de wercken* (Amsterdam, 1700), 229. Photograph: Warburg Institute, London.

Renaissance.[96] In a letter to Warburg from 1925, Saxl speaks with enthusiasm about his "discovery" of "Laocoön's youngest son" in a painting by Bronzino. Saxl remarked that Bronzino's iconography is linked with the "pathos images" of Northern painters, such as Cornelis van Haarlem, especially the agitated iconography of his *Massacre of the Innocents*. And the same serpentine line "in a higher level of the spiral" leads, according to Saxl, to the "young Rembrandt."[97] "Suggestion Bronzino-Laocoön interests me very much!" replies Warburg in a postcard two days later, and asks for a picture.[98] Saxl apparently provided the reference for an image, from which Warburg then made a few sketches to become better acquainted with Bronzino's mural. These sketches, then, apparently record the scholar's attempt to diagram the essential structure of Bronzino's composition, especially the relation between humans and snakes. Following Saxl's suggestion, this would allow Warburg to trace links with the iconography of Laocoön (Warburg has inscribed the term "Laokoon-Pathetik" next to one of his sketches). Warburg's drawing, therefore, is a *re-drawing*—less a tracing of the actual mural than a retracing of the mural's serpentine hyperlinks with past or future images and artworks.

In his impromptu sketches, Warburg appears to copy what are for him the most essential parts of the complex composition, such as the cross with the brazen serpent and two of Bronzino's human figures, one female and one male. The historian's drawings pay special attention to the man struggling with a snake coiled around his arm, the central figure in Bronzino's group. The man's arm is fully extended in an attempt to deflect the belligerent reptile approaching his head in the manner of the Laocoön group. Human agent and serpent look each other in the eye as if trying to fight this battle with the gaze. Warburg struggles to copy this detail of hand and snake, without much success, in two rough sketches. In a more diagrammatic version, he abstracts the snake and the hand into an undulating curve intercepted by a straight line, as if the man's arm were a mere stick, like the staff of Asclepius. But in Bronzino's fresco, the staff becomes a live bodily member.

Yet there are more transpositions at play here. Painted on the ceiling of the Kreuzlingen chapel (only a few yards away from the sanatorium hall in which Warburg delivered his lecture), the biblical story of the brazen serpent aims to narrate the defeat of paganism. But this is not what happens in Bronzino's mural. Perhaps motivated by what Warburg recognized as "Laokoon-Pathetik," the mannerist painter portrays a moment before Moses's intervention in which the serpents appear almost victorious over the humans. Bronzino portrays, then, not the demise, but the *revenge* of the snake. The "lowest" of all animals according to the Bible, "with no hands or feet," invalidates the human

hand, the most essential organ in human evolution. While in the Pueblo ritu-
als the snake was, as Warburg noted, "arrested by the hand," here the serpent
itself arrests the hand, and for Warburg that is something fundamentally "un-
graspable." Is it, then, merely a coincidence, or is it part of this unimaginable
event that at this very moment Warburg's *own* hand becomes arrested, and the
historian is unable to complete his drawing?

Not only the snake drawing remains incomplete, but the scholarly snake
thread that the sketch attempts to unwind also remains unresolved. Today
art historians know that Bronzino's fresco is neither the first nor the "young-
est son" of Laocoön; there were probably several other offspring, both in the
South and in the North, following the rediscovery of the antique ensemble.
The direction of Saxl's "spiral" between Laocoön and the young Rembrandt
may still be pointing in the right direction, and yet this particular snake thread
has more loops before and after Bronzino. What we are witnessing in this
lost episode between Warburg, Laocoön, and Bronzino is essentially another
specimen of an *empathetic* form of art history produced convulsively like the
frantic reactions of the decapitated frog. The art historian regresses into a poi-
gnant identification with his object, in spite of the critical distance that he is
struggling to maintain.

Since the discovery of the Laocoön group, an underlying serpentine
thread has wound itself through the discourses of art history and natural
history, traces of which one may discover from Winckelmann to Fergusson.
Warburg's intertwining of Laocoön with Darwin's physiological theory of ex-
pression reinscribed art history at the very mouth of this *ouroboric* circle and
demonstrated that the allegedly dead serpent of Laocoönism could perform
several more recoils.

A final snake thread

On the very bottom of Warburg's notecard with the quotation from Philo,
there is a brief citation in red ink that the scholar seems to have added lat-
er: "Snake found in Gaza, Benzinger, p. 328."[99] The book cited is Immanuel
Benzinger's *Hebraic Archaeology*, and the Warburg Library has all three of its
original editions.[100] The copy of the 1907 edition still contains Warburg's pen-
cil marks in the index, underlining various page numbers with references to
snakes; and on page 328 there is a page marker placed before the illustration
with two views of a snake sculpture from Gaza that corresponds to Warburg's
notes (fig. 2.22). Why was Warburg interested in the discovery of this tiny
snake (according to the drawing, the bronze sculpture is less than eight inches

Figure 2.22 Snake Found in Gaza. Illustration from Immanuel Benzinger, *Hebraische archäologie* (Tübingen: Mohr, 1907), 328. Aby Warburg, personal book copy with page marker. Library of the Warburg Institute, London.

long)? Benzinger ostensibly connects this bronze artifact with the story of the brazen serpent and its representation at the temple of Jerusalem. The philologist then offers a condensed account of the manifold associations of serpents in Mediterranean cultures: prophesies and oracles, the "tree and the water of life," Asclepius, but also the "devil" as well as a symbol of "chaos." The account closes with the "ultimate localization" of the snake in the sky as celestial constellation.[101] Which (if any) of these serpentine associations would Warburg have picked up? And why would this note from Benzinger be placed underneath some other snake notes in Yiddish referring to superstition and lisping (for which Warburg feels compelled to consult the authority of his grandmother)?[102] Could these tiny bronze artifacts provide a hyperlink between the praise of the snake in Philo and its exorcism by Moses in the Bible (which is how this narrative began and ended)? It would be futile to try to close the circle. Some of these serpentine threads will have to stay open and bifurcate further, but it is precisely this open-ended predicament that may lead into a viable conclusion.

From Philo to the Moki and from Darwin to Bronzino, the paper snakes, frogs, and lizards leaping out of the scholar's note boxes present a sample not only of the iconography, but also of the very pattern of Warburgian research. For Warburg, the serpent primarily is not an object, but a *method*—the mobile ideogram of a continuous epistemological research. Along with the cultural remnants of bygone eras, these marginal notes record the vestiges from a reanimated form of scholarship. Made out of dissimilar fragments and in manic pursuit of clandestine details, Warburg's drafts initially appear as a cluster of disparate pathways; eventually two or three of these threads meet and create a knot, and then a series of these knots creates a piece of fabric—a fabric that has the pliancy of an accessory-in-motion and the uncanny capacity for mimicry of the snake. Perhaps the old snakeskin paper cover enveloping Warburg's card-box titled "Iconology-Synthesis," then, hints not only at the content, but also at the very pattern that this resilient art historical "synthesis" must retrace to "propel itself" *without* using its feet.

3

The Afterlife of Crystals

Art Historical Biology and the Animation of the Inorganic

Abstraction

Look at the photographic portrait of Wilhelm Worringer in old age (fig. 3.1).[1] Watch closely the contemplative face with the wrinkled forehead, sunken cheeks, and finally the eyes, deeply recessed under heavy eyebrows. Slightly turned away from the camera, the art historian's gaze appears abstract, yet highly vivid. His right hand is raised in the typified gesture of the "thinker"; but here, the sitter's palm does not rest on his forehead (as it did in an earlier drawn portrait of him), and instead brushes the side of his eardrum.[2] It is as if the art historian does not see, but *listens*. In his old age, the grand maestro of abstraction can still hear "the voiceless solemn music of the Pantheon" or "the mighty orchestral crescendos" and "deafening fortissimo of space" inside the Gothic cathedral—all the "sensuous-supersensuous" sounds that reverberate from the compositions of his early art historical career.

It is then not just any sound that is emitted by this photograph, but the echo of a synaesthetic memory. The sitter's open hand serves not only as a hearing aid, but also as an instrument of *haptic* vision. Just as prehistoric men and ancient Egyptians groped in the dark to retrieve their artifacts from the fearful viscosity of *horror vacui*, so too does the art historian touch his face to

Figure 3.1 Photographic
portrait of Wilhelm Wor-
ringer used as frontispiece in
Wilhelm Worringer, *Fragen
und Gegenfragen: Schriften
zum Kunstproblem* (Munich:
R. Piper, 1956). Photograph
by Ruth Schram.

draw a mental picture of the world around him. Worringer's gesture attests
to the subject's effort to reassemble the materiality of his face and defend it
from external reality. This face, or every face, as Deleuze would say, "is a horror
story."[3] Faciality unveils a premonition of mortality—the fear of being pet-
rified by one's own gaze. Contrary to Riegl, Worringer's self-reflexive touch
does not make sense of the visible, but rather protects him from what the
visual discloses. In its strenuous effort to grasp an unlocatable threat from the
external world, the art historian becomes blind; while being photographed,

Worringer *abstracts* himself from the picture, and thus refuses to become the subject of external vision.

But why should this author be photographed in the first place, or why wait so long for his "close-up" to be published? Was it not Worringer who declared that illustrations in art history books are for mere "showcase and exhibition," that "they concern the publisher almost more than the author," and that if ultimately pictures are to be inserted they ought to perform as "sounds" accompanying the text with their "musical" overtones?[4] And was it not Worringer who, in 1920, while declaring the bankruptcy of expressionist art at the same time promoted the achievements of "expressionist" art history by saying that expressionism "is more legitimately at home in the new pictures in our mind than in those on our walls"?[5] Based on such iconoclast aesthetics, the art historian's texts are ultimately a peculiar assemblage of rhetorical ornaments, graphic diagrams, and plaster models—different planes that, however, fail to construct a three-dimensional continuum. Worringer's own historiography manifests a textual form of agoraphobia; it suffers from the very "dread of space" that instigates the creative drive of his artist subjects. The author's late photographic portrait is another specimen of its *anti*visual demonstrations— a belatedly inserted musical illustration to the art historian's written body of work.

Is there a correspondence between Worringer's late photographic portrait and the presumed origin of his first book, *Abstraction and Empathy*? I refer to the author's unexpected meeting with Georg Simmel inside the Trocadéro in Paris recounted in the preface to the book's 1948 edition: "Not a soul in the museum . . . And my impatient glance is frequently directed toward the clock. Then an interruption! A door in the background opens, admitting two further visitors. What a surprise as they draw nearer: one of them is known to me! It is the Berlin philosopher Georg Simmel . . . Well, besides my own steps, those of Simmel and his companion now ring past the monuments. Of their conversation all I can hear is an unintelligible echo."[6] Like most of Worringer's art historical descriptions, this memory is conveyed less by images than it is by *sounds*. The narration follows an auditory trail analogous to the performance of a stage production on the radio: the museum's silence, the clock ticking on the wall, the sound of the door opening, the "ringing" of footsteps, and finally the "unintelligible echo" of a conversation. But the essential similarity between Worringer's late photographic portrait and the setting of this early memory is in the sudden *flash*—the "explosive act of birth in the world of ideas" that followed the young art history student's encounter with the philosopher and culminated in his doctoral dissertation. Looking

again at Worringer's portrait, it is as if a beam of artificial light suddenly hit the sitter's face while he was unaware of his surroundings. The camera flash creates a cinematographic flashback in which memories from real life and art historical fictions are superimposed. In all its studio clarity, Worringer's portrait appears blurred by the filmic strip that runs in front of his eyes. Despite its stillness, the photograph latently vibrates with the *static* animation of the inorganic.

So what is the animation of the inorganic and what could the late portrait of its author say about it? Like Worringer's photograph, the animation of the inorganic is both a face and a background; figurative *and* abstract, non-optical yet "supersensuously" palpable. It oscillates between vision and hallucination, memory and presence, reality and myth. Like the young student's flash of ideas in the Trocadéro and like the photographic flash commemorating the end of his career, the animation of the inorganic is an overwhelming epistemological *blitzkrieg* that commenced at the beginning of the last century and that has sustained its artificial glare ever since. Traversed by two world wars and numerous revolutions, the same inorganic effervescence is always on the verge of vanishing into the background—the very epistemological obscurity from which its animistic content reemerged almost a century earlier. In a moment the projector will be turned off. From the shadows of the Germanic forests and the plaster casts of the Trocadéro, the art historian will return to the darkness of his university office and dusty vaults of his library. It is as if this face never emerged from the frame, its features never captured by the material world that the historian abhorred. In his late photographic portrait, the elderly master of twentieth-century abstraction remains stubbornly unphotographed, yet inorganically animated.

Latent movement

If this stylized portrait then represents the aftermath and the encounter with Simmel the origin of Worringer's aesthetic ideas, what might be the other events, figures, or textual sources that inform the background for the art historian's discovery of an inorganic version of abstraction—a latently animated form of representation that fuses crystalline patterns and vegetal ornaments into a unified ambience of life? To offer one possible answer, we turn to an example from another mentor, whom Worringer never met, yet whose writings were enormously influential for the young art historian.

In a note from an unpublished lecture of 1898, which preceded the publication of his *Late Roman Industry*, Alois Riegl discusses certain typological

distinctions in early Christian architecture: "The centralized building is related to the plant which lacks a will and stands even closer to the crystalline qualities [*Krystallinismus*] of inorganic material. In contrast, the longitudinal building takes into consideration the spiritual as it externalizes itself in the animal in distinction with the plant. The Christian devotional building is meant to be interior space [*Innenraum*]."[7]

Initially, Riegl's note seems incomprehensible (no wonder it did not make it into the published text). Why is the rectangular basilica like an animal and the circular rotunda like a crystal or a plant? According to nineteenth-century morphological discourses the reverse should be true: the organic was circular and the inorganic polygonal or cubic.[8] The issue is ostensibly resolved when Riegl later states that a basilica has "kinetic qualities" granting the building a form of "movement" (*Bewegung*) as opposed to the "nonkinetic repose" or "immobility" (*Ruhe*) of the rotunda.[9] Therefore, the basilica of Saint Peter's ostensibly moves like an animal running along a horizontal axis, while Santa Constanza (to choose two contemporaneous Roman examples illustrated in Riegl's book) stands quietly in space like a plant or crystal.

One might be tempted to dismiss all this as artificial subtleties of late nineteenth-century *Kunstwissenschaft* relying on pseudomorphic analogies between buildings and natural objects. But Riegl's distinctions are not based on resemblance. Not only do they reiterate a shift in the focus of art and architectural history from façade and elevation to typology and plan, but they also presage an imminent transition from external form to the psychological qualities of interior space (*Innerraum*). The basilica of Saint Peter's is like an animal not because it looks like an animal, but because it moves, feels, behaves, and even *thinks* like an animal; this is why the basilica partakes of the "spiritual" (*das Geistige*), as Riegl would later note.[10] External morphology matters less. What counts is internal intensity, rhythm, what Riegl calls *Bewegungsmachung*—that is, movement-in-the-making, an energy more potential than active, more intuited than seen.

While working on these lectures, Riegl was reading Saint Augustine and his commentators.[11] If the basilica moves and thinks, then it has the two highest degrees of the soul originally described by Aristotle and reconfigured by Saint Augustine in his *De Anima*. These two qualities are self-propelled movement (found in animals and humans) and intellect (found only in man). And yet the rotunda is animated by a different type of soul; it has the soul of a plant, what Riegl and Schopenhauer, following medieval scholastic interpreters of Aristotle, would call *anima vegetativa*.[12] Buildings, like plants, partake of this vegetal soul; both organisms have no external movement of their own, yet

Figure 3.2 Egyptian lotus, Attic acanthus, and Arabesque ornamental motifs from Alois Riegl, *Stilfragen Grundlegungen zu einer Geschichte der Ornamentik* (c. 1893) (Berlin: C. Schmidt, 1923).

they are permeated by an impervious will impelling them to expand upward and defy gravity.[13]

One could detect a similar transition from external animal movement to internal vegetal impulse in Riegl's earlier work on ornamentation in his *Questions of Style* (*Stilfragen*) of 1893. From the hard immobility of the Egyptian lotus to the spiraling vivacity of the Mycenean tendril, and from the rhythmic balance of the Attic acanthus to the naturalist exuberance of Greco-Roman vine motifs, Riegl traces the diagrammatic development of these ornaments from stillness to animation (fig. 3.2).[14] However, Riegl's ornamental plants do not come from the ground; they are inorganic. By increasingly distancing themselves from their vegetal origin, they become intellectual patterns. The same mental "plant motifs" transform while migrating from one region to another. Even the Egyptian lotus or the Attic or Corinthian acanthus motifs are not attached to a single national *root*. Their very "life" and animation consists in their perpetual movement away from their origin.

While Riegl refuted the naturalist origins of so-called vegetal motifs, the essential characteristics of such ornaments replicate the plants' external movements. In their continuous gyration, the spiral patterns examined by the art historian ostensibly simulate Charles Darwin's diagrams of the "stimulus movements" of vegetal organisms. Recording the various positions of climbing plants during the course of a day, Darwin proved that tendrils move in a circular fashion, which he termed *circumnutation*.[15] In the diagrams illustrating Darwin's experiments, the perpetual spiraling of the tendril was abstracted into an angular network of points, arrows, and dotted zigzag lines (fig. 3.3). The graceful curvature of the tendril turned into a polyhedral surface—something that looked more like a crystal than a spiraling stem. This drawing process seemingly retraced the conceptual crystallization of plant life. Darwin's circumnutating diagrams are ultimately fossils of movement substituting motion by a series of arrests.

In their ostensible inertia, vegetal and mineral motifs contained a form of *latent* life, similar to "*la vie latente*" discovered by the early twentieth-century

Figure 3.3 Diagram of plant movement (circumnutation) from Charles Darwin, *The Power of Movement in Plants* (London: John Murray 1880).

physiologist Paul Bequerel in plant seeds, which even when placed in "life-denying" conditions, such as extreme cold or total lack of hydration, could still eventually germinate.[16] In "latently" living bodies, animation coincides with the anticipation or even the postponement of life.

The primary characteristic of this (almost) suspended animation was its slowness. "It takes hours for the leaves to turn towards the light; it takes minutes perhaps a quarter of an hour, for the tendrils to twine around their support; even a snail moves more quickly," Gustav Theodor Fechner had remarked in his *Soul of Plants*.[17] Yet, however slow or coy, movement was definitely present. Human anticipation enhanced this nearly invisible form of animation.

Just as Darwin's climbing tendrils turn into petroglyphs, so do Riegl's meandering ornaments ultimately transform into crystals. The final stage of this crystallization process is the *arabesque*, a synthesis between the lively animation of the tendril and the geometric regularity of the crystal. This tangle of lines is a continuous fabric, simultaneously animate and inorganic. It is a crystal with a soul—a form of soul denunciated by Aristotle, yet acknowledged by pre-Socratic philosophers and rediscovered by Riegl's contemporary monist natural philosophers.

Living crystals

Starting in the late 1880s, and based on findings by chemist and botanist Friedrich Reinitzer, the crystallographer Otto Lehmann conducted a series of experiments that radically transformed scientific opinions on crystals. Lehmann's eventual triumph was the analytic description of "liquid" or "flowing"

crystals (*flüssige or fliessende Kristalle*), a term coined by the crystallographer in 1904. As a tribute to Heraclitus, who 2,500 years earlier had declared that "everything flows" (*ta panta rhei*)—including stones—Lehmann also called these substances *rheocrystals*. By using a specially formulated microscope and through the application of polarized light, the crystallographer managed to measure changes in the expansion and contraction of rheocrystals under heat and cold, which allowed him to argue that they had plastic qualities.[18]

Figure 3.4 Drawings of liquid crystal reproduction: *top,* Otto Lehmann, *Die neue Welt der flüssigen Kristalle und deren Bedeutung für Physik, Chemie, Technik und Biologie* (Leipzig: Akad. Verlagsgesellschaft m.b.H, 1911); *bottom,* Ernst Haeckel, *Kristallseelen; Studien über das anorganische Leben* (Leipzig: Kröner, 1917), 27.

Like the *biocrystals* discovered by Haeckel in 1872, liquid crystals were a mixture of mineral substances, such as calcite or flint, with organic plasma. Yet rheocrystals also had the ability to form a skin through which they appeared to breathe like living organisms. Moreover, these flowing crystals, although sexless, could multiply by means of a peculiar form of "copulation." For example, when two spindle-form rheocrystals came into contact, their skins would combine and the substance of one crystal would flow into the other until their bodies merged into a single new longer crystal. In fact, when Haeckel reproduced Lehmann's drawing in his publications, he expanded the width of the newly combined crystal to make it look bigger and fatter, as if this visual enhancement might increase the fertile effect of the crystals' reproductive union (fig. 3.4).[19] As Haeckel wrote, this form of reproduction was basically a "homophagy" of inorganic bodies, a crystal cannibalism: "They grow by eating one another. It is usually the stabile form that eats the labile one."[20] This was but one more sign of the advantages of immobility over movement, in fact a perfect example of how immobility can become *pregnant* with a new form of life.

Equally important to how these crystals behaved was how they looked. Their structure had nothing to do with the hexagonal snowflakes and other symmetrical polyhedra of the nineteenth century, such as the regular architectonic formations we are used to seeing in the books of Semper, Ruskin, and Viollet-le-Duc. In Lehmann's microphotographs, the new crystals appeared flowing and circular, producing ambient light effects. They formed complex spider webs, or were filled with oil-like patches expanding in a mucus substance (fig. 3.5). Had these crystals been discovered in the 1960s, they would have been called psychedelic (and it would then be easier to envisage Haeckel's claim half a century earlier that they had souls).

To further demonstrate the spectacular qualities of his liquid crystals, Lehmann created more than one scientific film in which he successfully combined the techniques of microscopy and cinematography. Thus, the animation of crystals became what it always has been: *cinematographic,* a matter of projection. Lehmann projected life onto these hybrid substances and now film projected that life back.[21] The life of crystals was a new chapter in what Hans Vaihinger would call "the philosophy of as if," already omnipresent in early twentieth-century intellectual discourses and now applied by Lehmann to molecular physics.[22]

Next to the crystals' animation also lurked their virtual *animalization.* Lehmann discovered that differences in temperature inside the body of several ammonite crystals created certain winding threads that moved in a "wrig-

Figure 3.5 Microphotographs of liquid crystals from Otto Lehmann, *Die neue Welt der flüssigen Kristalle und deren Bedeutung für Physik, Chemie, Technik und Biologie* (Leipzig: Akad. Verlagsgesellschaft m.b.H, 1911).

Figure 3.6 Microphotographs of "crystal worms" or "snake" deformations inside crystals from Otto Lehmann, *Die neue Welt der flüssigen Kristalle und deren Bedeutung für Physik, Chemie, Technik und Biologie* (Leipzig: Akad. Verlagsgesellschaft m.b.H, 1911).

gling" fashion (*Schlängelbewegung*) (fig. 3.6).[23] These thin twisted tubes, or "snakes" (*Schlangen*), as Lehmann called them, could divide into smaller segments and multiply arbitrarily.[24] When concentrated in one place, they gave the impression of "marine microorganisms" or "crystal worms" (*Kristall-würmer*) arrested inside a glass surface.[25] By nature parasitical, these "worms" did not erode, but rather enhanced the life of the crystal organism. Such serpentine lines marked a unique coincidence between the anorganicism of the snake and the inorganicism of the crystal. Since the snake threads were created by differences in temperature, the crystals that contained them not only possessed movement, but also feeling and sensation; and since they had sensation, these crystals also had a soul.[26]

In 1917, Haeckel, Lehmann's mentor, published *Crystal Souls: Studies of Inorganic Life*, which largely relied on his protégé's texts and illustrations (fig. 3.7). Following the same tactics that would later discredit much of his scientific reputation, Haeckel also made certain minute yet tactical alterations on Lehmann's images, such as coloring several of the plates or changing cer-

KRISTALLSEELEN

STUDIEN ÜBER DAS
ANORGANISCHE LEBEN
VON
ERNST HAECKEL

1917

ALFRED KRÖNER VERLAG IN LEIPZIG

Figure 3.7 Book cover of
Ernst Haeckel, *Kristallseelen:
Studien über das anorgani-
sche Leben* (Leipzig: Kröner,
1917).

tain dimensions in some drawings (see plate 4).[27] While reducing the bulk
of Lehmann's scientific experiments and measurement tables, Haeckel em-
ployed his own philosophy of monism to expand the more speculative sec-
tion of *Kristallseelen*. While Lehmann had called these substances "seemingly
living crystals" (*scheinbar lebende Kristalle*), Haeckel upgraded them to speci-
mens of "real life" (*wirkliches Leben*).[28] Liquid crystals were then part of the
larger circle of life—and, in fact, of Haeckel's own life: *Crystal Souls* was the
revered biophilosopher's last major book, published when he was eighty-three
years old. It is as if this notorious career was not only consolidated, but also
regenerated by these liquid crystals whose spindles pointed back to Haeckel's
original preoccupations with similar transgressive species in nature.

Indeed, the illustration of the natural object on the cover of *Kristallseelen*
is not one of Lehmann's rheocrystals, but one of Haeckel's own studies of ra-
diolarians, first published by the scientist in the 1860s. The radiolarians were
living organisms with crystalline geometry, animals of perfect symmetry and
design, whose radial structure was rendered even more perfect by Haeckel's
imaginative illustrations, many of which were later included in his widely pop-
ular *Artforms of Nature*.[29]

The substitution of living crystals by radiolarians on the cover of *Kristall-
seelen* underlines the correspondence or even the confusion between the two
types of ambient organisms. If the radiolarians were crystalline animals, then
the rheocrystals were animal-like crystals—the one was the inverted picture
of the other. Radiolarians and liquid crystals were the double proof that the
distinction between the organic and the inorganic state did not exist. All mat-
ter was animate; all substance was one. This was the main principle of Haeck-
el's doctrine of monism, which encompassed physics, biology, ethics, and re-
ligion. All matter had force and energy. In the organic, this force was active; in
the inorganic, it was latent yet potent, and much more potent than the matter
we call living.

The life of the inorganic world

Monism not only reflected the *animatism* described by contemporary ethnog-
raphers in the religious ideas of tribal peoples, but also revived the belief in
a monist, universal science. Drawing from Haeckel's monist principles and
Lehmann's recent discoveries, the medical doctor and polymath Walter Hirt
published a book titled *The Life of the Inorganic World*.[30] Lamenting specializa-
tion, Hirt proposes a methodological fusion of the fields of botany, chemistry,
histology, geology, medicine, physics, physiology, and zoology in an attempt

to discover analogies between biological and mineralogical sciences. The blurring of the limits among scientific faculties reflects the abrogation of distinctions between the several degrees of life. After all, argues Hirt, certain proteins that are considered essential for the production of life are in fact absent from several animal substances, such as nails, teeth, or hair. Life and death are not definite conditions. Even living organisms can periodically escape the biological demands of life, such as animals during the period of hibernation or the Indian fakirs, who in their prolonged periods of meditation become as imperturbable as stones, reminiscent of the deanimated plant spores in Becquerel's experiments on "latent life."

According to Hirt, there are in fact seven life processes that are analogous between animals and minerals, and that legitimize the life claims of the inorganic. Most of such processes address the communication of a natural body with the outer world, such as skin formation, procreation, and reproduction, as well as the fundamental principle of "breathing"—the rhythmically alternating inhalation and exhalation of living substances. To prove that mineral objects establish a similar exchange, the scientist cited an example from his everyday experience: "I contemplate the paper-weight [made out of stone] laying on my writing table. It expands and contracts depending on whether I sit in front of it and my warm breath is close to it or I move around the room and distance myself from it. It reacts to the opening of the door and the draft through the window cracks. Its movements are imperceptible and immeasurable, but they happen, and in correspondence with the constant contractions and expansions of the stone, air goes into the stone and then is pressed out again. The stone breathes."[31]

It is the weight of words that makes the invisible expansions and contractions of the mineral paper weight palpable. Once again a pneumatic form of agency mediates between the subject and the object. This mediation creates a parallel move from bodily empathy to animation, the infusion of life in all substances by the common denominator of air. In Hirt, the metaphysical principles of animism have transformed into the physiological origins of animation.

Next to the processes of life, such as breathing and procreation, were those of death and degeneration, and thus Hirt ascribed to inorganic bodies a number of pathological "illnesses." Interestingly, his examples of metal sicknesses are drawn from a number of building pathologies, such as an infectious "tin pest" that had caused several roofs of houses, churches, and town halls within the same city to collapse almost simultaneously. Hirt illustrates similar afflictions in a variety of metal objects, such as the pipes of church organs, metal coins, coffeepots, and door handles (fig. 3.8). [32] But even when they become

Figure 3.8 Illustrations of the effects of "tin pest" in metal objects: tin medal with the representation of Balthasar Beckker seriously sick from tin pest; tin coffeepot under tin pest; infected places in door handle (after Dr. A. Neuburger). Walter Hirt, *Das Leben der Anorganischen Welt: Eine Naturwissenschaftliche Skizze* (Munich: E. Reinhardt, 1914).

Zinnmedaille, Balthasar Beckker darstellend, stark an der Zinnpest erkrankt.

Zinnerne Kaffeekanne, von der Zinnpest befallen.

Infizierte Stelle an einem Türdrücker.

Nach Dr. A. Neuburger.

sick or even "poisoned," inorganic materials cannot actually die, observed Hirt; they in fact have a life that can extend for tens of thousands of years (as in the case of fossils). Only by "conflagration" can certain metals be killed; but even then, many of them do not die, but instead transform into other minerals, as is the case with diamonds, which under extreme heat transform into graphite or quartz, and then tridymite. In the inorganic world, death can only be

signified through the "loss of form," the transformation into an "amorphous" substance.

Such life-sustaining processes reveal that inorganic bodies were capable of "adaptation" (*Anpassung*), the most essential principle in the evolution of living organisms. Hirt set out to illustrate how inorganic materials, such as those active in geological formations, transform their substance and shape in order to adapt to other inorganic layers that they encounter.[33] Yet next to the relational behavior manifested by the process of "adaptation," the ultimate proof of the existence of life in the inorganic world was its claim to psychological properties and, most importantly, memory.[34] Mnemo-scientists such as Richard Semon (whose theories were known to Warburg) would support that each chemical alteration left an *engram*—that is, an imprint—that determined the future behavior of matter, whether human tissue, magnet, or stone.[35] In his theory of *hysteresis,* otherwise described as "inorganic memory" (*anorganisches Gedächtnis*), Haeckel defended the ability of inorganic bodies for customized behavior, and Hirt echoed that claim. Inorganic bodies, too, remembered what happened to them, and these memories determined the way they behaved.[36] Memory was conditioned by sensation. Not only do inorganic materials react to heat, cold, and light, but they even "listen" to their environment by responding to sound (and here Hirt quoted Léconte's 1858 description of flames dancing to music).[37] The *acoustic* quality of inorganic matter corroborated the ability of metals to establish correspondences with other parts of nature.

For Hirt, the connection of inorganic materials with life was not a *homology,* as in Haeckel's monism, but an *analogy*—a diagonal relation predicated on distance that allowed the heterogeneous parts of nature to communicate and respond to one another. The inorganic *listens* and becomes animate by receiving the signals of living processes, and then reflecting them back into the world. Its life subsists in its analogical capacity.

Crystalline art

This new form of communication with the outer world revealed the inherent *aesthetic* capacities of inorganic matter. The crystal's ability for refraction and the creation of analogies allowed art historians such as Riegl and Worringer to use it as a composite theoretical model for inventing new forms of interaction between subjects, art objects, and natural processes. In fact, in his early texts, Worringer makes explicit references to both monism and Lehmann's liquid crystals. For example, in *Abstraction and Empathy* and while discussing

the similarities between "linear" and "vegetal" ornamental styles, Worringer refers to a "monistic point of view" (*monistische Anschauung*) according to which "organic regularity . . . differs only in degree from that of the inorganic-crystalline" (*AE* 60).[38] And in his later essay on contemporary "Art historical questions," Worringer evokes "the phenomenon of liquid crystals" (*das Phänomen der flüssigen Kristalle*) as an example of the impeding "crystallization of our thinking" as means of overcoming the polarity between the creation of art and human thought.[39] Such minute yet symptomatic cross-references disclose that the parallels between turn-of-the-century histories of art and contemporaneous biological and crystallographic discourses are based less on iconographic than methodological affinities. Crystals in turn-of-the-century art historical texts are no mere metaphors, but analogical patterns consolidating systems of epistemic transformation.

. . .

If Riegl's analogy between the early Christian rotunda and the crystal reflected a notion of self-sustained immobility, his well-known "crystalline" description of the reliefs covering part of the triumphal Arch of Constantine in Rome (again in his *Late Roman Industry*) creates a pattern of movement and transformation. Against Vasari and Burckhardt, who had dismissed the early Christian reliefs as "clumsy" and "crude," respectively,[40] Riegl defends their artistic merits by elevating them to proponents of a new aesthetic idiom:

> One always thought that the Constantinian reliefs were lacking exactly what belonged specifically to the classical reliefs. That is beautiful liveliness [*Schönlebendigkeit*] . . . in its place we have, however, found another form of beauty which is expressed in the strictest symmetrical composition and which we might call crystalline, because it constitutes the first and eternal principle of form for the inanimate [*leblosen*] raw material and because it comes comparatively closest to absolute beauty (material individuality) . . . To be sure, this lofty regular beauty is not living [*lebendige*] beauty. On the other hand, the figures of these reliefs are by no means lacking in liveliness [*Lebendigkeit*]—only this does not lie in the tactile modeling of the joints, and not at all in the tactile and normal-visual modeling of the nude or of drapery, but in the lively alternation of light and dark, the effect of which is especially vivid from a distance. Thus liveliness is present here and indeed extreme, because it rests on momentary visual impression, but it is not beautiful . . . in the Constantinian reliefs the two targets of all plastic creation—beauty and verisimilitude [*Lebenswarheit*]—were just as much striven after

and also, in fact, achieved, as in Classical art; but whereas in the latter they were fused into a harmonious equipoise (beautiful liveliness), they have now split up into their extremes again: on the one hand the loftiest regular beauty in the strictest form of crystallinism, on the other verisimilitude in the most extreme form of the momentary optical effect.[41]

Some of the neologisms in Riegl's dialectic description disclose the verbal fluctuation preceding the formation of a new language. But this novel dialect is articulated through the same terms it aims to oppose: "beauty," "liveliness," "verisimilitude"—venerable concepts that are then inverted, split, and recombined with their opposites so as to dismantle their entrenched allegiances. Beauty is no longer attached to either "liveliness" or verisimilitude; and yet there is an "extreme" form of liveliness that is "not beautiful," as well as an "absolute" form of beauty that is not conventionally lively. As in Warburg's texts and almost all turn-of-the-century discourses of animation and life, Riegl's analysis primarily relies on the use of polarities; but the inherent analogies and secret affinities between the terms the author strives to oppose render such antithetical poles unstable.

The beauty of the Constantinian reliefs is closer to what is normally considered ugly and their animation akin to rigidity and stiffness. This static form of animation, strange and unfamiliar to the Western beholder, coincides with the crystallization of the human figure. The bodies depicted in these sculptures are both humans *and* crystals, figures *and* geometric motifs that gradually become animated. As Riegl describes, the limbs of such "cubic bodies" do not register as separate members or *organs*; they are part of an *inorganic* fabric animated by ambient light effects. Even if (as Riegl remarks) the represented fabrics remain absolutely stiff, the Constantinian marble frieze, as a whole, appears to flutter like drapery. Unlike the "crystalline" masses of the Egyptian pyramids, which are entirely self-absorbed in their "material individuality," the crystallinism of the Constantinian reliefs traces a new paradigm of collective formation. As in the mineralogical studies by Lehmann and Hirt, the crystal body communicates with the outer world via its ambient perception—its reaction to light and air—and thus becomes animate.

In the central section of *Abstraction and Empathy*, Worringer quotes the previous passage from Riegl in its entirety, using it as an introduction to his own view of animation from an *inorganic* perspective. Although Worringer acclaims Riegl's reevaluation of the Constantinian reliefs, he disagrees with his use of *verisimilitude*, or "true-to-life" quality as an aesthetic goal behind the sculptures' interplay with light and shadow: "To designate this carefully

thought out alternation of light and dark as a means for the attainment of verisimilitude, as Riegl does—correct as it is from Riegl's point of view—might lead to misconceptions. It is true that the plain surface is unquestionably given liveliness and verisimilitude [*Lebendigkeit und Lebenswahrheit*] by this interaction, but this animation [*Belebung*] proceeds according to abstract principles, so that the overall impression becomes increasingly that of a pattern" (*AE* 95–96).[42] Here lies a crucial difference between liveliness and animation. Worringer's animation is not a surface simulation of life (*Lebendigkeit*), but rather a form of energy that seemingly vivifies the artwork from within (*Belebung*). Riegl's *Lebendigkeit* describes a "lively" quality in objects; Worringer's *Belebung* designates the very act or process by which an object becomes alive. Moreover, Worringer's animation has ultimately little to do with external reality, ambient light effects, or shifting optical conditions, but rather addresses a number of mental patterns that remain constant. The very act of animation as a form of "enlivening" subsists in the gradual removal from real life.

What is the animation of the inorganic?

While Worringer spent little time describing particular artistic examples, in the central section of *Abstraction and Empathy*, following his discussion of Riegl's analysis of the Constantinian reliefs, he offers a lengthy description of a certain type of ornament. This is the so-called Northern interlace or strapwork (*Bandverflechtungsornament*), which, according to the author, "dominated the whole North of Europe during the first millennium A.D" (*AE* 76). Worringer argues that while in the South such interlaced ornaments became totally abstract and geometric, in the North the same patterns moved in a different direction:

> In spite of the purely linear, inorganic basis of this ornamental style we hesitate to term it abstract. Rather it is impossible to mistake the restless life contained in this tangle of lines. This unrest, this seeking has no organic life that draws us gently into its movement; but there is life there, a vigorous, urgent life, that compels us joylessly to follow its movements. Thus, on an inorganic fundament, there is heightened movement, heightened expression. Here we have the decisive formula for the whole medieval North. Here are the elements which later on culminate in Gothic. The need for empathy of these inharmonious people does not take the nearest-at-hand path to the organic, because the harmonious motion of the organic is not sufficiently expressive for it; it needs rather that uncanny pathos which attaches to the animation of

the inorganic. The inner disharmony and unclarity of these peoples situated far before knowledge and living in a harsh and repellent nature could have borne no clearer fruit. (*AE* 76–77)[43]

However abstract, Worringer's speech is always in empathy with his subject. He is making full use of the figurative rhetoric of empathy to substantiate a practice of abstraction. From the microscopic details of the interlace ornament to the anxious *Weltanschauung* of the inharmonious Northerners, the argument unfolds in a series of concentric formulations that vacillate in scale. The art historian eloquently *draws* for us the ornament he refuses to illustrate.

This rhetorical paradox forebodes a sequence of epistemological tensions. Unlike Hirt, who tried to legitimize the presence of life in the inorganic world, Worringer's "animation of the inorganic" is an act of transgression: it stirs the trespassing of life into a domain where the living had not previously tread. The animation of the inorganic is not a dialectical synthesis between the animate and the inanimate, the organic and the inorganic, or abstraction and empathy. It has little to do with Haeckel's monist resolutions. Describing interlacing patterns once again in *Form Problems of the Gothic*, Worringer cautions that this category of ornament is neither a "union of elementary contrary principles" nor "a harmonious interpenetration of two opposing tendencies but of an impure, and to a certain extent uncanny [*unheimlich*] amalgamation of them."[44] In other words, the ornamental offspring of the animation of the inorganic is and will always remain a source of permanent contradiction. Like Riegl's basilica, it is both a moving animal and an inert pattern; like Lehmann's fluid crystals, it is both solid and liquid. As Deleuze proclaimed (after Worringer): "It is inorganic, yet alive, all the more alive for being inorganic."[45]

Such "hybrid" contradictions extend to the two main psychological concepts of *Abstraction and Empathy*. Worringer's 1907 dissertation has often been understood as a polemic against empathy, or even as the "death knell" of this aesthetic theory.[46] However, a close reading of the text reveals that the two attitudes are not polar opposites. Worringer ultimately advocates an empathetic view of abstraction or (in what a more appropriate description might be) an abstract form of empathy. He speaks of an empathy that is "transferred onto mechanical values" (*AE* 112), or of "[f]orces" that "are intensified to the maximum by a power of empathy extending to the abstract" (*AE* 117). As in the anthropological descriptions of animatism, the subject does not identify with any singular object, but instead with a cluster of forces diffused in a collectivity of impersonal patterns: ornaments, sounds, and rhythms. Ob-

jects and subjects become part of an actively homogeneous field. *Abstraction and Empathy* is then not simply a text about the juxtaposition of two aesthetic modes, but also the contest between two epistemological mentalities concerning the agency of objects. On the one hand, Worringer's text is informed by Western conceptions of animation—the illusive liveliness of fabrics and the static movement of ornamental motifs—and on the other, the animism of tribal cultures that Worringer would have witnessed in the Trocadéro next to the "cold" plaster casts of medieval sculpture.

Here we might return to Arnheim's review of Worringer's *Abstraction and Empathy* and the psychologist's juxtaposition of empathy with animation.[47] For Arnheim, empathy signified the subject's tendency to impose her own subjectivity over things, while animation manifested the object's autonomous solicitation of the human subject. Perhaps Worringer's notion of the "animation of the inorganic" (which Arnheim does not mention) is the closest that Worringer came to recognizing the role of animation in granting agency to inert things. Even if Worringer's Northerner enthuses in the vitality of his ornaments, he appears to have no power over them. Worringer claims that the tendency toward the inorganic is an impulse that is involuntary: "we follow it joylessly" (*AE* 77), as a reflex that is *not* guided by subjective volition. There are essentially two forms of "life," and that of the "Northern line" appears to be stronger than our own.

Here, Worringer's repeated use of the word "uncanny" (*unheimlich*) is prescient. While Worringer initially uses the term to designate phenomena that concern the movement of inanimate objects (for example, marionettes[48])— thus resonating with the early conceptualization of the term in the contemporary work of Emil Jentsch—ultimately Worringer's understanding of the uncanny as a "pathos for the animation of the inorganic" presages the reformulation of the term by Freud.[49] Like Freud's conception of the uncanny, Worringer's "uncanny pathos" describes a negative form of identification in which the subject is forced to come to terms with an entity that he disavows and yet that bears an inverted symmetry to himself. There is something in the inorganic ornament that Worringer's distressed Northerner recognizes as himself—an element that renders *him* inorganic, while at the same time solidifies his attachment to the geometric pattern.

For the same reasons, the animation of the inorganic is not motivated by a positive impulse, but instead by an increasing resistance. Toward the end of *Abstraction and Empathy* Worringer repeats, verbatim, his description of the interlace ornament and the (anti)aesthetic urges of the Northerners, yet just before the end of that passage he inserts an additional clause: "because

their disharmony could not express itself through the medium of the organic; *it needed rather that intensification of a resistance [die Steigerung eines Widerstandes]*, it needed that uncanny pathos which attaches to the animation of the inorganic" (*AE* 109, my emphasis). Resistance enters the text as an additional ornament, a rhetorical accent that pushes the limits of the exuberant formulation further. There are in fact a number of these obstacles facilitating the movement of the historian's arguments throughout his texts, such as, for example, the "blocks" or turns increasing the force of "jagged" lines associated with the Gothic style (*FG* 43) or the "valves" of certain baroque architectural elements creating a type of pressure that is neither organic (vital) nor inorganic (mechanical), but "superorganic [*überorganische*]" (*FG* 131). Contrary to the pneumatic model of movement, which is based on a continuous flow, this erratic progression is essentially *hydraulic*, as progress is checked in certain strategic points to enhance growth. Similar to the vitalist model put forward by Bergson in his *Creative Evolution*, and also by Freud in his theorization of the branching or bifurcation of neurological pathways (*Die Bahnung*), obstruction does not hinder progress, but ultimately facilitates it.

Even the term *anhaften*, which Worringer uses to describe how the "uncanny pathos" *attaches* itself to the "animation of the inorganic," is the same verb employed by Freud in his writings to characterize the transformation of the (nutritive) instinct to the (sexual) drive.[50] The animation of the inorganic, as described by Worringer, derives from a similar vicissitude: it redirects the original goal of aesthetic enjoyment supported by the organic principles of empathy toward the *end* of inorganic animation—a form of instinctual *anaclisis* that attaches the subject of life to the vicissitudes of death. The inorganic is then the "vegetal" offshoot produced by a blockage of the organic stem, which then branches into antithetical directions. Abstraction and empathy, or empathy and animation, are only one set of these endlessly bifurcating pathways.

Worringer's theoretical graphs (which extend those of Riegl) converge at the conclusion that there is not simply an unconscious drive toward ornament, but that the drive itself (as Freud describes it) is something inherently *ornamental*.[51] Similar to an ornament, the drive creates forms that surpass the functional instinctual purpose and proliferate by regurgitating their own substance through the processes of branching, splitting, and rotating. Resistance, obstruction, and attachment are the three syntactical processes that articulate a new *grammar* of ornament. If behind Warburg's animated accessories were the rhetorical *figurae* of Alberti, Worringer's "animation of the inorganic" discloses a less classical rhetorical origin.

Inorganic extensions: fabrics and hair

But there are more of these ornamental or "accessory" links. Worringer is not only interested in abstract geometric ornament, but also in adornments and clothing—the body's inorganic extensions. What was the young art history student doing at the Trocadéro just before he met Simmel? "I compel myself to study 'the rendering of drapery,' nothing more," recounted Worringer in his autobiographic preface. Apparently the young art history student was examining the representation of fabric in casts of medieval cathedral sculpture, which were then exhibited at the Trocadéro together with artifacts from the French colonies.[52] The inception of *Abstraction and Empathy*, then, is indebted to the movement of drapery and its active capacity to mediate between the animism of tribal artifacts and the animation of Western art representations. Similar to Warburg, whose own dissertation was based on his conversations with Schmarsow on the use of windblown garments in Renaissance painting, for Worringer drapery acts as a scenographic introduction to an encounter with his own mentor, Simmel.

Even if while writing his dissertation the young student ventured to more general theoretical problems, the observations he might have drawn from his compulsory art historical assignment at the Trocadéro proved expedient in more than one way. Because fabric is not only at the origin of *Abstraction and Empathy*; in fact Worringer's published dissertation closes with an elaborate apotheosis of Gothic drapery as a multifaceted "organism of its own" and with an independent "phraseology of forms" that shifts from the "crinkled" and "angular" styles of earlier periods to the "rhythmic swing" of late Gothic (*AE* 119). Such rhythm is essentially a counterpoint, since the body and the drapery compete with one another like "two separate orchestras" attempting to "drown each other's voice" (*AE* 120) (fig. 3.9, *right*). Similar to Warburg's early Renaissance accessory, the drapery, discloses a double form of *inorganicism*: first, in terms of its material, and second, on account of its movement away from or even *against* the comportment of the organic body. But if Warburg was steered by the violent external mobility (*äussere Beweglichkeit*) of painted accessories, Worringer was more interested in an inner, impalpable simulation of life (*innere Lebendigkeit*) in surface ornaments and stylized patterns.

Similarly while Warburg was primarily interested in the semblance of external movement in Renaissance accessories, including hair and fabrics, Worringer is captivated by the inert form of both Egyptian and Gothic adornments. In *Abstraction and Empathy*, he refers to the "stiffly stylized voluminous wigs" of Egyptian figures, which exploit "the opportunity of embellishing cu-

Figure 3.9 Treatment of drapery and hair in Gothic sculptures: *left*, Petrus, St. Pierre at Moissac; *right*, St. Laurentius, wood sculpture, Karlsruhe, state collections (photograph by W. Kraft). Both images from Wilhelm Worringer, *Formprobleme der Gotik* (Munich: R. Piper, 1930).

bic values with abstract values" (*AE* 92–93). Like an accessory, abstraction acts here not as a form of subtraction, but as the additional "embellishment" of an elementary form. Egyptian headdresses, robes, and aprons exhibit a similar *accessory* abstraction, evident in the "stiffness and rigidity" with which these flowing extensions are simultaneously suppressed and (aesthetically) augmented. In contrast, and though they too are stylized, "the rolled up ends" and winding "ribbons" of beards and locks of hair in male figures of medieval sculpture appear animated by the "living geometry" of the Gothic (*AE* 110) (fig. 3.9, *left*).

Whether a piece of fabric, a hair wig, or a vegetable, Worringer's inorganic abstraction both effaces and reanimates the ornamented object. As in Riegl's treatment of so-called vegetal motifs, Worringer's inorganic animation describes a double form of movement: first, a latent motion that addresses the object itself, and second, a continuous slippage from one object to the next—from fabric to plant to ornament—that renders the *nature* of these animated objects ineffective.

On the animalization of the inorganic

This furtive *deorganization* extends to Worringer's rare yet highly prescient references to animal ornament. Since the art historian offers no illustrations in *Abstraction and Empathy*, we can only imagine what his Northern interlace or strap decorations might look like by leafing through the various historical almanacs of ornamental motifs circulating at the time. One example would be the ribbon frames of medieval Gospel images, themselves derived from Roman tessellated mosaic patterns, numerous examples of which appear in Owen Jones's well-known *Grammar of Ornament*, as well as in the illustrations chosen by Reinhard Piper for Worringer's *Form Problems of the Gothic*.[53] But while Worringer emphasizes the "purely inorganic framework" of these motifs, the illustrations of actual artifacts from Nordic or Celtic origin tell otherwise. Next to the abstract patterns, there are frames where the geometric lines intertwine with zoomorphic forms or even whole animals, such as rabbits, serpents, and beaked monsters (fig. 3.10). With the precision of evolutionists, historians of ornament have analyzed the material transformations taking place in these monstrous decorations in which abstract lines, dots, and bands merge with animal tails, claws, and eyes.[54]

Figure 3.10 Band ornament without and with animal figures. Details of miniature of St. Matthew, the St. Cuthbert Gospels. From Wilhelm Worringer, *Formprobleme der Gotik* (Munich: R. Piper, 1930).

Perhaps the most well-known treatment of such ornament is the seminal study of 1904 by the Swedish archaeologist Bernhard Salin, *Die altgermanische Thier-Ornamentik* (*The Old Germanic Animal Ornamentation*), which was reviewed by Riegl.[55] Salin's main object is the evolution of the Northern fibula with movable clasps, initially furnished with plain "buttons," yet gradually decorated with applied ornamentation in the form of bird heads and quadruped animals. Salin distinguished three styles in the fibula's zoomorphic ornamentation: style 1 (sixth CE BC) marks the dissolution of animal figures into separate body parts, such as heads, trunks, front or back feet, tails, and crooked beaks. While Salin refers to this form of dismemberment as a "degeneration" (*Degenerierung*) of animal form, in his review Riegl sees it as a "positive progress" that leads to the "denaturalization" (*Entnatürlichung*) of animal ornament. In style 2 (seventh CE BC) these dispersed body parts start to recombine into new hybrid schematizations that oscillate between geometry and animal morphology. Finally in the eighth century, the "unclarity of these unnatural connections," as Riegl describes Salin's last stylistic category, "rises to such a degree that it arrives at the opposite extreme: the lively animal ornamentation transforms into a geometric one" and this transition "suspends" and ultimately "kills" the ornament's former animality (fig. 3.11).[56] Once more geometry and life engaged in an animal battle; and even if geometry ultimately prevailed, the ornament's animal past would never entirely vanish.

Figure 3.11 Illustration of Northern animal ornament from Bernhard Salin, *Die Altgermanische Thierornamentik* (Stockholm: Walström & Widstrand, 1935), 277. Parts of the same illustration appear in Worringer *Formprobleme der Gotik*.

Riegl criticizes Salin for attempting to establish definite chronological boundaries for the three styles, as the actual dating of certain archaeological findings demonstrated that there were often regressions—or, as Riegl calls them, "anachronisms"—into earlier patterns, by which animal heads, legs, and beaks would be reattached to the body of the Northern fibula. While in the natural evolution of organisms it is not possible for certain extinct body parts to reappear (even if they survive as rudiments), this was possible in the history of ornamentation. In Northern animal decoration serpents can regain their lost feet. The animate yet inorganic geometry described by Worringer is furtively reenergized by the restitution of these regressive animal potentialities—the ability to return to a previous biological condition, including man's animal or mineral origins. The animation of the inorganic subsists in the latent *animalization* of its origin.

To be sure, Worringer was familiar with the animal origin of what he misrecognizes as abstract patterns, but following the arguments of Northern archaeologists, he insists that what are "misleadingly" called animal ornaments, such as "dragon or serpent coils," do not follow "any natural model" but are embellishments of rhythmic geometric patterns.[57] While occluded from

606. *Golland, Schwed.* Br. $\frac{1}{1}$.

a b c

606 a—c. Details der Fig. 606.

607. *Golland, Schwed.* Br. $\frac{1}{1}$.

a

b

Abstraction and Empathy, many of these Nordic zoomorphic ornaments would in fact resurface among the illustrations selected by Piper, the publisher of Worringer's next book, *Form Problems of the Gothic*, first published in 1911. Also, the cover of several of the reprinted editions of *Abstraction and Empathy* is embossed with a Northern circular ornament with interlocking petrified serpents (fig. 3.12). As in the geometric snake motifs analyzed by Küster, it was as if the figurative unconscious of abstraction was belatedly revealing its animal head; this time, the monstrous capital appeared on the very *cover* that was supposed to shroud its existence.

The serpents lurking inside these crystalline ornaments reanimate another crystallographic pattern. I refer to the mineral "snakes," the sliding worms created inside liquid crystals, which, as Lehmann showed, moved inside ammonite minerals in a serpentine fashion. Remember that Lehmann attributed the formation of these winding threads to differences in temperature. In a similar fashion, Worringer too would attribute the formation of Gothic abstract tessellated ornament to differences in the *état* or *temperature d'âme*, changes in the psychological temperature created by the migration of the same ornamental motif from the Mediterranean world to Northern European countries.

Yet there are further implicit connections between Worringer's Northern ornaments and the visual models of contemporary crystallography. Toward the end of his *New World of Crystals*, Lehmann traces certain correspondences between rheocrystals and "nonstatic" magnet systems. By analyzing the molecular structure of dynamic electromagnetic "space lattices" (*Raumgitter*), the crystallographer describes the elasticity and deformation that is common in both liquid crystals and certain types of magnets (fig. 3.13).[58] The models representing the molecular "space lattices" of dynamic inorganic matter appear analogous to the forms of interlace ornament described by Worringer. A common cubic quality transforms the abstract tangle of lines into an energy network. Like interlacing ornaments, the diagonal "force lines" (*Kraftlinien*) of such lattices have the tendency to loop, intertwine, and form knots with one another, reinforcing the strength of the space grid. Similar to the technological transformations outlined by Warburg in his lecture on snake ritual, serpents and other animate forces have transformed into invisible microscopic structures. At this point we understand that in his seeming neglect of physiomorphology, Riegl was in fact being infinitely subtle. Morphology still plays a role, yet now formal affinities shift from the external to the internal or molecular level. The proper dimension for the contemporary reanimation of the inorganic is the *micro* or atomic scale.

WILHELM WORRINGER
ABSTRAKTION UND
EINFÜHLUNG

Figure 3.12 Cover of Wilhelm Worringer, *Abstraktion und Einfühlung* (Munich: R. Piper, 1919).

Figure 3.13 Models of molecular electromagnetic space lattices from Otto Lehmann, *Die neue Welt der flüssigen Kristalle und deren Bedeutung für Physik, Chemie, Technik und Biologie* (Leipzig: Akad. Verlagsgesellschaft, m.b.H, 1911).

Figures and frames

The same animals moving inside the crystalline lattices also act as allegories of a pervading contradiction in the historiography of Worringer, and perhaps Riegl, too. On the one hand, there is a tendency to abstract the figure, to schematize or erase its outline, and to empty it of any content; but on the other hand, there is a strong insistence on issues of identity: racial, ethnic, national, religious, and implicitly sexual. In his introduction to *Late Roman Industry*, Riegl had argued that architecture and the applied arts reveal the laws of the *Kunstwollen* with an almost "mathematical clarity" because, unlike the "figurative arts" of sculpture and painting, they are less encumbered by issues of "content," such as "religious" or "patriotic" associations.[59] Content and context, or figure and frame, become one in Riegl's statement; and yet historians of architecture and applied ornamentation know that its claims are hard to sustain. Even Riegl himself, while attempting to eliminate or *tame* animal ornaments into geometric patterns, concurred with Salin that such motifs act as evidence for the migration of Northern and Latin peoples: the animals' rhythmic traces in metal fibulas track the periodic movement of human populations on the European ground. The task of most Northern historians examining the art of migration periods was not to celebrate the plurality of its ornamental expression in a variety of peoples but to corroborate the singularity of its origin in a single race. In *Form Problems of the Gothic,* Worringer would infamously argue that even if one accepts the existence of Celtic, Latin, French, English, and even Saracenic Gothic, "Germanic blood is the *conditio sine qua non*" of that style (*FG* 39), and therefore such art can only flourish in areas traversed by Germans.[60]

In a 1913 lecture on ornament Worringer argued that even the abstract sociality of decoration, predicated upon the impersonal rhythm of dance, is demarcated by distinctions imposed by "race psychology."[61] There is then a twofold understanding of the human body in this context. First, the body as physiological *content*, an abstract organism animated by mechanical or animal intensities and organic rhythms; and second, the body as *outline*, a geometric figure that represents a generic identity or *type* with a specific location in the anthropological horizon. Context in Worringer becomes internalized within the body and is then projected onto its physical profile. The tendency toward the crystal becomes an inherent organic disposition, and the animation of the inorganic acquires a psychologically mobile yet ethnologically static *anima* or soul.

Ultimately Worringer's animation is a latent form of collective animosity, suppressed and then reenergized by a growing resistance. Like Warburg's no-

tion of pagan antiquity, his "secret" (*geheime*) Gothic can never have a real life, yet can experience multiple afterlives. However, while Warburg's reanimation of archaic animism was ostensibly expended in the flowing movement of accessories, Worringer's "animation of the inorganic" never breaks the surface—it remains internalized within a cubic enclosure.[62] *Form Problems of the Gothic* ends with Worringer's aspiration for the reunification of European art under the banner of the Gothic. In his late texts following the end of World War II, Worringer would invoke the resurrection of *Ars Una*, the unified art of the Middle Ages, whose legacy never materialized in the modern age—an era radically divided in the numerous *-isms* of twentieth-century movements of "studio art."[63] And yet it may be that at least part of Worringer's inorganicism survived the death of his monist aspirations.

Two external worlds

Far, then, from being disengaged from context, Worringer's "ethnopsychological" abstraction is largely determined by it. Following contemporary biological and aesthetic theories, Worringer claims that the main factor distinguishing the different *types* of art-producing-humanity is the "shifting juxtaposition [*Auseinandersetzung*] between man and the external world."[64] The polarity between abstraction and empathy is in fact the product of two different external worlds, both of which appear to be equally treacherous. The first is "the world of phenomenal appearances [*Erscheinungswelt*]"—the world of the "pure Greek" who lives in empathetic plenitude with his comfortable surroundings and its "evershifting play" of perceptions. The second is the hostile external world of the Northerner, who maintains a contested relationship with the "inharmonious nature" he lives in, but never comfortably inhabits. This second external world has a haunting permanence in contrast with the transience of the first. Both worlds have a problematic relation to the visible. The menacing world of the Northerner is uniformly obscure as much as that of the Southern is deceptively luminous.

In his account of strapwork ornament, Worringer had attributed the "uncanny pathos" behind the animation of the inorganic to the "harsh and repellent nature" that surrounds the Northerners (*AE* 77). As in Hirt's study of life in the inorganic world, the proof of animation in Worringer's *inorganic* art is in its (mired) communication with the outer world—an antagonistic relationship that extends to prehistory. According to the art historian, the origin of humanity does not reside in the Bible's "man of paradise" or Laugier's "happy primitive";[65] instead it is more akin to Darwin's frightened animal or "mon-

ster." Imprinted in the "organic memory" of the human species, the effects of this menacing environment can never disappear: "modern man is as lost and helpless as the primitive" (*AE* 18). The "dread of space" felt in recent times is "not a physical fear," but a type of "spiritual space fear" or "agoraphobia" (*geistige Raumscheu*) (*AE* 129).[66]

Worringer's abstraction primarily describes a *phobic* mode of animation, but there are also ways his inorganic vitalism can become *extensional*. Worringer's agoraphobic is not the isolated individual refusing to leave home, but a hypersensitive person always in contact with the world around him. By converting the animal monsters of his fear into an interlaced ornament, the distressed Northerner manages to use his anxiety productively: he *weaves* his psychological perturbations into artful hair braids. In other words, the agoraphobic is, for Worringer, the quintessential aesthetic subject of modernity. The universe around him becomes expressive with an abstract noise. Dizziness is the physical proof of his animated response: "Any one who is at all sensitive to the impressions of space can never enter the great Gothic cathedrals without experiencing a dizziness caused by space [*Raumschwindel*]" (*FG* 160). Such vertigo is liberating, even pleasurable (although this term might be too "empathetic" to describe such self-defying "bliss"). The animation of the inorganic transforms a material contradiction into a psychological one. It is the objectification of our fears, but also the formal pleasure we extract out of them. It is the sign of the agoraphobic who has advanced (or regressed) so far in his affliction that he has started enjoying his anxiety.

Considering his fateful meeting in the Trocadéro and later correspondence with Simmel, one might think that there is a synergy between Worringer's theory of abstraction and the sociologist's concept of estrangement—the feeling of "distance" that immobilizes the "mental life" of modern metropolitan citizens.[67] But if indeed there is such a connection, it is an inverse one. Instead of disparaging estrangement like Simmel (and later Kracauer), Worringer essentially celebrates it. While for Simmel estrangement is a malaise of modern life, Worringer transfers the same affliction to the Gothic, turning it into a necessary condition for *being* in the world and making art. While Simmel's metropolitan subjects are fundamentally bewildered by the "overstimulating" environments they inhabit, Worringer's equally confounded Goths turn their bewilderment into "sublime hysteria." The historian's space-stricken Northerner demonstrates how the concrete walls of abstraction are permeated by the liquid waves of empathy or how *phobic* animation can become an *extensional* experience.

But what kind of environment would sustain the "animation of the inorganic" in the modern era? If the primitive caveman was chased by mammoth beasts and the ancient Goth was distressed by the inclement weather, what are the contemporary conditions that recreate the "hostile external world" in the twentieth century—a world that in its technological euphoria appears closer to the luxurious vegetation of the Greeks than the harsh glaciers of the Northerners?

Critics have already associated Worringer's abstraction of "sensible-supersensible" modalities with the enigmatic aesthetics of capitalism.[68] It has also been stated that Worringer's animated "ornaments" and inorganically "undifferentiated crowds" presage the "mass ornaments" of the Tiller girls in the Weimar era and later on the Nuremberg rallies.[69] One might object that in both his earlier and later work Worringer makes use of anticapitalist rhetoric.[70] But even in *Abstraction and Empathy*, which was written in 1905, one perceives that the "world of transient phenomenal appearances" is not only a hint against French impressionism, but also of the fleeting fashions of turn-of-the-century commodity culture. Furthermore, Worringer's aversion to the organic "curvilinear" lines of classical art reproaches *Jugendstil* and, more broadly, an entire line of aesthetics of "bourgeois naturalness" extending beyond the prerogative of the Renaissance. In other words, capitalism is behind *both* of Worringer's external worlds: "the phenomenal world of appearances" surrounding classical men *and* the "harsh and repellent nature" enveloping the Northerners. Capitalism is both Gothic and Greek, abstract and empathetic.

By essentially inverting Simmel's concept of estrangement, Worringer ultimately restored it, succeeding in demonstrating the spiritual satisfaction modern subjects obtain from the very mode of society enacted in the Western metropolis—an interaction predicated on *distance*. While in the first instance his abstraction is directed against bourgeois aesthetics, ultimately it constructs a psychological support upon which modern sensibility not only survives but *thrives* within a climate of "empathetic abstraction." This aesthetic shift represents an instinctual vicissitude not limited to turn-of-the-century subjects. There is perhaps something of Worringer's anxious *Northerners* in all of us today, irrespective of racial or national background.

Inorganic progeny

As shown by Lehmann and Hirt, one of the animate qualities of living crystals was their capacity for procreation. Not only could inorganic matter reproduce

itself, but it figured as the very matrix of reproductive relations. In his universal histories of the world, Haeckel reiterated the evolutionary principle that all life originates from the inorganic.[71] All protozoa and protophyta stem from the prebiotic inorganic phase of the earth, where eventually all creation will one day return.

Based on similar assumptions, Nietzsche ultimately portrayed inert matter as "the maternal womb" (*Mutterschoss*), and even argued that one should greet one's "return" to the inorganic state with a "celebration."[72] Published in 1901, the twelfth volume of Nietzsche's collected works, which contains this and other posthumous aphorisms of the *Gay Science* epoch, was widely read.[73] During the 1920s the French critic Charles Andler compiled several of the same aphorisms in a section titled "La matière inorganique" from his intellectual biography of Nietzsche. Based on Nietzche's maternal metaphor, Andler writes: "inorganic matter is the maternal bosom" (*le giron maternel*).[74] In his "Propositions sur le fascisme" of 1937, Georges Bataille (mis)quotes the same phrase from Andler's biography, stating that "inorganic matter is the maternal *breast*" (*le sein maternel*).[75] From Nietzsche's "womb" to Bataille's "breast," inorganic matter is recast as, or even *reborn* in a fe/male body.

Like Lehmann's liquid crystals, the children of Nietzsche's inorganic bosom continued to procreate. Worringer was only one out of several neophytes who wanted to suckle that hard inorganic breast. "The morphological law of inorganic nature still echoes like a dim memory in our human organism," writes the author in his doctoral dissertation (*AE* 36), suggesting that all of us preserve remnants of our mineral origins in our bodies. That is why we synchronically vibrate with crystalline forms whenever we visit a Gothic cathedral and why we would greet our return to inert matter with a celebration. One of the most fervent participants of such celebrations was T. E. Hulme, the first propagandist of Worringer's ideas in England and a declared "militarist" who died in the First World War while fighting with the British Royal Artillery.[76] Hulme had apparently listened to the German art historian's lecture on ornamentation during the Berlin Art Historical Conference of 1913 (also attended by Warburg).[77] Unlike Hirt, who construed a new inorganic science to establish continuities between all faculties of knowledge, Hulme enlists the inorganic to erect permanent partitions between art and nature.[78] Arguing against the romantic notions of organic continuity, Hulme claimed that there are unbridgeable gaps between the "circles" of biology and the physical sciences, as well as the areas of human history or psychology and the "inhuman" perfection of the inorganic realm, which art and ethics should inhabit. "Geometry through life and back to geometry": Hulme summarized his con-

centric theoretical system implying that geometry presides *over* life, or that life can only exist while circumscribed by geometry.[79] In its dictatorial simplicity Hulme's geological stratification of the arts and sciences presents the topographical outline of a certain strand of modernism that was fossilized in its very birth by the rigidity of its inorganic aspirations.

Hulme's vision would be partially realized in *The Green Child* (1935), the only novel by his future editor Herbert Read. Read envisions a utopian community of half-vegetal humans living in rock caves and having as their singular occupation the cultivation of crystals—hexagonal, pentagonal, rhomboid, or cubic, which correspond to the various forms of art, baroque or classical, of the terrestrial world.[80] All members of that amicable society aspire to achieve "perfection" via a process of bodily and intellectual "crystallization," which is completed after the green people's death. In the novel's closing lines, the male narrator is posthumously reunited in "crystal harmony" with his female partner, whose tresses spread "like a tracery of stone" and intertwine with the "coral intricacy" of his beard.[81] Hair, coral, and crystal represent different degrees of inorganic collectivity.

Read's utopian novel reflects the political dimensions of inorganic ideology. While in the nineteenth century, social cohesion would be identified with organic systems, by the beginning of the twentieth century it was the *inorganic* that posed a new form of absolute and impersonal collectivity. There was a need to move beyond the intrinsic changeability of organic forms to a more general and immutable order. "In contrast to sensory or organic art, abstract art is usually collective," Otto Rank would write, "it moves beyond the 'autonomous individualism' of primitive man and the 'lordly masters' towards the detachment from nature expressed in commerce and collective social formations."[82] A black-and-white cartoon portraying a triangular crystal stabbing the round belly of a capitalist, from a 1919 issue of *Simplicissimus*, reveals the political allegories behind the morphological battle between amoebas and crystals, as well as the belief and consequent disappointment in this new world of crystalline formations (fig. 3.14).[83]

The satirical cartoon portends the ambivalence that the brilliant prestige of the inorganic would inevitably provoke. Such ambivalence perhaps reached its peak in 1930s Europe when inorganic power was compromised by an apparent "return to the organic," yet the iconography of metallic warriors and workers (as in the novels of Ernst Jünger) was never more prevalent.[84] These divided cultural responses suggest that not only the inorganic has memory, as scientists like Semon had argued, but also that we, too, might have a memory of it. Such memory includes not only the organic traces of our primordial

"Die Kurve, die Grundform des Kapitalismusses, ist überwunden. Die neue Zeit bricht an. Dröhnend marschiert der Kubus durch das All."

Figure 3.14 "The curve, the primary form of capitalism, is overcome. The new day dawns. Threateningly, the cubes march through the universe." Cartoon in *Simplicissimus* 24, no. 7 (May 13, 1919): 94.

origins, but also certain historical events, the memories of which are fairly recent and are associated with crystals. One would think that after the infamous "night of broken glass" of 1938, known as *Kristallnacht*, no one would ever speak again of crystals. Suddenly Lehmann's "living crystals" became Ernst Bloch's "crystal of death" (*Todeskristall*).[85] This is the new mnemonic engram embedded by the inorganic on the tissue of Western culture. What we experience today is perhaps not the animation of the inorganic, but the reanimation of that inorganic memory.

While in the early twentieth century the inorganic represented the possibility of an alternative form of community, by the end of the Second World War that promise had evaporated. After the 1950s the inorganic coldness of modern artifacts becomes the very symbol of antisocial and even antihumanist behavior. For example, in his postwar critique of modernism, *The Lost Center*, the Austrian art historian and ex-member of the Nazi party Hans Sedlmayr, also a loyal follower of Worringer,[86] presented the "descent to the inorganic" as one of the central pathological symptoms of contemporary art and architecture: "Man has no true part in the inorganic world at all, for that world is essentially extra human. A shift, therefore, of the incidence of spiritual and mental activities towards the inorganic must inevitably be a negative thing. It makes him less and not more than a human being."[87] In Sedlmayr the revulsion against the inorganic represents an idiopathic backlash—a loop in which humanist and organicist nostalgia retraces its inorganic origin or double, which is now making a return.

. . .

Perhaps Haeckel's theory of *hysteresis* or "inorganic memory" was closer to what Freudian psychoanalysis would describe as "repression"—a psychical process through which a subdued idea does not disappear, but continues to exist in a latent form. The latent energy of the inorganic parallels its covert presence in cultural memory as well as periodic resurgence from oblivion.

The legacy of Lehmann's snake worms was that the very forces that eroded the crystal also triggered its regeneration. The interaction of life with the inorganic world was cyclical. Punctuated by resurgences and catastrophes, the inorganic prompted the succession of life by long periods of *afterlife*, which even if seemingly inert were consummately animated.

In fact, Lehmann's theory of liquid crystals experienced several such afterlives. During the interwar period, scientists disputed Lehmann's claims and argued that these organisms were not crystals, but the products of emulsion between two different compounds; thus the entire theory of liquid crystals appeared to have collapsed. After two decades of silence, new experiments in the 1950s and '60s brought these crystals back to vibrant life mainly because of their benefits in electro-optic applications. Today, liquid crystals are used in a plethora of consumer products, from alarm clocks and wristwatches to television and computer screens employing liquid crystal display (LCD) technologies.[88] Once invisible, yet now omnipresent, Lehmann's liquid crystals not only survived but have triumphed, despite the cracks or snake worms in the scientist's original hypothesis.

134

135
Liquid Crystals
Photomicrograph: Dr. O. Lehmann
Leipzig

135

136
Beryllium + 3% Iron,
Photomicrograph: H. P. Roth, Massachusetts Institute of Technology

Figure 3.15 Page spread with photomicrographs of liquid crystals by O. Lehmann and photomicrograph of beryllium plus 3 percent iron by H. P. Roth from Gyorgy Kepes, *The New Landscape of Art and Science* (Chicago: Paul Theobald, 1956).

As part of their postwar revival, liquid crystals appeared among the illustrations of one of the most prominent publications of postwar visual culture, György Kepes's modern almanac, *The New Landscape in Art and Science*, first published in 1956 after several years of preparation (fig. 3.15).[89] Here, Lehmann's microphotographs of bloblike and spider crystals (as well as Haeckel's radiolarians) mingled with the biomorphic furniture and molecular structures of postwar total design, such as the Eames's chairs and Buckminster Fuller's geodesic domes. The *new* landscape discovered by Kepes was already old— fossilized by the inorganic relics of monism, which was now bracketed under mo(der)nism. Such visual remnants demonstrate that the inorganic not only has memory but also a history that is still alive—tracing a latent *biology* as well as an archaeology of modern living space. The tendrils of Riegl's crystallized arabesques and the loops of Worringer's strapwork ornaments have transformed into marine plants within the pristine aquarium of modern architecture. Art turns once more into natural history, this time not by the ossifying stylizations of art history, but by the monumentalizing techniques of art and architectural practice.

Perhaps the person who benefited the most from the postwar *reanimation* of the inorganic was Worringer. Following a long hiatus in his publishing production between 1933 and 1945, the art historian's popularity reached new heights in the postwar era, following the republication of his early work. But while after World War I it was *Form Problems of the Gothic* that was repeatedly reprinted in Germany, after World War II it was *Abstraction and Empathy* that scored an international success with its first English translation in 1953, followed by several later editions. Yet there is an essential difference in the legacy of these two books. While *Form Problems of the Gothic* contributed to the empathetic preservation of the war trauma in Weimar Germany, *Abstraction and Empathy*, whose nationalistic overtones are less overt, contributed to the provisional masking of that trauma. Once again, the abstraction of Worringer's argument had an empathetic effect; but while in *Form Problems of the Gothic* this novel empathy provoked a passionate resurgence of nationalist sentiment, in *Abstraction and Empathy* (considering its legacy in the 1950s and after) was subdued within the soothing *apathy* of the "international style." A number of historiographic developments document this transition.

In a 1948 article on the British artist Ben Nicholson, Herbert Read—the critic who, following Hulme, popularized Worringer's work in the English-speaking world *before* the translation of *Abstraction of Empathy*—found an opportunity to make another overarching statement about the German art historian, who was also his personal friend. Read claimed that Worringer's theories of abstraction expressed the urgency of a current "need" that led to "a world wide movement affecting all the arts" in the twentieth century; as Read added parenthetically, "(for the music of a composer like Schoenberg comes into comparison, as well as the main trend of modern architecture)."[90] But Worringer never wrote about the International Style and if the German art historian has anything to do with Schoenberg it would be less with the Viennese composer's atonal compositions after 1909 than the dramatic expressionism of his early work (such as the boisterous *Gurrelieder*, written around 1900). Worringer also has little to do with the geometric circles of Ben Nicholson, the vibrating rectangles of Rothko, or the crystalline sculptures of Tony Smith, in spite of the attempts of several postwar critics, historians, or book publishers to associate the German art historian with these and other works of modern art.[91]

Part of the modernist repackaging of Worringer is illustrated by the post–World War II editions of *Abstraction and Empathy*, in which the petrified snakes on the cover of the early German editions are substituted by a crys-

talline design on the dust jacket of the 1959 German edition followed by an abstract composition with a blue rectangle and a brown elliptical shape on the cover of the first English paperback (fig. 3.16).[92] However superficial, such attempts speak for the urgency not only to translate, but also to *convert* Worringer into modern English.

There are, indeed, certain statements in Worringer's 1907 dissertation that during the era of postwar reconstruction in the 1950s might have caused contemporary readers some discomfort. Why does one have to continue living in a "harsh and repellent nature" to create art? How does this Northern *Angst* comply with the abstract art that decorates our living rooms? Is it not possible to add a little empathy to our abstraction? Perhaps with such questions in mind, in the same article on Nicholson, Read suggested some modifications in Worringer's original scheme:

Figure 3.16 Book covers of Wilhelm Worringer: *left, Abstruktion und Einfühlung* (Munich: R. Piper, 1959); *right, Abstraction and Empathy* (New York: Meridian Books, 1967).

What we now must affirm is the possibility, not merely of an individual reaction, but even of the alternation, within the individual consciousness, of both attitudes [i.e., abstraction *and* empathy]. In a superficial sense, this may be interpreted as no more than an alternation of optimistic and pessimistic moods. Admitting the existentialist analysis of man's position in the universe, it is still possible for the individual to react positively or negatively, with despair or with courage, with fear or with confidence. In certain cases it seems possible for an individual to alternate between the extremes represented by this polarity—to tend in one psychological phase towards an affirmation of the world which results in a naturalistic style, and in another morphological phase to tend towards a rejection of that world which results in an abstract style of art.[93]

In other words we do not have to wait for centuries or even millennia to shift from empathy to abstraction. And perhaps we do not need to be Northerners or Southerners in order to subscribe to one or the other *Weltgefühl*. This was no longer the time for permanent commitments. The artist can create with a little bit of empathy and a little bit of abstraction and can "alternate" from one to the other according to his or her "mood." Nicholson, Barbra Hepworth, John Nash, Henry Moore, but also Read himself (who shifted camps from surrealism to the *Abstraction-Création* group by Mondrian and Gabo) presented similar instances of "periodic alternation" between abstraction and (super)realism.[94] However individualist, such mixed attitude was not uncommon. During the 1950s, modernist culture revealed an *état-d'âme* that was a little abstract and a little empathetic, but never a whole lot of anything. Some new sparkle had to illuminate Worringer's bleak vision—some *sugar* had to make this black German coffee palatable for other tastes. One final example demonstrates the (ill) effects of such sweetening.

La Dolce Vita

In 1965, nine years after the collection of essays in which his photographic portrait appeared, Worringer died. Herbert Read wrote an obituary in the journal *Encounter*, again praising Worringer (who never embraced modern art) as "a man who perhaps more than any other single individual was responsible for the philosophical justification of the way in which modern art has developed during the past fifty years."[95] Attempting to recapitulate Worringer's main argument in *Abstraction and Empathy* one last time, Read abandoned Hulme's summary and instead presented a version of his own that included a new set of terms:

At this point Worringer introduced the concept of alienation, which he derived from Hegel rather than Marx. Aesthetic experience, he concluded, is dual by nature—it has two opposite poles. But these poles are only gradations of a common need—the need for self-alienation. In one direction (Empathy) the individual is seeking to lose himself in the enjoyment of the harmonic form of an alien object (the work of art); in the other direction the individual is seeking deliverance from the fortuitousness of humanity as a whole, from the seeming arbitrariness of organic existence in general, in the contemplation of something necessary and irrefragable. In the one case "la dolce vita," distraction whether spiritual or sensuous; in the other case "the uncanny pathos which attaches to the animation of the inorganic."[96]

While trying to distance Worringer's abstraction from Marx's "alienation" and realign it with Hegel's phenomenological aesthetics, Read raises "alienation," a term he had not used before, to the ultimate goal of both abstraction and empathy. Suddenly "alienation" had become familiar and did not need to state its allegiance to artistic abstraction. But the most striking new term used by the English critic is the Italian phrase *la dolce vita*, connoting an empathetic "self-loss" that is further juxtaposed with "the uncanny pathos for the animation of the inorganic." Possibly *la dolce vita* is vaguely reminiscent of the "bourgeois naturalness" attributed by Worringer to the "felicitous" culture of the Renaissance, "with which," as the author argues in the last page of his dissertation, "the last style, the Gothic, goes down" (*AE* 120–21). But perhaps there was a more current example of decadence that triggered an association with the Italian phrase in Read's mind.

Though a longstanding Italian expression, the term *dolce vita* did not become common parlance in English until Fellini's film of the same title scored an international success following its 1960 *Palm d'Or* in Cannes. But what does Fellini have to do with Worringer? And how is his phantasmagoric critique of postwar Italian celebrity culture related to Worringer's abstraction?

As suggested by the title, *La Dolce Vita* is inundated by scenes of Roman festivities and all kinds of modern saturnalia, including a number of private parties. Yet one of these social gatherings has a much more somber ambience from all others. It is a quiet dinner party with Indian food, Oriental music, and lots of philosophical discussion, which takes place at the house of Mr. Steiner, a wealthy German living in Rome with his Italian wife and two young children (fig. 3.17). Mr. Steiner has no relation to all the other frivolous friends of Marcello (the central character of the young paparazzo, played by Marcello Mastroianni). Steiner is more of an introverted intellectual, dedicated to his

Figure 3.17 *La Dolce Vita*, directed by Federico Fellini (1960).

books and his family. The first time he appears in the film, he is inside a church talking with Marcello about a rare book that he has discovered. He then plays Bach's famous toccata and fugue for organ in D minor for his friend (perhaps Read would have empathized with Mr. Steiner).[97]

But let us return to the dinner party. There is plenty of wit and philosophical debate, as well as a little art talk in front of one of Mr. Steiner's paintings, which is a "still life" by Giorgio Morandi.[98] Among the guests there is an elderly American poetess dressed in white with a hoarse voice and a strong English accent in her Italian. During one of her philosophical reflections, she suddenly turns to Mr. Steiner and says to him in a loud tone: "Tu sei il vero primitivo; primitivo come una guglia gotica! [You are the true primitive, primitive like a Gothic spire]." The party's conversation is being taped. The tape recorder plays again this last phrase, though interrupted by the (prerecorded) blasts of a thunderstorm, a clamor reminiscent of a battle-blizzard and that makes Mr. Steiner very anxious for a moment. The party scene ends with an "iris-in" frame on Mr. Steiner's face, as he confesses to Marcello how "detached" he feels from the world.

Whether Fellini's poetess had read Worringer or not, she proved to be right about Mr. Steiner's persona. However "detached" and peaceful, Fellini's character was both "really primitive" and "Gothic." In one of the last scenes of the film, Marcello gets a phone call informing him that Mr. Steiner has shot himself after killing both of his children. Marcello goes to Mr. Steiner's apartment, where the police have arrived to recover the bodies and to search for evidence and motives. An inspector pushes the button in the tape recorder, and the poetess's voice is again heard saying: "You are the true primitive, primitive like a Gothic spire!"

Worringer was prescient in sensing the introverted violence that "the uncanny pathos which attaches to the animation of the inorganic" can foment. Even if the sounds of the Northerners' "harsh and repellent nature" are artificially reproduced by Mr. Steiner's tape recorder, their effects are uncannily real. Worringer strove to distinguish the Goths from the so-called primitives, yet his readers never really saw the difference. Postwar audiences never made up their minds between abstraction and distraction, Bach and la Cucaracha, alienation and la dolce vita.

In one of the last scenes of Fellini's film, we see another group of party guests wandering around the spiral staircase of an old castle. When someone asks, "When was this castle built?" Julio (the palazzo's young heir and a descendant of Pope Julius II) answers, "Five centuries ago." Fellini's spiral staircase brings us full circle to Worringer's concluding statement in *Abstraction*

and Empathy: "[With] the Renaissance, the great period of 'bourgeois natural-
ness' commences" (*AE* 120).

So this is the end of the story of the "animation of the inorganic" (although
it has led us only to the middle of this book). It seems that things did not ma-
terialize as "spiritually" as Worringer might have expected. Because the finale
of this scenario is not staged in the "harsh and repellent nature" of the Nordic
glaciers, but rather in the sunny weather of Warburg's Rome and the saturnalia
of the eternal city's postwar "repaganization." There is still music playing in the
air, but it is not the "sensuous-supersensuous" sounds of Schoenberg's string
quartets; it is the tawdry sound of a saxophone rehearsing the leitmotif of the
international *succès* of the late fifties, "Arriverderci Roma," heard when Sylvia,
played by Anita Ekberg, dances with Marcello in the Thermes of Caracalla
before her rock 'n' roll bacchanal and her reenactment of the *Birth of Venus* in
the pool of Fontana di Trevi. Renaissance nymph and Nordic goddess of the
forest, along with water, crystals, rocks, fabrics, and hair: everything is con-
densed in a monist figure enacting the sensuous reanimation of the in/organic
(fig. 3.18).[99] But let us return to the soundtrack.[100] Remember the lyrics of the

Figure 3.18 Anita Ekberg
(Sylvia) in Fontana di
Trevi. *La Dolce Vita*,
directed by Federico
Fellini (1960).

popular refrain? "*Arrivederci Roma . . . goodbye . . . au revoir!*" And yet we know
that *arrivederci* does not mean "goodbye," but *au revoir*; and as for the occlud-
ed *Aufwiedersehen*, it had already been sung loud enough decades earlier, and
it did not need to be repeated.

Inorganic Culture

4

Nudes in the Forest

Models, Sciences, and Legends in a Landscape by Léger

Contact

A hand approaches a tree trunk as if attempting to grasp the cylindrical surface (fig. 4.1). The two figures share a line, but do not intersect; they are tangential or, possibly, asymptotic. And yet both sides appear affected by this momentary coincidence. The trunk has bent at the point where the fingers have touched it. The crooked shaft is the plant's automatic response to the hand's probing. Both hand and tree appear to *flourish* with such reflexes. The sharply bent elbow speaks of a contact that might have just taken place and that produced a sparkle; but as the fingers' curved phalanges disclose, the tension has now alleviated. The hand still leans on the tree, tempted to repeat the offer. Yet, it remains inactive—paralyzed by the prohibition that has now grown roots inside it.

The erect palm could be an illustration of Worringer's "resistance to the external world," a refusal of empathy with an environment that appears hostile, and yet is magnetically captivating. All relations between animate and inanimate bodies are regulated by the laws of attraction and repulsion that control the behavior of inorganic matter. There can be no full unions between such objects other than their peripheral marriage of contours. Unlike Hirt's miner-

Figure 4.1 Fernand Léger, detail of *Nudes in the Forest* (1910-11). Kröller-Müller Museum, Otterlo, Netherlands.

als, which established analogies with the outer world, here, each crystalline body is limited to itself, defending what Riegl would have called its "closed material individuality" against the solicitations of neighboring objects.

Turning our gaze from that isolated detail to the picture as a whole, we discover a similar inorganic conduct (see plate 5). Three figures turning away from one another, refusing to communicate or even look at each other; while from a distance they seem to merge into the landscape, the three actors remain essentially secluded inside their radiant exteriors. Their surfaces act as "electrical insulators"—the permanently erected yet invisible walls of taboo objects. While being embedded in the picture, their bodies inhabit a negative, impossible space. Following Freud, such spatial prohibitions are perhaps the outcome of a common origin between the three figures—a secret ancestry that they share with all objects of this landscape, which, while brimming with the vegetal affluence of a forest, bears the fragmentariness of a crystal mine.

The model and the monument

Let us now, with a Foucaultian pirouette, attempt to name the painting on which all objects of this landscape are immured. The large picture painted by

Fernand Léger between 1909 and 1910 and now hanging at the Kröller-Müller Museum in Otterlo is generally known today by the title *Nudes in the Forest* (*Nus dans la forêt*). In its first reviews, critics refer to the same painting as *Nudes in a Landscape* (*Nus dans un paysage*). Nonetheless, the image appears to have also had a third title that precedes all others. In a rather impatient letter to his agent, Léonce Rosenberg, dating from 1919, Léger, who at that point had problems with selling any of his recent works, would fiercely defend the merits of one of his earliest paintings:

> You are probably unaware of my painting (1910) "Nude model in a landscape" [*Modèle nu dans un paysage*]—title once attributed to "Nudes in the forest"—there you would have been able to see that, with no pretensions, I was the one who went the furthest in the constructive reaction against the aim of impressionism. They are nothing but forms linked together by a will to move [*dans une volonté de mouvement*] and stripped of all sensualism: no one pushed the spirit of reaction further, as you will be able to see for yourself when a general exhibition takes place (as I hope it will). For two years, I was manipulating the forms I was building; I was the toughest and most conscientious mason one could ever ask for. Bit by bit, I resurfaced, step by step; color slowly reappeared, nuanced, timid, and coded like that of Cezanne, whose influence I was under.[1]

There are plenty of things one could say—"with no pretensions"—about Léger's self-promotion, yet for now let us focus on an apparent oversight. Although on many occasions art historians have quoted parts of the same letter, no one—not even Léger himself—seems to have been troubled by the fact that in the original title mentioned by the painter, *Nude Model in a Landscape*, the plural of "nudes" (*nus*) is reduced into a singular "nude" (*nu*). In the original catalog from the exhibition in which the painting was first exhibited in 1911, the work is simply titled *Nude in a Landscape* (*Nu dans un paysage*): the "model" might be missing, but the singular (mode) is still there.[2] Whether these two *singular* titles were given by the painter or "attributed" (as Léger writes) by others, the fact remains that in its first outing, the painting featured only *one* nude inside a landscape—yet one that was a *model*. Either one nude model in three different poses or three different nudes as variations of a single model: in both cases the image points to one paradigmatic origin.

But what if we consider that model not only in iconographic terms, but also as a methodological pattern? What if we take not only the three nudes but Léger's entire painting as model?[3] One of the defining properties of a

model is its capacity to perform as a testing ground for a variety of experimental hypotheses. In terms of its applications, a model is intrinsically plural. In accordance with Léger's own tripartite model, we could perhaps choose three scientific faculties to test the performance of his painting: *historiography*, *ethnography*, and *crystallography*—three *graphs* that delineate the limits of the objects traced within the painter's landscape. Partly following and partly contradicting the epistemological divisions imposed by Hulme in his *Speculations*, Léger pairs in a single frame the "human" and the "inorganic" sciences—from anthropology to mineralogy, and from social history and politics to geometry and energy physics—using crystal patterns to create a number of analogies.

What then triggers the animation of this painting is primarily not the chronodiagrammatic simultaneity of the human model in motion à la Marey, Muybridge, and later Duchamp, nor the kinematic properties of the painter's cylindrical forms, but the simultaneous progression of a prismatic array of scientific discourses. This is what "links" these forms "together by a will to move," as Léger claimed in his letter, and crystallizes the figures' multifaceted yet (unlike Duchamp) never jumbled outlines.

· · ·

Few people seem to have understood the encyclopedic scope of Léger's work and its ostensible relation to science. One of them was his colleague Jean Metzinger, who in an article of 1911 wrote: "Fernand Léger takes the measure of the day and the night, weighs masses, calculates stresses. His composition *Les Nus dans un paysage* is a living body [*corps vivant*]whose organs are figures and trees. An austere painter, Fernand Léger is passionately drawn towards that profound side of painting that approaches the biological sciences, and which was foreshadowed by the likes of Michelangelo and Leonardo. And is it not there after all that we can find the materials with which we would like to build the monument of our own times?"[4]

Metzinger makes a monumental claim. The artist implicitly argues that Léger's project is not only informed by the sciences but also attempts to establish its own science. Every form portrays an actual object and a scientific diagram—a "living body" and the mechanical trace of its performance. Neither Metzinger nor Léger appear to make any distinction between "biology" and physics, the study of organic and inorganic entities in nature: all are "organs" of one body breathing *from* the painting. Inadvertently, then, Metzinger uncovers not only the vitalism of Léger's project or the "unanimism" of his clouds, but also the underlying *monism* of his landscape.[5]

But first, why build a monument for something that has just started? And then why build such a memorial from the "materials" of the "biological sciences"—materials that by definition are transient and associated with decay? It is as if Metzinger is asking less for an inaugural than for a commemorative tribute pointing to the end of the modern effort. It is then appropriate to use the materials of such monist "biology," a science that could fuse the transformations of life with the constancy of the inorganic state, to build the foundation for a modern monument. Léger is perhaps only the first in a series of twentieth-century Leonardos who would pile up biological and mineralogical fragments to erect premature memorials to their own times.

Can one combine the notions of the model and the monument to offer a critique of Léger's painting? In sympathy with the young painter, one could imitate his strategy of mixing pêle-mêle art, history, and the sciences in the making of his model. Like the nihilistically ambitious novice, the historian, too, could attempt to show everything with a single gesture, to bare *all* like the unclothed model, and then pretend he does not care in what manner that "all" emerges from his mind or his unconscious. In the end, one can always hammer a nail (which exists in Léger's painting) so that the whole rubble hangs up nicely on the wall—together with one's own pieces.[6] This "all-in-one" attitude explains why the model must remain singular and never be repeated.

Bathers in the forest

"In quite a few tribes," Durkheim writes, "the word for initiation means 'that which is of the forest.'"[7] Considering the multitude of forests that appeared in the art scene of the beginning of the previous century, the wood represents a similar "initiation" experience for a number of painters from the emerging avant-gardes.

After the great Cézanne retrospective of 1907, where two of the three large *Bathers* were exhibited for the first time, French salons were populated by pictures of nude figures inside forests or lakeshores. Between 1907 and 1908, in one of his apparent afterthoughts on the completed *Demoiselles d'Avignon*, Picasso did a painting later known as *Nus dans la forêt*, housed today at the Musée Picasso (fig. 4.2). The painting depicts three women interlocked with one another other and with a tree branch. In 1908, Picasso painted his *Dryad*, also known as *Nu dans la forêt*, which shows a single female figure surrounded by trees (in an earlier drawing the same figure is sitting on a throne).[8]

Finally, during the same years Picasso was working on two series of studies, one entitled *Bathers in the Wood* (1907–8) and the other *Bathers* (or

Figure 4.2 Pablo Picasso, *Nudes in the Forest* (also known as *Three Women under a Tree*), oil on canvas, (1907–8). Musée Picasso, Paris.

Nudes) in a Landscape (1908–9) (fig. 4.3).[9] Though he never converted any of the two series into a large painting, Picasso seems to have used a part of his drawing for the *Bathers in the Wood* for his grand composition *Three Women* of 1908–9, eliminating some of the figures as well as the scenery of the forest.

One might be tempted to read in these series of drawings by Picasso part of the undocumented prehistory of Léger's 1910 *Nudes in the Forest* (since no preparatory drawings for the painting appear to have survived). There are a number of syntactical correspondences in the positioning and postures of the figures (both standing and reclining). These "nudes" or "bathers" change abruptly in number from singular to plural and reposition themselves from within "*a* landscape" to "*the* forest" (from an indefinite pronoun to the definitive article) as variations of an original "model" that tends to efface itself from the title. Léger's three figure variations and Picasso's *Three Women* point to the triadic nature of beauty as described by Hubert Damisch following the studies of Greek mythology by Georges Dumezil.[10] But if classical iconographic mod-

Figure 4.3 Left, Pablo Picasso, *Study for Bathers in the Wood*, charcoal on paper (1908); *right*, Pablo Picasso, *Bathers in a Landscape* (1909), India ink on paper. Musée Picasso, Paris.

els—from Botticelli's Three Graces in the *Primavera* to Raphael's *Judgment of Paris*—pronounce the interlocking intimacy between the three figures, Léger anticlassical landscape brings forward the inorganic conditions that keep these characters apart. Their familial kinship articulates not a unitary principle but the very laws of *avoidance* to which all bodies must adhere.

Perhaps this is also the main distinction between Picasso and Léger. While Picasso makes his bodies mingle amorously with one another in groups of two or more figures, Léger's nudes appear entirely isolated. In Picasso, one may sense the self-dissolving union with the objects of nature according to the precepts of the empathetic model presented by Flaubert.[11] In Léger the identification with nature has long been forgotten, and now is the moment of uncanny repulsion. In Léger all types of marriages are forbidden by the rules of a strangely impervious exogamy, while in Picasso all figures marry freely among themselves and with the trees. Moreover the wood in Léger's painting did not disappear, as it did in Picasso's, where it was replaced by the walls of the atelier. On the contrary, in Léger the forest survived and stated its presence in the title of the painting, for years to come.

A heap of pneumatics

Durkheim's description of the forest as a place of "initiation" was particularly true for Léger, who, at that point, as he attested in his letter to Rosenberg, was trying to break away from postimpressionism. As Léger repeatedly claimed, he was working on his first big canvas for two whole years, 1909 to 1910, under dramatic personal conditions. The painting was finally exhibited in the

twenty-seventh Salon des Indépendants in the spring of 1911. It was hung together with two other drawings by Léger in the legendary salle 41, known as "the cubist room," among a number of now well-known works by other painters, such as Delaunay's *Tour Eiffel*, Le Fauconnier's *Abondance*, Gleizes's *Femme aux phlox*, Marie Laurencin's *Les jeunes filles*, and paintings by Metzinger, Vlaminck, and others.

A number of these paintings inadvertently served as a prelude—or perhaps an *afterlude*—to Henri Rousseau, who had died in the fall of the previous year and whose work was exhibited in room 42. In his preliminary review of the salon on April 20, Apollinaire celebrated the work of the late master, but also remarked that all the "energy" and "effort towards novelty" of that year resided in rooms 41 and 43 (the room of the young Fauves).[12] I would like, however, to focus on a comment that Apollinaire made on April 21, the day that the exhibition opened. After struggling to find a few sympathetic things to write about the works of all other painters, the critic chose to conclude his remarks on room 41 with a rather exasperated reference to the work of Léger: "M.Firmin [*sic*] Léger has again the least human tone in this room. His art is difficult. He creates, if one may say, cylindrical painting, and he has not avoided giving his composition the savage appearance of a heap of pneumatics [*pneumatiques entassés*]. But never mind! The discipline he has imposed on himself will soon bring order to his ideas, and one can already perceive the originality of his talent and his palette."[13] Let us disregard the final niceties and concentrate on the *core* of the matter, which is rather crude. I refer to Apollinaire's comparison between Léger's "cylindrical" compositions and a "heap" or "pile of pneumatics." Here, the word "pneumatic" might have little to do with the ethereal *pneuma* envisioned by the ancient writer inside the bodies of serpents. As mentioned earlier, aside from telecommunication devices, the contemporary French meaning of the word *pneu* or *pneumatique* primarily referred to the rubber containers of compressed air, most prominently bicycle and motorcar tires.

Apparently Apollinaire's presurrealist comment was entirely au courant. What he recognized in Léger's landscape was a common sight of everyday life. In 1911, not only the entire French countryside but a significant part of the earthly landscape was increasingly covered by a "heap of pneumatics." After the end of the depression of 1882, economic paralysis in France was succeeded by an animated frenzy of production that lasted until the Great War. Among the factors that contributed to such reanimation were the technological furnishing and exploitation of the colonies and especially the market of gold, crystals, and rubber, as well as the armament trade supplying material for

the colonial wars in Africa. A third factor was the growing production of vehicles, velocipedes, automobiles, and their pneumatic attire, which depended on the raw material imported from the colonies.

In 1911, the word *pneu* in France was indispensably connected with one name: Michelin, the leading company of pneumatic products during that period, not only in France but also around the world. Starting from their rubber processing plants in Clermont Ferrand in Auvergne in 1889, the brothers André and Edouard Michelin (both of whom had studied art in the École des Beaux-Arts) managed to turn their family business into a colossal international enterprise.[14] Within less than two decades, the company launched products, factories, and marketing stations in England, Italy, Germany, and North America. Brazil, Africa, and Japan were to follow.[15] The advertising campaign that bolstered that success was unprecedented.[16] One of the company's most effective strategies was the series of the Michelin maps and travel guides, both regional and international, which encouraged prospective bourgeois motorists to drive in and out of the country and enjoy the pleasures of nature, leisure, and speed.[17]

This new relationship to nature is portrayed in the publicity images of championship races (*coupes*) that established the professional reputation of Michelin tires. Most of these images are based on a fixed iconographic pattern: in the background, a quasi-agricultural landscape with trees and a few farmhouses, and in the foreground, the competitive vehicle driving on a dirt road and accented by a cloud of fumes (fig. 4.4).[18] Successors to the Roman

Figure 4.4 Michelin Coupe Florio Brescia advertising poster (1907).

legionaries, French motorists now invade the European forest. The advertising image proposes a novel way of experiencing nature: that of *cutting through* it.

But the most popular component of Michelin's campaign was its official fetish, the "Bibendum," a humanoid bon homme made of rubber car tires bursting with air, and whose name also became the most audible slogan of the firm.[19] The affichiste O'Gallop pasted the anthropomorphic figure upon a German beer poster, adding the Latin inscription *Nunc est Bibendum* ("and now let us drink") and the subtitle "the Michelin tire drinks every obstacle." (fig. 4.5)[20] From that moment on, "Bibendum," the invitation to drink, became a proper name characterizing not only the Michelin firm, but a whole era of French culture that liked to think it could "drink up" every obstacle by enhancing the exterior layers of its skin.

Michelin's buoyant production expanded beyond the circle of industrial activity. Significantly, the Bibendum would appear dancing the waltz in a ball-

Figure 4.5 "Nunc est Bibendum! Le pneu Michelin boit l'obstacle!" Michelin advertising poster (1898).

room in Paris, conducting an orchestra in London, descending into an arena in Spain, participating in a rodeo in America and opening the carnival in Nice. This paradoxical combination of sports and races with smoking and drinking in addition to a light variety of cultural activities would remain Bibendum's distinctly French cocktail of favorite pursuits. From time to time, as Michelin introduced a new product, the pneumatic figure would change shape. In a poster of 1905, the bespectacled bon viveur transformed into a combative kickboxer, and as war approached, he slimmed down even more to become an American strongman training with resistance weights (fig. 4.6).

In one of the posters for the Exerciseur model circulating between 1911 and 1914, the Bibendum trains while sitting on an anthropomorphized group of nails, which finally give up, crooked and exhausted. Either enforcing the Bibendum's foot or menacing its posterior, nails are everywhere in these posters. The mineral spindle acts as a marker of resilience, but also signifies

Figure 4.6 Michelin advertising posters: *left*, Semelle tires (1905); *right*, "Le pneu Michelin peut s'assesoir sur ses ennemis." Exerciseur Michelin advertising campaign (1909–14).

the threat of imminent deflation. Apart from their lightness, endurance, and smoothness in driving, the main advantage that made Michelin pneumatics pioneering was the short amount of time in which, if they failed, they could be dismounted, patched, and remounted for further use. The promise of a "quick fix" could counteract the prospect of transforming into an indiscriminate "pile," such as the one Apollinaire envisioned in Léger's painting. The poet's phrase *pneumatiques entassés* also corresponds to the endless field of deflated car tires depicted in the photograph of 1910 (juxtaposed earlier with a pile of snakes; see fig. 2.13) used by Moholy-Nagy in his *von material bis architektur* as a representation of *faktur* or "surface aspect."[21] Léger's mineral landscape presents another instance of such modern "massing" produced by the ossification of formerly buoyant objects.

Apollinaire's unorthodox statement penetrates, then, both the surface and the *core* of Léger's painting. In all their cylindrical rigidity, the figures of *Nudes in the Forest* are pneumatic in their very conduct. Like the Bibendum, Léger's inorganic humanoids are also pumped up with air and occasionally enforced with metallic prostheses to repel "every obstacle." Whenever in danger, they increase their pneumatic volume to intimidate their opponents. Like the industrious bon viveur, the painter's nude characters work hard, but with the same efficacy, ardor, and resilience they also drink, dance, and revel; in critical moments when they come apart they can always get quickly fixed and go on working and carousing. They are massive, but light; infinitely expandable, but also compressed and limited, floating like spirits with convulsing gestures before finally extinguishing into air.

Camouflage

As a postscript to the history of Michelin, during the First World War, its factories not only remained open, but with the help of female volunteers they participated in the war effort at full speed. They supplied everything from rubber gloves, coats, and sleeping bags to artillery, bombs, cars, and airplanes.[22] At its premises in Clermont-Ferrand, Michelin also established a hospital for those wounded in battle, where the convalescents would use the company's pneumatic equipment, including rubber bands, for exercising their atrophied limbs. In a photograph of the hospital refectory, the recovering patients are having their meal under the Michelin Exerciseur posters (fig. 4.7).[23] Like the therapeutic serpents of archaic Greece and the healing snakes of Pueblo animistic rituals, modern day pneumatics were believed to have restorative properties.

Figure 4.7 Michelin hospital and rehabilitation center with posters of Bibendum in the background, c. 1914–17. Clermont-Ferrand, France. (Photographer unknown.)

However, this was not the first war in which either the rubber industry or Léger's painting were implicated. While in its formal and thematic approach *Nudes in the Forest* appears almost as a singular experiment, there is a set of later images that bear a host of correspondences with that early painting. I refer to a group of drawings from 1915–16 that Léger made as a soldier in combat during the Great War, which portray either military equipment, such as canons on wheels, or artillery corps inside the forests of Argonne and during the forest battle near Verdun (fig. 4.8).[24] Such sketches offer a familiar sight: a heap of cylindrical forms, some of them vertical, denoting trees, and some lying scattered on the ground, resembling disassembled human bodies or fallen tree trunks mixed with machine guns and other pieces of artillery. In his letters from the front Léger conveys with photographic accuracy the images of "human debris," such as "mummified heads" and "extraordinary hands" with "fingers bitten through by the teeth,"[25] but the painter would state that what "formed" him was "the cylindrical head of a canon" as the sun fell on it—"the crudity of the object in itself" (*la crudité de l'objet en lui-même*).[26] Bataille speaks of the "artificial" process of "crystallization" that alters army recruits during their "painful transformation in the barracks."[27] But how could these "painful" crystallizations apply to the processes of painting? In one of his

Figure 4.8 Fernand Léger, *Dessins de guerre* (drawings from WWI): *left, La cuisine roulante; right, Le sapeur.* Argonne (fall 1915).

letters Léger compares the "pure abstraction" of cubism with the ordered handling of "quantities" in military organization.[28] Above all, the forest—*la maison forestière, l'abri, le grand cimetière*, as Léger would call the wood of Argonne in his letters—becomes the stage that "authorizes all pictorial fantasies."[29] And here, if we go back to the forest of Léger's earlier painting, we may discover something different.

In the right upper corner of the painting, there is a small oblique cylindrical form that initially looks like another slanting tree trunk emerging from behind a circular concentric shape. The cylinder, painted in metallic gray, is crowned by a cluster of radial forms that sprout out of its top like an explosion of branches (see plate 6). Upon closer inspection, the outermost of these triangular arrowheads has a fiery bronze color that appears nowhere else in the painting. We shall never decipher whether this assemblage of forms stands for a tree or an erupting "cannon on wheels." Not only the represented object but also the form itself practices a form of camouflage. Such a representational technique has ostensibly been used as a compositional strategy throughout the 1910 painting.[30] Watch, for example, the reclining figure in the foreground,

whose leg and foot appear to transform into the disassembled components of a multibarreled machine gun, while the vegetal bands sprouting next to the tree flow over like ammunition strips (see plate 5). In fact these cascading forms, while flowing *over* the thigh, also appear to dissect the same member; they allow us to imagine the figure's interior and prove that the artist's "tubes" are in fact *not* hollow. It is as if in this direct superimposition of vegetal and human forms (which is almost unique in the painting) Léger uses camouflage *in reverse* and in an attempt to project the core instead of covering the surface of objects.

In his late interviews, Léger would grumble that when his large tableau was first exhibited, critics would mockingly incite the audience to "search for the nudes inside the forest": *Cherchez les nus dans la forêt!*[31] While evidently shortsighted, the comment speaks for the laborious *research* that both the artist and the viewer have to undertake when confronted with the figures of this painting. When viewed from a distance all objects lose their strong individual outlines and transform into an indistinct "heap" of forms. Léger invents a *mass* camouflage: a form of mimicry based not on the resources of a single body, but on the solidarity between all bodies that wish to disappear. In fact Léger's pictorial mimicry is predicated less on the effect of camouflage, in which an animal body uses part of its milieu to cover itself, but rather on mimetic "disguise," through which the organism radically alters its color and appearance by organic means to assimilate itself inside the mineral or vegetal milieu. But, as Roger Caillois would ask, what drives such "psychasthenic" behavior? Is it the functional need for protection or the desire for luxurious play?[32] And does the inorganic cover of such animated disguise reveal a vital necessity of life or a suicidal harkening for inertia? Léger's painting appears to disclose—and leave open—both of these possibilities.

Forest wars

But what if a similar sense of camouflage expanded to the very wars covered *by* the painting? How many combative operations can the painting's field host? In some often-quoted reminiscences Léger would polemically defend his early work by invoking his first large tableau: "With all my forces, I wanted to go to the antipodes of impressionism. I was taken by a veritable obsession; I wanted to 'dislocate' bodies [*"deboiter" les corps*]. They called me 'tubist,' right? This would not go down without exoneration. I spent two years in my personal battle with the volumes of *Nudes in the Forest*, which I completed in 1910. I wanted to push them as far as possible. It was nothing but a battle of volumes

[*qu'une bataille de volumes*]. I felt that I could not grasp the color, the volume was enough."[33]

A similar phraseology is used again in a discussion that Léger had during the last year of his life (1955) with Blaise Cendrars on the subject of landscape:

> B. C.: About the nudes in the forest, the nudes in the landscape . . .
>
> F. L.: Exhibited in 1911 . . . there was a history of violence, of construction in there, of anti-impressionism, and more, all the same, later, a return [*un retour*] . . . There is a game [*jeu*], whose outcome has not been decided in the first combat. The *Nudes in the Forest*, I can say this, I have been working on that for two years.[34]

These retroactively polemical statements implicitly suggest that *Nudes in the Forest* represents a "battle" that is not only of "volumes." Beyond the war against impressionism and coupled with the battle against les bonhommes he sneered at, in Léger's personal agenda there is also his animated competition with the emerging cubists—*Monsieur Picasso, Braque et companie*—for precedent in artistic innovation.[35] But as Léger states, no war is decided in the first battle (*coup*) or round of events. Rather, war is destined to return as an *après-coup*—the French term for the Freudian *Nachträglichkeit* or "deferred action." Perhaps what the painter witnessed in the forest of Argonne in 1915 was for him a case of déjà vu: his 1911 painting making a return to battle. This is one of the many ways we can grasp the painter's coy statement that *Nudes in the Forest* represents "all the same, a return" (*un retour*), which is part of a repetitive play (*jeu*).

This does not mean that *Nudes in the Forest* represents either a prophecy or a premonition of the First World War. Several years prior to 1909, when Léger started the battle with his own painting, there were a number of combats already taking place inside forests. And while these conflicts did not unfold on European grounds, they certainly involved the forces of the French and other European infantry. Enduring for decades, the most sensational of such conflicts took place in the colonies, particularly those in Africa. Following the 1884 Berlin conference's division of the African continent into zones of "protection," the immediate profiteering of the colonies' natural resources sparked frenzied disputes between European political powers and oppressed African natives.[36] A particularly infamous case, reported by Roger Casement in 1904, was the grisly exploitation of the natives in Congo by French and Belgian officials, which involved starvation, shootings, and gruesome bodily

mutilations of the indigenous people in order to increase the production of Indian rubber.[37]

Alternatively, in France the best documented of these events were the bloodstained insurrections in Madagascar—a culmination of centuries of civil and colonial conflicts among the natives and the imperialist forces of France and England.[38] With the growing industry of pneumatic and other rubber goods in turn-of-the-century Europe, one of the central economic concerns triggering this international conflict was Madagascar's importance as a source for Indian rubber, or *caoutchouc*.[39] But Madagascar was also the mythic "virgin island," unknown in the West until the 1500s, with an exceedingly polymorphic natural and mineral wealth including considerable sources of gold, silver, and various rare minerals and crystals.[40]

One year after the French invasion, or so-called expedition of 1895, Madagascar was finally officially annexed to France.[41] However, local rebellions by the native tribes were still erupting in several regions of the island, prompting the French government to send general Gallieni to establish order. Gallieni added to the goal of "pacification" the objectives of "colonization"—that is, to make Madagascar French (*franciser Madagascar*)—by means of "organization" (in the Saint-Simonian meaning of the term). In his illustrated memoirs published in 1908, Gallieni elaborately describes the immense effort of opening up roads, tunnels, canals, and even a railway line through the tropical forest—a "civilizing process" that was often interrupted by the combative resistance of natives.[42] The photographs documenting these infrastructural endeavors reveal none of these local obstacles; similar to the advertising posters of the Michelin races, they instead illustrate a railway construction progressing to infinity by "cutting through" the forest (fig. 4.9).

After nine years, Gallieni finally left the island in 1905, having allegedly completed the process of "pacification," although sporadic revolts would still occur from time to time. The forested area in the southeast part of the island was particularly susceptible to "guerrilla warfare" and in 1904 became the site of a violent uprising that took a year to subdue.[43] Perhaps the most legendary feature of Madagascar's topography is its great rainforest, the Alabe (*ala* meaning "forest" in the local dialect), which extends over two thousand miles and encircles the island with its overabundant vegetation and great waterfalls. Up until the French invasion of 1895 and before Gallieni's aggressive "organization," the Alabe was considered impenetrable by European explorers and was inhabited by the Tanala tribesmen, who, unlike the rest of the island's natives, escaped the influence of Christian missionaries and remained untouched by European civilization. An illustration of the forest in Galieni's memoirs shows

LE PONT DE LA MANTANA (KIL. 61 500) ET LA GARE DE LOHARIANDAVA.

HALTE EN FORÊT.

Figure 4.9 Construction of railway lines in Madagascar: *left*, "The bridge of Mantava (Km. 61,500) and the station of Lohariandava"; *right*, "Halt in the forest." Général Gallieni, *Neuf ans à Madagascar* (Paris: Hachette, 1908).

an idyllic scene in which the peaceful natives bathing in a river, as well as some of the trees on its shore, appear as if they have been pasted on top of the original landscape (fig. 4.10). Whether this is or is not a montage, the depiction of the colonial forest remains a *composite* representation.

While there are some traces of "battle" in both the individual features as well as the pictorial operations of *Nudes in the Forest*, there are hardly any clues that such activities might originate in a forest that is African. Even the assemblage of angular forms that crown all three figures, and which appear to simulate the headgear of African or American tribesmen, are "disguised" as mineral or vegetal forms—akin to forest bushes—echoing similar head covers worn by bush guerrillas, or *guet-apens*, as Léger would call his fellow fighters in Argonne.[44] Each object-form beckons with suggestions—including geographic ones—yet simultaneously appears to withdraw any final evidence. The forms' coyness speaks of the composite geographic *model* articulated by the painting's forest. But whether in Europe or in Africa and whether destructive or productive, there is always an *activity* happening inside the forest—some form of labor, akin to the arboreal processes of "dream-work," that keeps the painting's operations in motion.

The myth of the woodcutters

For in the dawn of history Europe was covered with immense primeval forests, in which the scattered clearings must have appeared like islets in

SAINTE-MARIE. UNE BAIGNADE INDIGÈNE. JE RETROUVE LÀ LES MÊMES ASPECTS QU'AUTREFOIS, LA MÊME PUISSANCE DE VÉGÉTATION TROPICALE.
(CL. DE M. REY.)

Figure 4.10 "Sainte-Marie. Indigenous bathers. There, I rediscover the same aspects as in times past, the same force of tropical vegetation. Photograph by M. Rey." Général Gallieni, *Neuf ans à Madagascar* (Paris: Hachette, 1908).

an ocean of green. Down to the first century before our era, the Hercynian forest stretched eastward from the Rhine for a distance at once vast and unknown; Germans whom Caesar questioned had traveled for two months through it without reaching the end. Four centuries later it was visited by the emperor Julian, and the solitude, the gloom, the silence of the forest appear to have made a deep impression on his sensitive nature. He declared that he knew nothing like it in the Roman Empire.[45]

Next to the ethnographic impressions of African and Amazonian forests, the collective imagination of turn-of-the-century Europe appears haunted by the memory of a primeval forest that once covered its mainland—recounted here by Frazer in his *Golden Bough*. Whatever memories Léger might have had from the woods of Normandy and Argonne or the painted forests of Cézanne and Uccello, it was in the "exotic" and "tropical landscapes" of Rousseau that the young painter would have glimpsed that primeval forest reconstructed by comparative ethnography and divided by colonial expansion.[46] Discussing whether *Nudes in the Forest* might have been "influenced" by Rousseau, Léger suggested that such connection "might be true . . . but it is an unconscious one" (*C'est peut-être vrai . . . mais c'est inconsient*).[47] At least the painter confesses that his "unconscious" was active while making this painting. One might argue that in fact it was working at full speed, producing images at the frenetic pace of a cinematographic machine. And so too were the imaginations of his critics.

One year after Léger's big painting was exhibited, and in his chapter on the young artist in *Les Peintres Cubistes*, Apollinaire made another short comment about the painter's early picture—without actually naming it: "The woodcutters [*les bûcherons*] were carrying on themselves the trace of the blows which their axe left on the trees, and the general color participated in the deep and greenish light descending from the foliage."[48] First, there is no foliage in Léger's forest. Most of his trees do not even have branches; the painter would perhaps never allow anything to overshadow the metallic brilliance of his cylinders. Yet, more importantly, Léger never mentioned that his figures were woodcutters, nor did he ever make any allusion to an iconographic scenario for his early tableau; for him it remained just "a battle of volumes." On the contrary, it is later art critics and historians, who, following Apollinaire's conjecture (and partly their own associations with Léger's 1950s *Constructeurs*), established a scenario of working labor as if *Nus dans la foret* was a "genre painting."[49] The woodcutting theme also prescribed the gender identity of the painting's figures: *Es stellte dar Männer, zwischen Bäumen*—"it represented men among trees"—recounts Kahnweiler, who once owned the painting in his collection.[50] Like the previous comment by Apollinaire, the description is set in the past tense, which suggests that Kahnweiler talks about his memory of the painting rather than his actual viewing of it. Most critics and even the artist himself tend to talk about *Nudes in the Forest* as a "memory-image"—a dreamlike composite "representation" that authorizes a host of prescient misrecognitions.

Because if we in fact look at the painting, there is no clear indication that the nudes are male—in fact all three figures appear to give entirely contradictory signs about their gender—or that they are woodcutters or any other type of workers.[51] It might be that the figure on the left, which is the one that apparently inspired Apollinaire's idea of woodcutting, is about to deliver a blow (fig. 4.11). But in a closer look, the tool necessary for such an action, the axe, which is the only active agent in Apollinaire's phrase, is not shown. If we assume that the right hand of the figure is grasping a tree branch and bending it in order to cut it, then it is the left hand that is supposed to hold the axe and deliver the blow, but the latter is half hidden behind the figure's voluminous headgear. Instead, we are left only with the right hand in the front, and it appears detached from the rest of the arm, as if twisted or thoroughly severed from the elbow.

Apollinaire was right about the idiopathic nature of the purported action: the alleged woodcutter appears to have cut his own hand. The empty grip is suspended in midair like a votive replica hanging by a thread from a

Figure 4.11 Fernand Léger, detail of *Nudes in the Forest.*

tree branch. Mark also that this is the only tree branch among dozens of bare trunks in this picture—an originary *stem* that one has to keep holding onto. Inadvertently Apollinaire's comment speaks of the intimate ties between the trees and the humans—a form of attachment forged by reciprocal *cutting*. Contemporary ethnography elaborates on this unique form of bonding.

From Frazer we learn that the ancestors of modern men had the custom of marrying themselves with trees. They would often embrace and kiss their trunks with love and respect and perform ceremonial dances around them.[52] At night the male members of a tribe would leave their houses to fertilize the trees with their seed, just as they did to impregnate their wives.[53] But far from being only a passive receptacle, the tree fetish had active demands from its devotees.[54] Whenever sowing their fields, archaic tribes would offer as a sacrifice human blood or the very hearts of the men belonging to the "sacred tree."[55] Sometimes the members of the tribe would chop off the head, arms, and legs of a stranger and hang them from the trees or scatter them in their

fields to ensure a good crop.[56] The sacrifice would take place at the roots of the tree, while its boughs served as a pulpit.[57]

If we look carefully at the left corner of Léger's painting we will see that the roots of the tree next to the alleged woodcutter are considerably lower. (See plate 5.) Whether deriving from a late compositional change or a premeditated perspectival treatment of the ground, the result is that the left figure seems to be kneeling or even *hanging* from the tree, like the willing victim of a ceremonial abasement. Moreover, the figure's two feet are bent, which means that he is not standing but kneeling on the ground as if prostrating himself.

The cutter's hands are raised as if trying to avoid his own blows. This could be an alternative application of Warburg's *Pathosformel*, in which the dying Orpheus raises his arm in order to protect himself from the deadly blows of the persecuting maenads (fig. 4.12). The difference is that Léger chooses to show this gesture not in profile, as in the antique example, but en face and syncopated. Léger conflates in one movement both the blow and the defensive reaction, as well as the figures of the tree, Orpheus, and the maenads. It is as

Figure 4.12 Albrecht Dürer, detail of *The Death of Orpheus* (1494). Pen drawing.

if Léger acknowledges that this gesture has already been performed too many times, yet always in vain. Facing death, the only thing that the body can do is to automatically petrify and either turn into a tree—like Daphne—or inanimate its existence beforehand in the essentially vocal sign of a gesture.[58]

· · ·

But what if we were to look again at the painting, this time with a "naked eye"? At first sight, Léger's effort to replicate the three postures—standing, laying, kneeling—of his model in three distinct figures and recombining them in a single frame appears similar in scope with contemporary chronodiagrammatic experiments. In fact, it is in Muybridge's photographs of the human body in motion that naked figures holding an axe *do* appear. The same subjects engage in a variety of work-related activities, such as lifting an axe, cutting wood, digging with a pickaxe, as well as squatting or resting on the ground.[59] Like Muybridge, Léger, too, is interested in bodily performance, yet less in the body's organic capacities than its inorganic or superorganic possibilities—not what bodies are but what they *could* or *will have been*.

Here, we may recall Léger's self-avowed "obsession" to "disjoint" (*deboîter*) the body while working on the canvas of *Nudes in the Forest*.[60] *Deboîter*: to disconnect, to uncouple a mechanical instrument such as a pipe, or to dislocate a human limb, as if "to pull one's shoulder out."[61] All of these interventions occur in graphic detail in Léger's canvas. The limbs are first cut off from the bone, and then the sliced body parts are reassembled. In the right hand of the reclining figure, the wrist between the lower arm and the palm of the hand is represented as unfolding in an angular cluster of intersecting partitions connected by hinges. Body parts can now partially rotate and simultaneously transition from curvature to flatness. The hands resemble instruments, such as pliers, pickaxes, or shovels. It then becomes obvious why, as opposed to Muybridge's photographs, in Léger's painting there is no axe or any other implement. The body parts themselves are the instruments or "organs," as Metzinger called them, embedded in the "living body" of the painting.

In Léger's painting *The Seamstress* (*La Couseuse*), exhibited one year earlier than *Nus dans la forêt* in the Salon des Indépendants in 1910, needle and thread are nowhere to be found, except in a tiny black stroke (fig. 4.13). The productive activity of sewing that gives the painting its title is transferred onto these extraordinary hands in the center of the picture, which look like metallic pliers or parts of a sewing machine. "Their hands resemble their utensils—their utensils resemble their hands," writes Léger in the caption of one of his late drawings of workers' hands.[62] Unlike Marx, who criticized the

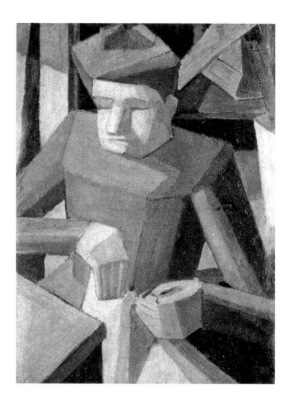

Figure 4.13 The Seamstress (La Couseuse) (1910).
Oil on canvas. Centre de création industrielle,
Centre Georges Pompidou (donation Louise and
Michel Leiris).

substitution of human hands and traditional "tools" by mechanical parts that mimicked their function,[63] Léger makes no distinction between hand and apparatus—the organic body and what Warburg described as the *Gerät*. In Léger the inorganic instrument appropriates the organic member: the entire body is taken over by its prosthetic parts (which is the morphological logic of the Bibendum).

Such transformations show that, unlike Muybridge, the object of Léger's own scientific experiment is not the instantaneous impact of movement, but the *(très) longue durée* of evolution—a process that combined morphological prosthesis with abstraction. Most of the hands and feet of Léger's nudes appear with only four phalanges or toes. Tylor describes that members of the tribe would offer parts of their own body, such as toes and fingers, to the sacred tree, and that such an act would in fact strengthen the mutilated subject. In principle, the benefits are the same as those described by the turn-of-the-century theorists of "regressive evolution": gaining strength while losing limbs, advancing by stepping backward. The conduct of "winning by losing" expands to the organism's relation to its surroundings, including its first habitat, the forest.

General morphology

In his posthumously published text *Le Jesuve*,[64] Georges Bataille describes the awkward but stubborn efforts of man's ancestors to stand upright during their departure from the forest. Léger's picture is an illustration of this double operation: on the one hand, his standing or collapsing protohumans might well be apprenticing performers who use tree trunks as models of their own erect posture, and on the other, they are woodcutters "slaying" these same trees in order to clear their way out of the forest. It is as if these egotistic infants, after managing to stand upright, strive to get rid of their orthopedic mechanisms— the hands of mother nature and the vegetative *trotte-bébé* of trees—by slicing everything into pieces, including their own bodies.

According to Bataille, the first side effect of the successful effort of ape-humans to stand upright was the shameful sight of the "obscene blossoming of their bald, haloed anuses, bursting like boils." The very origin of bipedalism and the emergence of *Homo erectus* was then marked by those "filthy protuberances, dazzlingly colored excremental sculls" blemishing the appearance of the new noble species.[65] Because any horizontal projection was antagonistic of the vertical posture during the course of evolution, the protruding anus "secluded itself deep within flesh, deep inside the buttocks and it now forms a projection only in squatting and excretion."[66]

Most of the self-inflicted incisions observed by Apollinaire are concentrated on the curvatures of Léger's nudes, especially the two pairs of buttocks that are visible in the painting: first in the squatting figure, in which both buttocks are given the familiar "watermelon" treatment, while the posterior of the third figure on the right appears to be carved out of a series of flattened-out surfaces. In his 1919 letter to Rosenberg, Léger emphasized his intention to "strip" his forms of "all sensualism." Buttocks are perhaps the very powerhouse of that hedonist progeny from Renoir back to "Rubens and company."[67] But remember Freud in his essay on Jensen's *Gradiva*, describing the repressed sexuality of geometric figurations: "On a cylinder, the diameter of whose surface is *m*, describe a cone . . . etc."[68] Perhaps in all their hideous ugliness, Léger's grotesque ape-humans still carry the essence of *ideal* beauty in their erect spines: the smell of phallic erection continues to permeate their bodies' nude cylinders. Like the rubber fetish of the Bibendum, Léger's nudes are inflated by a desire that is hermetically sealed inside their skins (as if they were rubber condoms, the industry of which was apparently *bursting* around the turn of the century), precluding the possibility of exterior release and procreation.[69]

Bataille would describe that following the obfuscation of the anus, all possibilities for "the liberation of energy" were then directed toward the head and found their way out through the orifices of the face, the voice, the eyes, the gaze, and transubstantiated into "tears, bursts of laughter or sobs."[70] But Léger's figures appear faceless or almost headless. In spite of their mechanical versatility, they have a very limited capacity for expression. Their performances have to be mediated through the inorganic realm: the mask, the hardened skin, the reflective landscape.

Right underneath Léger's reclining figure, there are a series of quasi-spherical forms with eye sockets reminiscent of Bataille's "excremental skulls" (see plate 5); such fossils speak not of a survival or recovery but of a permanent *displacement* of human expression. Fully erect and with their curvatures flattened, the human model(s) are now ready to move out of the wood. Perhaps the "men" that Kahnweiler remembered seeing "between trees" speak of this *past* anthropological perspective.

Capital treatments

But there are more misplaced heads, as well as traces of *pre-bipedalism* in Léger's landscape, and the reclining figure in the middle offers clues for both. Its head appears to be severed at the throat while the neck remains intact until the line of the scalp, including the left ear: the figure can perhaps *listen* but it cannot see (fig. 4.14). In a different reading it could also be that the mod-

Figure 4.14 Fernand Léger, detail of *Nudes in the Forest*.

el is intensely crouching, and in that case the head is not cut but drastically *abridged*. But ultimately it does not matter whether the figure does have a head or not because it does not *need* one. All bodily reactions in this organism are reflexive. As shown in the opening sequence between the tree and the hand, the body spasmodically reacts to any contact with the ionized environment. Therefore even if the head still exists, it is entirely redundant; the headdress rhetorically accents its purely ornamental nature.

Following the Cartesian dictum in which the head poses as the seat of authority, then all three of Léger's nudes are essentially headless. Their ornamented capitals have no control over the bodies they are crowning: they are more headgears—accessory extensions—than heads. On the contrary, it is the extremities, the arms and feet that pose as autonomous animated agents. From the macabre experiments performed on livestock in La Mettrie's *L'Homme Machine* to the electrophysiological testings performed by Galvani and other scientists on decapitated frogs (whose "gruesome convulsions" we witnessed earlier, as cited by Maudsley, Darwin, and Warburg), Western science knew for centuries that the nerves producing automatic responses in animal bodies are not attached either to the brain or anywhere else in the head but reside on the spine.[71] And this Léger's reclining nude certainly has: in fact the back of that figure appears hyperinflated. All possibilities of expression are gathered in this hunchback, whose bulging cover appears to be looking back at the spectator from the center of the painting. This gazing "blind spot" discloses the painting's fundamental *dorsality*—its inverted perspective toward an earlier anthropological state.

On the top of the headless neck there is a form resembling the bushlike cascading forms that crown the rest of the figures. Only this time the undulating form has a brick-red color that is significantly more red than anything else in the painting. It is as if the headless body is involuntarily *blushing*. It shows no head and yet it still holds strong to its headpiece. Ethnographic accounts offer a parallel description of such capital treatments.

In agreement with Western practices, the head in tribal cultures signifies the seat of social authority. It is tabooed and sensitive to injury and disrespect.[72] Everything set around the head has special significance. The headpiece constituted the very emblem of a clan, imitating with tufts of hair the forms of its sacred totem.[73] It was the sign of pride of every male and it was deeply shameful to have it shaved.[74] As in Western cultures, "it is the crown which makes the king": the ceremonial headpiece made out of feathers of exotic birds was an indispensable accessory of the formal attire of the priest, the magician, or the monarch of the clan.

Ceremonial headpieces extended to the fatal crowns of the sacrificial victims, whether they were ordinary members of the clan or the king himself.[75] Decapitation was the accustomed way of execution for the ruling monarch of the tribe, marking the definitive loss of his despotic power. The throat would first be slashed and then the head would be cut off and thrown to the exhilarated people. The one who caught it would become the new despot.[76]

Gestural anthropology

At this point enters the third model positioned opposite the reclining figure. The two nudes—one vertical, the other horizontal—are placed at a considerable distance from each other. While turning their backs toward one another, they appear to be in correspondence, as if the two bodies evolved symmetrically across a diagonal line. Such axis is the vector of an undisclosed kinship that bonds these two figures. This standing nude also lacks a face; it is as if the head has been taken over by an elongation of the spine. The same figure is crowned by a piece of headgear with long extensions, as if it were feathered

Figure 4.15 Fernand Léger, detail of *Nudes in the Forest*.

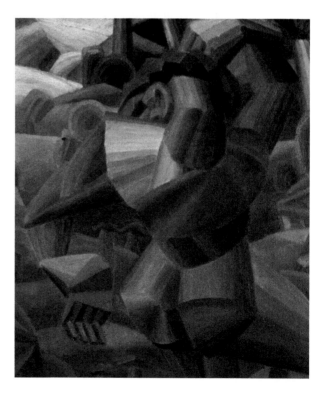

(fig. 4.15).[77] If the nude on the left does something resembling woodcutting, and the middle one is resting on the ground, this third figure lifts its right leg from the ground and waves its right arm, as if dancing.

The upright movement of the arm seems complimentary to that of the "woodcutter" on the left, even though this gesture is shown not en face but in profile. Moreover, here the arm waves freely in the air—a movement that appears, unlike the branch grasped by the woodcutter, to be aimed at no transitive object. This is perhaps the origin of one of Léger's signature gestures, which would be repeated in dozens of his later works and performed predominantly by dancing female figures (fig. 4.16).[78] Of course, similar gestures have been endlessly rehearsed from Tanagrea female statuettes to the female nudes of Rodin, Bougereau, and Picasso (as in *Demoiselles* and in *Three Women*). But in Léger there are a number of differences from all other models. Contrary to most precedents, in Léger's nude the hand is in front and not behind the head. The arm does not raise itself to enhance the prominence of the face as a beautifying gesture, but to undermine it as an ironic device. Even if it (r)evolves around a central axis, the gesture has a radically eccentric aim that leads the dancing figure into a self-obliterating ecstasy.

Figure 4.16 Left, Fernand Léger, *Étude pour "La Danse," trois femmes* (1919). Pencil on paper. Collection Claude Berri, Paris. *Right,* Fernand Léger, detail of *La Danse* (1929). Museum of Grenoble.

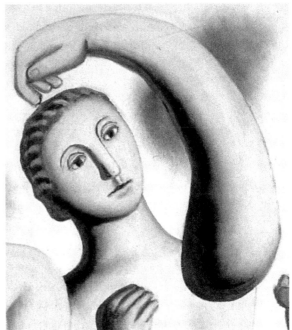

Léger's nude raises its harlequinesque thigh and whirls around the vector defined by its raised arm. By doing so, it unwraps all exterior layers of its flesh as if to unmask the kernel hiding inside it. Here the arm itself performs Léger's intent of "dislocating" (*deboîter*) the body by shattering its organic articulation and destabilizing its position in space. The formerly narcissistic gesture turns into an act of automutilation progressing from the extremities to the contested center of the head. In the contorting spasms of enthusiasm produced by the semi-acephalous figure, we are then witnessing another form of decapitation produced not by a single blow but by a revolving incision—a decapitation unfolding while *spinning* and with no instrument or axe.

There is a considerable distance between the right figure and the rest, as if it demarcates its own space within the landscape. From the sociological studies of Roger Caillois, we learn that the executioner in a tribe was considered sacred but untouchable: even his residence was far away from the rest of the houses inhabited by the tribe. Frequently he would be a person chosen from a neighboring village and would be entrusted with the mission to decapitate the king and everyone who was in close contact with the ruler.[79] But the story has one final *twist*. It is well known that in the end, the official executioner of the divine king had the duty to execute himself as well.[80] The victim's oblation presages the killer's own destiny. The executioner can only expiate his contagious sin with his own destruction. After all the dancing and rejoicing, the ecstatic subject would give itself the final blow.

This self-shattering behavior is echoed by all of the members of a tribe during a religious festival. Referring to the extreme "transports of enthusiasm" when people are coming together in such ceremonies, Durkheim compared them to "some sort of electricity" that brings all participants to an "extreme degree of exaltation." Passions burst out as "violent gestures, cries, downright howls and deafening noises of all kind." Then, inside the group, movements tend to be coordinated following the regular rhythms of song and dance while losing "none of their natural fury"—a rhythmic crystallization of collective forms of expression, similar to the dynamic patterns observed by Warburg in his description of Pueblo dancing rituals.

However, such expressions of festive rejoicing mirror similar performances in periods of intense mourning. The mourner "submits himself to all sorts of unnatural exercises: He fasts, he mortifies himself inflicting several mutilations upon himself." The same persons could be seen lying extended on the ground motionless for hours and then dance in an extreme state of excitation verging on delirium.[81] We may be able to glimpse a similar violent rite performed in the scene of *Nudes in the Forest*, but we are unable to distinguish

between mourning and rejoicing. In their creative frenzy, Léger's primeval *deconstructeurs* start chopping parts of their own organic branches: their heraldic dances end in an orgy of self-mutilation.

The final conclusion of Frazer's multivolume opus of the *Golden Bough* was that in primitive societies the sacrificial execution of the divine king was the duplication of the ceremonial killing of the tree spirit, that is, "a rite of renewal of power in the face of an inevitable decay." One had to slay the head of nature to regenerate growth.[82] Human and vegetal bodies were interchangeable as the containers of a collective animistic substance, therefore they had to periodically be renewed. Léger's picture could serve as an illustration of that indispensable ambiguity of sacrificial practice, oscillating between destruction and creation, demolition and erection, without allowing us to decipher which phase we are witnessing or in what way the two phases are different.

According to Durkheim, ceremonial procedures, although they might attempt to satisfy opposite objectives, have the ability to substitute for one another. This constitutes the "plasticity" of rites, "the extreme generality of their useful influence."[83] Such plasticity guarantees the continuation of those rituals from prehistory to the modern world—a survival visually exemplified by the persistence of archaic gestures, which for Vignoli signified the resolution of mythical language into "vivified physical forms."[84] It is then this *gestural* form of anthropological practice that animates the landscape of *Nudes in the Forest* and vivifies the history of its fossilized forms.

Pagan allegories

In 1907, Aby Warburg published a small paper on two newly exhibited sixteenth-century Flemish tapestries in the Musée des Arts Decoratifs in Paris. The tapestries depicted peasants at work inside a forest, cutting and collecting wood (fig. 4.17). As usual, Warburg's text had an unorthodox conclusion. The art historian suggested that these "workers" were essentially the "Northern buffoons"—the "licensed fools" or "court jesters of late medieval civilization." Such comic figures were later replaced by the naked ancient satyrs of the Italian Renaissance until they were again restored in the North by Bruegel.[85] In his addenda, Warburg went a step further toward a more pathological reading of these images: "So: the tapestry, in its role and significance as a conveyance for imagery, clearly emerges as a vast Ship of Fools [*Narrenschiff*]."[86] The last term refers to the *Stultifera Navis*—the late medieval "ship of fools" we saw earlier in relation to the turn-of-the-century victims of "demonic" animation.

Figure 4.17 Peasants Working.
Fifteenth-century Flemish
tapestries. Musèe des Arts
Decoratifs, Paris from Aby
Warburg, *Arbeitende Bauern
auf burgundischen Teppichen*
(Leipzig: E. A. Seemann,
1906).

What is striking in Warburg's interpretation and its associational extensions is that a simple scene of labor and jolly merrymaking suddenly transformed into the Northern version of a pagan festivity or Dionysian madness camouflaged under the rubric of work. Perhaps this is another aspect of what Durkheim describes as the "plasticity of ritual": the point when an extraordinary event such as the festival is reduced to a daily routine.

Warburg's interpretation of the Flemish tapestries helps us explain the creative misunderstanding behind both of Apollinaire's comments about Léger's figures: like the pneumatic jesters of Michelin, Léger's nudes are also *acting* as if they are woodcutting or performing some other type of work, but essentially they could be naked satyrs or buffoons. Perhaps not only Léger's 1950s *Constructeurs*, but also the clowns, acrobats, and ballerinas of his 1948 *Grand Parade* have their origin in the archaic company of 1911.

. . .

Finally, the affinity of Michelin's Bibendum with Léger's figures is not primarily in its material or form but rather in the representational capacity of its name. According to the anthropologist Max Müller (as quoted by Durkheim), the first words invented by mankind describe activities, such as "striking, pushing, rubbing, lying down, getting up, pressing, mounting, descending, walking, etc.," which means that "man generalized and named his principal modes of action before generalizing and naming the phenomena of nature."[87] Bibendum takes its name from the infinitive form of a verb signifying an action—drinking—or the invitation to perform that act: "Let us drink!" Perhaps the captions we read over the headgear of the figures of *Nudes in the Forest* also designate certain generalizations of action; however, they do not simply read as "working," "fighting," "dancing," "cutting," "resting," "killing," and "rejoicing," but as elegantly persuasive *incitations* to perform all of the above.

Elementary forms

It makes, then, little sense in speculating on the identity—gender, ethnicity, race, and occupation—of Léger's nudes. His figures are the pictorial representatives of a general *model* invented by late nineteenth-century comparative anthropology. E. B. Tylor would interchangeably observe the same customs of "savages" in the African Malagasy, the Mezoamerican Aztec, or the Australian aboriginal—location and period make little difference. For Frazer, human sacrifices performed under the auspices of the "mistletoe" were as common for the Aztecs and the Zulus as they were for the Dorians and the Druids.[88]

But perhaps Léger, while painting his *Nudes* in 1909–11, was actually up to date with contemporary developments in ethnographic and anthropological research. In the pioneering works of early structural anthropologists, such as Levy-Bruhl and Durkheim, the broad comparative method of the early British school was rejected, and the area of research was limited to a specific example of a native group manifesting the elemental properties of thought and social behavior.[89] However, this single origin was shown to be the *kernel* or "elementary form" of subsequent patterns of human mentality. Léger's nude *model* is, then, a representation of such primary anthropological form; his figures aim to function as the structural "kernels" of contemporary patterns of behavior—organic and inorganic, human and pictorial. In all its formal complexity and convoluted composition, there is something deeply *elementary* in this modern forest.

Looking at the painting in this frame, Léger's nudes could indeed appear simultaneously as Aztecs, American Indians, and aboriginal Australians. But they could also represent some old European race, such as Worringer's Northerners. But whatever might be the material, color, and historical costume of these characters, their *texture* is that of turn-of-the-century avant-gardists: an outlandish clan of warrior artists and aggressive technocrats who would in a short time expand their metallic settlements from France to Germany, England, North America, and a little later Bolshevik Russia. Léger, the brutal "builder" of French avant-garde, would foreground such an invasion. And here they are: marching nude inside the forest. After twelve centuries, Léger's Northern ancestors are coming down again to the European mainland, destroying everything that stands in their way.[90] Reinvigorated by a new sense of "order," these modern "barbarians" are driving through the wood in their motorcars.[91] We all have been waiting for them for so long. But in the end, their clangorous arrival also created a form of disappointment: "Now that the barbarians are here, taking charge of the market and legislating new laws, what are we going to do without expecting them?"[92]

Arcadian I

There is smoke rising over Léger's forest. In the background the forest of Argonne is in flames too, and in the foreground Picasso's dryad, the high priestess of the forest, ascends back on her throne to give the sacrificial orders. The wood howls from the spirits of unrepentant ancestors, who once streamed through the main street called "Arcadian," endlessly crying out the name of their beloved goddess of the forest: "*Great is Diana of the Ephesians! Great is*

Diana of the Ephesians!"[93] And all of us modern neopagans, in awe, whisper: "*Great, great, indeed!*"

Landscape regeneration

Were this analysis to end here, it would neglect the painting's other half— that is, the landscape adorned with a variety of objects to which the human figures are attached. The three nudes are sympathetically connected with the luminous forms of their milieu, as if their own legacy were determined by the objects that surround them. Frazer's analysis of the sacrificial "killing of the divine king" discloses the essential relation between the human representatives of power and the objects of nature. The energy charging the king's body was transferred "like electricity" to all the things that he touched. If the despot showed the slightest signs of deterioration, a great catastrophe could destroy the entire land.[94] Consequently his head had to be cut off before it grew weak, to facilitate growth and regeneration.

While related to animism, Frazer's model is mostly empathetic. Following the laws of "sympathetic magic," the mental and physical state of the sovereign subject is reproduced by the objects of his dominion.[95] But in Léger, we witness a different animated state. The same mineral forms seem to stand for both subjects and objects. Any interaction between these "volumes" causes a series of reciprocal effects; yet it is impossible to decipher who or what initiates such energy and movement. There is a *static* form of animation running through the ionized forest. It is as an invisible form of vibration that keeps all bodies in a perpetual state of excitation. Ultimately there may be no *actual* growth or regeneration in such a landscape, but like the invitation issued by Bibendum, there is a perpetual incitation to engage in consumptive and reproductive activities.

Léger's was not the only painting of the 1911 "cubist room" that dealt with the regeneration of natural resources: There was, most notably, Le Fauconnier's *L'Abondance*, which depicts a gesticulating female nude accompanied by a male child carrying fruit, reminiscent of the Renaissance Pomona.[96] Picasso had already worked on a similar theme in a painting titled *The Harvesters* of 1907, which shows a male figure making an identical gesture (fig. 4.18). Both Fauconnier's and Picasso's figures raise their arms as if directing the (re)productive forces of the universe.[97] Immediately after the spring 1911 salon, Léger was also working on the theme of *Abondance*, which was the title of two études from 1911–12 showing a female nude stuffing herself with fruit (fig. 4.19).[98] *Nudes in the Forest* also represents the perpetual circulation of

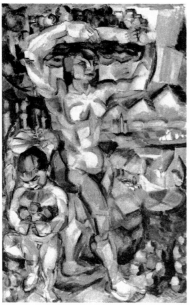

Figure 4.18 *Left*, Henri Le Fauconnier, *L'Abondance* (1910–11). Oil on canvas. Gemeentemuseum, La Haye. *Right*, Pablo Picasso, *The Harversters* (1907). Oil on canvas. Carmen Thyssen-Bornemisza Collection on deposit at Museo Thyssen-Bornemisza.

Figure 4.19 Fernand Léger, *L'Abondance* (1911–12). Pen and ink on paper. Private collection, France.

natural material through digestion, incorporation, and reproduction techniques. There is, however, a departure from all previous precedents: while former examples portray an "organic" form of regeneration, Léger's painting makes an obvious detour through the inorganic realm.

Fossils, ornaments, and crystals

On the lower right edge of *Nudes in the Forest*, next to the right foot of the rotating figure, there is a miniature form that resembles an inverted leaf; it is in fact the fossil or petroglyph of a leaf (fig. 4.20). Significantly, the only trace of what Apollinaire described as the painting's "foliage" is a mineral form. The fossil is the marker of an evolution that leaves a negative imprint on the landscape. It represents another model that all other forms could follow, as if mineralization was the ultimate goal of the forest's vegetal and animal content.

Notice, for example, the green semicircular forms scattered throughout the forest. Made of progressively darker colored zones, they resemble less vegetal organisms than architectural ornaments (vaguely reminiscent of the "closed lotus bud" motifs of Egyptian columns). Léger's ornaments retain their "freestanding" character as decorations that are essential to the texture

Figure 4.20 Fernand Léger, detail of *Nudes in the Forest*.

and the structure of the painting. In Riegl's terms, they are *"filler* elements" that inundate the core. While remaining closed, their budding patterns serve as growth ideograms broadcasting their formal impact on the landscape.

The painting's mineralogical forms also act as virtual *portals* to the geological content of the landscape. In fact, the most animate element in Léger's painting is the one that is essentially unseen: the ground—or the underground—whose several layers are constantly fluctuating. Almost entirely covered by truncated forms, yet endlessly shifting in level as if in motion, the ground best exemplifies the "living body" that Metzinger envisioned in Léger's canvas.

There is something between the solid and the liquid in Léger's landscape, a fluctuation between mineral layers and fluid sources. Such amalgamations are reminiscent of the cosmogonic theories of Neptunists, according to whom the earth was initially covered by "primeval waters" carrying mineral constituents that gradually precipitated into various stages of crystalline matter.[99] In pre-Cartesian times, it was believed that sea pebbles and stones grow with water germs, like marine plants, and acquire their solidity and size later *in life.*[100] What is perhaps parallel between these ancient and contemporary mineralogical discourses and Léger's painting is the promise of growth and transformation within a structural condition that is inherently resistant to change: crystallography and avant-garde art support in common the polemical infusion of life in previously inert schematizations, and that is what the "animation of the inorganic" polemically *stands* for.

Soon after their "discovery" by Lehmann, liquid crystals became well known in France; a French crystallographer renamed them *cristaux plastiques*—"plastic crystals."[101] Part of their plasticity was the crystals' capacity for deformation. Scientists would analyze how the irregular structure of mixed crystalline bodies would react when "contaminated" by simulations of the complex processes of living organisms, such as the cone-shaped deformities evolving inside the quadrant mass of mixed crystals.[102] Léger's landscape portrays a similar *contamination* of the inorganic by the processes of organic life, and vice versa. Such deformations are in fact more evident in his nudes, especially the one

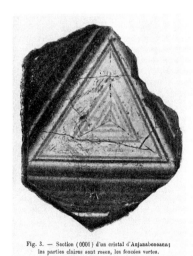

Fig. 3. — Section (0001) d'un cristal d'Anjanabonoana;
les parties claires sont roses, les foncées vertes.
(*Réduction d'une photographie faite par contact direct.*)

on the right, whose conical spine appears as a warping mass branching off the rectangular mass of the figure's torso.

Another novel plastic quality discovered in crystals was their ability for reproduction, as shown in the cannibal-like "copulations" of liquid crystals narrated by Haeckel in his *Crystal Souls*. Each of the "volumes" of Léger's landscape acts as a unit that endlessly multiplies. For example, within the curved crystalline mass painted next to the head of the woodcutter, there is a smaller particle with a different directionality of rhomboids that is whiter in color. This small form looks like an excrescence of the bigger stone—a "fetus" generated by the turbulence of the inorganic matrix.

A number of crystal and other mineral specimens studied by turn-of-the-century mineralogists were brought to Europe from the colonies, either in raw form or in sculptures and bodily adornments that were exhibited in ethnographic collections, such as the one of Trocadéro.[103] Under the microscope, such minerals appeared even more colorful and ornamental than the exotic artifacts to which they were attached; their ambient geometric patterns externalized the artful transformations of their inner lives (fig. 4.21).

Ethnography, in fact, offers another explanation of how inorganic substances, such as crystals, can partake in the biological cycle of organic life. According to ethnographic accounts, quartz crystals or "white stones" were considered to be the excrement of god. The Supreme Being was symbolically transformed into excrement—the substance coming out from the anus of the

Figure 4.21 Microphotographs of crystals from Madagascar: *left*, "Section (00001) of a crystal from Anjanabonoana," with red and green colors; *center*, "Triangular striations from corrosion on an aspect (0001) of beryl rich in alkalines"; *right*, "Base strip of bityite viewed in parallel polarized light." Alfred Lacroix, "Les minéraux des filons de pegmatite à tourmaline lithique de Madagascar," *Bulletin de la Société Française de Minéralogie* (1908): 5.

Fig. 5. — Cannelures triangulaires de corrosion sur une face (0001) de béryl riche en alcalis.

Fig. 8. — Lame basique de bityite vue en lumière polarisée parallèle.

medicine man.[104] In Léger's painting, glittering forms like crystal feces are absorbed both by the figures and the landscape. Like his fruit-stuffed *Abondance* of 1912, the nudes of this earlier landscape appear to aggrandize themselves, first by incorporating the nutrients of the mineral environment, and then by excreting the solidified substance from their mutilated buttocks. If that circular hypothesis is valid, then the "pile of pneumatic" objects, which Apollinaire saw rising in the middle of this landscape, are only the recycled product of a sublimated form of coprophagy.

Metzinger's comment on the relation of Léger's project with the "biological sciences" might be correct after all, yet only if we expand the definition of those sciences to include the emerging *biology* of the inorganic. One of the main characteristics of this monistic episteme is the *animistic* generality of its "influence"—its expansion onto bodies and forms throughout the spectrum of material creation. This generality of impact, reminiscent of the "plasticity of rituals" described by Durkheim, might support the convergence of the crystallographic with the ethnographic model within the context of the same landscape. Léger's homogenizing scientific project is, after all, comparable to that of totemic ethnography; it describes a reclassification of substances through the processes of painting.

The "clearing"

Part of this perpetual metabolism is the destabilizing process of mimicry that contributes to the general osmosis among Léger's forms. But here the sense of disguise practiced by the nude figures also expands to the mineral objects of the landscape: they too behave as something they are not. The ultimate example of such *inorganic* mimicry is the deceptive *opening* in the center of the painting (see plate 7). This luminous *clearing* could be the way out of the forest—the redeeming product of the woodcutters' (self-)destructive efforts. However, that window appears to be filled with a cluster of volumes. The luminous cubic forms resembling gigantic ice blocks appear as magnifications of crystals of a rhomboid parallelepiped structure.[105] Camouflaged as a mineral compound, the bright opening of the forest proves to be the ultimate closure, a perspective paradoxically false and yet mesmerizing.

Art historians have wondered why Léger, having already painted *Le Pont* (fig. 4.22), which shows landscape objects in abrupt transformations of scale, returns in *Nudes in the Forest* to a more traditional perspective through which objects, trunks, and figures gradually diminish in size as they gain distance from the foreground. However, the blown-up cubes inside the illusory clear-

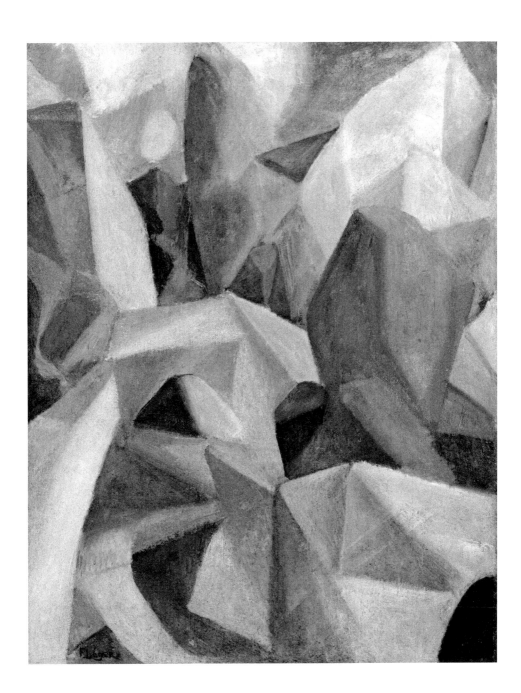

Figure 4.22 Fernand Léger,
Le Pont (1909–10). Oil on
canvas. MoMA.

ing of the forest demonstrate that this *closed* perspective is hilariously false, or in fact *open* to a revealing error.

It is as if with this pictorial pun, Léger (*le gangster*, as his friends would later call him) makes his final joke. Like the crystals conquering the earth in the 1919 satirical cartoon in *Simplicissimus*, here, once again, crystals are

rolling down the hill victorious—together with the "barbarians"! The heap of mineral forms is a web assimilating everything into its substance. The luminous rhomboids resemble ice or earth cubes, similar to the glaciers that would appear above the trees in photographs of forests by late nineteenth-century photographers.[106] Glaciation is the origin and final destination of the cosmic landscape—the endpoint where this schizophrenic metamorphosis of objects could ultimately crystallize.

The abrupt transition and its almost "telepathic" disregard for distance are prophetic. It represents not only a spatial but a temporal abridgment, allegorizing human intervention. As Durkheim would argue, in primitive magic man cannot just wait; he *has* to intervene in the course of things with his ritual gestures to make things happen faster.[107] But contrary to the fertility of spring that Le Fauconnier's *Abondance* appears to invoke, the gestures of Léger's shamans are only speeding up the end. Everything should be left to expire and from the pile of deflated pneumatics the new world of crystals will emerge: such is the painting's alternative ecological message.

There is indeed something paradoxically *organic* in Léger's crystalline forest. His early twentieth-century *terminators* show how the representatives of *Homo faber* are sowing the seeds of their own demise. Their instrumentalized bodies struggle to fulfill their inorganic potential and, like Caillois's insects, return to inertia. Remember that Nietzsche (and after him Bataille) had called the inorganic mankind's "maternal bosom," to which "it would be a celebration to return."[108] Looking again at Léger's figures, it is as if these "lost sons" are already celebrating their return to inert matter while they are still alive.

. . .

But Léger's false perspective enacts one more temporal reversal. It describes the future anterior, in which this painting operates vis-à-vis the artist's later production. Because it might be true that the cartoonlike puffed-up bodies of the 1948 *Grand Parade* with their disassembled body parts might better suit Apollinaire's description of Léger's forms as a "pile of pneumatics." And it might also be true that Léger's buoyant *Constructeurs* of the 1950s are morphologically closer to the Bibendum than the mineral characters of his early painting. In that sense, Apollinaire's comment was not only current, but also prophetic on a deeper level. However, inside the gloomy forest of 1910, both the tambourine player and the pneumatic figures of Bibendum are disguised as what they *will have been* and what in the end everything will turn into: a heap of crystalline feces disguised as motorcar tires, a pile of excremental

skulls turning into fossils that have survived the deluge and are now scenically displayed inside the narthex of Léger's painted field.

Architecture

Last but not least, there is architecture—how could it be missing from such a monument? In his 1919 letter to Rosenberg, Léger presented himself as "the most conscientious mason" while working on the "apparent architecture" of his early painting, referring obviously to its formal composition.[109] Yet actual buildings are also represented in the 1910 landscape, even though miniscule and relegated to the margin of the picture—reminiscent of distant architectural ruins in classical landscape paintings.

Figure 4.23 Fernand Léger, detail of *Nudes in the Forest.*

First, on the painting's extreme right side, there are a couple of miniature constructions with thick pillars and rhomboid pediments resembling entrances to primeval temples or funereal monuments (fig. 4.23). A round form hiding behind the unusual pediment is reminiscent of the symbolic entrances to African cities—such as the capital of Tananarive, which was formerly encircled by a wall, and whose portal included a large flat circular stone used as a door, rolled in front of the entrance (fig. 4.24).

Perhaps, then, these miniscule *spolios* in Léger's landscape signify an equally symbolic passage from the natural realm to the urban environment, that maybe hiding behind the crystals or the glaciers. It is instructive in this respect to remember how quickly in Léger's war drawings the tree trunks of the Argonne forest transformed into the housing blocks and hotel marquees of the city of Verdun (fig. 4.25).[110] It is also telling that either during or immediately after he painted *Nudes in the Forest*, around 1910 and 1911, Léger started working on the various versions of *Smoke over the Rooftops of Paris* (fig. 4.26). It is as if the forest was the prelude to the city, or, more intriguingly, as if the two visions were actually superimposed. After the clearing of the forest and the bar-

ANCIENNE PORTE MALGACHE A TANANARIVE.

Figure 4.24 Photograph of "Ancient Malagache portal in Tananarive." Général Gallieni, *Neuf ans à Madagascar* (Paris: Hachette, 1908).

Figure 4.25 Fernand Léger, *Dessins de guerre* (1915–16). Drawing of the city of Verdun and forest.

Figure 4.26 Fernand Léger, *Fumée sur les toits* (1910). Oil on canvas. Formerly at the Minneapolis Institute of Art.

Figure 4.27 Fernand Léger, detail of *Nudes in the Forest*.

barians' conflagrations, urban planning is to follow, but first the architect must "mark the spot."

In addition to the minuscule "portals," there is also a set of two pairs of miniature architectural elements *planted* in the middle of the landscape, resembling freestanding columns (fig. 4.27). While the first two seem to be crowned by flat and square capitals, the two lower columns are each crowned by a curved, undulating top. In African architecture such sigmoid forms are known as "voucranes"—the horned skulls of bulls crowning the sacred "elevated stones" erected as funeral monuments (fig. 4.28).[111] The animal remains evoke the mortal flock killed at the time of obsequies and whose body parts were attached to a "standing stone."[112] Those kinds of monuments were erected when the actual corpse of the dead could not be found.

But why are those columnar monuments so small—not taller than the nail that lies a little farther down on the canvas? Just like the nail, the budding capitals destabilize the scale of the painted forest. And yet, by doing so, they harmonize themselves with the *organic* schedule of the landscape. With time, they *too* shall grow and turn into trees or pillars: they are the architectural progeny of both the nudes and the forest.

Yet above all, such miniscule features act as signifiers of the larger "architecture" that exists within Léger's forest. Philologists cited by Frazer claim that the first "tectonic" terms used to connote a temple in German are related to the forest. Invoking the "sacred groves" of the Druids, Frazer would contend that for most European cul-

Figure 4.28 Photograph of voucranes and elevated stones, Madagascar. J. Faublée, *L'ethnographie de Madagascar* (Paris, 1946).

tures, natural woods were the oldest sanctuaries.[113] Apollinaire's invocation of an illusory "greenish light descending from the foliage" marks the presence of a natural skylight, such as the domes made out of trees described by Frazer. Such stories would feed the eighteenth-century myth of the Gothic cathedral's origin in the natural grove analyzed by Baltrušaitis.[114] However, Apollinaire's greenish light could also be reminiscent of other cathedrals, such as Delaunay's sloping *Saint-Severin* or *Eiffel Tower among Trees* (1909)—uniting the iron structures of modernity with the archaic texture of the wood. Together with Léger's mineral forest, these arboreal monuments are part of a series of "sunken cathedrals" (*cathédrales englouties*)—buildings submerged by the unbearable weight of their organic aspirations.[115] All three of these projects

correspond to Metzinger's proposal for a modern "biological" monument—an edifice erected on the basis of its imminent decay.

In all its fragmentary composition, Léger's painting is, then, monumentally architectural. It is not only a monolith marking with its preposterous presence the beginning of the French avant-garde, but also a glass *cenotaph* for an originary period of pictorial modernity and its ill-fated ambitions of pairing Saint-Simonian organicism with Nietzschean nihilism, medieval collectivity with pneumatic technology, the war against the bourgeois with the organizational methods of industrial capitalism—all blending indiscriminately under the sounds of Wagnerian choruses and the drumming of African tom-toms. On the one hand, the cornerstone of a manifold clangorous creation, but on the other, a tombstone that seals the fate of the entire edifice in the glass coffin of the forest.[116]

Foundation sacrifice

There is a legend that important buildings are often predicated on an ancient crime, which explains the sense of guilt that permeates such edifices. According to ethnographic accounts, ambitious architectural tasks addressed to collective purposes, such as bridges or city walls, demanded a great oblation from their builders. The foundation stone of such structures often had to be expiated with a human sacrifice so that the building would be "impregnable"—resistant to any danger. The expiatory rite is one of the first animistic customs described in *Primitive Culture* by Tylor, who calls it a "foundation sacrifice"—a concept that would be described again later by Frazer in *The Golden Bough*.[117] The retribution demanded by the building was always a great price to pay. Not just any person would be appropriate for the offering, but an undefended creature that was a dearly beloved one, such as the master builder's wife or only daughter.[118] Sometimes the victim's heart would be buried underneath the cornerstone, or in some cases the entire body would be walled up alive. Frazer would also mention a softer version that is more related to the art of tracing (as well as the very *history* of painting). In later times, instead of immuring a real person, the builders would measure his body and capture his shadow; they would then place the foundation stone upon that outline so that the soul would not escape.[119] If indeed *Nudes in the Forest* is about the regeneration of the landscape and the building of a vital monument, it is inevitable that it would entail the depiction of a foundation sacrifice. But as in Frazer's "softer" version of that ritual, such representation offers not a corps but only a *model* in three different "outlines" that might include the "builder's" own.

One year before he died in 1955, Léger gave three interviews in which he mentioned his 1911 painting, which by that time, perhaps overshadowed by the popularity of his recent work, appeared to have been forgotten.[120] The artist himself erected a monument to his early work by reciting its title *three* times—as many as the iterations of the model posing in his early landscape. He had put everything on this canvas—paleolithic fossils and modern pneumatics, archaic monuments and machinic body parts—as if this first big painting would also be the last. This was the recipe not for a "monument to modern times," as Metzinger had asked, but for a monumental disaster. And yet it is exactly in its failure that the allegorical value of this epic effort lies (perhaps more eloquently than in some of the painter's later "successes"). Because it might be true that, in spite of Léger's own claims, his painting never matched the innovations of the same period marked by Picasso or Braque. But its forgotten contribution lies elsewhere. *Nudes in the Forest* proposes a pictorial model equally methodical and arbitrary to concocting histories of the world. By collecting fossils and other mineral specimens, the painter ultimately creates an *Histoire naturelle* or a condensed version of the *Création du monde*—an encyclopedia of the natural sciences in its modernist redaction into a four-by-six-foot canvas.[121]

Arcadian II

Instead of a grand cenotaph, a tiny marker in the form of a nail rises from the bottom of the forest (fig. 4.29). Its function is similar to the mineral tombstone in Poussin's *Et in Arcadia ego*. Léger's pneumatic wasteland offers the modernist version of that idyllic region and the "absence in presence" it enacts by its reinscription in painting.[122]

The *ego* stands here for the collective *we*, the plural *n(o)us* that puts *us* nude inside the forest—(similar to the "let *us* drink" of the Bibendum). But this polycephalic *n(o)us* or *we* is none other than the acephalic *I*—the original model of the painting—which now steps forth center stage and starts reciting a delirious confession:

> *We* were nude inside the forest! *We* are guilty for this crime, and do not want to be so! For having touched the sacred tree, for cursing and hitting it when it refused to do what we had asked it to do (and then trying to slay it, but cutting our own hand instead). No, there was no axe, and before us there were

Figure 4.29 Fernand Léger, detail of *Nudes in the Forest*.

three others.[123] We saw them planting a few stones before their final exit from the forest. But we shall never know where they all went: they might have driven forth into the city or walked all the way back into the glaciers.

5

Malicious Houses

Animism and Animosity in German Architecture and Film from Mies to Murnau

Parallel gestures

Frame one: The close shot of a draped window. Through the open frame we see the outline of a row of houses with "brick facades and stubby gables."[1] A beam of light falls diagonally on the houses' walls, unveiling a series of dark openings (fig. 5.1).

Frame two: The wide shot of a nineteenth-century bedchamber over-stuffed with a canopy bed, a heavy armchair, a pedimented mirror, and silhou-ette portraits on the wall. Gradually, a spherical object starts rotating behind the ruffled bedclothes. It is the head of Nosferatu, glancing at the window. The vampire slowly rises from the bed, clutches his heart with his left hand, and then starts running across the room.

Frame one: But before Nosferatu runs, Murnau's camera moves and re-turns to the close shot of the window. The screen is gradually invaded by the vampire's clawed hand. As Nosferatu moves, the raised elbow of his right arm extends parallel to the windowsill. Just before he slips out of the frame, Nosferatu is immobilized by the sunlight. Reflexively, the vampire's right arm starts moving upward, and then his whole body starts rotating toward the opposite side of the window frame. When the 180-degree turn is complete,

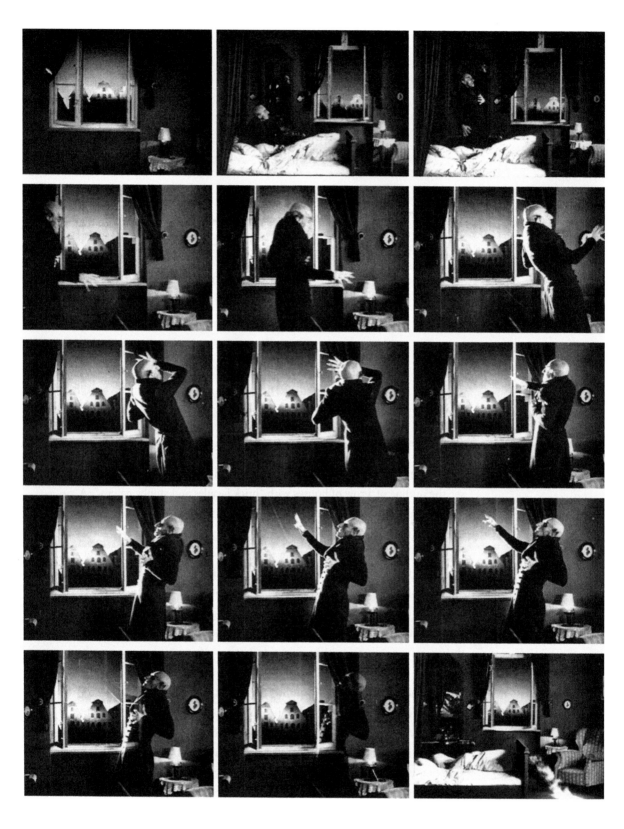

Nosferatu extends his arm forward until it is parallel with and above one of the slanting rooftops visible through the window. Holding the same gesture, he gradually vanishes, leaving the window frame unobstructed.

Frame two: Murnau's camera returns to the wide shot of the interior, where a diagonal column of smoke is now rising from the carpet floor. Like Nosferatu's arm a few moments before, the line of smoke appears parallel with the oblique rooftops visible through the window.

All of these directorial maneuvers staging the vampire's demise appear to be unscripted. In Henrik Galeen's original screenplay for F. W. Murnau's film, during his death scene Nosferatu does not run across the room, but collapses next to Ellen's bed. Instead of standing up and extending his arm, he kneels down on the floor and tries to "shield himself from the light."[2] Perhaps the ingenious setting of the curtained window—arranged by the film's set designer, architect Albin Grau—might have inspired the change of action.

Notice the momentous geometry of Nosferatu's final hand signals (fig. 5.2, *top*). Not only does his right hand extend parallel to the slanting rooftop projected through the window, but the elbow of his left hand appears almost parallel in the same direction. According to Euclidean geometry, two parallel lines define one plane. Yet here such vectors define more than a single surface. They extend to a symbolic level—that of language. Arm and roof communicate. Parallel to one another, they are in correspondence.

Arrested between the director's camera frame and the designer's window frame, Nosferatu behaves like a panic-stricken animal attempting to disappear by blending into his milieu. But the architecture that is supposed to protect him contributes instead to his ruin. Notice that during the brief moment when Nosferatu becomes transparent, the rear edge of the window frame penetrates his chest at the exact spot where the vampire had earlier clutched himself. As in Bram Stoker's *Dracula,* a wooden stake pierces the vampire's heart and finally kills him. The sunlight only introduced the ending; the window frame completed the "light plot" (fig. 5.2, *bottom*).[3]

The parallel gesturing of hands and scenery during Nosferatu's transfiguration is not without precedent in the film. Earlier, when the vampire mounts the stairs to Ellen's bedroom, the elbow of his right arm moves exactly parallel to the diagonal handrail, as does his left upper arm (fig. 5.3). The fact that both Nosferatu's body and the handrail appear as coplanar shadows makes even clearer that such parallel gestures are exercises in projective geometry—they forecast the outcome of an impending action. The French director Eric Rohmer detects similar parallel alignments between subjects and objects in Murnau's later magnum opus, *Faust* (fig. 5.4).[4] Rohmer shows how stylized

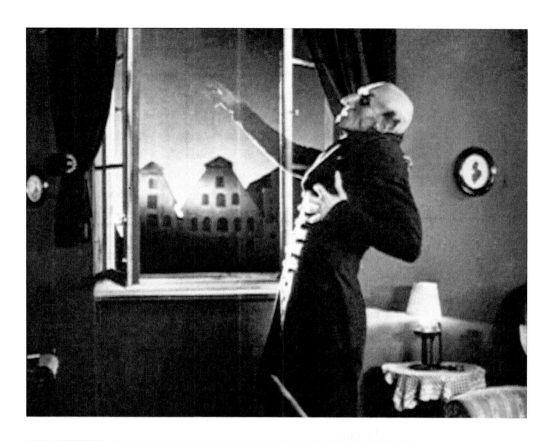

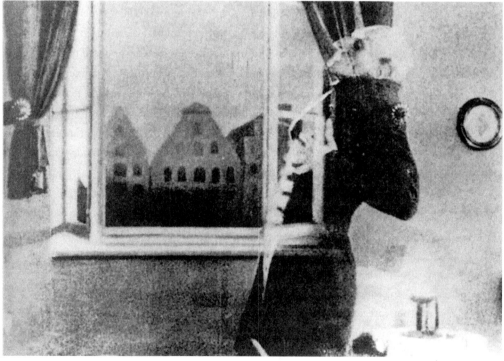

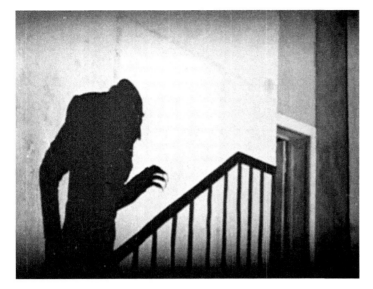

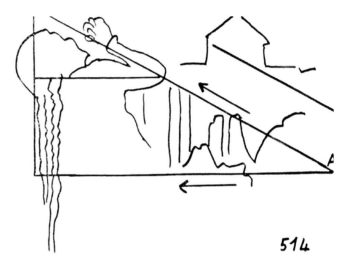

Figure 5.3 Nosferatu: A Symphony of Horror, directed by F. W. Murnau (1922).

Figure 5.4 Eric Rohmer, diagram showing the organization of space in a scene from Murnau's *Faust* in Eric Rohmer, *L'organisation de l'espace dans le Faust de Murnau* (Paris : Union Générale d'Editions, 1977).

Figure 5.2 Nosferatu: A Symphony of Horror, directed by F. W. Murnau (1922). *Top*, film still; *bottom*, "NOSFERATU: The vampire, defeated by love, dissolves into thin air." Publicity photograph with "x-ray effect" as published in Siegfried Kracauer, *From Caligari to Hitler: A Psychological History of the German Film* (New York: Riverside Press, 1947), fig. 5.

514

gestures in Murnau—from the arms of the pleading Marguerite raised parallel to the sloping contours of a church façade model to the hands of a prophet brandishing a cross over the heads of a crowd—have the power to organize space as well as extend in time by presaging the outcome of the story.

A similar scene from Murnau's *Faust* portraying a highly prophetic hand signal helps decipher the cryptic meaning of Nosferatu's final gesture (fig. 5.5).[5] I refer to the moment when Mephistopheles performs a benediction over the head of the aging Faust, after which the hero regains the powers of his

Figure 5.5 *Faust*, directed by
F. W. Murnau (1925).

youth. This biblical laying on of hands signifies the passing of a rejuvenating
energy, even if that very gesture ultimately proves ruinous for Faust.

Nosferatu's gesture describes a similar energy transfer. With his left hand
attached to his heart and his right hand connected to his houses, the depleted
organism becomes part of an energy circuit, as if his own paralysis triggers the
buildings' secret animism. But the outcome of the vampire's gesture is equally
ambiguous with that of Mephistopheles's hand wave: it signals both a blessing
and a curse, ruin and regeneration for his former residence. While their mas-
ter vanishes, the houses pledge to avenge his demise, even though their own
future is equally uncertain.

"Each gesture . . . each step, each movement is determined with scientific
rigor according to the effect it will have on the spectator," observed a journal-
ist present on the set of *Nosferatu*.[6] If in Warburg's *Pathosformel* the object of
the gesture's formularization was individual human pathos, in Murnau it is the
effect of architectural space. Turn-of-the-century theorists and architects such
as August Schmarsow and Henry van de Velde argued that both line and space
originate in human gesture.[7] Nosferatu's inhuman hand signal not only orga-
nizes filmic space, as Rohmer argued, but also delineates an entire perspective
that transcends the filmic screen to form a larger architectural continuum. I
would then like to consider Nosferatu's farewell address as a crucial gesture
for the formation—the original *Gestaltung*—of modern architecture. The

vampire's theatrical transfiguration in front of the curtained window is only the preview of future urban transformations. Perhaps the sequel to *Nosferatu* occurred not on the stage sets of the endless remakes featuring Count Dracula and other "living dead," but in the domain of modern architecture, which during the time of Nosferatu's original release in 1922 was staging its own battles with a crowd of buildings that were only *half* living.

Model houses

The entire storyline of Murnau's film evolves around the selling and buying of old buildings. "Count Orlok, his grace from Transylvania, would like to buy a house in our little town!" says Herr Knock, Nosferatu's telepathic realtor, to his young clerk Hutter. "The deserted house, the handsome deserted house, opposite yours," proposes the Mephistophelic agent while pointing with his finger to the houses: "Offer him that!" When Hutter travels to the Carpathians and shows the housing contract to Nosferatu, the count decides to buy the house, but only after he sees Ellen's lovely throat in a locket portrait owned by Hutter. "I shall buy the house, the lovely empty house opposite yours!" says Nosferatu to Hutter. The symmetrical repetition of the Hoffmanesque phrase "the deserted house" (*das öde Haus*) in two different moments of the film narrative creates a verbal arch sealing the barter before it is even signed.[8] Due to the peculiar handwriting of the buying contract, replete with cabalistic signs and astrological symbols, we are prevented from knowing the exact details of the bargain. We know, however, that it includes an exchange of houses for blood: architecture becomes animated via its financial equivalence to a life source.

Let us now look more closely at the houses that are causing this commotion. The four buildings serving as Nosferatu's "handsome" residence in the fictional city of Wisborg were in fact salt warehouses in Lübeck, built around the beginning of the eighteenth century next to a tributary of the river Elbe, where they still stand today. One can see the same buildings in every photographic survey of northern European architecture from the turn of the century together with other gabled houses from the same town (fig. 5.6).[9] While living in Lübeck from 1902 to 1903, Edward Munch produced an ink drawing of the houses, which the ex–art history student Murnau might have seen.[10]

Once the salt warehouses were discovered by Murnau's photography directors, Fritz Arno Wagner and Gunther Krampf, the old buildings colonized the graphic images announcing the film's release. In almost every publicity

ABBildung 107. Die alten Salzspeicher an der Obertrave.

Ende 16. und Anfang 17. Jahrhunderts.

Figure 5.6 "Old salt warehouses in the Obertrave. End of sixteenth, beginning of seventeenth centuries." Max Metzger, ed., *Die alte Profanarchitektur Lübecks* (Lübeck: Verlag von Charles Coleman, 1911).

poster by Albin Grau, the film's architect, art designer, and film producer, the warehouses' gables pose next to Nosferatu. Architecture both precedes and follows the vampire. Nosferatu moves into the buildings, and then the buildings move along with him. Wherever the vampire goes, the houses appear behind him—faithful companions on their master's nightly excursions to the city streets.

From the way these buildings appear to move and arbitrarily multiply, we sense that the Lübeck warehouses are in fact not the only models behind Nosferatu's residence. Hoffmann's phrase *das öde Haus* describes a building *model*, which (similar to Léger's *Nude*) is both singular and plural—akin to a building typology. There are in fact a number of similar architectural models that

serve as the mediators between the nineteenth-century past, which Murnau's *Nosferatu* portrays, and the modernist present it allegorizes. Listen to the testimony of a contemporary witness:

> In this age I now inhabit, a persistent feeling clings to me, as though at certain hours of the night and early morning gray, the houses took mysterious silent counsel together with one another . . . Often in my dreams would I witness the ghostly communings of these old houses, and in terror realize that they in very truth were the lords of the street, of its very life and essence, of which they could divest themselves at will, lending it during the day to its inhabitants, only to reclaim it plus exorbitant interest, when night came round again.[11]

The speaker is the narrator of Gustav Meyrink's novel *The Golem*—a contemporary psychological version of the medieval Jewish myth, which refers to a living statue in Prague. The old houses causing the narrator's inexplicable hallucinations are the ancient structures of Prague's Jewish ghetto. Meyrink expressly notes that some "malicious" and "hostile life" "permeated the very bricks of which" these buildings "were composed."[12]

Between 1907 and 1913, when Meyrink was writing his novel, most of the ghetto's houses built in the baroque period had already been demolished. The "sanitation process" for the center of Prague had started in 1895, and by 1904 only a few of the old structures remained.[13] Why then do these crumbling buildings, which are already dead—or at least half dead—become vibrantly alive as "the lords of the street" in Meyrink's novel? Why do such harmless old houses perform as fulcrums of hostility?

The sinister side of such houses was made even darker in Hugo Steiner-Prag's illustrations for Meyrink's novel. Houses, artifacts, and the aerial spirit of the Golem all seem to be made of the same material, which the narrator describes as "a stone like a lump of fat." Building materials are moldable like clay and mutable like plaster. Surfaces are sliced like paper or carved to simulate rock formations. Solid objects dissolve into liquid and finally evaporate to join the spiritual *beyond*.[14]

The original illustrator for Meyrink's *Golem* was the expressionist artist Alfred Kubin. After Meyrink's endless delays Kubin stepped down from the project and used his illustrations in his own novel, *The Other Side* (*Die Andere Seite*).[15] Kubin's dream city of Perle represents another form of architectural vampirism. Everything in this town is old, dead, and reanimated, including houses, clocks, fashions, and the Rembrandt paintings hanging on the walls.

"Oh I love old things!" says the narrator's wife.[16] Nevertheless, this love will not prevent such revered old things from being sadistically massacred in the novel's apocalyptic finale, when the entire city turns into a gelatinous mass of human, animal, and building debris.

Both in his text and illustrations, Kubin creates a psychographic architecture constructed not by building up but by digging out, unearthing, subtracting matter—a paradoxical attempt to create space for the void. This "negative" form of architecture is, to use Freud's term, *taboo*: it is prohibited to human habitation. Both Kubin's and Meyrink's characters suffer from multiple panic attacks. In the illustrations of both novels, human figures either lean against a wall, as though afraid to step inside a space, or they appear running, as if trying to escape.

It is remarkable that the same decrepit buildings incriminated by Meyrink and Kubin are at the same time consecrated in a long litany of illustrated publications eulogizing classicist and vernacular architecture in Germany published in the early 1900s. The fourth volume of Paul Schultze-Naumburg's *Kulturarbeiten* was devoted to city buildings and included photographs of the same Prague structures caricatured in *The Golem*.[17] Both in Kubin and in Schultze-Naumburg, one can see the same blurry human figures tentatively present in the empty cityscapes and even the same old woman precariously slanting as she's about to cross the street (fig. 5.7). Numerous other photographic collections published at the time lamented the contempt (*Verachtung*) bestowed upon the ancestral structures and sought to immortalize such buildings just before they were demolished by means of drawings and photographs.[18] Perhaps the most well known among these gloomy specimens of Germanic *Baukultur* was Paul Mebes's *Um 1800*, first published in 1908 and then republished in 1918 and again in 1920. By then the buildings' gloominess followed the shift from nationalist nostalgia to grief and melancholia following the Great War. More than ever now, urged Mebes in his preface, it was the architect's duty to treat "the work of our fathers" with "love and humility!"[19]

Yet one should be suspicious of this "love"—especially when it is addressed to paternal authority.[20] These accounts of patriotist architectural nostalgia ultimately do not revive, but *bury* the buildings they portray with photographic pomp and circumstance. Indeed, many of these collections conclude with photographs of graves, stele, and other funerary architectural accoutrements.[21] Such monumentalizing publications could propose another interpretation of Victor Hugo's *Ceci tuera cela*. Here the book does not "kill" the building, but instead helps bury it. The architectural folio does not repro-

Figure 5.7 Right, photographs of city buildings from Paul Schultze-Naumburg, *Kulturar-beiten* 4;. *left*, Alfred Kubin, illustration for Gustav Mey-rink, *Der Golem*, ed. E. F. Bleiber, trans. Madge Pemberton (c. 1928; repr., Dover: New York, 1986).

duce building models to be imitated, but consecrates monuments that will never be built again.

Indeed, one may detect in all of these accounts a similar equation of buildings with coffins, such as the one we see in Murnau's *Nosferatu*—an image reminiscent of the recent cholera pandemic in Europe of 1919.[22] After the "sick" houses are marked with a cross, the coffins immediately start parading in front of them, as if it is the buildings that are being transported to their resting place and not the human corpses. Coffins are Nosferatu's mobile home; wherever the vampire goes, his coffins travel with him. His buildings are mere parking garages for his wooden caravan. These images show that what we call animated architecture has less to do with the mobility of life and more with the dissemination of death. Every animation is a reanimation. Nosferatu's funerary architecture contains the germs of new building activity spreading with the rapidity of an infectious disease.

The mimicry of the inorganic

Nosferatu, then, portrays both types of animation we have previously analyzed. First, the material animation of substantive transmutations from the organic to the inorganic, from the animal to the vegetal and so on. The second animated mode enacted by Murnau's character is temporal: it refers to survivals and temporal reanimations of archaic themes inside the origins of twentieth-century modernism. Like Nosferatu, the objects of animation can never have a normal life; they live a perpetual *afterlife*. They are essentially vampires—a cluster of solidified desires that never properly live and never die.

But let us now focus on the more material and/or physical side of such transformations. Remember at this point the two interconnected scenes from Murnau's film in which Doctor Bulwer gives a group of students a demonstration of two curious natural specimens. First, an insectivorous plant, the well-known Venus flytrap (whose movements were studied by Darwin, among others), filmed while devouring an insect; Doctor Bulwer calls it "the vampire of the vegetable kingdom."[23] Second, a polyp, a small transparent amoeba seen through a microscope capturing a small fish with its pseudopodia—"another vampire," comments the Paracelsian doctor, "transparent, without substance, almost a phantom!" (fig. 5.8). Both of these animal and vegetal vampires are, of course, a metaphor for the transgressive nature of Nosferatu—both a bloodsucking amoeba and a murderous plant driven only by the nutritive part of his soul.

Figure 5.8 Left, Venus flytrap; *right*, polyp. *Nosferatu: A Symphony of Horror*, directed by F. W. Murnau (1922).

As these two examples from natural history show, animation in the turn of the century involves both evacuation and replenishment. As in Hirt's example of the "breathing stone," the animated substance periodically comes *in* and *out*

of mineral and seemingly inert objects. As human beings flee the old houses, other creatures settle in. In Meyrink it is the spirits, souls, or *animas*; in Kubin, *animals* take over the city: deer, ostriches, snakes, and all sorts of insects and marine organisms. Murnau's *Nosferatu* suffers a similar animal invasion: not only rats, but cats, spiders, horses, and hyenas—animals with whom Nosferatu secretly communicates. Animism becomes *animalism,* and animation leads to *animalization.* The sense of animal devolution extends to the architecture. Meyrink describes the squatting houses of the ghetto as "a herd of derelict animals" and then as "weeds rising from the ground."[24] From the animal to the vegetal, there is a sense of material recycling, as if architecture grazes its own decomposing substance. Léger's mineralogical landscape of 1910 portrayed a recycling process via the crystallization of pictorial form. The urban landscapes portrayed by Kubin and Meyrink describe a similar *inorganic* mimicry.

In his popular *Bios: The Principles of the World,* the influential biological theorist and natural philosopher Raoul Francé (also well known in the circles of the Bauhaus) elaborated a new "universal" theory of mimicry.[25] From tiny insects imitating decomposing leaves and crayfish emulating seaweeds to the Italian soldiers in the Austro-Italian war enveloped in froglike suits—all natural bodies sought to imitate something other than what they originally were. In order to continue living, organisms had to act as inanimate objects pretending that they were dead (fig. 5.9). Francé argued that this type of mimicry

Figure 5.9 Illustrations of mimicry and camouflage in marine animals, soldiers fighting in the Austro-Italian war, and "earth pyramids." R. H. Francé, *Bios: Die Gesetze der Welt* (Stuttgart: Walter Seifert Verlag, 1923).

Abb. 45. Der große Fetzenfisch (Phyllopteryx eques Cathr.) ein Beispiel vollkommener Schutzanpassung im Tangwald. Originalzeichnung.

Abb. 86. Mimikry der italienischen Soldaten im italienisch-österreichischen Kriege 1915/1918
Versuch, sich im Gewirr der Baumschatten durch ein Zebra- oder Tigermotiv unkenntlich zu machen. Ein Beispiel für mimetische Biotechnik

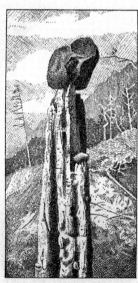

Abb. 44. Erdpyramide. Motiv vom Ritten bei Bozen. Originalzeichnung.

manifested the principle of universal "convergence," or "adaptation" (*Anpassung*): a material osmosis attempting to bring all natural organisms to a common degree of life.

Extending beyond animal bodies, Francé's theory of mimicry included the objects of inorganic nature, such as rock formations, mountains, and sand dunes that disguised themselves as earth pyramids: "Anything that bears a weight," says Francé, "whether it is ice or soil, a tree trunk or the leg of a stork . . . following the functional law of adaptation, everything turns into a column." For the monist scientist this architectural type of mimicry constituted "the mimicry of the inorganic."[76] Once more, there was no distinction between organic and inorganic bodies: all nature was one and had a soul.

Perhaps traces of Francé's monism contaminated the architectural modernism of his era. The sets for the film *Der Golem, wie er in die Welt kam* (1920) directed by Paul Wegener exhibit a material convergence between living bodies and architectural environments. While the story scripted by Wegener has

Figure 5.10 The Golem directed by Paul Wegener (1920). Sets by Hans Poelzig.

nothing to do with Meyrink's *Golem*, the stage set designed by Hanz Poelzig and constructed by his future wife, the sculptor Marianne Moeschke, is reminiscent of the ambient psychographic architecture of Hugo Steiger-Prag's illustrations for Meyrink's novel.[27]

Poelzig fills the rabbi's official salon with dripping stalactites and furniture with distorted edges that appear to be melting or burned (reminiscent of the stalactite ceiling of Poelzig's well-known *Grosses Schauspielhaus* for Max Reinhardt in Berlin of 1919). Notice that this is the room where the rabbi discovers, to his dismay, his daughter's illegitimate love for a Christian (fig. 5.10). Architecture remains physiognomic by indicating that formal transgression follows ethical transgression—the contravention of social and cultural norms.

While Poelzig's stage set appears organic and animated, the figure of the Golem, also played by Wegener, strives to look as inorganic and stony as possible. During the Golem's visit to the Christian palace, Wegener stands immobile, like a column in front of a decorated door. The door's tendril ornaments sprout from the Golem's Egyptian hairdo like the spirals of an Ionic capital. At the end of the scene, the Golem literally transforms into a column when, like Samson, he supports the pediment of the Christian palace (fig. 5.11). Wegener's human-architectural assemblage serves as an illustration of Francé's theory that every animate and inanimate body strives to imitate a column. However, the most effective example of the "mimicry of the inorganic" is the scene in which the Golem pursues the Christian intruder on the rooftop of the rabbi's tower. At first, all we see is an abstract mass of clay camouflaged

Figure 5.11 The Golem, directed by Paul Wegener (1920). Sets by Hans Poelzig.

Figure 5.12 The Golem, directed by Paul
Wegener (1920). Sets by Hans Poelzig.

inside the staircase (fig. 5.12). Suddenly, the head of
the enraged Golem emerges and petrifies his enemy
(and the spectator). Here the defensive skills of mim-
icry and camouflage turn into the offensive technique
of intimidation. Just like the Venus flytrap, the archi-
tecture modeled after the mimicry of the inorganic
appears as an apparatus of entrapment aiming at the
extinction of organic life.

Tilting

One of the physiognomic elements weighing on the
façades of buildings during the turn of the century
was the issue of tilting: the way that walls, windows,
and entire buildings deviated from the straight line.
Meyrink describes one of the derelict houses of the
ghetto as "slanting obliquely, with a roof like a retreat-
ing forehead . . . the one next to it jutting out like an
eye-tooth."[28] Tilting is obvious in the houses of Poel-
zig's *Golem* set: the oblique contours expand from
the curved rooftops and skewed interior walls of the
ghetto houses to the gesticulating rabbi's conical hats
that point in similarly oblique directions. This tilting
becomes even more prominent in the film's publicity
images, where the houses transform into transverse
flames that evoke the fire that nearly demolishes the
ghetto: tilting both follows and precedes destruction.

Just as in Poelzig's oblique stage set, so too in
Kubin's drawing *From Albania*; the tilting of the
buildings in the left extends to the elderly woman
in the foreground, the houses across the street, and
the tower in the background (fig. 5.13).[29] Although
weighed down by memories, the houses appear light
and pneumatic; they behave like inflated objects dis-
encumbered by history, able to be pushed sideways
by an invisible wind. In Kubin's image, the movement
of the tilted surface expresses not a gain but a loss of
agency on the part of the object, as in a process of *de-
animation*.

Figure 5.13 Alfred Kubin, *From Albania* (date unknown).

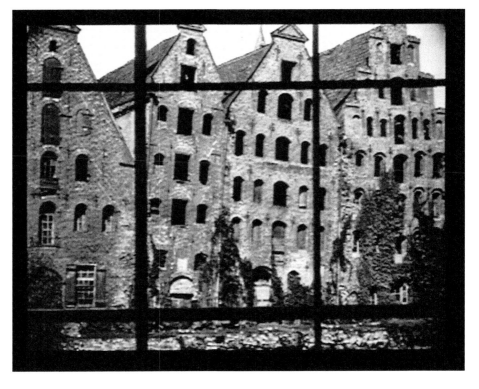

Figure 5.14 Nosferatu: A Symphony of Horror, directed by F. W. Murnau (1922).

Yet the most aberrant form of such tilting occurs in Murnau's *Nosferatu*. The first time the spectator sees the vampire's future residence, the Lübeck warehouses appear through a window grid that makes their contours appear slanted when in fact they are not (fig. 5.14). Apparently the film's designers have turned the added window grid (and perhaps the camera) a few degrees to the left to produce such a tilting effect. This optical manipulation shows that what is biased or off-center is ultimately not the object itself, but the entire *frame* through which we view it.

This serves as warning not to dismiss such optical effects as mere formal exercises; they reveal social, psychological, or political biases and are parts of a larger picture whose contours also diverge from the straight line. In *The Expression of the Emotions in Man and Animals*, Darwin remarked that "as he had seen in the Chinese . . . an angry man inclines his body towards his antagonist to attack him with his volley of abuse." As a sign of our animal past, the protrusion of the head or the whole body, according to Darwin, is a common gesture of *animosity* and of ferociously enraged humans. The exposure of the canine tooth by snarling dogs or hysterically sneering females expresses the same emotion (fig. 5.15).[30]

In addition to anti-Asian and misogynist biases, stereotypes of the oblique weighed on criminal behavior. At the center of the malicious physiognomy are the intensely tilting eyebrows—also typical in physiognomic depictions of anger. This intense frowning became permanently imprinted on the face of the "criminal man," the "innate" anatomical characteristics of whom were scientifically exposed by Cesare Lombroso in his widely known criminological studies. Indeed, among the "anomalies" detected by Lombroso on the physiognomy of "born criminals" were "the oblique eyelids, a Mongolian characteristic" that he illustrated with the portrait photograph of a young Italian criminal with a frowning expression. Here tilting becomes inherently sinister.[31]

Figure 5.15 Top, exposure of the canine tooth in sneering female. Charles Darwin, *The Expression of Emotions in Man and Animals* (1872; repr., Chicago: University of Chicago Press, 1965), plate IV.1. *Bottom,* portrait of a young criminal. Gina Lombroso, *Criminal Man: According to the Classifications of Cesare Lombroso* (New York: G. P. Putnam, 1911).

Physiognomic vestiges

Not only objects, but also theories that have seemingly expired, such as physiognomy, can become the subject of reanimation. But the sinister epitome of twentieth-century physiognomic rudiments, expressed in formal patterns such as tilting, is not exactly an auspicious sign. Kubin's and Meyrink's "malicious houses" do not wear a "happy face." Such demonizing or pathologizing of physiognomic images of buildings are omens of their imminent collapse. But before that happens, a similar failure is sympathetically transferred to the human subject whose face such architecture initially intended to portray, and now aspires to extinguish.

Indeed in several of these settings, architecture appears not to house but to persecute and gradually evacuate the human subject. In the drawing of a street scene by Kubin depicting a crowd persecuting a criminal (similar to a scene from Murnau's *Nosferatu*), the buildings framing the chase appear not only as witnesses, but also as the very agents of persecution (fig. 5.16). In another scene from *Nosferatu*, the sense of persecution by a building unfolds *inside* a house. At night, Ellen is awakened by Nosferatu's telepathic powers and sleepwalks toward the window. After faltering, she finally opens the window and looks at the buildings across the street. She is immediately struck

Figure 5.16 Left, Alfred Kubin, illustration for Meyrink's *Der Golem*; *right, Nosferatu: A Symphony of Horror*, directed by F. W. Murnau (1922).

by a telepathic energy emanating from the houses (fig. 5.17). Here, Murnau records some spectacular close-ups of Ellen's profile complemented by the building's façades, with her nose, brow, and chin echoed by the curvatures of the houses' gables. Repulsed by this contact, Ellen collapses in front of the window.

"There!" shouts Ellen to her fiancé during an earlier scene, pointing with her finger to the houses: "This is how I see it every night." But she does not name what she sees. When Hutter approaches the window, the only objects he can see are the houses' façades. Again in Murnau's frame, Hutter's face and even the form of his curly hair replicate the wavy outlines of the buildings' gables. In a last attempt to obstruct the view of the houses from his fiancée, Hutter raises his elbows and tries to cover them with his body (fig. 5.18). With his arms half-raised, his bodily posture emulates the houses' frame: instead of being erased from the window frame, the houses' outlines are now multiplied in front of it. The result of this subtle mimicry is overwhelming. As if pushed by the menacing double behind his back, Hutter collapses onto his fiancée's bed in tears.

What are we to make of these multiple human collapses in front of the same window frame—the very setting in front of which Nosferatu himself will also collapse later? Whose face is really showing through the window, and why do the human characters try to turn their own faces away from it? Perhaps what we are witnessing here is not only the collapse of human subjects, but also the equivocal effacement of architectural anthropomorphism. Physiognomic traits are reanimated in the 1920s, but only in order to crumble.[32] This is perhaps the cinematic

perspective opened up by Murnau's window—an architectural frame progressively disencumbered by the memory of human profiles.

Figurative values can only be reinserted in the building frame as shadows or projections. In one of the publicity images for *Nosferatu*, the houses' façades become the projection screen for the vampire's shadow, the sight of which causes the townspeople to run for cover. In the signature lithograph from Meyrink's *Golem*, the head of the spirit appears in profile inside the flick-

Figure 5.17 Nosferatu: A Symphony of Horror,
directed by F. W. Murnau (1922).

Figure 5.18 Nosferatu: A Symphony of Horror,
directed by F. W. Murnau (1922).

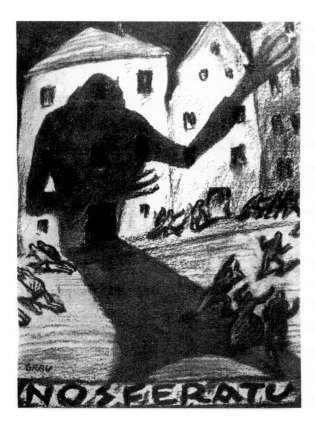

Figure 5.19 *Left*, publicity image for Murnau's *Nosferatu* (1922); *right*, Hugo Steiner-Prag, illustration for *Der Golem* by Gustav Meyrink.

ering outline of a house—as if the phantom were wearing the gabled rooftop as an oriental headgear (fig. 5.19). On the façade or under the roof, the human profile returns, but only as a shadow or an apparition inscribed within an equally ethereal building enclosure.

Smells and sounds

Gesture and physiognomy may signal a verbal form of communication, yet the language they articulate is predominantly a visual one. Nevertheless, in Kubin's and Meyrink's hallucinatory environments, animation is primarily *not* visual. There are other forms of experience that compel the sentient subject to attribute agency to these spaces. Such sensations refer mainly to olfactory and acoustic perceptions.

After his arrival in the Dream Kingdom, Kubin's narrator acquires a miraculous sharpening of his sense of smell and starts going about the city, "sniffing and snuffling" at buildings and objects like a quadruped.[33] The subject's

deanimation and gradual paralysis imply a reanimation or sharpening of his sense of smell. Smell dictates not only a sense, but also the *taste* of a place, which is more refined than vision; it establishes the identity of an environment more assertively than its morphological features. "First of all, there was a certain indescribable odor that pervaded the whole Dream Kingdom and clung to everything. Sometimes it was quite strong, sometimes it was barely perceptible. Where it was concentrated, this peculiar smell could be described as a mixture of flour and dried codfish. I could never find an explanation for its origin. Far more definite were the odors of individual objects. I analyzed them carefully and in the process I was often seized by strong revulsion. I was liable to become insulting in the company of people who seemed to smell wrong."[34] Kubin portrays this reinvigorated sense of smell as subjective and individual—hardly a means of collective communication. The city of Perle becomes like the tower of Babel, where each citizen smells, talks, and perceives the world differently. Yet gradually all of these distinct smells are unified into a single odor in the narrator's mind: "the smell of cheese," coming out of the houses' moldy walls.[35] This is the odor of putrefaction that assails the city and its inhabitants, and that will finally bring these uncoordinated individuals together as they, too, gradually decompose and merge into a moldy heap of lifeless remains.

The short-lived reanimation of smell is followed by an equally enigmatic revival of auditory cognition. Though inert and silent in the morning, Kubin's Perle turns into a veritable "theater of voices" at night: "And then those noises! There was disturbance all night long, and it was insidious. Disreputable crowds, including prostitutes from the bordellos in the French Quarter, penetrated into our neighborhood. Sounds of roaring, whistling, brawling, would draw close to our window and then recede. . . . Dreadful abysses opened up to one's aroused sensibilities."[36] If smells ostensibly enabled the citizens of Perle to orient themselves in space, then the "mysterious sounds" heard by the narrators of both Kubin and Meyrink clearly do the opposite. These echoes or "resonances" are in fact unlocatable—they usually come "from behind"— more akin to memories than actual perceptions. Such inexplicable noises make human subjects lose their sense of direction entirely and ultimately leap into metaphysical space. The origin of both smells and sounds is undetectable; there is no particular animate being, object, or even location that one can designate with certainty as the cause of such sensations. However, while odor is predominantly associated with emanations of organic (and, in the case of Kubin, mostly "rotting") bodies, the origin of sounds described by the same authors—such as crackling, grinning, and whistling produced by furniture,

stairs, doors, windows, reeking cellars, wells, and "yawning gateways"—is primarily associated with inanimate objects or machines.

In his memoirs, Warburg had associated the "screeching of a door" with the reflexive attribution of causality.[37] Even if it is hard to locate their spatial origin, sounds are inextricably linked with an agency, which recalls the idea of the anima. As Durkheim describes, although immaterial and therefore invisible, the soul is often audible, "announcing itself through the cracklings of trees."[38] Darwin, in his treatise on the emotions, remarked that infants know that "ruffling sounds indicate danger to them."[39] But now Kubin and Meyrink give a face and a place to this threatening agency, by relocating this malignant soul in physiognomically identifiable houses.[40]

In Meyrink the houses speak with a "suspicious, malicious grudging," but the things they say are what one fundamentally refuses to hear: "You're not done with us yet; you belong to us; we don't desire your happiness; happiness doesn't go with this house."[41] Although the houses' speech seems to be the sign of their malevolent omnipotence, in fact, it is nothing more than the mixed mumbling—curses and sighs—of their downfall. In the finale of Kubin's urban anti-utopia, temples and houses "clambered on top of one another" are heard to "utter strange words in a horribly loud rasping tone—a dark, incomprehensible language of houses."[42] While ostensibly attached to ancient doctrines of *architecture parlante*, Kubin's and Meyrink's constant noises announce the immolation and rebirth of an autonomously animated architecture. This building form is essentially mute—no more "whistling" or "grinning"; nevertheless, it is an architecture of "full speech" emptied of all anthropomorphic chatter.

Numb subjects

Complimentary to such an aural-olfactory form of animation is a sense of *inanimation* and paralysis that gradually pervades the same environments. While Kubin's citizens' smelling and hearing capacities are sharpened, their sense of touch is gradually eliminated. "I cannot feel my body!" complain some of Kubin's and Meyrink's characters. Objects frenetically move, while their users become gradually numb and lethargic. Buildings stubbornly stand erect, while their inhabitants are in the process of disintegration. Both the citizens of Perle and Meyrink's Jewish ghetto are afflicted by various forms of psychic disease, including phobias and panic attacks accompanied by bodily paralysis and the loss of speech. Subjects freeze through an inexplicable fear and turn into *statically* animated architectures.

Eventually, similar isolated incidents become generic characteristics. In Meyrink's *Golem*, the citizens' faces are "like wax-masks," while their bodies jump up and down like "India rubber balls";[43] they become automated and unreasoning, like Nosferatu's telepathic agent in Wisborg, and lack strong will like the depleted Hutter. While subjects are reduced in a mechanical existence, external objects become even more vividly tumultuous. To protect themselves from the uproar of the external world, the citizens of Perle yearn either for the delusion of the dream world or the temporary peace of anesthesia. Gradually humans lose their will to live, and near the end of Kubin's novel many of them commit mass suicide. The rest, incapable either of living or dying, are condemned to live the *half life* of a vegetable.

Such a reduction of animation on the part of the human subject has profound political and architectural consequences. People become malleable substances—servile creatures stupefied by mass hypnosis—in the hands of the city's invisible yet omnipresent masters. Patera, the American, or Nosferatu are the phantasmatic beings who extend their influence through the housing establishments that they create. Like Hutter and Ellen in *Nosferatu*, human characters become entrapped in a building plot without knowing its core premise. "It seemed to me that the people were there on account of the houses not the other way around," Kubin's narrator suggests, and thus inverts the anthropocentric premise of architecture. In both the filmic and the literary narratives, architecture and self-sanctioned authority are perfectly aligned in a common pattern of organization that remains secret. Only, in his final transubstantiation scene, Nosferatu's gestural alignment with the contours of his residence restages for the audience part of such privately organized agreement.

While mass paralysis spreads in Meyrink's ghetto, vision becomes blurred and is extended by hallucination. The first objects to be transformed by such expansive illusions are the buildings, which now turn into phantasmatic and allegorically fragmented apparitions. The sound of "sand on the rooftops," the human forms on "the plaster peeling on the old wall," the "faces on the iceflowers of the window pane": all the ruinous anthropomorphic metaphors in Meyrink's architectural iconography could indeed be the signs of a new "phantomlike" form of architecture that houses the fears and hallucinations of its benumbed subjects.[44] Ultimately, the "spiritual universe" portrayed by Kubin and Meyrink appears as the common side-effect of Schopenhauerian metaphysics and capitalist economy—a collective form of hallucination driving the human subject not on "the road to the stars" envisioned by Kubin, or the possibility of higher consciousness foreseen by Meyrink (and sanctified

by Madame Blavatsky), but rather to the widely spread anesthesia of modern urban spaces.[45]

The biblical wind

> I was thinking . . . while the curtain was flapping, how odd it is when the wind plays with inanimate objects. It's almost like a miracle when things that lie about without a particle of life in their bodies suddenly start to flutter. Haven't you ever felt that? Once I stood in a desolate square and watched a whole heap of scraps of paper chasing one another. I couldn't feel the wind, as I was in the shelter of a house, but there they were, all chasing each other, murder in their hearts. Next instant they appeared to have decided on an armistice, but all of a sudden some unendurable puff of bitterness seemed to blow through the lot of them, and off they went again hounding on his next door neighbor till they disappeared round the corner. One heavy piece of newspaper only lagged behind; it lay helplessly on the pavement, flapping venomously up and down, like a fish out of water, gasping for air. I couldn't help the thought that rose in me: if we, when all's said and done, aren't something similar to these little bits of fluttering paper. Driven hither and thither by some invisible, incomprehensible "wind" that dictates all our actions, while we in our simplicity think we have free will. Supposing life really were nothing but that mysterious whirlwind of which the Bible states, it "bloweth where it listeth, and thou hearest the sound thereof, but canst not tell whence it cometh and wither it goeth"! Isn't there a dream in which we fumble in deep pools after silver fish, and catch them, to wake and find nothing in our hands but a cold draught of air blowing through them?[46]

As in the episode of Darwin's dog and the parasol and Warburg's or Vignoli's iterations of the same incident, in this extraordinary passage from Meyrink's *The Golem*, animation is produced by a memory reflex. The flapping of the curtain triggers the memory of the paper scraps' "armistice," and then the gasping for air of a newspaper piece recalls the biblical "whirlwind," which has a recognizable sound, but an unknown origin and orientation. In fact the passage on the wind that "bloweth where it listeth" is from the Gospel according to John, and Warburg would jot down the same reference to the mysterious air or spirit (in Greek, *pneuma*) in his notes.[47] But as in Philo's quotation about the serpents' "pneuma," no textual or oral source is ever autonomous. In fact, behind Meyrink's own aerial description there is another text, which is much more recent than the Bible.

Between 1909 and 1914—the same period in which Meyrink was writing *The Golem*—the German author completed the translation of a number of novels by Charles Dickens, including *Martin Chuzzlewit*, which includes the following airy description: [48]

> It was a small tyranny for a respectable wind to go wreaking its vengeance on such poor creatures as the fallen leaves, but this wind happening to come up with a great heap of them just after venting its humor on the insulted Dragon, did so disperse and scatter them that they fled away, pell-mell, some here, some there, rolling over each other, whirling round and round upon their edges, taking frantic flights into the air, and playing all manner of extraordinary gambols in the extremity of their distress. Nor was this enough for its malicious fury: for not content with driving them abroad, it changed small parties of them and hunted them into the saw-pit, and below the planks and timbers in the yard, and, scattering the sawdust in the air, it looked for them underneath, and when it did meet with any, whew! How it drew them on all followed at their heels! [49]

There is an essential difference, concerning the portrayal of agency, between Dickens's and Meyrink's animated descriptions. In Dickens, the wind figures as the sole agent behind all actions—"wreaking," "hunting," "scattering," and "venting" like a "Dragon"—while the "poor" fallen leaves appear as passive victims, entirely defenseless against the menace of the aerial agent. On the contrary, in Meyrink the air almost disappears, as the narrator states that he was inside "the shelter of a house" and "couldn't feel the wind." All agency and malicious motivation is transferred into the scraps of newspaper, which appear autonomously motivated. In Meyrink we transition from the symbolism of fallen leaves to the codified information of textual fragments. Similar to the movement of fabric accessories analyzed by Warburg, the agency of air is pocketed within the foldings of eloquent material surfaces. As in Alberti, the presence of the wind becomes heuristic and serves as an "eccentric" or anachronistic form of quotation—a function corroborated by Meyrink's citation of the ancient passage from the scriptures and his covert quotation from early nineteenth-century textual sources, such as Dickens.

Meyrink's turn-of-the-century narrator essentially behaves like the metropolitan viewer of a *Schaufenster*—the display window of large department stores filled with vivaciously choreographed displays of commodities, often suspended in midair. [50] The artifacts' animated arrangement demonstrates another form of tilting, revealing not the *presence* but the artificial *absence* of

external pressure. Like the contemporary consumer, Meyrink's subject can watch the cinematic movement of artifacts behind the glass pane enacted as if in a vacuum.

While Meyrink describes the movement of inanimate objects as fundamentally hostile, he also proposes a medium for sheltering oneself against their malignant action. That sheltering apparatus is architecture—the protective enclosure represented by the glass window that can shield the subject from the "armistice" of artifacts, yet also allow him or her to trace their conspiring actions. It is now buildings—specifically glass *curtains*, which are no longer flapping, as in Meyrink's interior—that can turn the nineteenth century's legacy of a "hostile external world" into a modern animated spectacle. "You live and do me no harm"? Yes, but only if the enunciating subject is behind glass, *covered* by transparency. Architecture gains agency by abolishing its individual physiognomic persona as the domineering "lord of the street" and assuming the generic role of an all-pervading abstract apparatus—quite like that "mysterious whirlwind" wandering from the Bible.

The maliciousness of the object

Like Murnau in his restaging of Biedermeier Europe, Meyrink in his literary drawing from Dickens employs the nineteenth century as a source of quotation, but only to overturn its epistemological principles. The powerful agents of the past are reduced into phantasmatic apparitions fading behind the aberrant kineticism of things. But the very concept of "maliciousness" or animosity of objects is another one of these "old-fashioned" ideas bequeathed to us by the nineteenth century, which is now staging a return.

As is well known from its contemporary use in English, the word *animus*, apart from "spirit" or "soul," can also mean "enmity," "a hostile actuating feeling . . . shown in speech and action."[51] *Animus* is the "other side" of the anima displayed whenever animism shows the malicious face of animosity.[52] The English adjective "malicious" originates from the Latin noun *male*, which originally meant something "unpleasant" or "painful," and, only in a second way, "to deserve or invoke evil."[53] Here language reveals how an initial inner feeling of "unease" gradually gives birth to an external agency portrayed as "evil."

Researching the word "malicious" in library catalogs, one discovers the numerous uses that the word has in criminology and juridical literature.[54] Maliciousness figures ubiquitously in the indictment of false accusations, vindications against suspicions of conspiracy, calumny, defamation, and slander. The employment of the word reinforces the incriminating evidence by

determining that the illicit act was deliberate, driven by a sinister motivation. Lombroso would have insisted on the existence of a "malicious" nature in criminals externalized in their abnormal bodily characteristics. Maliciousness is the product of an age that, in spite of Nietzsche's objection, refused to view things "beyond good and evil."

The most lively description of maliciousness is offered by Friedrich Theodor Vischer—the German philosopher, aesthetician, literary critic, and politician whom we saw earlier in relation to Warburg. In his popular novel *Auch Einer* of 1878, Vischer attributes a demonic element to inert objects, which he describes as *die Tücke des Objekts*—a phrase that (for lack of a better English translation) is usually rendered as "the maliciousness of the object."[55] However, the German word *Tücke* lacks the agency or intention that the English word "maliciousness" connotes. *Tücke* originates in *Tuc*, which in high German refers to a violent movement, a strike coming from an unknown source.[56] The object in Vischer *happens* as an accident. It hits people on the head without warning.

Vischer's *striking* objects are usually familiar household items that suddenly refuse to obey our wishes and cause all types of misfortunes, such as quills and pens refusing to write, or buttons popping off a pair of trousers. Vischer heroically wars with these sneering artifacts, and when he finally manages to capture one, he shows no mercy. In the opening pages of *Auch Einer*, the protagonist is exasperated from looking for his eyeglasses until the missing article is discovered hiding inside a mouse hole among the shelves: "'Look right there; Do you see the mockery, the satanic *Schadenfreude* in this purely demonic glass-gaze? Out with the monster caught-up in surprise!' He held the eye-glasses up high, then let them fall down, and shouting with a festive voice 'The death penalty, Supplicium' he raised his foot and crushed them with the heel of his shoe, so that the pieces of glass flew around in little splinters and dust."[57] This sadistic extermination of a personal item shows that what we call "the maliciousness of the object" is in fact an excuse for the maliciousness of the subject. Though Vischer's writings on aesthetics have gained him recognition as one of the founders of the psychological theory of *empathy*, his *Tücke des Objects* shows a fundamental *antipathy* toward the external world, which is perceived as hostile and malignant. "Oh . . . we are born to sneeze to cough and to spit!" says the sickly old narrator in the novel (among all the furniture in F. T. Vischer's study, his spittoon takes pride of place next to his desk).[58] The tendency to violently expel an inner substance is extended to the subject's household environment. In another lively scene from *Auch Einer*, the narrator and one of his friends defenestrate a series of household items, including silver

and glassware, and then jubilate at the noise the flying artifacts produce when they hit the ground.

While an apparent advocate of architectural minimalism, Vischer in fact invents a new hyperornamented architecture built by the viscous matter of his illness—what his narrator calls "catarrh-like building style" (*Katarrhalischer Baustil*)—which is already present in several historical architectures, such as the classical ("purely catarrh-like") or the Gothic ("mixed catarrh-like" or "chilblain style—*Frostbeulenstil*").[59] Instead of fashioning buildings according to the image of a "well-built man" (following the Renaissance Vitruvian doctrine of proportions), Vischer reclassifies architecture based on the symptoms of organic sickness. Vischer's catarrh-like worldview (*Katarrhalische Weltanschauung*) describes a building culture that is splitting or even *spitting* itself up—regurgitating its own interior as a way of responding to both internal and external malaise. Echoing the stalactitic forms of Gaudi (and, a few decades later, Poelzig), such excrescent forms are not only the waste product of empathy theory, but also the molding substance of modern architectural experimentation. After reinventing the history of architecture according to the dripping patterns of his nose, the narrator of *Auch Einer* describes future architecture as an "antistyle" that will be "absolutely pure" and "uniquely right-angled."[60]

The ambivalence of emotion

Vischer's Hegelian metaphysics could never fully justify the animosity projected on the surface of artifacts. The philosopher's lively demonology was only part of the nineteenth century's tilting framework that weighed against the livelihood of objects. However, after the discovery of the unconscious and the invention of Freudian psychoanalysis, the same epistemological frame would become thoroughly inverted.

In the second chapter of *Totem and Taboo*, entitled "Taboo and the Ambivalence of Emotions," Freud interpreted the malicious character of the ancestral totem with the most cinematographic of all psychoanalytic metaphors, "projection."[61] Projection is the defensive mechanism by which the subject ejects his unwanted internal perceptions and displaces them into a building or an object. Primitive man and modern neurotic transpose their own aggression against paternal authority by housing it in the secure residence of the totem. In certain cases the object functioning as a scapegoat is a piece of architecture. The expiatory building is charged with an original sin, which explains the ambiguous prestige of this structure, encompassing both veneration and

guilt. "Do you know the sort of houses you are forced to live in?" asks one of the characters of *The Other Side*: "I can tell you: there is hardly one of them that was not sullied by blood, crime and shame before it was brought to this place. The Palace is patched together out of ruins of buildings that were the theater of bloody conspiracies and revolutions. . . . Fragments from the Escorial, from the Bastille, from ancient Roman arenas, were used in its construction. . . . Paris, Istanbul, and others gave of their worst horrors!"[62] Combined with animosity, animation here designates not only the transference of authority and agency but the diachronic misplacement of guilt. Architecture, as Kubin shows, has a remarkable ability to house such displacements and ambivalent emotions. Frazer comments that when pain becomes unbearable, the "sufferer often seeks to shift the burden of ill luck" into a building, for example a church, which now acts as a vessel of a negative energy that haunts the sacred edifice, yet also empowers it with an apotropaic power.[63] The same building that can do harm can also protect the endangered subject, who, while confronting its façade, vacillates with emotional ambivalence.

Perhaps, then, the ultimate secret safeguarded by the "malicious houses" of the turn of the century—aging edifices once venerated and now hated and despised—is the furtive animosity that their inheritors harbor against them, an emotional ambivalence produced by the heirs' own primeval crime. Freud's discovery of the hidden "totem meal," where the sons unite to kill and eat the father, presages modernism's own cannibalistic intentions.

"What thou hast inherited from thy fathers, acquire it to make it thine." The same instruction from part one of Goethe's *Faust*, quoted by Freud in the conclusion of *Totem and Taboo*, is also cited by Paul Mebes four years earlier in his first preface to *Um 1800*.[64] The interpretations of the architect and the psychoanalyst appear to be very different. Mebes asks for the preservation of architectural inheritance and urges other architects to treat "the work of our fathers" with love and respect. Freud, on the contrary, shows that what the descendants have "inherited" from their fathers has already been destroyed, and that what they now have to deal with and "acquire" is the guilt they have introjected.

The Freudian "ambivalence of emotion" enlightens the twofold attitude of German modernism apropos architectural tradition. On the side of history, the emergence of the politics of *Heimatschutz, völkisch* nostalgia, and historic preservation represented by Mebes and Schultze-Naumburg; and on the unrestrained, unconscious space of literature and film, the murderous houses of Meyrink, Kubin, and Murnau.[65] The houses are projected on a split screen: on the one side "mourning and melancholia," and on the other the oedipal

aggression of the modernist barbarians insisting on building their new totems in the center of their ancestors' graveyards.

"Mourning, however painful it may be, comes to a spontaneous end. When it has renounced everything that has been lost, then it has consumed itself, and our libido is once more free to replace the lost objects by fresh ones equally or still more precious."[66] Mourning, as Freud makes clear here, is *not* melancholia. Mourning is a dynamic condition leading to alternate resolutions including new building activity. My overall argument is that the golems, phantoms, and vampires invented by the literary and cinematic unconscious of the early twentieth century function as the concrete allegory of a new form of architecture. Behind the smoke of Meyrink's "mysterious explosion of the ghetto" emerge the equally transubstantiated objects of modern architecture veiled by a curtain wall. In *The Golem*, Meyrink argues that the collective "soul" of his era cannot bear to remain "formless"; it strives "to find plastic expression by penetrating the wall of actuality" in the "form" (*Gestalt*) of a "phantom."[67] The last part of this montage narrative shifts focus onto a modern architectural project that describes this phantasmatic *Gestaltung*.

Part two: the Miesian model

The fourth and last issue of Bruno Taut's *Frühlicht*, published in the summer of 1922, dedicated three pages to the designs of two skyscrapers with glass exteriors by Mies van der Rohe (fig. 5.20).[68] One of the projects was Mies's competition entry allegedly submitted in December 1921 for an apartment block on Berlin's Friedrichstrasse.[69] The competition design was a twenty-floor skyscraper with a triangular crystalline plan and was represented by a series of drawings. The second glass skyscraper was thirty floors high with an amoebic curvilinear floor plan for which the architect constructed a model and had several photographs made, two of which were prominently displayed in *Frühlicht*, next to Taut's own designs for a movie theater.

In the perspective views made for the first skyscraper, the surrounding apartment blocks are indicated only by solid dark silhouettes. In the model, the low-rising buildings, although made out of wood and plaster, show more details (fig. 5.21). According to Werner Graef, Mies's later assistant and co-member on the editorial board of *G*, Mies said of these houses, "Most people make drawings and the surrounding buildings pass also as their own."[70] That Mies clearly did not want: "I want to know what my buildings really look like on the vacant lot in question, however hideous their vicinity may be."[71] When the 1922 model was first exhibited in Berlin, the surrounding "hideousness"

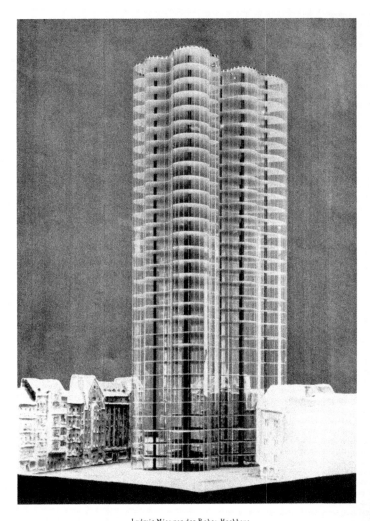

Ludwig Mies van der Rohe: Hochhaus

122

123

Mies van der Rohe:

Figure 5.20 Ludwig Mies van der Rohe, charcoal drawing of Friedrichstrasse skyscraper project (1921), and glass skyscraper model (1922), as illustrated in Bruno Taut, ed., *Frühlicht* 1, no. 4 (1922).

was noted: against the glass tower, remarked a critic, "how poor [*armselig*] the small houses with their snug façades and small towers appear."[72]

Due to their association with Mies's competition project, the houses of the model could be taken to represent the actual buildings of the Friedrichstrasse. A comparison with actual photographs of the area shows clearly that they do not.[73] The buildings on that section of the Friedrichstrasse in the early 1920s—the Comic Opera, the Savoy and Monopol hotels, the Admiral sports palace and baths—had all been recently constructed between 1889 and 1905,

Figure 5.21 Ludwig Mies van der Rohe, glass skyscraper model (1922). Detail with plaster model houses.

Figure 5.22 Ludwig Mies van der Rohe, glass skyscraper model (1922), as illustrated in *Qualität (Internationale Propaganda-Zeitschrift für Qualitätserzeugnisse)* 3, no. 5/12 (August 1922–March 1923).

and were certainly not "poor." Moreover, Mies's 1922 model usually appears with two rows of surrounding buildings, while the actual Friedrichstrasse plot, apart from the railway station, had only one. Yet again, in a photograph displayed on a publicity pamphlet that Mies made from the offprint of an article in the journal *Qualität* in 1922, the model of the glass tower appears framed on only one side by a single block of houses, while the other row is conspicuously missing (fig. 5.22).[74] Apparently the low-rise building props were not permanently affixed on the model so that they could be easily rearranged. Similar to Murnau's and Poelzig's cinematic house sets, they too are *mobile*.

These possibilities for transformation show that both the tower and the small houses are conceived as *models* primarily employed for the purposes of photographic reproduction. Similar to Léger's *Nudes,* here, too, the term *model* signifies an object of experimentation—a prototype that serves as the origin for a number of architectural hypotheses. Significantly, Mies's original model

INTERNATIONALE PROPAGANDA FÜR QUALITÄTSERZEUGNISSE / EINE MONATSSCHRIFT BETITELT

QUALITÄT

HERAUSGABE · SCHRIFTLEITUNG UND AUSSTATTUNG: CARL ERNST HINKEFUSS · CHARLOTTENBURG 9
GESCHÄFTSSTELLE: INTERNATIO G·M·B·H VERLAGSGESELLSCHAFT · BERLIN-CHARLOTTENBURG 9·

INHALTSVERZEICHNIS

ALLE SICH AUF DEN INHALT DER ZEITSCHRIFT QUALITÄT BEZIEHENDEN ANFRAGEN SIND AN DIE INTERNATIO G·M·B·H CHARLOTTENBURG 9 ZU RICHTEN

HOCHHÄUSER

QUALITÄT, 3. JAHRGANG, SCHLUSSHEFT 5/12 AUGUST 1922/MÄRZ 1923

was apparently photographed with at least three different backgrounds in various sessions. Apart from the studio shots reproduced in *Frühlicht* and *Qualität*, a series of aluminum prints depict the (photo)model "suspended outside the window" or "inside the balcony" of Mies's office in Berlin.[75] One of these photographs was reproduced in *Frühlicht* with the caption *Hochhaus von unten gesehen*, and, indeed, as with all the other photographs from the same session, it shows the glass tower "seen from below" without the surrounding houses.[76] A comparison between the image published in *Frühlicht* and the original print reveals that the photograph was cropped, leaving out a small triangle of what appears to be a lintel (fig. 5.23). The cropped lintel piece shows that the photographs from this series were shot from *inside* the window, looking out. An interior frame enveloping the model is missing in the publication; and this might not be the only part of the frame that is occluded in what is generally known about Mies's project.

Figure 5.23 Left, Ludwig Mies van der Rohe, glass skyscraper model (1922). Bruno Taut, ed., *Frühlicht* 1, no. 4 (1922). *Right*, same photograph (uncropped) in the Mies van der Rohe Archive, MoMA (MI 151).

Mies staged another photographic session for his glass tower, this time in a real outdoor setting, a Berlin park close to an exhibition hall where the model was displayed at the time.[77] Most of the photographs of the model in the park are taken in broad daylight, apparently following Mies's intentions to study the tower's glass surfaces in the sunlight.[78] Mies makes this intent explicit in his text in *Frühlicht,* and a drawing by his assistant Sergius Ruegenberg shows Mies studying the model from below with a sun disk pointed from above (fig. 5.24). The low houses again make their mark in the sketch, as indicated by a small zigzag squiggle next to the skyscraper.[79]

However, the Mies archive contains another print, perhaps never published, of the model from the same outdoor session in the park in which the tower is (artificially) enveloped in darkness, as if the photograph was taken at night (fig 5.25). The previously transparent tower now appears as an opaque dark monolith. A few gleaming spots on the model's glazing stripes are the

Figure 5.24 Drawing of Mies and the glass skyscraper model by Sergius Ruegenberg (1923–26).

Figure 5.25 Ludwig Mies van
der Rohe, glass skyscraper
model (1922). Mies van der
Rohe Archive, MoMA (MI
148).

only traces of light in the picture. While becoming totally opaque, the model gains another form of *dark* transparency: by merging with the park trees, the tower becomes even more phantasmatic than during the day.

This rare photograph suggests that the glass model was not only an experiment with the "interplay of light reflections," as Mies declared in his *Frühlicht* article, but also a play with the theatrical effect of nocturnal impressions.[80] Here photography, theater, and cinema intersect in a total work of art. Let us recall at this point that in its original publication in *Frühlicht*, Mies's glass model photographs were partially intermixed with Bruno Taut's drawings for a cinema, as if the two designs were part of the same project. While such coincidence might initially appear as a mere accident of the layout, it could be no less suggestive.[81] In its cinematic aspect, the glass tower still serves as a scientific model. By recording the changes in the appearance and mood of his skyscraper at various times of the day, Mies seems to construct a scientific film about the behavior of his building, just as plant physiologists would do for the movements of a plant. The previously inert tower starts "coming to life" through sequences of photographs, as in an animated film project. However, the fact that here not all of the photographic documentation is published, and that crucial parts are missing or have been concealed, makes such filmic montage a project in "suspended animation."

More facts are indeed hidden even in the widely known daylight shots of the model inside the park, most of which are apparently cropped. The Mies archive contains the architect's exact measurements for the cropping of these and other prints. Nevertheless, in one image reproduced in *Cahiers d'art* in 1928, the photograph appears uncropped (fig. 5.26).[82] The difference in this extended version is that it allows us to see more of the right side of the model, specifically the edges of the low-rise houses, which exceed the horizontal wooden base of the model. This extension of the photographic frame is revealing because it affords the viewer a peek at the other side of the houses, which *does not exist!* The photograph clearly shows that the wood and plaster buildings are not three-dimensional models, but two-dimensional props; they have no volume, only surface. They seem to be made specifically for the camera, and although ostensibly less photogenic than the glass skyscraper, they are equal partners in the cinematic ambience of the ensemble.[83]

The flatness of the houses did not prevent Mies from presenting them in the flesh in an exhibition titled *Internationale Architektur* (*International Architecture*) organized by Walter Gropius in 1923, first staged at the Bauhaus in Weimar and later in several other venues in Germany (fig. 5.27). In his correspondence with Gropius, Mies gives elaborate directions for the display of

Figure 5.26 Ludwig Mies van der
Rohe, glass skyscraper model (1922),
as illustrated in Christian Zervos, ed.,
Cahier d'art (1928).

Figure 5.27 Ludwig Mies van der
Rohe, glass skyscraper project model
and office building project model
(1923), installation view. Exhibition
Internationale Architektur, Bauhaus,
Weimar (1923).

his models and notes: "In this case, I would like to draw your attention to the small plaster models which seem to me *absolutely necessary additions* to my work." Mies uses the term *Zuthat*, or addition, a word similar to the term used by Warburg to describe fabric accessories as pictorial supplements. Mies initially insisted that he travel to Weimar to assemble the models himself (*die Modelle selbst montieren*), but finally he sent one of his assistants with parts of the model to be assembled with the parts Mies had already shipped.[84] In a photograph of the installation in Weimar, the model of the glass skyscraper can be seen from a distance, once again with a row of small houses, forming a new group with the model of Mies's 1922–23 design for a concrete office building. This last model, according to Werner Graef, was colored in red and gray stripes.[85] The overall ensemble must have been a rather heterogeneous assemblage of 2-D surfaces and 3-D volumes, of cinema and theater—a project suspended between different temporal frames and different degrees of realization. "I have tried it myself and the effect is excellent!" comments Mies to Gropius.[86] If the effect was "excellent," it was not because of the immediate visual response created in the spectator, but because of the long-lasting "side effects" envisioned by the architect, as he rearranged the frames of his assorted ensemble.

Sculptural additions

We do not know the identity of the traveling assistant who put Mies's model together for Gropius's show. Nevertheless, in an interview recorded in 1972, Werner Graef, another former assistant of Mies, divulges some crucial information about the 1922 model to Ludwig Glaeser, the first director of the Mies archive at MoMA. At some point during the interview, Glaeser starts discussing the glass skyscraper that Mies had put at his balcony, and in passing he mentions "the story about the sculptor whom Mies had hired" to make part of the model.[87]

"His name is Herzog!" Graef interrupts. "Herzog?" asks Glaeser. "Yes, he was an expressionist sculptor, Mies was with him in the Novembergruppe or so." We can hear Glaeser gasping at this point as if this name was the key to a hitherto unknown world, expressionistically obscured from historical sight.[88] To make sure there was no misunderstanding, Glaeser adds, "You mean the glass skyscraper . . . with the whole Berlin landscape." "Yes, I know that precisely!" insists Graef: "I had met the man briefly through Mies . . . he [Herzog] had told me specifically that he [Mies] told him 'make me a piece of Friedrichstrasse, as it once was; it does not have to be exact, only in principle.' And

Figure 5.28 *Left*, Oswald Herzog, photographic portrait of the artist with his sculpture *Geniessen*; *right*, Oswald Herzog, *Enjoyment* (*Geniessen*) (1920), sculpture.

Figure 5.29 *Left*, Hans and Wassily Luckhardt, House Buchtal, Berlin (1924). Columns and ceiling decoration by Oswald Herzog. *Right*, Otto Bartning, *Sternkirche* project (1922). Model by Oswald Herzog.

this he did very well!" "Yes, in the photographs it looks very effective!" agrees Glaeser. "Like the stage-set for an expressionist film ... not the *Cabinet of Doctor Caligari*, but it could have been something similar. It is interesting that now we know that man."

Although little has been written about Oswald Herzog, the expressionist artist had several remarkable achievements. Born in 1881, Herzog was indeed a sculptor and a member of the expressionist circles, specifically the Arbeitsrat für Kunst and the Novembergruppe. His name figures next to Mies in the architect's records of his activities in the Novembergruppe.[89] Herzog also drew several covers and wrote articles for Herwarth Walden's *Der Sturm* and other expressionist journals.[90] However, Herzog is mainly known for his sculpture,

small statues with programmatic titles such as *Enjoyment, Escape,* or *Ecstasy* (fig. 5.28). He received critical attention both in Germany and abroad, and in 1930 was hailed by an English critic as the leading sculptor of the "German inorganic school."[91] As part of his métier, Herzog not only constructed models for architects such as Mies, but also designed interior spaces, furniture, and façade elements for well-known architects such as the brothers Luckhardt (with whom Herzog did part of the design for the Haus Buchtal), as well as inner décor for Otto Bartning. He also constructed the model for Bartning's unrealized 1922 *Sternkirche* (*Star Church*), a project illustrated in several early accounts of modern architecture; and yet, Herzog's name is hardly ever mentioned.[92] In contrast to some of his figurative sculpture, most of Herzog's architectural designs are in a more abstract style reminiscent of the buildings of the Czech cubists (fig. 5.29). While he did become a member of the Nazi party and worked for them until he "disappeared" in 1941, his early sculpture was criticized by the national socialists and included in the 1937 *Entartete Kunst* exhibit.[93]

Most important, Herzog was also the author of four books and numerous articles on art theory.[94] He had in fact written an article in the very same issue of *Frühlicht* in which Mies's glass skyscraper model (part of which we now know was made by Herzog) first appeared. Although he had no academic education and most of his ideas seem heavily indebted to Kandinsky, Herzog's writings, even if not exactly original or lucid, are still significant. Herzog combines art theory with philosophy of life (*Lebensphilosophie*), as well as physics, relativity theory, and quantum mechanics: "Life is movement; movement is oscillations. . . . Oscillations are expressed in lines, which then create the expression of form."[95] The artist visualizes these oscillations as energy diagrams, which he then transfers to his sculptures. These abstract lines determine force relations between objects, which are understood as polarities of energy (fig. 5.30).

The concept of energy polarity applies to Mies's 1922 model. According to Herzog, artifacts, including buildings, are *not* mere things (*Dinge*); they are objects (*Gegenstände*), that is, analogical counterparts that stand opposite or even *against* one another. This oppositional quality in objects is similar to that in Vischer's work. However, in Herzog this energy is neither destructive nor "malicious." Art, according to Herzog, is created "by the reliving, the postexperience of an object"; it signifies "formation [*Gestaltung*] in the past."[96] The artifact is a fulcrum of transformative relations in time and space.

From his chairs to his skyscrapers, Mies's artifacts are precisely not mere "things," but rather analogical fulcrums much as Herzog would imagine that

Figure 5.30 Cover and diagrams for Oswald Herzog, *Zeit und Raum: Das Absolute in Kunst und Natur* (Berlin: Ottens Verlag, 1928).

an architectural *Gegenstand* should be. Seen in this frame, the low-rise houses surrounding the 1922 glass model are not the arbitrary fragments of a Dada-like collage; they are interdependent *Gegenstände* articulating a structural relationship. The animation of Mies's project is fuelled by the energy of historical dialectics.

Thus, Herzog seems to have constructed not only a material but also a theoretical frame for Mies's project. The sculptor's contribution is not to merely add some accessory structures to the architect's model, but to expand the building project to new plastic forms of experimentation, including the possibilities of animation. In his article "Space and Body Experience," published in *Frühlicht*, Herzog redefines all bodies as embodiments of a "soul" and as agents of "spatial energy." The article's conclusion seems to announce the appearance of Mies's glass tower a few pages later. Following certain references to the "space dynamic" of Gothic cathedrals, Herzog redefines artistic creation in quasi-animistic terms: "If you find a soul, then take materials and hide it inside them; it will give form to the bodies it uses."[97]

Mies's glass project seems to have such a hidden soul. The 1922 glass tower is indeed animated, not because of the amoebic shape of its floor plan or the eerie façades of the surrounding houses, but by the dynamic relationship between the two components of his ensemble. Indeed, the skyscraper and the low-rise houses behave like two isopolar magnets: they are both attracted and repulsed by one another. They are united and yet they remain at a distance, as if their positions are firmly fixed by opposing energy fields.

The syndrome of attraction-repulsion is central to understanding the almost circular organization of Mies's project (in some arrangements the houses are placed almost as radii springing from the tower). While being the

prototypical image of modernist alienation, Mies's inorganic assemblage has the coherence of an organic community. In fact, the ensemble resembles a medieval village with a cathedral rising high in the center and low-rise houses grazing around it. The ensemble also looks like the family photograph of a patriarch surrounded by his offspring, except that here it is one of the male members of the younger group who poses as the father. Remember Freud's conclusion in *Totem and Taboo*: "And in the act of devouring him [the father] they [the sons] accomplished their identification with him, each one of them acquiring a portion of his strength."[98] Mies's oedipal totem is the very legacy and redeeming executioner of his dying ancestors. In spite of its originality, the Miesian monolith is essentially a reconstructed organism—a building born by the transubstantiation of its fin-de-siècle progenitors.

Such secret "family" associations imply a juxtaposition not only with a historical "other" but also with the self. Even if according to Graef the houses were to be generic models of the Berlin landscape ("Friedrichstrasse or so . . . only in principle"), some of them resemble a number of private residences, which Mies was still building while he was working on his modernist reinvention. All of these "nice classicist villas à la Behrens" (as Graef referred to them in the same interview)—including the Haus Eichstädt (1921–22) or the Haus Mosler (1924–26)—have slanting brick tile roofs. One of Herzog's plaster houses in the center of the longer row even has a round window at the top underneath the pointed roof, reminiscent of the occuli in the classicist façades of Mies's signature design for the house of the philosopher Alois Riehl, built in 1914. It is as if part of the miniature houses of the 1922 model by Herzog was created by the decapitation of Mies's earlier body of work—as if Mies were bidding a Faustian farewell (à la Nosferatu) to his earlier career, while cannibalizing his earlier production.

In 1923, the skyscraper design reemerges in two drawings made for the cover of the third issue of *G*, which was sponsored by Mies and edited by Hans Richter.[99] Here the low-rise houses appear as a mere black rectangle devoid of any graphic details. This is the first time that the low houses were converted from plaster models to drawings (fig. 5.31). This is a significant change not only in the use of media, but also the signifying function of the tower. The *G* cover connotes that the model is an ideational fulcrum of pure relationship, whose perpetuity is even linguistic. The vertical tower and the horizontal row of low-rise houses construct a capital *L*—the *L* of *Gesta-L-tung*, a future-information.

According to some of Mies's later collaborators, the ultimate realization of his 1922 glass projects happened not in Berlin, but in New York more than

Figure 5.31 *Left*, Ludwig Mies van der Rohe, drawing for the cover of *G* (1923). *Right*, glass skyscraper (1922). Elevation. Mies van der Rohe Archive, MoMA.

thirty years later with the design of the Seagram Tower.[100] Here, too, several three- or four-story buildings occupied the surrounding blocks, the best known being the three-story racket club facing the skyscraper on Park Avenue, whose presence apparently led Mies to renegotiate the position of his tower. The capital *L* is again present, in more than one way; it almost turns into a hook, by which the tower wedges its connection with the rest of the city fabric. From the interior, the glass entrance appears to act as a frame projecting the historicist architecture across the street. The entire tower becomes both the screen and the apparatus of projection. Seen in that light, the 1922 glass model is an early cinematographic machine, creatively engineered for the projection of future architectures.

Parallel action

Yet instead of the buildings opposing the Seagram, one has to go back to the cinematic lineup of houses opposing the glass model of 1922 to fully compre-

hend the spectrum of the Miesian projection. Critics have already compared the low "shabby" houses of the 1922 project to Poelzig's Jewish houses for the *Golem*.[101] Further, Herzog's plaster sets seem to be constructed of the same melting matter as Kubin's demolition city of Perle. Through their windows they grin maliciously like Meyrink's decrepit housing entourage of the Jewish ghetto. The similarities also extend to *Nosferatu*'s deceptively slanting Lübeck warehouses, with their stubby gables. Significantly, Murnau's *Nosferatu* was released in Berlin in March 1922, only a few months before Mies's project appeared in *Frühlicht* and at precisely the time when Mies and Herzog should have been preparing the model for its photographic reproduction. Whether Mies had seen Murnau's film or not, the temporal coincidence in the staging of both performances is telling; their formal correlation even more so.

Remember Mies's quasi nocturnal view of his glass tower gleaming among the tree shadows. Like Count Orlok's ruinous castle on top of the Carpathians (which is first seen in a night sequence), Mies's glass tower acquires a "second life" at night. In *The Golem* Meyrink describes how buildings would become more powerful at night, when the evening put "a veil upon their features."[102] Mies's tower benefits in agency by a similar veiling: what is lost in intelligibility is gained in animation.

Concerning view angles: the shot of Mies's skyscraper *von unten gesehen* in *Frühlicht* is similar to the famous take of Nosferatu walking on the ship deck, shot from the ship cabin and therefore also "seen from below" (fig. 5.32). The worm's-eye-view in both camera angles invokes the same terror of the sublime produced by abnormally enlarged proportions. The curvilinear wings of the glass tower echo the folds of the vampire's cloak—both fabrics enveloping a substance that is allegedly immaterial.

But Mies's and Murnau's projects also share certain *syntactical* analogies concerning the use of the frame. Consider the placement of both sets of model houses *behind* a window frame. Mies's model of the glass tower is framed by the window of his Berlin office, against which the model was suspended in order to be photographed from below. In *Nosferatu,* the window of Ellen's house, as constructed by Albin Grau in his studio in Berlin, frames the replicas of the Lübeck warehouses that were propped behind it. In Mies the window frame was cropped to give the illusion of an outdoor setting; in Murnau it was exposed and flanked with curtains to enhance the illusion of a domestic interior.

In one of the pages in the typescript of *Nosferatu*, Murnau adds the instruction "With window-frame!" (*Mit Fensterkreuz!*), asking for crossed glazing bars to be put on top of the shot of the houses when the litany of coffins

Figure 5.32 *Left, Nosferatu: A Symphony of Horror,* directed by F. W. Murnau (1922). *Right,* Ludwig Mies van der Rohe, glass skyscraper model (1922). Bruno Taut, ed., *Frühlicht* 1, no. 4 (1922).

parades in front of them.[103] In Murnau, the frame represents a structural addition that compartmentalizes living action, just like architecture does. Think then of Mies's own framing techniques, from the photography of the 1922 glass model outside his office to the Seagram's glazing strips: both of these framing processes separate human action while simultaneously placing the subject within an infinite space. Herzog's model houses are part of this "added" frame.

The frame has one further function made visible when the rear edge of the window frame penetrates Nosferatu's body during his transfiguration scene. For a short moment, frame and figure appear to merge into an anamorphic assemblage, similar to a cubo-futurist vision, in which bodies are (inter)penetrated by building clusters. In the photographs of Mies's model the low-rise houses present a similar amalgamation with the glass building when their own frame is pierced by the tower grid. Their blurred outlines—and not the luminous ripple of "the light reflections" envisioned by Mies—are what we see projected through the glass.

However filmic or spiritualized Mies's and Murnau's objects may appear, they also have a physical side. Think again of the carnivorous plant and the transparent amoeba shown in *Nosferatu* by the Paracelsian doctor. Mies was an avid reader of natural philosophy (he had numerous works by Francé in his

library).[104] In its very texture, Mies's glass tower also resembles the transparent substance of a polyp as conceived in Francé's biomechanical plasmatics: like an amoeba, the skyscraper is infinitely divisible into units, but is still living in each and every one of its particles. The tower's innovative mushroom columns represent the evolutionary moment when the amoebic organism starts turning into a vertebrate by acquiring a spine.[105] "Unicellular organisms! Sometimes green or golden brown, and then they are harmless like plants. Sometimes transparent like plants, for these are voracious as wolves, and are the tigers of the world . . . the most voracious carnivora!"[106] As Francé attests, transparency is lethal. Like the amoeba of the ego described by Freud in his essay "On Narcissism," transparent creatures extend their pseudopodia in a seemingly friendly gesture only to capture their victims, take what they want, and throw away their empty carcasses in return.[107] In other words, transparency is murderous because of its illusory extensions. Like the diaphanous aggressors of Francé, Mies's glass tower transgresses the magnetic field that isolates it and devours the insectlike houses that surround it. But by doing so, it also inherits something of the houses' venomous maliciousness—the sleeping *poltergeist* buried in Friedrichstrasse, threatening to return.

"Architecture . . . is an expression of man's ability to assert himself and master his surroundings," Mies once said.[108] From Kubin's Perle to Meyrink's Prague, and from Mies's Berlin to Freud's modernist Vienna or the primitive jungle of *Totem and Taboo,* the basic presupposition that the early twentieth century has bequeathed to us is that we are living in a "hostile external world," that any relation of human subjects to external objects—including buildings—can be only in terms of mastery *or* destruction (which ultimately proves mutual). On the one side expands the two-dimensional space of the infinite projection of narcissism and magic—Mies's "play of light reflections" on the mirroring surface of his glass *Commendatore*; and underneath that side (Kubin's *The Other Side*) lies the 3-D horror of the "void"—the muddy pond inside the empty Friedrichstrasse plot. Animation is the flotation device we use to navigate between these two liquid domains.

. . .

Film critics observe that Murnau's *Nosferatu* is designed upon the narrative principles of *parallel* action. Nosferatu voyages by ship to Wisborg; his agent foresees his arrival; Doctor Bulwer demonstrates his carnivorous specimens; while Hutter races back to his hometown and Ellen waits for him at the shore. All these different episodes, incomplete or nonsensical when viewed individually, become meaningful once reviewed as part of a flowing montage in

which every image portends several incidents unfolding through the narrative. Could it be that the principle of "parallel action" permeates not only the film's story, but also the history of architecture? Could it be that the malicious houses of Kubin and Meyrink, the disintegrating façades of Poelzig and Murnau, and Herzog's plaster models opposite Mies's glass tower are parts of the same narrative unfolding in parallel action and on multiple levels, just like the ambiguous perspective described in Murnau's final window scene?

Parallel to the window frame of Murnau's nineteenth-century interior rises the curtain wall of Mies's glass exterior, ethereal and phantasmatic, invoking one of Adolphe Appia's Valhallas for Wagner's *Rheingold*. In the window opening from *Nosferatu* a familiar frame reveals a set of uncanny, phantomlike houses. In Mies's glass tower of the same year the curtain is closed. The uncanniness has been internalized inside the frame (fig. 5.33). The transparency of Mies's glass tower is both literal and *phenomenal*, as is the transparency of Nosferatu during his transfiguration scene. The space delineated by Count Orlok's final gesture has proved impossible. The opening left by his disappearance is eliminated, a mere animation trick.

Figure 5.33 Ludwig Mies van der Rohe, Friedrichstrasse skyscraper (1921). Elevation. Mies van der Rohe Archive, MoMA.

Nosferatu never returns to his ruinous castle in the Carpathians, as Murnau's last shot would have us believe. Depleted and no longer malicious, the frail vampire finds support in the architecture of the window. Before he turns into smoke, he turns into architecture, and then . . . he disappears. He effaces both the architecture and himself with a single gesture. But as Murnau's close-up shot reveals, Nosferatu does not vanish *in front* of the window; he fades away *inside* the window frame—he slips out of the picture, yet he still *sleeps* inside the window pane.

6

Daphne's Legacy

Architecture, Psychoanalysis, and Petrification

Daphne's introduction

If only architectural history books were more like issues of *Minotaure*. Imagine a page spread that on one half displays the Renaissance forests of "Ucello, lunar painter," and on the other the winter trees of Brassaï's photograph of Place Dauphine at night. The same volume would ideally be illustrated by the crystals, coral, and aragonites of André Breton's "convulsive beauty," followed by the nymphs of Paul Eluard's "most beautiful *cartes postales.*"[1] Moving in similar diagonal lines, the architecture of this book is equally divided between the crystal and the nymph, the forest and the metropolis. Such epistemological division becomes the frame through which the ancient figure of Daphne—the woman who transformed into a tree—reappears in modernity and in the course of this narrative (fig. 6.1).[2]

Daphne's first appearance in this book was in a diminutive drawing by Warburg in one of his dissertation addenda (see fig. 1.4).[3] Ovid's description of the nymph's flight from Apollo (quoted at length by Warburg in his dissertation) offered one of the oldest literary depictions of the iconography of accessories-in-motion. Looking at Warburg's small sketch surrounded by his notes, we realize that Daphne's vegetal extensions also serve as a diagram for

C. Monnet del. Baquoy Sc.

Daphné pourſuivie par Apollon, et changée
en Laurier par ſon Père.

*Figure 6.1 Daphne Pursued
by Apollo and Changed
into Laurel by her Father.
Engraving by C. Monnet
and Baquoy for a French and
Latin edition of Ovid's Meta-
morphoses, trans. abbé Banier
(Paris: Pissot, 1767).*

the endlessly bifurcating pathways grafted by scholarly research—the ways
that an inquiry can remain in motion, or occasionally petrify, through the per-
petual supplementation of textual appendages. What then is the "addition"
that Daphne can contribute both to the movement of accessories and to the
larger field of animation? And why should a book that describes this field not
just begin but also *end* with her arboreal figure?

[264] Chapter Six

After Léger's crystalline landscapes and Mies's glass skyscrapers, it might seem anachronistic to return to one of Warburg's ancient mythological characters. But also, why conclude an account of life-in-motion with a myth that has traditionally been linked to petrifaction and paralysis? And finally, why "regress" to the overt anthropomorphism of a female tree when the form of animism presented throughout this narrative distances itself from any "humanlike" origins? Regressions, anachronisms, and epistemological contradictions are inherent in the study of both temporal and material forms of animation. Like most of the objects previously presented, Daphne is never precisely a subject or an object, but a *field* of spatiotemporal extension. Her inert *end* poses another origin to which we must return in order to retrace the vicissitudes of life.

And there is a *reason* for this: philologists classify Ovid's retelling of Daphne's transformation as an *aetiological* myth (*aetion* in Greek refers to the cause or the "why" of things).[4] Early in the first volume of *Metamorphoses*, Ovid tells the story of Apollo slaying the python. To commemorate the god's feat, the Pythian games are instituted and the first winners are crowned with oak leaves. At this point, Ovid inserts the ancient story of Apollo and Daphne to explain the eventual substitution of laurel for the erstwhile oak.[5] Both of these explanations imply that Daphne's myth not only follows but also *connects* a series of historical events. Indeed, apart from aetiological myths, Daphne and the killing of the serpent also function as narratological *links*—the serpentine lines of the two figures becoming entwined threads of association. Often in old engravings of Ovid's *Metamorphoses* the tree nymph and the serpent appear side by side as mutual victims of Apollo. During the baroque, both Daphne and Apollo's battle with the python were used as interludes within the main action of theatrical plays.[6] The myth of Daphne then functions both as an interval and a transition—a pause (from action or even life itself) that does not terminate or rationalize anything but facilitates a number of astounding connections. Her body represents a model for an *anachronic* history that juxtaposes in a single frame what was before and what came after.

In his *Serpent and Tree Worship*, Fergusson described how these two symbols, tree and snake, became entangled with one another, as well as with the foundations of architectural history; yet an analysis of Daphne's legacy shows that the nymph has more than one link with the histories (and myths) of architecture. Daphne's own figure constitutes a manifold architectural model marked by a *split* in her arboreal foundation. Half woman and half tree, half living being and half statue, Daphne's divided body is an analogy in and of itself. Daphne has two psychological moods, two types of movement, two trees,

and two bodies. The nymph roams inside the wood and scatters her fragments in a forest of discourses. Enduring from antiquity to the Middle Ages, and from the Renaissance to the baroque—an era when her fame spiraled to its vertiginous peak—Daphne resurfaces in the literature, painting, sculpture, and opera of the first decades of the twentieth century.

In 1931, Picasso created a series of drawings for a new French edition of Ovid's *Metamorphoses* for the publishing house of Albert Skira. In the first issue of *Minotaure* an advertisement for the book appeared next to Lautréamont's *Maldoror*, illustrated by Dalí, and above Matisse's drawings for a collection of poems by Mallarmé.[7] The modern Daphne sprouts from the poetic fusion of pastoral harmony and decadent horror unfolding in the pages of *Minotaure*. It was perhaps in this momentous publishing coincidence that the surrealists rediscovered Daphne and developed a veritable infatuation with her architectural attributes.[8]

Along with that other famed female relic of antiquity, Freud's and Jensen's *Gradiva*, Daphne entered modernity as one of surrealism's marvelous anachronisms—her hair having turned into rococo stucco decoration, her spine into an art nouveau iron gate. The antique nymph presents this revolutionary (some would say reactionary) moment, when the putrefied Venuses of Bougereau and other fin-de-siècle academic painters would reawaken from their narcoleptic trance within the crystalline narthex of modernist pictorial practices. After spending twenty-five years hibernating inside Léger's glacial forest, the pneumatic *Nudes* would reawaken ever more revived. Of course, nothing could resuscitate such sleeping beauties except for a princely kiss— an amorous embrace generously provided by the aristocratic (as well as *collectivist*) lovers of surrealism striving to clear the ossified forest of modern art of "the painters of twisted trees" (Dalí's pejorative term for the followers of Cézanne, Braque, *et companie*, but not Picasso). The surrealists are Daphne's new Apollos—the modern centaurs endlessly pursuing their evasive nymphs and crowning their own marble busts with *their* female laurels (the relationship between Dalí and his Gala[tea] provides an appropriate example).

But Daphne's most fearsome predator is not any individual agent hiding behind a tree, but the entire *forest*—the convoluted sociohistorical framework in which her figure is embedded. Oscillating between frenzied movement and ecstatic paralysis, Daphne became an exemplary figure for surrealist artistic practices during the petrifying political climate of the late 1930s. On the original cover of Dalí's novel *Hidden Faces*, written in America in 1943, Daphne is pictured next to a rock marked by a bleeding swastika (fig. 6.2). She turns into both a tree and an architectural blueprint for the novel's

Figure 6.2 Salvador Dalí, monumental shield for *Hidden Faces* (1944). Watercolor and gouache. Gift of Dalí to the Spanish state.

central heroine, Solange de Cléda, a veritable "tree lady" whose arboreal figure is consumed inside the fiery forest of the Second World War.[9]

Chased by ruthless new Apollos and haunted by the ravages of war, the surrealist Daphne ultimately becomes hysterical, bipolar, mad. Oscillating between the serenity of her Arcadian origins and the turbulence of her metropolitan investment, Daphne's tree figure embodies the schizoid constitution of the artistic sensibility of the mid-1930s: half the spirituality of Mondrianian rectangles and half the frenzy of Dalinian putrefieds. Half tree and half woman, half this and half that; yet there is always an implicit *imbalance* spoiling Daphne's classical proportions. It then comes as no surprise that the author who offered the most discerning diagnosis of Daphne's architectural pathology was *not* an architectural historian, but a psychoanalyst (as well as former medievalist)—who was himself invested both in the Freudian and the surrealist project—that is, Jacques Lacan.

Branching pathways

During a lecture of his seventh seminar, *The Ethics of Psychoanalysis* (1959–60), Lacan made a brief reference—or "digression," as he called it—into the myth of Daphne. The nymph's petrification presented the analyst with an example of human behavior in a moment of mortifying pain:

> Isn't something of this suggested to us by the insight of the poets in that myth of Daphne transformed into a tree under the pressure of a pain from which she cannot flee? Isn't it true that the living being who has no possibility of escape suggests in its very form the presence of what one might call petrified pain? Doesn't what we do in the realm of stone suggest this? To the extent that we don't let it roll, but erect it, and make of it something fixed, isn't there in architecture itself a kind of actualization of pain [*n'y a-t-il pas dans l'architecture elle-même la présentification de la douleur*]?[10]

Lacan's speech appears to be in empathy with his anxious subject. Like the fleeing nymph, he meanders from one question to another; his discourse emulates the Solomonic columns of baroque buildings, which the psychoanalyst hints at immediately after his reference to Daphne. Notice that the word "architecture" appears only in the last of Lacan's four consecutive questions. Architecture is the convulsive form produced by the arrest of the psychoanalyst's spiraling questionnaire. Daphne represents both the conclusion—the

capital crowning a discourse—as well as the original frame through which we can retrace architecture.

In the discussion preceding his "digression" on the nymph, Lacan was describing the level of pleasurable or painful excitation that the human organism can regulate by the methods of "avoidance, movement or flight."[11] Petrification arises at the moment when excitation surpasses the limit the subject can bear and pain becomes "inescapable." When the nymph can no longer avoid pain by means of flight, she automatically formalizes her distress in the shape of a tree or an architectural edifice. What Lacan describes as the "actualization" or "presencing of pain" (*présentification de la douleur*) is in fact an externalization. By turning into laurel, Daphne does nothing other than to externalize the arborescent diagram of her nervous system—the gradual bifurcation of her psychological pathways.

In his "Project for a Scientific Psychoanalysis," written in 1895, Freud described in detail the branching patterns created by the "pathways" or "channels" that conduct the admission of neuron quantities into the system and adjust the levels of organic stimulation (fig. 6.3). In moments of psychological overflow, or when excitation encounters an obstacle that hinders its progression, the course of movement is deflected and the pathway appears to bifurcate. Freud characterized this branching process as "pathway making" (*Bahnung*); the same term was articulated in English (perhaps infelicitously) by James Strachey as *facilitation*.[12]

In the part of his lecture leading to the example of Daphne, Lacan refers to the cyclical trajectory of these conducting channels, which have a tendency to circle around an object that is no longer present. That absent object is what Lacan (after Freud) calls "the Thing" (*Das Ding*), an inaccessible entity whose

Figure 6.3 Sigmund Freud, diagrams illustrating the "pathways" of psychological excitation (*Die Bahnung*) from his "Project for a Scientific Psychology" (1895).

material absence structures the movement and direction of the pathways. However, the direction of these conducting channels is not entirely predetermined, because unlike their biological or vegetal counterparts, Freud's psychic networks are not fixed. When the limit of incoming excitation exceeds a certain "diameter," something like an explosion occurs where not only the neurons, the *matter* around which excitation scatters, but also the pathways, the *containers* of excitation, also multiply and acquire new shapes in order to manage the surplus of energy.[13] In this germinating moment, *die Bahnungen*, as Kaja Silverman writes, "branch off laterally" and shoot new offspring in order to accommodate further excitation.[14] This is the tree growing inside Daphne's psyche, which under intense pressure sprouts out of her skin, spreading into her hair, toes, and vegetal fingers. Ovid's affecting description of the actual moment of metamorphosis emphasizes the rapid cinematic sequence of changes in the nymph's body: "Scarce had she made her prayer when through her limbs a dragging languor spread, her tender bosom was wrapped in thin smooth bark, her slender arms were changed to branches and her hair to leaves; her feet but now so swift were anchored fast in numb stiff roots, her face and head became the crown of a green tree; all that remained of Daphne was her shining loveliness."[15] All transformations follow a peripheral trajectory from the appendages toward the core beneath the bodily surface. Consequently, in several pictorial representations of Daphne, the nymph retains a recognizably female form with only a few thin branches growing from her hair or fingers. This peripheral movement—reminiscent of the gyration of the animated accessories rendered by Botticelli (and Alberti)—rehearses the quasi-cyclical trajectory of the *Bahnung*—the circling around objects that are lost. The topical explosions of the same channels create the peripheral glow that, as Ovid writes, illuminates Daphne's tree with a "shining loveliness"—a layer of pure luminosity through which the nymph's inert body can communicate with the outer world.

Following Lacan's analogical description, Daphne has at least two trees: one growing inside her psyche and another growing out of her skin; yet both of these psychovegetal organisms are connected. In fact, from the moment she is born, the modern Daphne is institutionalized inside a forest. From the branching patterns of arterial networks and nerve circuitries in seventeenth- and eighteenth-century anatomical and physiological models to the classificatory and phylogenetic trees of nineteenth-century morphology, psychopathology, and evolutionary science, the destiny of the human subject unfolds on the bifurcating patterns of a forest. It is as if representation in the sciences

is no longer anthropomorphic, but rather *vegetomorphic*, as long as the tree portrays the inner gestalt of the human subject and "rustles" as an echo of her evolutionary background. In other words, the tree does not become a building following Daphne's petrification, for it is already a tectonic structure built inside her skin. If Léger showed how nudes behave inside a forest, then Freud and Lacan demonstrate how many forests preexist inside each nude.

. . .

If Freud's *Bahnung* echoed the peripheral architecture of Daphne's branches, then the psychoanalyst's image of the "protective shield" or "stimulus barrier" (*Reizschutz*) retraces Daphne's building surface of her tree bark. Freud describes the protective shield as the inorganic cover of the "living vesicle" that regulates the influx of exogenous stimuli into the mind.[16] Every painful experience leaves a scratch upon that hardened coating. A trauma creates a breach, a softened opening where the psyche becomes vulnerable. But the inorganic shield should not be understood as a wall that separates the psyche from the external world, for the inert layer filters the subject's connection to her surroundings, but does not terminate it. On the contrary, the shield acts as a threshold that sustains such communication. The "sacrifice" of living matter into the inorganic "frontline" (to use Freud's heroic military metaphor) warrants the preservation of psychic life—but only through the mediation of "inert" matter.[17]

One may portray Daphne's tree bark as a similar full-body carapace. Like the "living vesicle" covered by an inert coating, Daphne remains vibrantly alive within her wooden armor. Ovid writes that when Apollo placed his hand on Daphne's tree, "he felt beneath the bark, her heart still beating."[18] When Apollo embraces her, the laurel branches draw him closer to the trunk; but later, as Ovid describes, "the wood recoiled" from the god's kisses.[19] Daphne's rigid bark ignites the circuitry of desire, which oscillates between attraction and repulsion. In Worringer's aesthetic terms, Daphne's shield demonstrates how the streams of organic empathy continue to permeate the walls of inorganic abstraction.

. . .

Notice that Lacan uses the word *douleur* to describe Daphne's pain. *Douleur* does not signify an occasional discomfort or disquiet, but a permanent residue of grief coming from inside.[20] One should not perceive Daphne's reaction as an attempt to ward off or escape pain. According to Lacan, the nymph's

petrification does not signal the termination of her anxiety, but rather its topological arrest into a monument. Only while fleeing from Apollo does Daphne avoid pain; when she turns into a tree she indefinitely prolongs her distress in the depths of a monument. This is the temporal dimension of Lacan's *"presentification de la douleur,"* an "actualization of pain" located in the present.

We should not then perceive Daphne's tree as a system of defense. Her building is not a castle or a fortress; it is not an edifice of power, but of frailty. The nymph's petrified surface does not repel pain, but absorbs it. In other words, Daphne's monument is not a building *against* pain, but (as Anthony Vidler would phrase it) "a building *in* pain."[21]

Lacan's Daphne challenges Enlightenment presuppositions regarding the functionalist origins of architecture. The primary purpose of building is no longer to protect its user from discomfort—rain, cold, and other adverse climatic conditions—as once provided by Laugier's "primitive hut." On the contrary, as Worringer against Laugier would have argued, architecture's aim is to preserve and elaborate pain, to make the subject vulnerable to it, and to *build* the body while puncturing its veneer surface—creating perforations of pain and desire that operate as windows to the external world. Translating Lacanian terminology into building discourse, Daphne's *architecture silencieuse* articulates a practice of "full speech," as opposed to the "empty speech" of an *architecture parlante* that talks profusely and yet essentially says nothing.[22]

Since ethics was the subject of the seminar in which Lacan invoked Daphne, and based on the fact that Daphne also appears as an ethical allegory in medieval traditions, I would also like to employ her psychoanalytic framing to propose an alternative *ethics* of architecture. Following both Lacan and the surrealists, such an architectural manifesto would be based on an ethics of desire, and not of prohibition, as both ethics and architecture are normatively understood. More specifically, Daphne's architectural ethics would talk about desire the way that psychic excitation is "facilitated" (following Freud) and set in movement by the original *foreclosure* imposed by Daphne's virginal resistance—the "unyielding corset" (to use a term by Dalí)—of her rigid bark.

To illustrate this point, let us turn to a representation of Daphne from an illuminated manuscript of the *Letter of Othea* by Christine de Pisan (also present in Warburg's annotations) that was painted in 1460 and whose marvelous qualities would have appealed to both Lacan and the surrealists (fig. 6.4).[23] Stunned by Daphne's transformation, Apollo appears trapped between two types of architecture: the castle in the background and Daphne's skirted tree in the foreground. The latter is a fortress just as inaccessible as the palace rising

Figure 6.4 Apollo and Daphne, colored drawing from Christine de Pisan's *Epître d'Othea* (France, c. 1460). Ms. bodl. 421 from the Bodleian Library in Oxford, fol. 60r, reproduced in Wolfgang Stechow, *Apollo und Daphne* (Leipizig: Teubner, 1932).

from the hill. The castle inscribes a type of enclosure, the skirted tree a fore-closure. Here, we realize that the *congenital* relationship between architecture and the tree is located precisely in Daphne's opaque genitals and heavily clad flesh—the impenetrably shielded castle of the nymph's virginity, where architecture is immaculately conceived and then reborn.

In his *Tree-Cult of the Greeks*, the nineteenth-century theorist of tectonics Carl Bötticher argued that sacred trees in Greece and the European mainland were often the subjects of ceremonial *dressing* (*Bekleidung*), and that this ritual custom is related to the origin of the first forest temples (fig. 6.5).[24] Semper's *Bekleidung* or Loos's principle of *cladding*—the pliable foundations of both an ancient and modern architecture—here rediscover their female root.[25] This is further evidence that Lacan's improvised remark about the nymph's connections with architecture rest upon historical ground. As Bötticher further notes, according to Pliny and numerous other sources there was no Greek or Roman house, palace, or temple without a laurel planted at its entrance.[26] As Daphne's tree signals and Bötticher's *Tree Cult* documents, the origins of both the history and the historiography of architecture have their very *roots* in myth and animistic mentality.

ΔΙΩΝΗ ΜΑΙΝΑΣ

43. 43.

43a. 44. 44. 43 b.

Figure 6.5 Illustrations
of "tree dressing [*Baum
Bekleidung*] in the manner of
an anthropomorphic image,"
in Carl Bötticher, *Der Baum-
kultus der Hellenen* (Berlin,
1856).

No matter what period's style or "garment" clothes Daphne's tree monument,
her typological pattern stays the same. Her floor plan is circular; it replicates
the ring of Apollo's empty embrace—the void of his frustrated amorous pur-
suit. "My bride, he said, if you can never be, at least sweet laurel, you will be my
tree!" In fact, Daphne becomes not only a tree, but a plethora of objects: "My
lyre, my locks, my quiver you shall wreathe; you shall attend the conquering
lords of Rome. . . . you shall stand behind Augustus' gates, sure sentinel."[27] In
most versions of the myth, including Ovid's, Daphne ultimately transforms
into an ornament—an emblem on Apollo's lyre, a signature in his sword, a
vegetal crest on his hair—a rhythmic decorative motif, which, similar to one
of Freud's "overdetermined elements" in dreams, colonizes a sequence of nar-
ratives, including social, athletic, and artistic activities.

However, the difference between the Lacanian version of Daphne's myth
and all other retellings of her story is that the psychoanalyst's nymph not only
transforms into an ornament, but also expands into an architectural enclosure.
Up until now we envisioned the nymph as a decorative column capital or a
molding in a rococo ceiling, but in fact her living absence provides the very
floor plan of her edifice. While Daphne runs and before she turns into laurel,
the circular void of Apollo's embrace traces the plan of her future building.
After the nymph is transformed into a tree, Apollo cries, the poets tell us, and
his tears make the laurel grow.[28] Pain, tears, laurel—all grow in a vegetal cycle
that consolidates in the curved walls of an edifice.

Daphne's circular architectural form presents a fragment of the primor-
dial psychological technique of building *around* impossible objects of desire
whose voids become structural absences. Like the maternal metaphor in psy-
choanalysis, Daphne is the primary object that has to be relinquished in order
for the architect Apollo to continue building after wrecking and demolishing.
Daphne's *amor crudel* shows that the reason we restore pain and decorate it
with laurels, and the reason that, as Lacan would say, we "actualize" and (re)
present it in stone, is ultimately to keep psychic anguish in movement: to
transform the static monument of grief into something that mutates further,
via a "liberating" use of repetition.[29] There is no "reparation process" to be ful-
filled, no tower of "sublimation" to be raised. On the contrary, void, pain, and
lack are redesigned to augment their base impact. The void is further deep-
ened, not built upon; the original cavity is not covered but built around by a
number of branching architectural elements.

. . .

Further proof of Daphne's architectural transformation is evident in the most famous Daphne of all times—Bernini's *Apollo and Daphne* (also a model ostensibly fueling Lacan's description of the myth).[30] For even after Bernini finally completed his sculptural group circa 1625, his nymph would continue to mutate via her installation in the Villa Borghese.[31] The statue's first visitors describe it placed adjacent to a wall and not in the center of her *stanza*; Bernini's round sculpture would then transform into an ambient relief, in which the vegetal branches of the nymph would intertwine with the "burdened leaves" of column capitals, as well as the tendril ornaments and vine motifs on architraves.[32] But as soon as the statue was moved into the center of the same room, the nymph would start flourishing with more architectural features, including additional wall columns "to create symmetrical axes with Bernini's sculpture";[33] a vault ceiling intricately decorated around a painted representation of Daphne and Apollo;[34] a magnificent colored marble pavement, inlaid with "octagons, rectangles, and other geometrical shapes," centered around the plinth of Bernini's statue (see plate 8);[35] and finally more paintings of Daphne,[36] several antique and modern artworks (busts or reliefs) echoing the theme of metamorphosis, as well as furniture (tables, stools, antique vases, and a daybed) were added in the vicinity of the statue to complete Daphne's architectural establishment or metamorphosis. From top to bottom the entire room reflected the iconography of the statue, which now acted as the fulcrum of architectonic analogies. While adjacent to the wall, Daphne performed as a relief; when moved to the center, she "branched off" into a radial architectural environment, escaping her original enclosure. Bernini's Daphne discloses an architecturally *active* type of mourning, potent in both Freud and Lacan, which is perhaps in total contrast to the historicist melancholia of Dalí's post–World War II neoclassical pavilions.

Daphne surréaliste

And with this baroque interlude we may transition from the Lacanian to the Dalínian Daphne. The psychoanalyst and the artist shared an almost telepathic form of correspondence, which lasted over forty years—from their early writings on the critical use of paranoia in the pages of *Minotaure* during the 1930s to their spirited discussions on the diagrams of the Borromean Islands in the 1970s.[37] Daphne might be another common subject between these two authoritative Apollos—located somewhere between paranoia and the Borromean diagram. The rediscovery of Daphne might in fact be one of the very few

points at which Dalí precedes Lacan and does not simply emulate the psychoanalyst.

While, in the 1930s, Dalí painted several tree women, including portraits of Gala blossoming with olive branches, none of them emerges as a laurel. In *Hidden Faces*, the novel's tree lady is an oak. Only a small watercolor drawing of 1977 (part of a series of late works in which Dalí recapitulates the main iconographic obsessions of his career) is explicitly titled *Daphne: The Tree Woman* (see plate 9).[38] It took almost forty years for this Daphne to *find* her name, and for her artist (as Freud would say) to *refind* her.

In his Renaissance treatise, *50 Secrets of Magic Craftmanship* (1948), Dalí's iconographic symbolism of the tree woman ranges from source of artistic "inspiration" (as in the circular diagram of vegetal females emanating from the artist's head and then reentering his drawing through his fingers [fig. 6.6]) to overt sexual gratification (as in the drawing of two copulating trees demonstrating "sympathy and antipathy in vegetables" and in which the philosophical and reproductive cycles of such vegetal forms ostensibly coincide).[39] The

Figure 6.6 Salvador Dalí, *Inspiration Entering by the Five Fingers of the Hand*, from Salvador Dalí, *50 Secrets of Magic Craftsmanship*, trans. Haakon Chevalier (New York: Dial Press, 1948).

Inspiration entering by the five fingers of the hand.

Dalínian Daphne portrays the split between the tree woman's primitive sexual origins and the sublime iconography of her classical investment. She remains as chaste as a Raphaelesque Madonna, and yet she is repeatedly sodomized in public, like Millet's praying mantis fieldworker.

See, for example, the tree lady that Dalí produced in 1943 for the frontispiece of his novel *Hidden Faces* (in which Lacan makes an "objective chance" cameo appearance, anagramatized as Dr. Alcan [fig. 6.7]). In contrast to the fully clothed Daphne in the Renaissance manuscript by Christine de Pisan, the bust of Dalí's tree woman is fully exposed. Somewhere between a Northern baroque Judith and a wooden doll by Bellmer, this Daphne transforms from the virginal priestess of Ovid to a modern stripper in bondage. Her

Figure 6.7 Salvador Dalí, *Je suis la dame*, frontispiece for *Hidden Faces* (New York: Dial Press, 1944). India ink. Gift of Dalí to the Spanish state.

hands and legs are anchored to the tree while her torso is bared, ready to be whipped and penetrated by arrows like Saint Sebastian, Dalí's male model of "exquisite agony." In her ecstatic Saint Teresa–like smile, this Daphne prolongs her pain with rapturous endurance.

The Dalínian Daphne is neither masochist nor sadist; she is in between. As Dalí would say, she combines "pleasure and pain sublimated in an all-transcending identification with the object." Here, the object is a tree with an ambiguous gender: both phallic and female at the same time.[40] By shifting focus away from the subjectified origins of art and architecture and toward a phenomenal autonomy of the object, Daphne's tree is set on an entirely different epistemological pedestal; and here, Dalí's Daphne might run farther than Lacan's.

In a similar fashion to Lacan's comments on the "architecture of pain," in *Hidden Faces* Dalí writes about an "architecture of passion," buildings with "stairs of pain, gates of desire, columns of anguish and capitals of jealousy."[41] Dalí envisions the marvelous tree woman of his novel as a transparent edifice, elaborately ornamented with the female's personality attributes carved as architectural details:

> Solange de Cléda! He visualized her now as perfect, as a transparent Louis XIV fountain, in which all the attributes of her personality were architecturally transformed into the precious metals on which her spirit was "mounted" and which served her as an accessory and a pedestal. He would look at her and not see her: carved in celestial geometry, only the "silks" of the rock-crystal of her soul were visible in her limpidness. But if Solange's spirit because of its translucent purity seemed to him more and more inaccessible to the senses, all that might be called the ornamentation of "her fountain" now no longer appeared to him as light and virtual attributes. On the contrary each leaf of her modesty and each garland of her grace was chiseled with a minute detail and a refined art, as in a rare masterpiece of jewelry, so that the sculptured motifs, elaborately executed in the opaque metal of the border, only set off the smooth and unclouded diaphanousness of the receptacle that stood in the center of her deep being.[42]

Dalí in fact realized his idea of a transparent female cathedral one year later in an architectural portrait of Gala. The 1945 painting had the elaborate title, *My Wife, Nude, Contemplating Her Own Body Becoming Stairs, Three Vertebrae of a Column, Sky and Architecture*, and was later used as the color frontispiece for Dalí's treatise *50 Secrets of Magic Craftsmanship* of 1948 (fig. 6.8).[43] Like

Figure 6.8 Salvador Dalí, *My Wife Nude, Contemplating Her Own Flesh Becoming Stair, Three Vertebrae of a Column, Sky, and Architecture* (*Ma femme nue, regardant son propre corps devenir marches, trois vertèbres d'un colonne, ciel et architecture*) (1945). Oil on wood panel. Private collection, long-term loan to the San Francisco Museum of Modern Art.

Daphne and the laurel tree, Gala and her temple appear as two separate objects mirroring each other. Daphne is pursued (and arrested at a distance) by her building; architecture is her new Apollo.

Opposing modernism's renunciation of ornament, Dalí presents an antimodernist classicism made up of nothing *but* ornaments. The body disappears and is replaced by its accessories. Gala's comb turns into pedimented Palladian windows, her coiffeur into marble scrolls. Ever a minute reader of Renaissance paintings, Dalí does not neglect to reproduce a tiny serpentine strand that has escaped Gala's perfectly combed hair (reminiscent of Warburg's "unmotivated hair lock"), which is repeated in the scrolls of her building. Notice also the white sheets around Gala's buttocks, over her turquoise nightgown. The

sheets exude a hospital ambiance. Gala's building embodies *convalescence*—a "neoclassical" tempering of extremes, yet her winding hair lock divulges that the vestiges of earlier perturbations survive.

Like Daphne's tree, Gala's temple is both columnar and circular, solid and void; in fact, she is more void than solid, more sky than temple. She is transparent, almost like an x-ray, and yet her skeletal features bear the pink color of flesh. But there are more visual ambiguities in this building. Like several baroque representations of Daphne, including a well-known engraving by Andrea Schiavone, Dalí depicts his female temple from the back (which is also how Apollo, her pursuer, would see the fugitive nymph during her flight).[44] As art historians have established, seventeenth-century visitors of the Villa Borghese entering the *stanza* of *Apollo and Daphne* from either of its two doors would first view Bernini's statue from behind, witnessing the unfolding of the metamorphosis as they walked around it.[45] The view from the back dehumanizes the two would-be lovers but also renders them more properly architectural. The nymph's *dorsality*, mirroring the destiny of her pursuer, implies her continuing regression into the mineral depths of a monument, the circular "void" of her being.

Here Lacan would have a suggestion for Dalí and the rest of the surrealist architects. Despite formal resemblances, Dalí's anthropomorphous buildings and his Palladian corridors ultimately have little to do with Vitruvian proportions or classical theories of physiognomy and *caractère*; his architectures describe another type of proximity between the human, the built, and the vegetal. Lacan would admonish Dalí, claiming that the buildings that bear man's image should not be called *anthropomorphic*, but rather *egomorphic*. The *ego* should here be understood as the delineation of "man's image," which for Lacan is none other than the "wandering shadow of death."[46] Surrealist "biomorphic" architecture and Tzara's "intrauterine" abodes ultimately turn funereal. Both Tzara's uterus and Dalí's anus (markedly shadowed in both Gala's body and the "rear exit" of her temple) transform into a skull—proof that the rectum, as Leo Bersani would say, has indeed the tendency to become a grave. This is the darker side of Gala's architecturally splendid and beautiful behind.

· · ·

Now that we have seen both aspects of the Lacanian and the Dalínian Daphne, let us compare them. How can we combine Dalí's view of architecture as "the realization of solidified desires" with Lacan's theory of architecture as "an actualization of pain"? How is Dalí's "continuous transformation of liquid forms" compatible with Lacan's "fixity" of stone monuments?

According to Lacan, Daphne's rigidified skin acts as the very threshold between pleasure and *unpleasure* (following Freud's *Lust-Unlust* principle) marked by the limit of pain. Such limit is not fixed; its position can be raised as the organism plastically expands to accommodate more excitation. Following his reference to Daphne, Lacan mentioned the baroque as an era when "something was aimed towards *pleasure*," yet the same style "gave us forms which in a metaphorical language we call *tortured*."[47] Also consider the fact that Daphne intruded into Lacan's seminar right after a physiological remark on the human spine, which, as the psychoanalyst reminded his audience, acts as an axis where motility and sensation coexist.

In his well-known short story on the marionette theater, Heinrich von Kleist mentioned an actress who, during her performance as Daphne being pursued by Apollo, acted as if her "soul" was "in the vertebrae of her lower back." "She bends as if she were about to break, like a naiad from the school of Bernini," adds the character Herr C, before mentioning another actor, whose soul, during his performance as Paris presenting the apple to Venus, was "exactly in his elbow."[48] Like those two actors, Daphne establishes an *eccentric* form of animation in which the soul migrates from its original position to different centers located in the bodily periphery.

Obviously the convulsive figure by Bernini described by Kleist's Herr C refers to the master's *Daphne*. The spine of Bernini's Daphne is markedly twisted; it has nothing to do with the quiescent posture of Gala's back and her columnar vertebrae. While Gala's temple conveyed convalescence, the memory of the baroque Daphne exudes disorder and sublime hysteria. One can imagine that both Charcot and Freud would most likely classify Daphne as a hysteric. Freud would certainly attribute her affliction to her apparent sexual frigidity. The transition from the delirium of her frenzied flight to her ecstatic tree posture would represent the two alternating phases of her malady.

The nymph's inflected spine traces the secret alignment between Lacan's Daphne and Dalí's well-known 1933 *Minotaure* article on "the terrifying and edible beauty of modern style architecture."[49] The art nouveau imagery of vegetal nymphs and ecstatic sculptures was replete with the contorted spines and convulsive gestures that Dalí would later describe as a veering "hysterico-epileptic seraglio." Despite its rehearsed performance, the body of the female hysteric presents an architecture that could pose as what Lacan would call the "presencing of pain" in all its disparaging permanency.[50] However smiling or serene, Guimard's ecstatic nymphs and masochist columns *prolong* their pain into a vegetal amnesia; they turn their torture into pleasure and cling to it with mineral endurance.

But there are no hysterical bodily convulsions, intense gesticulations, or rigid contortions in the famous collage that Dalí made to illustrate the architecture of sexual ecstasy in *Minotaure*. There are only a series of disembodied heads with open mouths (fig. 6.9). The epileptic seraglio had become cerebral. The architecture of hysteria is all in the head. With mouth agape and eyes wide shut, Dalí reminds us that architecture is *not* about the reality of the

Figure 6.9 Salvador Dalí, *The Phenomenon of Ecstasy* collage, *Minotaure*, nos. 3–4 (December 1933).

external world but about the interiorized space of fantasy. Rather than an architecture of erecting and "filling in," Dalí presents an architecture of emptying out and unearthing. It would perhaps be unproductive to search for Daphne's architecture in the external forms of a building; she is more of an "interior design"—the product of an architectural implosion.

In medieval illustrations, Daphne appears as a marvelous monster with a female human body and a bulbous bush or an entire tree on her shoulders instead of a head—a figure that art historians have compared to the well-known figure of Mandragora (fig. 6.10).[51] Similarly, the archetype of Daphne's architecture is indeed a "tree head"—a tree that does not grow within a house like a monumental pole (as in the stage set for the first act of Wagner's *Die Valkyrie*), but a tree that has *become* the house. The wooden enclosure around Daphne's head projects an internal model of her mind, like a cinematic apparatus or a television. Daphne's architecture is not solid or fixed like her statue. On the contrary, it is a cluster of filmic projections. Her tree bark acts both as a source and projection screen for the ornamental scribbles of her fear.

Daphne's ecstatic schism between torment and exuberance in fact characterizes the bipolar constitution of the architectural modernism of the 1930s, internally split between the spiritual flatness of *Abstraction-création* and the "salivating muscles" of streamlined motor cars and buildings. Even functionalist modernism, what Dalí (after Tristan Tzara) calls "the architecture of self punishment," is saturated with Daphne's baroque prolongation of pain.[52] Although totally transformed morphologically, Daphne's *anima vegetativa*—art

Figure 6.10 Left, Apollo and Daphne, woodcut from Les cent histoires de Troye (late fifteenth century) (Paris: Phil. Pigouchet), 87; center, book illustration of Ovid's Metamorphoses (1497); right, drawing of Mandragora, Hrabanus Maurus-Kodex in Montecassino (1023 AD). All illustrations from Stechow, Apollo und Daphne.

nouveau's vegetal soul—still vibrates inside the bark of modernist environ-
ments. While mute and ineffable, Daphne's glass tree reverberates with the
erogenous cries of the architecture of self-punishment indulging in a series of
amorous prostrations.

But where is Daphne in such modernist environments? Recall the branch-
es, hands, and other forms projecting from Dalí's plaster facade in his infamous
pavilion of *The Dream of Venus* made for the 1939 World's Fair in Long Island,
New York (fig. 6.11). If the baroque Daphne "expressed" herself through a
cluster of vegetal excrescences, modern baroque Daphne externalizes her
presence in a series of *protrusions*. The nymph's petrified posture accumulates
an excess of energy, which is externalized as an aerodynamic protuberance
jutting out from the flatness of her wooden frame.

Figure 6.11 Eric Schaal, Sal-
vador Dalí's *Dream of Venus*,
1939 World's Fair, Long
Island, New York. Exterior
night view. Eric Schaal Estate,
courtesy Jan Van der Donk
Rare Books.

As Dalí describes in his theory of aerodynamic forms, modern artifacts are also the products of intense pressure from their environment. Like "black-heads squeezed out from an oily nose," streamlined cars and buildings strive to escape from the asphyxiating pressure of modern space, which both hinders and facilitates their production.[53] Like Daphne's virginal bark, modernist artifacts are the products of a stringent resistance formation; they are produced *not* by the flowing function of desire, but from its blockage; streamlined architecture does not simply emulate the external morphology of the automobile, but also the internal mechanism of its footbrake.

Such correspondences were evident in the Renaissance landscape of the 1939 World's Fair, in which, five centuries after Botticelli's *Primavera*, Venus

Figure 6.12 Photograph of female models for *The Dream of Venus* watertank show directed by Salvador Dalí with a reproduction of Botticelli's Venus. 1939 World's Fair, Long Island, New York. (Photographer unknown.)

and Mercury would reunite: the ancient goddess from a large-scale reproduction of Botticelli's *Birth of Venus* pasted on the façade of Dalí's *Dream of Venus*, and Mercury as a streamlined metal sculpture suspended above the entrance of the Ford Pavilion. In a brilliantly improvised photo opportunity, Dalí arranged the seminaked "liquid beauties" of his watertank peepshow around the oversize reproduction of Botticelli's Venus as it was lying on the ground waiting to be plastered on the wall (fig. 6.12).[54] This *peripheral* array of figures rehearses the theme of accessories-in-motion—the animated fabrics, which here are replaced by the living priestesses of the ancient goddess. A number of anthropomorphic tree sculptures installed in other pavilions of the 1939 fair completed the iconographic cycle of this preposterous mythological and technological extravaganza.[55] Perhaps the presence of these humanoid trees among the motorcars of the Ford Pavilion and Dalí's modern naiads was not fortuitous: for Dalí, the contemporary Daphne would be a composite portrait of all three of these hybrid objects.

See, for example, how Dalí's fossilized automobiles emulate Daphne's petrified leap—both flying apparatuses standing on one "wheel." In fact Daphne's arrested flight reminds us of *Minotaure's* emblematic photograph of "the speeding locomotive abandoned for years to the delirium of the virgin forest," described by Breton and inserted in an article by Benjamin Perret (fig. 6.13).[56] Arrested by her sister trees, Daphne turns into a Duchampian vegeto-biomorphic bride-machine, as virginal and delirious as the surrealist forest. Daphne could indeed be a Duchampian bride of the "tree type," whose "blossoming," as illustrated in both in her classical and modern iconography, is indeed "cinematic."[57] As an object "linking motion with repose," Daphne perfectly fulfills Breton's first principle of *convulsive beauty* as articulated in his famous article in *Minotaure*. Oscillating between woman, tree, and stone,

Figure 6.13 Left, photograph of abandoned locomotive, *Minotaure*, no. 10 (1937); *center*, detail of Wilhelm Baur, *Apollo and Daphne* (1639), from Stechow, *Apollo und Daphne*; *right*, Salvador Dalí, detail of *Apparition of the Town of Delft* (*Apparition de la ville de Delft*) (1935–36). India ink and pencil on paper. Private collection.

Daphne also fulfills Breton's second principle, that of the paranoid mimicry between organic and inorganic materials.[58] By way of Daphne's tree, Breton's crystal returns full circle to Eluard's fossilized nymphs.

Not only does Daphne offer an alternative illustration of Breton's theory, but one of the original illustrations of Breton's article also offers an alternative depiction of Daphne in one of her modernist *re-* or *disembodiments*. I refer to Breton's portrayal of "automatic writing" depicting an x-ray of radioactivity, which echoes the branches of an illuminated tree seen from above (fig. 6.14).[59] This is what ultimately remains after all of Daphne's foliage has fallen down: a naked diagram, a cluster of nerves, a network of luminous pathways spinning like galactic nebulae inside the hollow section of a tree. "All that remained of Daphne was her shining loveliness" Ovid wrote; yet in the modern psychographic Daphne, such shine mainly irradiates *underneath* the nymph's universal surface.

Figure 6.14 André Breton, *L'image, telle qu'elle se produit dans l'écriture automatique*, Minotaure, no. 5 (1934): 10.

. . .

And yet it would perhaps be antisurrealist in spirit if we abandoned Daphne in such a state of abstract cosmic disarray. There must be another pathway leading from the naked diagram back to the nymph and to the recovery of her female persona. All of the modern authors we have seen thus far—Lacan, Dalí, Breton—are male.[60] Can there ever be a contemporary Daphne recreated by a female? Claude Cahun's 1931 photographic self-portrait titled *Je tends les bras* of 1931 presents such possibility (fig. 6.15).[61] Cahun's Daphne is literally petrified: her tree has turned into a stone wall. But here the woman does not turn into or enter an enclosure, but struggles to come out of it. This Daphne does not obediently comply with her architecture. Even though there is no sign of her head, the female *speaks* eloquently of her desire. Her arms perform a demonstration. Even the colorful bracelets around the artist's wrist

Figure 6.15 Claude Cahun, *Je tends les bras*, self-portrait (1931). Collection John Wakeham, Jersey.

echo the greater circle of her vacuous embrace. It is as if the original *Thing* of Daphne's absence has here been scattered into these little *things*—the circular accessories adorning her body. Although enveloped by an inorganic barrier, this Daphne has infinite animate extensions. Her arms wave like tentacles or the semifunctioning appendages of a tadpole, whose feet break through for the first time into the limits of the real world. Cahun's self-portrait reveals that Lacan's "presencing of pain" can have a meaning that is not only symbolic and passive, but also actively political and real. The petrified figure has not just an elegiac past, but also a lively future, which demonstrates that however terminal, Daphne's metamorphosis is never finite.

Accessories-in-inertia

Daphne's *breathless* correspondences disclose why her figure acts almost as an emblem in the historiography of Aby Warburg; such a *link* prompts a return to the book's first historiographic themes before it closes. Similar to the rest of her pursuers, Warburg's interest in the nymph was persistent. Next to his descriptions and drawings of the nymph in the early drafts of his dissertation, his Zettelkästen contain two files with notes on the thematic of Daphne (one of them placed next to the subject of Orpheus), which date from Warburg's student years and continue through to his final writings (fig. 6.16).[62] Daphne also makes an impromptu appearance in Warburg's *Theatrical Costumes for Italian Intermezzi* (1895), published two years after his dissertation.[63] But perhaps Daphne herself acts as a historiographic intermezzo inserted before (as well as *after*) the conclusion of a scholarly career.

Figure 6.16 Aby Warburg, "1501 Woodcut—Apollo and Daphne." Manuscript notes and sketch of Daphne from an Italian edition of Ovid's *Metamorphoses*. WIA, III.39.4, " Botticelli, Drafts and Notes," 9. Photograph: Warburg Institute.

Warburg, after all, would return to the nymph in the essays of his final years, such as his notes on representations from Ovid (1927)[64] and his grand opus, the "memory atlas" *Mnemosyne* (1928–29). A number of depictions of Apollo and Daphne—including those by Dürer, Pollaiulo, and Schiavone—are included on the same atlas panel that shows Botticelli's *Birth of Venus* and *Primavera* (fig. 6.17). This spatial adjacency discloses a variety of common threads—historical, iconographic, and morphological—between these different mythological representations linked by their common uses of accessories-in-motion.[65]

However, since most of the images of Daphne posted on Warburg's atlas panel represent the nymph's "arrest," no flying draperies or windblown hair are depicted. For example, a woodcut by a Renaissance German master renders Daphne as a rigid figure with an entirely wooden trunk, crowned by straight branches yet without signs of clothing or human hair.[66] Here, Daphne's former

p. vij Cap. XXXIIII

Apollo saetato per lo amore di daphne
incomiciola lo caldamte ad amarra
& lei fugendo spregiava lo amore
di phebo: & fugendo p̄ le silue
& boschi andaua vestita di pelle
di fere saluatiche seguitando
diana dea di castitate & fugia
ongli cupelli sparti & scapigliata
legati senza alcuna acima
dura. Molti huomini eo dimanda-
vano

 Cap. XXXV

Phebo desiderana conzozersi con
daphne per matrimonio & la
dota fugędo lo negava. Pecohe
era eenato le prime vedea gli
dizordinati copegli di daphne
pendere per lo collo & dicea: ohe
seria costei se la pettinasse &
conzassese con maestrevole
mano: uedi come sono gli ochi soi
resplendeti similli ale stelle. poi risguar-
dana la bella bocha. & cio alui non
bastana lo vedere lodana le braccia:
le mani & le deta pensando che le
cose copte srano assai migliore &
piu belle. La dona si come lei lo
uede fugia incontanente piu ueloce

A.

auf d Volka Apollo u Amor.

A.

4 Proetus begrüßte sie zu Efa, Nti
Mädchen aber vaigerte sich meßfleß
ihn fort. Denn als der Tag anbray
[?] sah er vie Dephnes Haare nac
auf den Nacken parffiialen und
sagte zu sich: Wie würden sie erst
aussehen wenn sie sie kämmute was
mit gusfickte haar frisch

Figure 6.17 Aby Warburg, *Der Bilderatlas Mnemosyne* (1927–29). Detail of panel no. 39, " Botticelli. Ideal Style . . . Images of Venus. Apollo and Daphne = Metamorphosis."

movement has been transferred into the flowing hair and swirling mantel of Apollo, as if the psychological excitation of the scene has been driven to the very edge of the ensemble. In his sketch of the same woodcut, Warburg traces in close detail the intricate folding of Apollo's fabric, as if in an attempt to map this curious transposition of movement (fig. 6.18).[67]

Figure 6.18 *Left*, German Master 1B, woodcut with Apollo and Daphne (L 11) from Stechow, *Apollo und Daphne*; *right*, drawing of the same woodcut with manuscript notes by Aby Warburg. WIA. ZK [12], "Antike Vorprägung," 061/035564. Photo: The Warburg Institute, London.

But Warburg never questioned what happens to Daphne's fluttering garments when the nymph turns into a tree; in other words, what is the fate of clothing after the body of the carrier is removed from the human realm? As art historians later noticed, painters adopted several solutions to this problem. The illustration of Christine de Pisan's *Letter to Othea* demonstrates that Daphne can remain skirted after her metamorphosis, or even fully clothed, as in Pollauilo's painting of the nymph.[68] In this case, the dress functions as the rudiment of the human condition: its stillness connotes that the carrier has been removed from the earthly domain. As pointed out by Warburg, it was Alberti in his *Della Pittura* who instructed artists to depict branches that "twist upwards and downwards" and then to paint the folds of garments in the same manner, adding that "folds should grow like branches from the trunk of the tree."[69] In other words, there was already a "vegetal" pattern inside the movement of the fabric. Daphne's clothed branches represent the point at which object and metaphor, as well as pattern and artifact, ostensibly merge.

Later artists would evade the question of clothing by depicting the nymph entirely nude, as in the case of Bernini's Daphne, who is only partially covered by the mounting pieces of the tree bark. But there is also an intermediate group of representations of Daphne that exhibit an apparent continuity between bark and clothing. In the woodcut attributed to Schiavone, for example, which shows Daphne and Apollo from behind, the nymph's skirt appears to dissolve within the tree's trunk and lower branches before it finally merges with the ground (fig. 6.19). Like her flesh, her skirt has also transformed into wood. Hair, fabric, bark, and earth appear as a single undulating surface consisting equally of organic and inorganic materials.

Even Bernini's nude Daphne displays a similar continuity, not only in the tree roots growing from her toenails, but also in the profile views of her

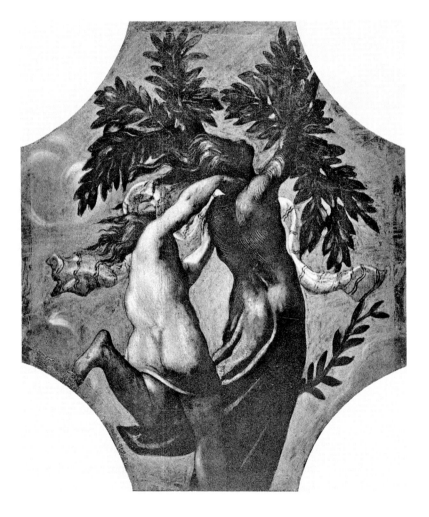

Figure 6.19 Apollo and Daphne, attributed to Andrea Schiavone (Modena), illustrated in Stechow, Apollo und Daphne.

hair and arms, which, while transforming into vegetal substances, become almost entirely *abstract*. Flesh, hair, leaves, and fabrics become indistinguishable (fig. 6.20). Everything turns into a sprawling mass, suffused by a protean indeterminacy reminiscent of the mythic cosmogonic associations in Ovid's *Metamorphoses*. While heavily inert, the abstrusely sculpted marble pieces appear to fly in the air with incomparable buoyancy. Since Bernini's statue was originally situated in a lateral axis adjacent to a wall, spectators would have had

Figure 6.20 Bernini, side view of *Apollo and Daphne* (c. 1624). Galleria Borghese, Rome.

difficulty seeing these wildly transforming masses. Perhaps in its resolutely de-humanizing aspect, such chaotic interpenetration of materials was deeply *obscene* or unimaginable. Bernini achieves an incomparable degree of animation through the depiction of peripheral bodies or accessories *not* in motion, but in an enigmatic form of stillness. *Accessories-in-motion* turn into *accessories-in-inertia*: the fact that Daphne initially carries the former and ultimately embodies the latter demonstrates the essential continuity between forms of *dynamic* and *static* animation.

Coral Daphne

One discovers additional evidence of the nymph's sustained affinity with both vegetal and mineral realms in a pair of sixteenth-century silver statuettes of Daphne by the German master Wenzel Jamnitzer in which a piece of coral is affixed to the top of her head, representing the tree (fig. 6.21).[70] A vegetal organism resembling a stone that grows and breaths, coral is ideal for the plastic representation of Daphne.[71] Ambiguously situated between the earthly realm and the marine underworld, coral emulates the twofold nature of Daphne, who as the daughter of Gea (earth) and the river Peneus, combines fluvial sources with solid earth layers.

Figure 6.21 Left, Wenzel Jamnitzer, *Daphne*, statuette made of silver and coral (Nuremberg, c. 1570–75). Écouen, Musée national de la Renaissance. *Right*, Wenzel Jamnitzer, *Daphne*, statuette made of silver and coral (Nuremberg, c. 1579–86). Staatliche Kunstsammlungen, Dresden.

Because coral growth does not emanate from a core, like a tree, but extends laterally, the crown of the two sixteenth-century statuettes is essentially a circular flat disk, reminiscent of a mirror. When seen in profile, the coral top turns into an increasingly thin cluster of lines extending from the nymph's hair (fig. 6.22). Since the two material parts of the statuette are almost the same height, the nymph's coral crown appears as an inverted projection of her silver base. Looking at the statuette's tilting profile, it is as if the mineral Daphne merges with the symmetrical reflection of her figure projected upon her vegetal counterpart. Such mirroring creates a virtual circle between subterranean and marine life. Half silver and half coralline, half mass and half surface, the sixteenth-century statuette manifests not only the division, but also the essential continuity between varying spatial dimensions and materials. This Daphne demonstrates the essential *plasticity* of so-called inert matter. It proves that the inorganic is not monolithic; instead it combines two opposite sides, one of fixity and stillness, the other of metamorphosis and change (see plate 10).

Transgressing Aristotle's fixed hierarchy of the four material degrees of the soul, Daphne appears to make leaps across that scale.[72] She drops two steps down from the human to the vegetal condition, yet momentarily she also

visits the animal realm, when Ovid describes her as a frightened "hare" chased by Apollo the "hound."[73] From the animal state she will again drop down two degrees to the realm of stone, as she petrifies into a tree or, as Lacan described, into an architectural monument. While Bataille described the human species as the product of a genealogical development from the ape-human to an architectural edifice, Daphne does not exactly follow such an idealizing progression.[74] The nymph does not go through the stages of life in a straight line, but rather in a jagged, erratic one; she makes zigzags in the course of her (d)evolution, retracing the undulating curves of her meandering flight.

Daphne's four types

Though preoccupied by Daphne's flight, Warburg never wrote extensively on her figure. Like several of the aborted subjects of his dissertation, the arboreal nymph remained a shared thread among several open-ended investigations, some of which would be carried through by other scholars of his circle.

In September 1928, Fritz Saxl, then codirector of the Warburg Library in Hamburg (KBW), was confronted with an almost uncanny coincidence. Upon returning to Hamburg from a trip to Göttingen, where he had met with Wolfgang Stechow, a young scholar and assistant at the Warburg Library who was researching the iconographic theme of Daphne, Saxl received a manuscript by another scholar, Valentin Müller, assistant at the Berlin Archaeological Institute,

Figure 6.22 Wenzel Jamnitzer, side view of *Daphne*, statuette made of silver and coral (Nuremberg, c. 1570–75). Écouen, Musée national de la Renaissance.

who was also working on antique representations of the nymph. Müller had forwarded to Saxl his manuscript, hoping that it would be published by the KBW. However, the Warburg Library was already committed to publishing Stechow's research. In a rather diplomatic reply to Müller, Saxl proposed that the Berlin archaeologist contact Stechow to discuss their common interests. He also suggested that, since Müller's study mainly dealt with Greco-Roman art and Stechow's with the "afterlife" of Daphne in the Renaissance and baroque periods, both studies could be published in one volume of the *Studien* produced annually by the KBW.[75] In a separate letter to Stechow, Saxl recounted the "comic story" of discovering another work on Daphne and repeated his plea for the two scholars to collaborate.[76] However, after a series of exchanges, such a collaboration did not materialize.[77] Müller's study would eventually be published in 1929 by the German Archaeological Institute in Rome, and Stechow's in 1932 as a monograph in the KBW *Studien*, three years after the death of Warburg, who maintained an active interest in Stechow's project.[78] Even in her historiographic legacy, the nymph continues to bifurcate.

While they were never *married* in the same book, the studies by Müller and Stechow share a number of methodological similarities. They both aim at a structural interpretation of the various representations of the myth via a combination of iconographic analysis and formal and typological analysis. Examining representations of Daphne in antique artworks, Müller distinguishes four "types" (fig. 6.23). In the first, the nymph appears entirely human, save for a few subtle signs of her vegetal transformation, such as the small laurel twig that she holds in her hand or that grows from her hair, as shown in a mural from Pompeii. In the second type, there are much more extensive changes in the female body: the nymph appears to be merging with the tree while the tree branches grow directly from the arms, as demonstrated by the ancient sculpture exhibited in the Villa Borghese. The third type portrays a different form of transformation, in which the human body remains essentially unaltered, yet is enveloped peripherally by the tree as if the latter were a garment or accessory worn on top of the human skin. The distance between the human and the vegetal state is increased in Müller's fourth type, in which Daphne appears merely "standing" inside a tree, as shown in a Coptic tapestry. In this case, the human and vegetal contours are superimposed on top of one another, yet they entirely lack the sense of fusion that was discernible mainly in the second type.[79]

Searching not only for the iconographic but also the ethnological origins of Daphne's representations, Müller attributed the first two types to Greek sources, and the last two to Middle Eastern—predominantly Syrian and

Abb. 1. Pompeji, Casa dei capitelli colorati.

Abb. 3. Mosaik im Museum zu Tebessa.

Abb. 4. Mosaik aus Marino.

Abb. 6. Koptischer Stoff.

Egyptian—prototypes.[80] The Berlin scholar suggested that the Greek models emphasize movement and "becoming" (*Werden*), while the Oriental ones convey *stasis* and eternal "being" (*Sein*). Based on terminology borrowed from Riegl, Müller further characterized the Greek type as "organic"—due to its associations of internal change and rhythmic transformation—while the Coptic one was deemed "crystalline" for its connotations of solidity, permanence, and endurance.[81] While the organic Daphne emphasized hybridity and unification and portrayed the "equality of being" among all natural states, her

crystalline rendition was based on a mere "addition of heterogeneous proper-
ties" and demonstrated a rigid form of hierarchy. Müller compared the crys-
talline version of the Coptic Daphne to the animal-headed gods of Egyptian
religion, whose human and animal components, though solidly attached to
one another, remain fixed and limited *within themselves*. Müller concluded
that it was the Greek organic model of "life and movement" that triumphantly
survived in Daphne's pictorial legacy in the modern era, beginning with the
Renaissance and continuing with the baroque.

Cinematic Daphne

Figure 6.23 Valentin Müller,
four types of Daphne repre-
sentations in antiquity. *Top
left*, fresco, Casa dei capitelli
colorati, Pompeii; *top right*,
mosaic, Museum of Tebe-
ssa; *bottom left*, mosaic from
Marino; *bottom right*, Coptic
fabric. From Valentin Müller
"Die typen der Daphne-
Darstellung," *Mitteilungen
des deutschen archäologischen
Instituts* 44, no. 2 (1929).

Figure 6.24 Cassone paint-
ing of the story of Daphne,.
(Florentine[?], c. 1450). From
Stechow, *Apollo und Daphne*.

And here is where Stechow takes up the baton in Daphne's typological chase:
If Müller emphasized "contour" and "becoming," the main concepts of the
young art historian of the Warburg circle were "movement" and "transforma-
tion." Underlining the periodicity in Daphne's iconographic evolution, Ste-
chow's investigation appears to be informed by the cinematic problematic
of Panofsky's early essays on "rhythmic art."[82] The young art historian shows
how medieval and Renaissance illustrators use Ovid's version of Daphne's
metamorphosis like a script, based on a succession of different action scenes:
Apollo sees Daphne; Apollo chases Daphne; Daphne transforms into laurel
tree; Apollo laments in front of the tree (fig. 6.24).

Based on the previous sequence of actions, Stechow distinguishes two
iconographic themes involved in all representations of Daphne: "flight or pur-
suit" (*Flucht* or *Verfolgung*) and "metamorphosis" (*Verwandlung*). Medieval
illustrations are static and never represent Daphne's flight or amorous pursuit
by Apollo. They usually depict Apollo either watching in amazement or offer-
ing the laurel crown to Daphne, who is in the midst of her metamorphosis.
But in medieval depictions of the nymph there is no real interaction between

 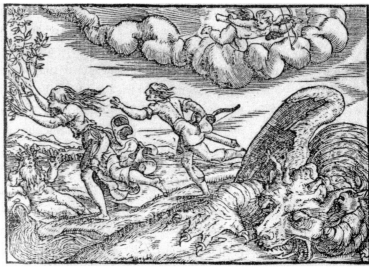

Figure 6.25 Left, static representation of Apollo and Daphne from the early Renaissance, *Apollo and Daphne*, miniature from Christine de Pisan, *Epître d'Othea* (French, c. 1405–10), ms. harl. 4431, British Museum London, fol. 134v; *right*, illustration of Daphne's metamorphosis during flight from the late Renaissance, woodcut with Daphne and Apollo from L. Dolce, *Transformazioni* (Venice, 1553). From Stechow, *Apollo und Daphne*.

the human and the vegetal components: the tree is merely piled up on top of the woman (or the other way around), similar to Müller's fourth Daphne type. The metamorphosis appears suspended rather than evolving (fig. 6.25).

On the contrary, Renaissance artists—and here Stechow echoes the themes of Warburg's dissertation—introduce "movement" (*Bewegung*) and "intensified liveliness" (*gesteigerte Lebendigkeit*) by representing the scene of Daphne's flight.[83] In the early Renaissance, flight and metamorphosis appear in two or more separate scenes: Apollo runs after the nymph and then embraces the laurel. But in the late Renaissance, the two scenes are compacted into a single moment: Daphne sprouts branches while she runs, with one leg raised and the other already merging with the ground. It is as if the nymph keeps moving even after she is petrified.

Stechow's two themes—*flight* and *metamorphosis*—imply that Daphne essentially embodies two types of movement. While the nymph flees from Apollo, she meanders across the trees. When she is arrested, her body spirals across the axis of her own tree. The first movement is horizontal, the second is vertical. While perpendicular in direction, the two movements follow a similar curvilinear pattern. During her flight, Daphne follows a serpentine pathway as she meanders between the trees. In two consecutive images from a fifteenth-century Florentine *cassone* painting, Daphne's winding trail is represented by a snakelike band. It is as if her own pathway retraces the body of the python, earlier extinguished by Apollo (fig. 6.26). The second movement

Figure 6.26 Daphne in flight, meandering pathway: Cassone painting with the pursuit of Daphne by Apollo. London, collection of Earl of Harewood (originally from Florence, c. 1450). From Stechow, *Apollo und Daphne*.

is essentially invisible, but all the more diagrammatic. As soon as Daphne is arrested, instead of ceasing, movement and action twist frenetically upward. The first motion is an externalized dynamic form based on continuous progress in space and similar to Warburg's concept of surface mobility (*äussere Beweglichkeit*). The second movement is a static imperceptible vibration reminiscent of the inner liveliness, which "attaches" to the "animation of the inorganic." In Deleuze's (and Worringer's) terms, Daphne "is inorganic yet alive and all the more alive for being inorganic."[84]

• • •

Stechow is not the only author who realized the cinematic potential of Daphne's metamorphosis. In a 1914 article titled "Cinema as an Instrument of Liberation and as Transfiguration Art," the well-known Italian poet and critic Gabrielle d'Annunzio (who is mentioned in Warburg's correspondence, while the German art historian lived in Florence)[85] praises the cinematographic potential in Ovid's *Metamorphoses* and then singles out an "experiment" he performed with one of the Ovidian characters: "The *Metamorphoses* of Ovid! Here is a true screenplay. [In cinema], there is no technical limit in the representation of a dream. I wanted to experiment with the Daphne fable. I only did an arm that starts to foliate from the fingertips until it is transformed into a rich bay bough as in the painting of Antonio Pollaiulo . . . There, supernatural life was represented as palpitating reality."[86] D'Annunzio's infatuation with

[303] Daphne's Legacy

the nymph turns into an obsession when, toward the end of his essay, he declares: "I cannot stop thinking of the delicate arm of Daphne transformed into a leafy bough. The true and unique property of cinema is transfiguration and I say that Ovid is its poet."[87] For D'Annunzio, Daphne expresses the extensive "transformability of forms" and only cinema can recover that animate potentiality contained in Ovid.

Commentators have noted the authorial agency manifested in the phrase "I only did an arm," and yet the poet's obsession by the same "leafy bough" shows that the same hand can be quite active and become an agent in and of itself. Daphne's arm has the autonomous reflexivity of Warburg's *Pathosformel* and cinema reproduces this gestural automatism. However, Daphne's raised arm expresses a very different pathos formula than the one Warburg identified in the figure of Orpheus. Here, the subject does not try to abort a fateful outcome, but voluntarily welcomes it. Daphne herself asked her father Peneus to "change" her and "destroy" her "baleful beauty";[88] Peneus simply granted her wish to be transported from the earthly realm. Daphne's "leafy arm"—as seen earlier in Bernini and now in D'Annunzio—is the organic appendage of her *being* that plunges into the animated abyss of *becoming*.

Symmetrical identifications

Figure 6.27 Figure 1.1 Carlo Cignani, *Apollo und Daphne.* Parma, Palazzo del Giardino. From Stechow, *Apollo und Daphne.*

Stechow remarks that Daphne's iconography changes upon the appearance of her father, who was invoked (yet was not necessarily present) in the description of the myth by Ovid (fig. 6.27).[89] The introduction of Peneus's figure causes a seminal alteration in the geometry of the scene between the two would-be lovers by producing a series of compositional triangulations. If the female Daphne is a model of frantic speed, Peneus exudes *slowness*. The horizontal body of the river god, crawling between earth and water, is in perfect contrast with the vertical agitated figure of his daughter.

It is well known that toward the end of his life Warburg identified with a similar catatonic figure. Describing his work as a psychological "reflex" that expressed the essential "schizophrenia of western civilization," the art historian juxtaposed the figure of the "manic" or "ecstatic nymph" on one side, and the "depressive" or "mourning river god" on the other.[90] It was in fact Warburg (and more recently Hubert Damisch) who reminded us that a similar "river god" included in one of Raphael's depictions of the *Judgment of Paris* transformed into one of the figures of the leisurely group in the center of Manet's *Dejeuner sur l'herbe*—an iconographic transformation that shows that Daph-

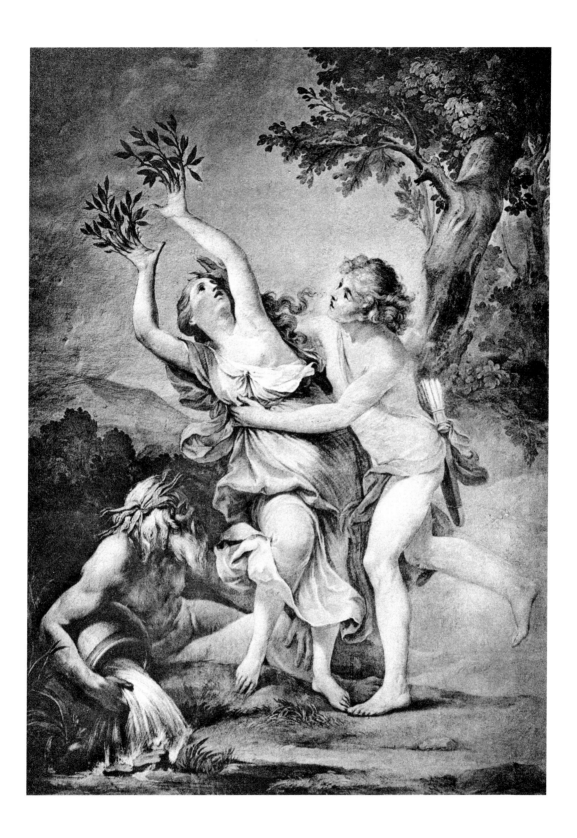

ne's father has his own art historical legacy, which meanders as much as that of his daughter.[91]

All of these iconographic transformations signify that Daphne's legacy is tied to the afterlife of other characters, who are in turn attached to her fate. She is not a single figure, but a constellation of versatile identifications. Apollo, too, becomes Daphne, and transforms into a tree. Lacan explicitly states such in yet another of his "digressions" to the Ovidian myth during his 1963 seminar on the topic of anxiety: "They tell us that it is Daphne who transforms herself into a tree, and that is where they are hiding something from us. They are hiding it—this is very surprising—because they are not hiding it from us at all. After the transformation, the laurel is not Daphne; it is Apollo. The particular [attribute] of the god is that once satisfied, he transforms himself into the object of his desire, even if in so doing he must petrify himself at that point." [92]

Figure 6.28 Barthel Beham, *Apollo and Daphne*. Engraving. From Stechow, *Apollo und Daphne*.

Action and effect both mirror and at the same time paralyze one another. The subject freezes the very moment he (re)unites with the object of his desire; he becomes *it*—an entity that becomes mortified by its realization.

As in Dalí's "transcendent" union with the object, the male subject is both shattered and reconstituted by an idiopathic form of identification. Indeed, in a sixteenth-century engraving by Barthel Beham, illustrated in Stechow, it is Apollo who becomes petrified. The god raises his arm to protect himself from a timorous Daphne in a gesture that echoes that of Orpheus (fig. 6.28).[93] The nymph turns into a maenad by raising her vegetal arm as if to lash the god, and thus assumes the role of the pursuer. Apollo is persecuted by his own wish—an inverted symmetry that further binds the two figures in one and the same ensemble.

In one of the final addenda to his dissertation, Warburg links Petrarch's sonnet "Laura and Lauro"—modeled after Daphne and Apollo—to Lorenzo's identification with his beloved Simonetta (which, according to Warburg, acted as a source of inspiration for Botticelli's portrayal of ill-fated love in the *Primavera*).[94] In empathy with the grieving male hero, Petrarch exclaims "*Anch'Io son Lauro*," acknowledging the poet's own transformation into laurel. In a manuscript illustration

of Petrarch's sonnet reproduced in Stechow's book, the male poet, crowned by a laurel, appears enclosed inside a tree trunk with leafy arms raised high on air.[95]

It is as if the *mobility of identity* occasioned by the use of "accessories-in-motion" is ultimately arrested into a single identification. Enveloped by the same vegetal form, a host of figures regress to a common inorganic level. In the end everyone and everything becomes a Daphne. In her unique transformation, the nymph turns into a general effect—a *field* of psychological and physiological responses in which all animate bodies are homogenized.

Daphne's landscape

Stechow closes his account by appending two more Daphne representations that could not be classified under any of the iconographic types the art historian had previously established. Both of these images point to the ultimate transformation of the nymph not into a tree or other individual object, but into a form of landscape. First, a fresco by Bernardino Luini in Brera, Milan, which depicts a nude female figure projecting from a tree in an idyllic landscape together with a young man in a pensive pose, as well as an older male figure that emerges from the water. The three characters share a number of similarities with the personages of Daphne, Apollo, and Peneus, but Stechow could only tentatively identify them as such (and in fact later scholars have rejected such an identification) (fig. 6.29).[96] As in Cohun's self-portrait, the nude female is not *entering into* the tree, but instead she is gradually *coming out*. But here, Luini's figure does not attempt to escape her enclosure. She protrudes plastically from the trunk, as if she was projected through the bark. Her image intrudes not only the tree, but also the memory of the two men who do not *see* but *envision* her without returning her gaze—for they inhabit a different space than she. This figure also extends her arm, yet not in a frightened defense, but as an invitation to join her vegetal realm—an area that may ostensibly coexist with, while at the same time transcends the earthly territory. Luini's representation proves once more that the vegetal realm in which this female has descended is not a finite or a solid state, but a plastic threshold from which she can periodically emerge *reanimated*.

Daphne's reappearance as a phantasmatic female figure recurs in the last of Stechow's illustrations, a painting of Apollo crowned by a laurel by Dosso Dossi installed in the Galleria Borghese, across from Bernini's *Apollo and Daphne* (fig. 6.30).[97] Warburg mentions this painting in his notes on Daphne, describing Apollo as rapturously "enthralled" (*begeistert*).[98] Yet the

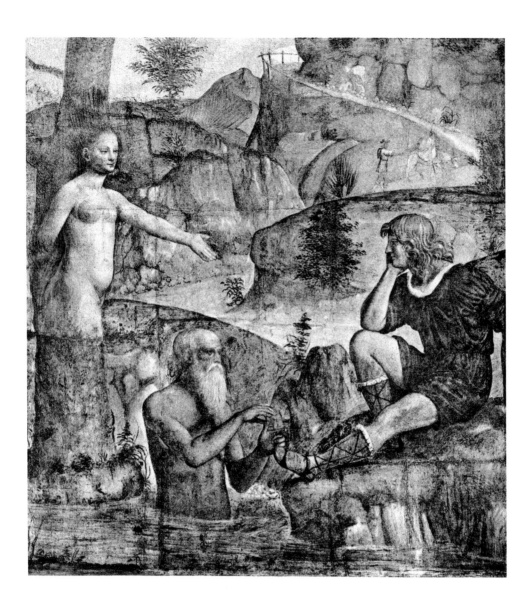

Figure 6.29 Bernardino Luini, *Apollo and Daphne* (according to Stechow). Fresco fragment, Brera Pinacotec, Milan. From Stechow, *Apollo und Daphne.*

nymph herself is hardly visible in Dossi's image; radically shrunken in size, she appears underneath Apollo's arm as she vanishes inside the trees. It is as if Daphne has transformed into Apollo's *viola da braccio*—the baroque string instrument that would replace the lyre that antique poets had placed in the hands of the sun god. But more than a musical instrument or any other individual object, Dossi's Daphne essentially transforms into a background as her figure merges with the forest to become a miniscule ornament. The nymph's miniaturization paradoxically marks the radical expansion of her figure into the infinite space of a forest.

Figure 6.30 Dosso Dossi, *Apollo* (1524).
Oil on canvas. Room of Bernini's *Apollo
and Daphne*, Galleria Borghese, Rome.
From Stechow, *Apollo und Daphne*.

Sonorous abstraction

Perhaps the most spectacular of Daphne's "abstract" metamorphoses occurs
in musical theater. For if Daphne and architecture might put forth a novel
combination, Daphne and opera definitely does not. Stechow in fact closes
his account with an analysis of the first Italian opera—a *Dafne* by Jacomo
Peri and Ottavio Rinuccini (1597–98).[99] The first German opera (1627, by
Heinrich Schütz) also takes *Daphne* as its subject.[100] In many early theatrical
representations of Daphne, including Rinuccini's opera, Daphne's transfor-
mation does not occur on stage; instead, we learn about it from a messen-

Daphne's Legacy

ger, a shepherd who tries to convey the nymph's tragic fate in an ornamented aria. With Daphne absent during the denouement, her role in the narrative consequently diminishes while Apollo's increases—a proportional character shift not unlike that of Eurydice, who, in the operas by Monteverdi and later composers, gradually disappears under the weight of Orpheus.[101] Despite the eponymous title of the opera, the leading lady hardly appears on the stage. She is present as an *absence*—a void that structures the narrative.

This tradition changes during the baroque era, whose theatrical intermezzi and other spectacular displays would labor to represent all of Ovid's *belle metamorfosi* in front of the audience through the use of ingenious artifice. In the Daphne *opera mascherata*, for example, the actor-singer would be replaced on stage by a vegetal machine—a "talking tree" with flailing branches.[102] But this was the baroque Daphne. While equally spectacular and fastidious in mechanical inventions, the *modern baroque* Daphne portrays a different form of abstraction.

This is the case with the most well-known twentieth-century Daphne—the heroine of the 1938 opera *Daphne* (subtitled *A Bucolic Tragedy*) by Richard Strauss, which was performed in several theaters on fascist territory

Figure 6.31 Left, stage set for the first performance of Richard Strauss's opera *Daphne* (1938), Dresden Staatsoper. Stage sets by Adolf Mahnke. Costumes by Leonhard Fanto. *Right*, the soprano Margarete Teschemacher singing the role of Daphne in its first performance in Dresden, wearing a dress with flower motifs copied from Botticelli's *Primavera*.

throughout the Second World War (fig. 6.31).[103] In the opera's last scene, after Daphne renounces Apollo, the god disappears, and then the scene suddenly changes. As marked in Strauss's and Joseph Gregor's libretto: "It becomes solid dark. Daphne gets herself together and hurries to the background. Suddenly she is fixed in place [*festgebannt*]." As Daphne runs, the string accompaniment becomes frantic. Suddenly, a clash is heard that marks Daphne's arrest; the tempo drops from "very fast" (*sehr schnell*) to "moderately slow" (*mässig langsam*), and the music is now played exclusively by the wind instruments. From the dark stage we hear Daphne's voice without seeing her. Singing in a very high dissonant tone, the soprano murmurs: "I'm coming, I'm coming, verdant brothers! [*Ich komme, Ich komme, grünende Brüder!*]" Following these orgasmic exclamations, the nymph's voice disappears, and the orchestra alone narrates the metamorphosis in a highly melodic interlude that lasts for several minutes. In the final bars of the opera, the singer's voice is heard again, but as a wordless vocalism marked *pianissimo* and expiring before the final lagging bars played by the string instruments. "The tree alone sings": such was Strauss's expressed intent for his finale.[104]

In Strauss's opera, Daphne turns not only into a tree, but also into a sonorous abstraction. Even if paralyzed within neoclassicist aesthetics, the composer's "bucolic" heroine is quintessentially modern. Her transformation into an ambient background portrays the *ineffable* character of her metamorphosis. From now on she will no longer transform into a tree; she'll simply disappear.

Daphne in the city

Daphne, then, acts as both figure and ground, object and landscape. The nymph was partly a tree even before she ultimately transformed into one. In Strauss's *Daphne*, the only objects with which the nymph could identify were trees, which she considered her brothers or sisters and by which she is devoured while running inside the forest during her flight from the god. We could diagnose her affliction as "legendary psychasthenia," the fear of being consumed by space, explored by Caillois in his article on insect mimicry first published in *Minotaure* in 1935.[105] Daphne's metamorphosis is a form of camouflage, by which the subject performs a lethal turn toward the enclosure that inhibits its progression. Similar to turn-of-the-century agoraphobics, the nymph instantly freezes in space, yet she continues breathing within the limits of her vegetal inertia. Daphne, then, is related not only to the origins of architecture, as suggested by Lacan, but she also represents the psychological effects *caused* by architecture—architecture is her new Apollo.

In a modern retelling of the myth that appears in a 1926 popular (and rather unimaginative) novel titled *Daphne* by Jacques Chenevière, after having an argument with her impatient lover, the female heroine suddenly disappears into the shadows of a park.[106] The transformation's lack of reason is mirrored by its abstract "nonobjective" form. In fact, here Daphne hardly transforms. She simply vanishes from sight: she could be anywhere inside the park. Like Breton's *Nadja* (who was always afraid of trees), the mysterious female withdraws from visibility by retreating into an arboreal asylum.[107]

We saw how Léger's forest gradually created a virtual entry to the modern city. The twentieth-century representations of Daphne, from Dalí to Strauss to Chenevière, describe a similarly metropolitan perspective. By sliding inside her arboreal setting, Daphne becomes one with her environment. Not only does she become architectural, as Lacan would put it, but she becomes *urban*. She exposes herself to the metropolitan milieu by expanding her distress into a circuitry of ever-expanding intensity.

Léger's pictorial statement in his *Nus dans la fôret* that *"we* [*n(o)us*]," too, have become nudes or trees inside a forest echoes Petrarch's confession *"Anch'Io son Lauro"*—"me, too," a male laurel. But here this "me" or "we" does not signify an idiopathic form of personal identification, but the uncanny assimilation with an intersubjective domain. Perhaps the architectural legacy of Lacan's "actualization of pain" is better represented not by the "masochist" (as Dalí would say) buildings of modern architecture, but by the complex architecture of the *bodies* housed inside these arboreal abodes. Considering the amount of excitation that modern subjects have learned to tolerate, *they, too,* have become trees deserving to be crowned by a laurel. Turn-of-the-century sociologists like Simmel, concerned about the overstimulation of the metropolitan subjects' "mental life," would be overwhelmed by the miraculous perseverance of these semivegetal organisms, who strive to enhance their persona by rigidifying the external surface of their skin. Like fin-de-siècle agoraphobics, Daphne embodies life inside paralysis, the frenzy of inertia, *inanimate* animation. Her vegetative amnesia is the quintessential aesthetic mode of the modern viewer's "animation"; once again, *pleasure* would be too "empathetic" a term to describe this mortifying bliss.

Daphne from beyond

Philologists tell us that in addition to a *link* with ancient or contemporary narratives, Daphne's myth also functions as a cosmogonic origin describing the earliest states of creation. Daphne appears on the frontispiece of several of

Ovid's seventeenth- and eighteenth-century printed editions, representing not only the inspiration of the poet, but also a number of cosmic elements— such as earth and water—associated with the emergence of the world from chaos.[108] But if Botticelli's *Birth of Venus* (following Warburg's reading) was essentially a Renaissance "cosmogonic allegory," and Léger's *Nudes in the Forest* presented the modernist version of a *Création du monde*, what cosmic transformations might Daphne's twentieth-century revival presage?

Perhaps similar to Warburg's animated accessories and Léger's inorganic nudes, Daphne's cosmic allegory does not signify a cataclysmic evolutionary change, but a more subtle epistemological transition—an "abstract" metamorphosis signaling the transfusion of the human subject within the larger network of her technological surroundings. Daphne's metamorphosis describes those radical instances of paralysis in which the body transforms into a landscape of arboreal effects precariously oscillating between life and mortality reminiscent of the Laocoönian problematic. Both Daphne and Laocoön depict those critical moments in which causes and effects, as well as sensation and memory, become fused in a cluster of intertwined bodies—snakes, hair, branches—objects with no definable shape, agency, or limit. In such statically animated assemblages, everything becomes a heap of indeterminate forms, reminiscent of the pile of bodies and vegetal debris portrayed in Léger's *Nudes in the Forest*.

A prerequisite for such animistic transactions is their "abstraction"—the unknown origin (and outcome) of their figurative, gestural metamorphoses—a main attribute of the modern Daphne. Hence it would be a misunderstanding if, after reviewing the several reappearances of Daphne in the twentieth century, we assumed that her figure is ubiquitously *visible*. Though she might be everywhere, similar to snake motifs, Daphne's own ornamental pattern becomes increasingly imperceptible. As in the finale of Strauss's opera, her "voice" emerges neither from the foreground nor the background of the stage, but simply from somewhere "beyond."

In his ninth seminar on the concept of identification, Lacan would return to the figure of Daphne via another momentous digression. Following a remark on myth and "the limit of mortality" defined by the "beyond [*au-delà*]"—a domain that, for Lacan, signifies a point of reference or even a "perspective" within analytic practice—the psychoanalyst added: "Hence this point of view is not one that is ever completely abstracted from our thought; in an era when the tattered fingers of Daphne's plant, on the verge of appearing as a figure against the ground charred by the giant mushroom of our omnipotence—which is always present in the horizon of our imagination—are

here to remind us of *the beyond* from whence the viewpoint of reality may bear upon."[109] Once more, the associations are breathless, as well as breathtaking. Daphne is no longer a tree, a statue, or a monument; she is the representative of an elusive yet terminal domain that lies at the end of a perspective. Moreover, the nymph is not a negative or positive object of identification, but instead represents the very act of an entire *plane* of identification that is "beyond" reach. But similar to the vegetal figure painted by Luini, Lacan's Daphne is essentially a "field"—a region that, while nourished or embellished by the vegetal effervescences or "mushrooms" of our psychic powers, remains separate from human consciousness.

How can we then bridge Lacan's first reference to Daphne as the "presencing of pain" in architecture to this last invocation of the same figure as the general representative of a transcendental domain? It appears that Daphne's ultimate architectural significance is her function as a permeable *limit*, not only between "pain and pleasure," as Lacan's seminar on ethics earlier demonstrated, but also between physics and metaphysics—as his seminar on identification would later disclose. Her very fixation in space opens up an entire perspective that can never be located on a single plane. Wall, enclosure, and, finally, the extension into ineffable landscape may act as the three stations of Daphne's architectural metamorphosis, yet none of them marks a finite stage.

Daphne's epilogue

If Daphne essentially serves as an introduction to the field of animation as well as a model of perpetual transition, it might be doubly paradoxical to present her myth as a general *conclusion* to this entire narrative. However, the nymph's vegetal appendages do not function as endpoints, but rather as extensions that can infinitely protract. Following the growth of such bifurcating excrescences, all conclusions must remain open ended.

The principle of bifurcation informs not only Daphne's vegetal morphology, but also her twentieth-century legacy—a heritage equally invested in the aggression of Dalí's aerodynamic forms and the serene soliloquy of Strauss's pastoral libretto. Such a split invites us to revisit the polarity between *phobic* and *extensional* forms of animation traced in the introduction to this book. From Darwin's dog and the swaying parasol to Meyrink's and Murnau's "malicious" houses, most of the examples arrayed in this history describe a form of animation designated as *phobic*. Daphne's petrification belongs to a similar category. Provoked by an unknown source, fear and a growing anxiety in-

stigate her metamorphosis. At the same time, following her transformation into a vegetal organism, Daphne becomes a figure of physical and temporal extension, as she turns her fear into an ecstatic form of communication with nature. The nymph then becomes an emblem for both types of animation, *phobic* and *extensional*, as well as (to invoke Vignoli's two categories) for *static* and *dynamic* vivifying states. But, like Worringer's concept of the "animation of the inorganic," Daphne does not harmoniously fuse or abrogate these oppositional states. She instead reifies the radical division that sets such polarities in motion.

It is as if Daphne's torn figure traces the rift that runs throughout the shifting ground of this eclectic history of animation: on the one hand, the "hostile external world" of turn-of-the-century anthropology, psychoanalysis, and history; and on the other, the pacifying "being-in-the-world" of a certain philosophy and metaphysics. But these two areas of animation are not symmetrically proportioned. Overwhelmed by instances of *phobic* animation, the narrative of this book only offered rare glimpses of its *extensional* side. Perhaps it is no accident that the only tentative alternative to this phobic predicament appears in the final chapter of this book, and yet only as a *myth*—Daphne's "expedient" or "objective fiction" derived from a historical mythology of *as if*. Meanwhile the relics of "phobic animation" not only survive but thrive and "maliciously" reproduce. Certainly, Freud's "hostile external world" does not begin with the fin de siècle and does not finish with the Second World War; for there are still several menacing Apollos running through the forests of the modern world, as well as unresponsive nymphs that reanimate their belligerent objectives.

· · ·

Facing an external environment that both threatens and invites, modern subjects react with a mixture of contraction and extension. They can say *yes* or utter *no* by the language of their gestures. However, the small branches sprouting from Daphne's fingertips show that even when organisms resist an impending threat and close their boundaries to their surroundings, their extremities automatically explode with manifold extensions (fig. 6.32). The subject's body reflexively protracts and heralds the external world that previously assailed her. Daphne's *inorganic* animation attests to the extensibility afforded by resistance—a reaction formation that shows the vital capacity of modern organisms (and modern architectures) to outgrow the boundaries of their petrification.

It is no accident that all three main *models* in the second part of this narrative—Léger's *Nudes*, Murnau's *Nosferatu*, and now Daphne—raise their arm

Figure 6.32 Caesar van Everdingen, detail of *Apollo and Daphne* (seventeenth century). Frans Hals Museum, Haarlem. From Stechow, *Apollo und Daphne*.

not only to resist, but also to welcome the very agency that takes hold of their existence. In its immobilizing "languor," this inexplicable force is the very agent of animation that *lifts* the human subject, while at the same time causes it to vanish.

Daphne's architectures—classical, baroque, art nouveau, streamlined, and surrealist—stand as solid proof of how modern subjects have learned to manipulate their fears and the miraculous plasticity of their desires. The nymph's built legacy displays the way that bodies in modernity have transformed their masochism into a house of pain, using their inorganic modes of resistance to engage in a transspecies communication with other forms of matter, whether vegetal, animal, or mineral—anything that might facilitate their flight from what we call *human*.

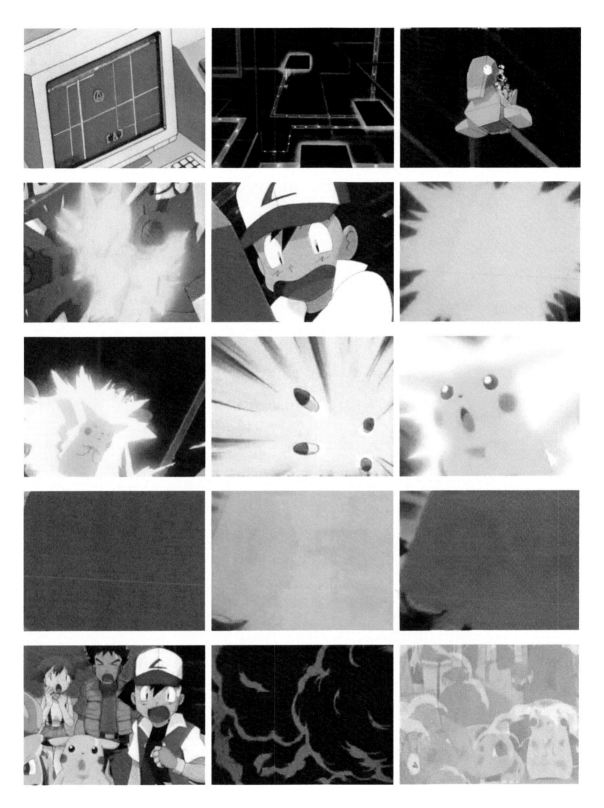

Plate 1 *Pokémon* cartoon series. From the episode *"Dennō
Senshi Porigon"* ("Computer Warrior Porygon"), 1997.

Plate 2 Sandro Botticelli, detail of
The Birth of Venus. Uffizi, Florence.

Plate 3 Aby Warburg, Zettelkasten no. 6, "Ikonologie-
Synthese," Warburg Institute Archive. Photograph: Ian
Jones for the Warburg Institute, London.

Plate 4 Colored frontispiece, Ernst Haeckel,
*Kristallseelen: Studien über das anorganische
Leben* (Leipzig: Kröner, 1917).

Flüssige Kristalle.

2. Zusammenfließen zweier Kristalle von ölsaurem Ammoniak.

6. Tropfen in I. Hauptlage.

8. Molekular-struktur.

9. Tropfen in polarisiertem Licht.

11. Tropfen zwischen gekreuzten Nicols.

3. Zylinder-Kristalltropfen.

4. Zwilling 5. Drilling zwischen gekreuzten Nicols.

7. Kristalltropfen in I. Hauptlage zusammenfließend.

1. Fließende Kristalle von p-Azoxybenzoesäureester.

14. Tropfen in II. Hauptlage

13. Molekular-struktur.

10. Kristalltropfen in polarisiertem Licht.

12. Tropfen zwischen gekreuzten Nicols

15. Gepreßter Tropfen in II. Hauptlage.

18. Gepreßte Tropfen zwischen halbgekreuzten Nicols.

20. Verdrehte Tropfen in natürlichem Licht.

16. II. Hauptlage 17. II. Hauptlage zwischen gekreuzten Nicols.

24. Zusammengeflossene Tropfen in polarisiertem Licht.

23. Zusammengeflossene Tropfen mit Grenzlinien.

19. Verdrehter Tropfen in II. Hauptlage.

22. Doppel-tropfen.

21. Tropfen in II. Hauptlage im Magnetfeld (Pfeilrichtung).

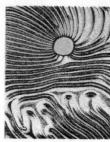

25. Keilförmige Masse zwischen gekreuzten Nicols

26. Verzerrte Masse in natürlichem Licht.

27. Verzerrte Mischsubstanz in polarisiertem Licht.

28. Trichitische Schicht-kristalltropfen.

Bibliograph. Institut, Leipzig

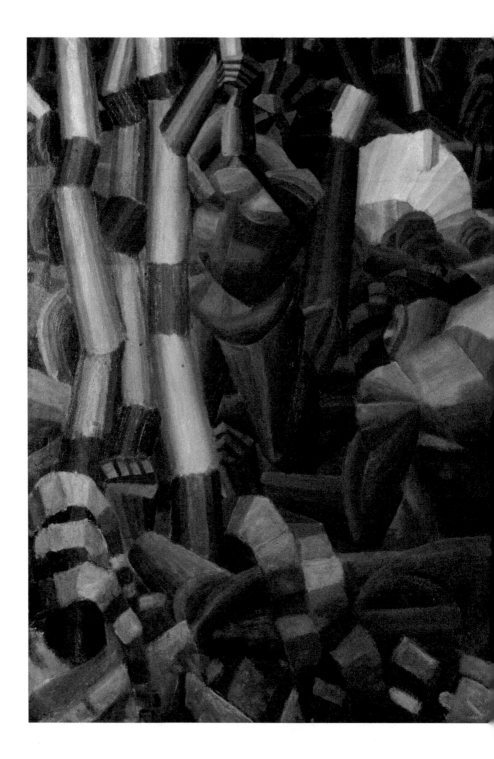

Plate 5 Fernand Léger, *Nudes in the Forest*
(1910–11). Kröller-Müller Museum, Otterlo,
Netherlands.

Plate 6 Fernand Léger,
detail of *Nudes in the
Forest.*

Plate 7 Fernand Léger, detail of *Nudes in the Forest*.

giardino

Nᵒ V du plan

Plate 8 Charles Percier, perspective view of
the Stanza of *Apollo and Daphne* by Lorenzo
Bernini (c. 1624) in the Galleria Borghese,
Rome. Watercolor and pencil (c. 1786–91).
Institut de France, Paris.

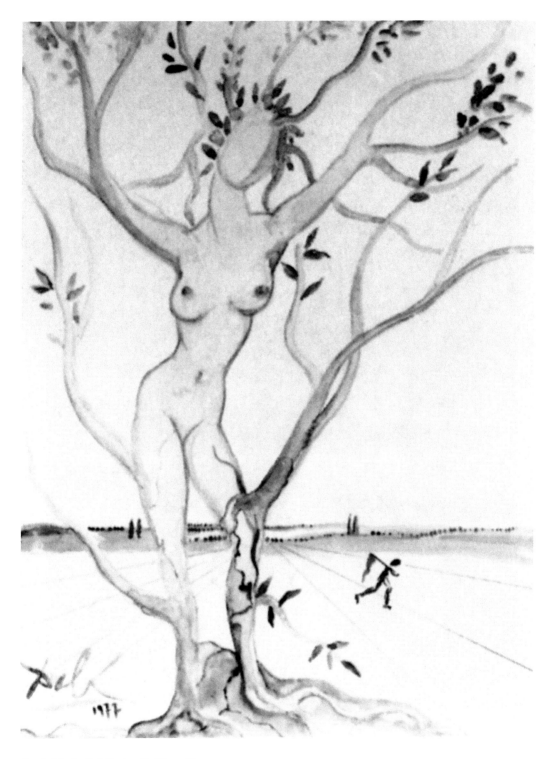

Plate 9 Salvador Dalí, *Daphne: The Woman-Tree*
(*Daphne: La femme arbre*). Watercolor on cardboard
(1977). Collection Italcambio.

Plate 10 Wenzel Jamnitzer, detail of *Daphne*. Statuette
made of silver and coral (Nuremberg, c. 1570–75).
Écouen, Musée national de la Renaissance.

Notes

Introduction

1. Sheryl WuDunn, "TV Cartoon's Flashes Send 700 Japanese into Seizures," *New York Times*, December 18, 1997, A3; "Pocket Monsters Shock TV Viewers into Convulsions," *Japan Times*, December 17, 1997; and J. Snyder, "Cartoon Sickens Children" and "Monster TV Cartoon Mystifies Japan," Reuters report on *ABC News*, December 17, 1997.

2. B. Radford and R. Bartholomew, "Pokémon Contagion: Photosensitive Epilepsy or Mass Psychogenic Illness?" *Southern Medical* 94, no. 2 (1 February 2001), pp. 197–204.

3. *"Dennō Senshi Porigon"* ("Computer Warrior Porygon") *Pokémon*, season 1, episode no. 38, first televised in Japan on December 16, 1997. The sequence of flashes that triggered the mishap happened twenty minutes into the program.

4. Umberto Eco, "The Wolf and the Lamb: The Rhetoric of Oppression," in *Turning Back the Clock: Hot Wars and Media Populism*, trans. Alastair McEwan (Orlando: Harvest Books, 2008), 56–57; Joseph Tobin, ed., *Picachu's Global Adventure: The Rise and Fall of Pokémon* (Durham: Duke University Press, 2004).

5. Millard Meis, *Painting in Florence and Siena after the Black Death* (New York: Harper & Row, 1964), 106. For a brief description of the episode, see *Leggenda Minore di S. Caterina da Siena e lettere dei suoi discepoli*, ed. F. Grottanelli (Bologna: G. Romagnoli, 1868), 156. For a more embellished description, see Johannes Jorgensen, *Saint Catherine of Sienna*, trans. I. Lund (London: Longmans, Green and Co., 1939), 371.

6. Rudolf Arnheim, "Abstraction and Empathy in Retrospect," *Confinia Psychiatrica* 10, no. 1 (1967): 7; also revised as "Wilhelm Worringer on Abstraction and Empathy," in *New Essays on the Psychology of Art* (Berkeley: University of California Press, 1986), 50–62.

7. Arnheim, "Abstraction and Empathy in Retrospect," 7.

8. In fact the next day Catherine had another severe attack, which left her unconscious for hours. In the last three months of her life, although paralyzed and refusing any food, she is said to have remained perfectly "clear in spirit." Jorgensen, *Saint Catherine of Sienna*, 372–94.

9. On Giottos Navicella and its legacy, see Helmtrud Köhren-Jansen, *Giottos Navicella: Bildtradition, Deutung, Rezeptionsgeschichte* (Worms am Rhein: Wernersche Verlagsgesellschaft, 1993).

10. Leon Battista Alberti, *On Painting and On Sculpture: The Latin Texts of De Pictura and De Statua*, ed. and trans. Cecil Grayson (London: Phaidon, 1972), 82–83.

11. See David Castriota's annotations on the origin of spiral motifs in Cycladic and Near Eastern art in Alois Riegl, *Problems of Style: Foundations for a History of Ornament*, trans. Evelyn Kain (Princeton: Princeton University Press, 1993), 322bb–323c. On the depiction of water in early Christian art, see Henry Maguire, *Earth and Ocean: The Terrestrial World in Early Byzantine Art* (University Park: Pennsylvania State University Press, 1987).

12. For the Pisanello-style drawing in the Biblioteca Ambrosiana in Milan (dated around 1420–30), see Köhren-Jansen, *Giottos Navicella*, 230–31.

13. Hubert Damisch reiterates an argument by Claude Levi-Strauss: "Because always obstructed and of necessity destined to failure, there being no origin save one that is an invention, in all senses of the world." Hubert Damisch, *The Origin of Perspective*, trans. John Goodman (Cambridge, MA: MIT Press, 1994), 47.

14. Jean-Martin Charcot and Paul Richer, *Les Démoniaques dans l'art* (Paris: Delahaye & Lecrosnier, 1887), 44–45. Debora Silverman reproduces Richer's drawings of the modern hysteric and Catherine's religious ecstasy (after a fresco in Sienna) in her *Art Nouveau in Fin-de-siècle France: Politics, Psychology and Style* (Berkeley: University of California Press, 1989), 99.

15. Michel Foucault, *Madness and Civilization: A History of Insanity in the Age of Reason*, trans. R. Howard (New York: Vintage Books, 1988), 3–37.

16. Charles Darwin, *The Descent of Man and Selection in Relation to Sex* (1871; repr., New York: Appleton & Co. 1873), 1:64–65.

17. For a list of Darwin's dogs, see R. B. Freeman, *Charles Darwin: A Companion* (Kent: Dawson Archon, 1978). For the presence of dogs in Darwin's texts, see Kay Harel, "It's Dogged as Does It: A Biography of the Everpresent Canine in Charles Darwin's Days," *Southwest Review* 93, no. 3 (Fall 2008): 368–78.

18. Darwin, *The Descent of Man*, 64–65.

19. Darwin, *The Descent of Man*, 64.

20. See the entry "Animism" in the *Encyclopaedia Britannica*, 11th ed. (1910–11), 53–55.

21. Herbert Spencer, *The Principles of Sociology* (1876; repr., New York: D. Appleton & Co., 1897), 1:125–33.

22. Spencer, *The Principles of Sociology*, 127.

23. Tito Vignoli, *Myth and Science: An Essay*, (1880; repr., New York: D. Appleton and Co., 1882). For the original Italian edition, see *Mito e Scienzia* (Milan: Dumolard, 1879). For the contemporary German edition, see *Mythus und Wissenshaft: eine Studie* (Leipzig: Brockhaus, 1880). For Vignoli's influence on Warburg, see Ernst Gombrich, *Aby Warburg: An Intellectual Biography* (Chicago: Chicago University Press, 1986), 68–71.

24. Vignoli, *Myth and Science*, 162.

25. Though drawing more from Leibniz than Darwin, a century later Gilles Deleuze would again invoke the example of the stick and the dog: "a man has tiptoed up to the dog from behind, when he has raised the instrument in order to strike it then upon the dog's body." The impression of "the stick being raised up" makes "the animal always look about" anxiously; "it is the soul that watches out," with "the animal or animated state par excellence" being "disquiet." Gilles Deleuze, *The Fold: Leibniz and the Baroque*, trans. Tom Conley (Minneapolis: University of Minnesota Press, 1993), 56.

26. Vignoli, *Myth and Science*, 58–59, 119.

27. Vignoli, *Myth and Science*, 57.

28. See Vignoli's *Mythus und Wissenshaft*, 50, in the library of the Warburg Institute and Warburg Institute Archive, London (WIA), Zettelkästen (ZK) 41, "Aesthetik," 041/021131.

29. Figure 14, "Head of Snarling Dog. From life by Mr. Wood," in Charles Darwin, *The Expression of the Emotions in Man and Animals* (1872; repr., Chicago: University of Chicago Press, 1965), 117. Citations are to the 1965 edition. For Warburg's notes on Darwin's book, see WIA, ZK 1, "Ausdruckskunde," 001/000038-62.

30. WIA, Section III: Aby Warburg's Papers (III.) 93.4, "Bilder aus dem Gebiet der Pueblo-Indianer. Lecture draft, 1923, including autobiographical parts and additions," 26. A large section of the same passage is cited in Gombrich, *Aby Warburg*, 217–18. An English translation of Warburg's draft has been published as "Memories of a Journey through the Pueblo Region," in Philippe-Alain Michaud, *Aby Warburg and the Image in Motion* (Cambridge, MA: Zone, 2004), 310.

31. For a comprehensive survey of theories of animism and its opposition to the doctrines of materialism and mechanicism, see William McDougall, *Body and Mind: A History and a Defense of Animism* (New York: Macmillan Co., 1911). For the conception of the soul in Greek religion and philosophy, see the classic study by Erwin Rohde, *Psyche: Seelencult und Unsterblichkeitsglaube der Griechen* (Freiburg and Leipzig: Mohr, 1894). For an English edition, see *Psyche; The Cult of Souls and Belief in Immortality among the Greeks*, trans. W. B. Hillis (London: Kegan Paul, 1925). Less informative English studies by non-ethnographers include George William Gilmore, *Animism or Thought Currents of Primitive Peoples* (Boston: Marshall Jones Co., 1919); and Edward Clodd, *Animism: The Seed of Religion* (London: A. Constable, 1905). For a later psychoanalytic treatment of animism, see Geza Róheim, *Animism, Magic, and the Divine King* (New York: Alfred A. Knopf, 1930).

32. The works of Georg Ernest Stahl (1660–1734) were reissued in the nineteenth century as *Oeuvres médico-philosophiques et pratiques* (Paris: Bailliére, 1859–64). For a nineteenth-century review of his theories, see Albert Lemoine, *Le vitalisme et l'animisme de Stahl* (Paris: Bailliére, 1864).

33. For a turn-of-the-century assessment of Fechner's work, see Kurd Lasswitz, *G. Th. Fechner*, 2nd ed. (Stuttgart: Frommann, 1902); and for an analysis of Fechner's concept of the soul and the notion of "Beseelung" (*besouling*) or *panpsychism*, see Berhold Oelze, *Gustav Theodor Fechner: Seele und Beseelung* (Munich: Waxmann, 1989).

34. Edward Burnett Tylor, *Primitive Culture: Researches into the Development of Mythology, Philosophy, Religion, Language, Art and Custom* (c. 1871), 4th ed. (London: John Murray, 1903).

35. Tylor, *Primitive Culture*, 1:477.

36. These are Tylor's references to earlier texts that contain an analysis of fetishism in tribal societies, in particular the work of Charles de Brosses, *Du culte des dieux fétiches* (1760). Tylor, *Primitive Culture*, 1:477.

37. Tylor, *Primitive Culture*, 1:429.

38. On the Chinese "automatism" rituals involving bamboo pieces, see *Encyclopaedia Britannica*, 11th ed. (1910–11), 53–54. On bamboo pieces buried on the ground as vessels of the spirit of the enemy, see Róheim, *Animism, Magic, and the Divine King*, 10.

39. Tylor, *Primitive Culture*, 1:155.

40. Tylor, *Primitive Culture*, 1:479.

41. Gustav Theodor Fechner, excerpt from *Nanna, the Soul of Plants* (1848), quoted in Walter Lowrie, ed., *Religion of a Scientist: Selections from Gustav Th. Fechner* (New York: Pantheon Books, 1946), 174.

42. On animatism, see the study by A. C. Krujt, *Het Animisme in den Indischen archipel*

(Gravenhage: M. Nijhoff, 1906). Excerpts from Krujt's study are quoted in Lucien Lévy-Bruhl, *How Natives Think* (*Les fonctions mentales dans les sociétés inférieures*, c. 1910), trans. L. Clare (New York: Washington Square Press, 1966), 365. On the "preanimistic" stage, see Wilhelm Wundt, *Völkerpsychologie: Eine Untersuchung der Entwicklungsgesetze* (Leipzig: Alfred Kröner, 1920), 4:26–28. On animatism, see R. R. Marett, "Preanimistic Religion," in *Folk-Lore* 11 (1900): 162–82; as well as the entry on "animism" in *Encyclopaedia Britannica*, 11th ed. (1910–11), 53. Freud also distinguishes between animism and animatism in "Totem and Taboo: Some Points of Agreement between the Mental Lives of Savages and Neurotics" (c. 1913), in *The Standard Edition of the Complete Psychological Works of Sigmund Freud*, trans. James Strachey (London: Hogarth Press, 1955), 13:91.

43. Tylor, *Primitive Culture*, 1:156.

44. Tylor, *Primitive Culture*, 1:156, 158. Despite the value it may have as a cultural phenomenon, the "occult" side of animism or "spiritism" is only of marginal theoretical interest to this study. On that subject, see Pierre Mariel, *Dictionnaire des Sociétes Secrètes en Occident* (Paris: Culture, art, loisirs, 1971); and James Webb, *The Occult Establishment* (La Salle, IL: Open Court Pub. Co., 1976).

45. From George Grote, *History of Greece* (London: John Murray, 1851–56); cited in Tylor, *Primitive Culture*, 1:286.

46. Tylor, *Primitive Culture*, 1:285.

47. Spencer, *The Principles of Sociology*, 131.

48. Émile Durkheim, *The Elementary Forms of the Religious Life* (*Les Formes élémentaires de la vie religieuse*, c. 1912), trans. J. W. Swain (New York: Free Press, 1965), 83–84.

49. From George Grote, *History of Greece*, 3:104; cited in Tylor, *Primitive Culture*, 1:286.

50. Friedrich Theodor Vischer, *Auch einer; Eine Reisebekanntschaft* (1878; repr., Stuttgart: Deutsche Verlags-Anstalt, 1923).

51. WIA, ZK (unnumbered), "Ae.[sthetik]-Aphorismen" and WIA, III.43.3, "Grundlegende Bruchstücke zu einer monistischen Kunstpsychologie," 1. See also the essay by Horst Bredekamp, "Du lebst und thust mir nichts: Anmerkungen zur Aktualität Aby Warburgs," in *Aby Warburg: Akten des internationalen Symposions Hamburg 1990*, ed. H. Bredekamp et al. (Weinheim: Acta Humaniora, 1991), 3f; and Frank Fehrenbach, "'Du lebst und thust mir nichts': Aby Warburg und die Lebendigkeit der Kunst," in Hartmut Böhme and Johannes Endress, eds., *Der Code der Leidenschaften: Fetischismus in den Künsten.* (Munich: Fink, 2010), 124–45.

52. Gombrich, *Aby Warburg*, 71.

53. On the role of empathy theory in Warburg's early work, see Matthew Rampley, "From Symbol to Allegory: Aby Warburg's Theory of Art," *Art Bulletin* 79, no. 1 (1997): 41–55.

54. In one of his aesthetic aphorisms written in September 14, 1890, Warburg noted: "Two periods can be distinguished in man's perception of objects: 1. Anything alive is assumed to be hostile (*Alles Lebende wird als feindlich angenommen*) and capable of movement and pursuit, so that a position is taken up accordingly 2. Anything alive is examined for the limitation of its movement, law, force. It turns out that man is not only a beast of prey but also a slothful creature." See WIA, III.43.3, "Grundlegende Bruchstücke," 39–40; also cited in Gombrich, *Aby Warburg*, 76.

55. For a theoretical analysis of desire attributed to images, see W. J. T. Mitchell, *What Do Pictures Want?* (Chicago: Chicago University Press, 2005). For a collection of essays on the artwork as a "living being," see Ulrich Pfisterer and Anja Zimmermann, eds., *Animationen/Transgressionen: Das Kunstwerk als Lebewesen* (Berlin: Akademie Verlag, 2005). On

image and speech action, see Horst Bredekamp, *Theories des Bildakts* (Berlin: Suhrkamp, 2010), which was published as this book was going to press. My own study examines objects instead of images and does not attempt to attribute either desire or speech to any form of representation.

56. WIA, III.43.3, "Grundlegende Bruchstücke," 1.

57. For a different view of that polarity, see T. J. Clark, *The Sight of Death* (New Haven: Yale University Press, 2006), 235–36.

58. On the notion of the object as an entity that can pose questions, yet not offer answers, I am indebted to the idea of the "enigmatic signifier" by Jean Laplanche; see his seminar discussions in Jean Laplanche, *Seduction, Translation, and the Drives*, ed. John Fletcher and Martin Stanton (London: ICA, 1992), 21–63. On the communicative aspects of objects, see Kaja Silverman, "The Language of Things," in *World Spectators* (Stanford: Stanford Univ. Press, 2000), 127–46; and Lorraine Daston, ed., *Things That Talk: Object Lessons from Art and Science* (New York: Zone Books, 2008).

59. Durkheim, *Elementary Forms*, 217.

60. See Durkheim's early lectures on socialism and the Saint-Simonians in Émile Durkheim, *Le Socialisme; Sa Définition—Ses Débuts. La Doctrine Saint-Simonienne*, ed. Marcel Mauss (Paris: Alcan, 1928).

61. The model of animation proposed here is close to the anthropological theory of art outlined by Alfred Gell in his formidable study on art and agency. However, the agency of the animated object, as described by Durkheim, lacks the "intentionality" or specificity of action attributed to the agent—either the "artist" or the "index" (artwork)—by Gell. See Alfred Gell, *Art and Agency: An Anthropological Theory* (Oxford: Oxford University Press, 1998).

62. Durkheim, *Elementary Forms*, 53.

63. Max Horkheimer and Theodor Adorno, *Dialectic of Enlightenment* (c. 1944), trans. John Cumming, (New York: Continuum, 1995), 28.

Chapter One

1. Thomas Carlyle, *Sartor Resartus*, ed. Peter Sabor (Oxford: Oxford University Press, 1987), 5. Warburg's manuscript annotations are in his personal copy of the German edition, housed at the library of the Warburg Institute, London: *Sartor Resartus, oder, Leben und Meinungen des Herrn Teufelsdröckh: in drei Büchern*, trans. Thomas A. Fischer (Leipzig: O. Wiegand, 1882), 4.

2. Carlyle, *Sartor Resartus* (English), 30.

3. Carlyle, *Sartor Resartus* (English), 34–36.

4. Carlyle, *Sartor Resartus* (English), 44.

5. Warburg Institute Archive (WIA), General Correspondence (GC), Aby Warburg to Mary Herz, December 8, 1891, and Max Warburg to Aby Warburg June 14, 1891. A portrait of Carlyle painted by Whistler would later grace the reception room of Warburg's library in Hamburg. WIA, GC, Warburg to Paul and Felix Warburg, November 5, 1926. For the importance of Carlyle's *Sartor Resartus* in Warburg's intellectual formation, see Bernd Villhauer, *Aby Warburgs Theorie der Kultur: Detail und Sinnhorizont* (Berlin: Akademie Verlag, 2002), 39–44.

6. WIA, III.40.1.1.1, "*Sandro Botticellis 'Geburt der Venus' und 'Frühling,'* 1893. *Handexemplar* (personal copy interleaved with notes)." For the published dissertation, see Aby Warburg, *Sandro Botticellis "Geburt der Venus" und "Frühling": eine Untersuchung über die*

Vorstellungen von der Antike in der italienischen Frührenaissance (Hamburg: Voss, 1893). The dissertation including an edited version of Warburg's addenda was published in Aby Warburg, *Gesammelte Schriften. Die Erneuerung der heidnischen Antike* (hereafter cited as GS), ed. Gertrud Bing and Fritz Rougement (Berlin: Taubner,1932), 1–60, 302–28. For the English edition: Aby Warburg, *The Renewal of Pagan Antiquity,* ed. Kurt Forster, trans. David Britt (Los Angeles: Getty Research Institute, 1999), 89–156.

7. WIA, III.38.1.2. "Botticelli, 1888-1891. Introduction. Early Draft"; Warburg, GS, 58.

8. See Gertrud Bing's preface in Warburg, GS, xvii.

9. WIA, III.40.1.1.1. "*Sandro Botticellis 'Geburt der Venus' und 'Frühling'* 1893. *Handexemplar,*" 27.

10. Carlyle, *Sartor Resartus,* note 1.

11. "[V]ielleicht erinnern Sie sich noch eines Winterabends, wo wir zusammen bei Paoli saßen (in Sorgen um unseren armen unvergessenen Ernst Burmester) und ich Ihnen das große Geheimnis anvertraute, daß ich über Filippino Lippis flatternde Gewandung und die Antike schreiben wolle. Sie hatten damals Recht, darüber zu lächeln. Jetzt nach 18 schweren Dienstjahren versuche ich es von neuem; es sollte mich herzlich freuen, wenn Sie diese meine Bemühungen der Mühe wert finden, die Ihnen damals der Florentinische Exodus machte; Ihnen verdanke ich die innere Aufforderung zur Hingabe an die Florentinischen Daemonen und da ich von dem 8. (außer Semrau) noch der einzige Combattant auf italienischem Felde bin, so meinte ich an diesem Festtag nicht fehlen zu dürfen." WIA, GC, Aby Warburg to August Schmarsow, July 24, 1907. The letter is written on the occasion of Warburg's contribution to a Festschrift for Schmarsow, which took the form of an essay on Francesco Sassetti. See Warburg, "Francesco Sassettis letztwillige Verfügung," in *Kunstwissenschaftliche Beiträge A. Schmarsow gewidmet,* ed. H. Weizsäcker (Leipzig: Hiersemann, 1907), 129–52. Max Semrau was a German art historian of Italian and Northern European art. Together with Schmarsow he coedited a publication series on Italian art historical research.

12. For the relation of Renaissance art to antiquity, see the following works mentioned in Warburg's notes and dissertation: Georg Voigt, *Die Wiederbelebung des classischen Alterthums, oder, Das erste Jahrhundert des Humanismus,* 3rd ed. (Berlin: G. Reimer, 1893); and Eugène Müntz, *Les Précurseurs de la Renaissance* (Paris: Librairie de l'Art, 1882). For Schmarsow's treatment of similar themes, see his *Melozzo da Forli: ein Beitrag zur Kunst- und Kulturgeschichte Italiens im 15. Jahrhundert* (Berlin: W. Spemann, 1886); and *Donatello: Eine Studie über den Entwicklungsgang des Künstlers und die Reihenfolge seiner Werke* (Breslau: Verein für Geschichte der Bildenden Künste, 1886).

13. F. T. Vischer, *Über das Erhabene und Komische und andere Texte zur Ästhetik,* ed. Willi Oelmüller (Frankfurt: Suhrkamp Verlag, 1967), 158.

14. August Schmarsow, "Schluss," part 2 of "Die Neuordnung Florentiner Museen," *Nationalzeitung,* no. 414 (July 11, 1893), 2–3; quotation on 2.

15. "9. Kampf gegen die Philister. [F]latternde Gewänder (entgegengesetzte Richtungen). Volute im Helm." WIA, III.33.2.8."Von Nicolo Pisano bis Michelangelo. Vorlesung von Prof. A. Schmarsow gehalten im Kunsthistorischen Institut zu Florenz, W-S 88/89, Lecture Notes" (December 10–14, 1888), 67. For Schmarsow's published lecture on Ghiberti's gates, see August Schmarsow, *Ghibertis Kompositionsgesetze an der Nordtür des Florentiner Baptisteriums* (Leipzig: B. G. Teubner, 1899). On the same theme, see Georges Didi-Huberman, "Bewegende Bewegungen: Die Schleier der *Ninfa* nach Aby Warburg," in *Ikonologie des Zwischenraums: der Schleier als Medium und Metapher,* ed. J. Endres, B. Wittmann, and G. Wolf (Paderborn: Fink, 2005), 339–40.

16. "Symmetrie mit angedeuteter unbestimmter *Dominante.* Camera della Segnatura.

Disputá mit bestimmten Axen. Schule v[on] Athen mit unbestimmten Axen. Plato–Aristo-
teles, der Verstand kommt nicht zusammen." On the same page there are also notes dated
November 29, 1888, that mention Giotto and the Florence baptistery. WIA, III.33.2.7.
"Masolino und Masaccio. *Übungen*, KHIF, Notes," 92.

17. For an example of Schmarsow's theoretical exposition of the architectonic prin-
ciples of "symmetry" and "direction," see his *Kompositionsgesetze in der Kunst des Mittelalters*
(Leipzig: B. G. Teubner, 1915).

18. WIA, III.33.2.7. "Masolino und Masaccio. *Übungen*, KHIF," 91 verso.

19. See "microscopical appearance of hairs under various sources," illustration by James
F. Babcock in *A System of Legal Medicine*, by Allan McLane Hamilton and Lawrence God-
kin with the collaboration of James F. Babcock and Lewis Balch et al. (New York: E. B.
Treat, 1894).

20. Carlyle, *Sartor Resartus*, 3 (German), 5 (English).

21. See Warburg's research notes on "Hair" (*Haar*) and "hair-styles" and "hair-gear"
(*Haartracht*), as well as adornments for the head (*Kopfschmuck*) in WIA, ZK 29a, "Gerät–
Tracht," 010/004651–84.

22. "Viertel der Augen bedeckt; unteres Augenlid . . . leicht berührt; kein Fensterchen.
Iris . . . braun, schwarze Pupille, schwarz gerädert." WIA, III.33.2.7. "Masolino und Masac-
cio. *Übungen*, KHIF," 34–41 (here 38).

23. Darwin, *The Expression of the Emotions*, 83–146. Warburg's extensive notes from
Darwin's book are contained in WIA, ZK 1, "Ausdruckskunde" 001/000038-62 (see also
note 29 in the introduction).

24. Darwin, *The Expression of the Emotions*, 294–97.

25. Robert Vischer, *Luca Signorelli und die Italienische Renaissance, eine kunsthistorische
Monographie* (Leipzig: Verlag von Veit & Co, 1879), 156–57.

26. Vischer, *Luca Signorelli*, 158–59.

27. "Gerade Gewand und Haar sind die kritischen Mittel des Subjectiven in der Malerei."
Vischer, *Luca Signorelli*, 159.

28. See Friedrich Theodor Vischer, "Das Symbol" (in *Philosophische Aufsätze, Eduard
Zeller gewidmet*, 1887), offprint with Aby Warburg's manuscript notes, the library of the
Warburg Institute, London; also included in F. T. Vischer, *Altes und Neues, Neue Folge*, ed.
Robert Vischer (Stuttgart: A. Bonz, 1889).

29. For commentaries on the relationship between Vischer's essay on the symbol and
Warburg's research, see Gombrich, *An Intellectual Biography*, 72–76; and Karen Lang, *Chaos
and Cosmos: On the Image in Aesthetics and Art History* (Ithaca: Cornell University Press,
2006), 109–13.

30. WIA, ZK (unnumbered), "Ae.[sthetik]–Aphorismen."

31. F. T. Vischer, "Das Symbol," in *Altes und Neues*, 302.

32. A reproduction of Raphael's Sistine Madonna appears in a drawing and a photograph
of Vischer's "Arbeitszimmer" in his residences in Berlin and Stuttgart. *Auch einer: Friedrich
Theodor Vischer zum 100. Totestag*, ed. Andrea Berger-Fix (Ludwigsburg: Städtisches Muse-
um, 1987), 86–87.

33. Vischer, "Das Symbol," 303.

34. Warburg, *Renewal*, 144. In earlier drafts, the same footnote includes Heinrich
Wölfflin, *Renaissance und Barock* (Munich: Ackermann, 1888); and Alfred Biese, *Das As-
sociationsprincip und der Anthropomorphismus in der Aesthetik: ein Beitrag zur Aesthetik des
Naturschönen* (Kiel: Schmidt, 1890). WIA, III.38.1.2, "Botticelli, 1888–91. Introduction.
Early Draft," 1. In his latter addenda Warbug added the work on empathy by his philosophy

professor at Strassburg, Theobald Ziegler, "Zur Genesis eines ästhetischen Begriffs," in *Zeitschrift für vergleichende Literaturgeschichte* (1894), 7. See Warburg, *Renewal*, 405.

35. Vignoli, *Myth and Science*, 59–60, and *Mythus und Wissenshaft*, 52–53. For Vignoli's influence on Warburg, see Gombrich, *Intellectual Biography*, 29, 216.

36. For the psychographic aspects of Warburg's draperies, see Didi-Huberman, "Bewegende Bewegungen," and Sigrid Schade, "Charcot and the Hysterical Body: The Pathos Formula as an Aesthetic Staging of Psychiatric Discourse," *Art History* 18, no. 4 (December 1995): 499–517. On the "rhetoric of draping," see Gabriele Brandstetter, "Ein Stück in Tüchern: Rhetorik der Drapierung bei A. Warburg, M. Emmanuel, G. Clérambault," in *Vorträge aus dem Warburg-Haus*, Band 4, ed. M.Warnke et al. (Berlin: Akademie Verlag, 2000), 105–39.

37. For a complete collection of Warburg's dissertation reviews (excluding Schmarsow's), see WIA, III.40.1.5. "Botticelli: Reviews and Letters of Thanks, 1893–95."

38. In her foreword to Warburg's collected writings, Gertrud Bing notes that the dissertation on Botticelli "may not exactly offer the easiest introduction to Warburg's writings," and then adds that in "his earliest work [*Erstlingsarbeit*], the abundance of material does not seem to come under the same effortless conceptual control as in the later essays." Warburg, *Renewal*, 83; and GS, xiv.

39. Gombrich, *Intellectual Biography*, 59.

40. Warburg's solution to the overflow of his ideas was to utilize an entirely different textual format, recording his critical insights in the manner of aphorisms. WIA, ZK "Ae. [sthetik]–Aphorismen"; and WIA, III.43,44. "*Grundlegende Bruchstücke zu einer pragmatischen Ausdruckskunde (monistischen Kunstpsychologie)*."

41. Aby Warburg, WIA, III.33.2.3. "Filippino Lippi. Übung, KHIF," 8. See also the life of Filippo Lippi (Filippino) in Giorgio Vasari, *Lives of the Painters, Sculptors, and Architects*, ed. D. Ekserdjian, trans. Gaston du C. de Vere (New York: Knopf, 1996) 1:565.

42. Hermann Ulmann, *Fra Filippo Lippi als Lehrer Sandro Botticellis* (Breslau: Schottlaender, 1890).

43. WIA, III.39.4. "Continuation of Botticelli, Drafts and Notes," 10.

44. In his well-known *Stones of Rimini*, Adrian Stokes linked Agostino's swirling reliefs to Aristotle's theory of motion in the *Physics*. Adrian Stokes, *Stones of Rimini* (London: Faber & Faber, 1934). Much of Stokes's knowledge about the monument was based on the monograph by Corrado Ricci, *Il Tempio Malatestiano in Rimini* (Milan: Bestetti &Tumminelli, 1925).

45. Ernst Burmeister, *Der bildnerische Schmuck des Tempio Malatestiano zu Rimini* (diss., University of Breslau, 1891), cited in Warburg, *Renewal*, 146n. Burmeister's published dissertation contains a note that the "complete treatment" of the subject would be published in Schmarsow's series on *Italienischen Forschungen zur Kunstgeschichte*, a publication that was unrealized.

46. "*Rimini: pneumatische Sphärenvorstellung im Gegensatz zur fetischistischen. Antikische Form.*" Aby Warburg, "Tafel 25," in *Der Bilderatlas Mnemosyne* (*Gessamelte Schriften: Studienausgabe*, II.1), 2nd ed., ed. Martin Warnke (Berlin: Akademie Verlag, 2003), 42–43. For further commentary, see Dorothee Bauerle, "Die Restitution der pathetischen Gebärdensprache all'antica–Agostino di Duccio," in *Gespenstergeschichten für ganz Erwachsene: Ein Kommentar zu Aby Warburgs Bilderatlas Mnemosyne* (Munich: Lit. Verlag, 1988), 91–92.

47. See discarded draft: "The Spring of Botticelli: An Investigation in the History of Style (on Iconographic Principles) by Aby Warburg" (*Der Frühling des Botticelli: Eine Stilgeschichtliche Untersuchung (auf ikonogr.[aphische] Grundlage) von Aby Warburg*); WIA, III.39.4.

"Continuation of Botticelli, Drafts and Notes," 11. In a letter by Ulmann, his former colleague suggests that Warburg look at the literary sources of the *Primavera*, though he makes no mention of *The Birth of Venus*. WIA, GC, Ulmann to Warburg, April 7, 1890.

48. "Die Gewandbehandlung in der Florentiner Kunst d.[er] ersten Hälfte des Quattrocento" (draft by Aby Warburg dated 28.IV.89, Bonn). WIA, III.39.1.1. "Botticelli, 1888-1906. Discarded Drafts," 11.

49. See Aby Warburg, drafts titled "Allgemeines z. Gewandung." WIA, III.39.1.1, "Botticelli, 1888–1906. Discarded Drafts," 1–5, 15.

50. See Warburg's sketch of a map entitled "Villen," which marks the position of the Tornabuoni villa and other buildings outside the city of Florence that, according to a description by Vasari, contained a number of artworks. WIA, III.38.3.1. "Botticelli, 1888–91: 'Reich der Venus' Notes and Drafts," 20.

51. On the role of taxonomy and classification in Warburg's work, see Sigrid Weigel, "Aby Warburgs 'Göttin im Exil,'" in *Vörtrage aus dem Warburg-Haus*, Band 4, 65–103. On the role of diagrams in Warburg's thought, see Kurt Forster, "Aby Warburg: His Study of Art on Two Continents," trans. David Britt, *October* 77 (Summer 1996): 5–24. On "orientation" and its relation to mapping, see Claudia Wedepohl, "Ideengeographie. Ein Versuch zu Aby Warburgs Wanderstraßen der Kultur," in *Entgrenzte Räume. Kulturelle Transfers um 1900 und in der Gegenwart*, ed. H. Mitterbauer and K. Scherke (Vienna: Passagen Verlag, 2005); and Dorothea McEwan, "Aby Warburg's (1866–1929) Dots and Lines. Mapping the Diffusion of Astrological Motifs in Art History," *German Studies Review* 29, no. 2 (2006): 243–68.

52. WIA, III.38.2, "Botticelli, 'Geburt der Venus,' Notes and Drafts," 10.

53. WIA, III.39.4, "Continuation of Botticelli, Drafts and Notes," 18.

54. Warburg, *Renewal*, 89; and GS, 5.

55. Warburg, *Renewal*, 98–101; and GS, 14–15 (for the original quotations in Latin and Italian).

56. Warburg uses a German-Italian edition of Alberti's text by Hubert Janitschek, who was one of his dissertation advisers at Strassburg. See Hubert Janitschek, ed., *Leone Battista Alberti's kleinere kunsttheoretische Schriften* (Vienna: Wilhelm Braumüller, 1877), 128–31. Janitschek's German subtitle for this particular section is "Von dem Ausdruck der Bewegung an leblosen Dingen" ("On the Expression of Movement in Lifeless Things"), 128. Warburg also quotes from a review of Janitschek's edition by Anton Springer in Lützow, *Zeitschrift für bildende Kunst*, 14 (1879), 60–63. Warburg had also encountered the same passage in Robert Vischer's monograph on Signorelli. See Vischer, *Signorelli*, 156–57; and Warburg, *Renewal*, 95.

57. For the Latin text and an English translation, see Leon Battista Alberti, *On Painting and On Sculpture: the Latin Texts of De Pictura and De Statua*, ed. and trans. Cecil Grayson (London: Phaidon, 1972), 86–87 (translation modified). For the Italian text, see Janitschek, *Alberti's kleinere kunsttheoretische Schriften*.

58. Warburg, *Renewal*, 96; and GS, 11.

59. Alberti in Grayson, *On Painting and On Sculpture*, 82–83; and in Janitschek, *Alberti's kleinere kunsttheoretische Schriften*, 124–25. In his classic analysis of Alberti's text, Michael Baxandall shows that these movements emulate rhetorical figures illustrated in Quintilian's treatise on *The Education of the Orator*. Michael Baxandall, *Giotto and the Orators: Humanist Observers of Painting in Italy and the Discovery of Pictorial Composition, 1350–1450* (Oxford: Clarendon Press, 1971), 18–19.

60. WIA, III.38.1.4, "Botticelli, 1888–91. Introduction. More Complete Draft," 13.

61. Alberti in Grayson, *On Painting and On Scuplture*, 84–85.

62. Warburg, *Renewal*, 96; and GS, 11. The same point is stressed in Springer's review of Janitschek's bilingual edition of Alberti's writings on the theory of art: "A further suggestion [made by Alberti is that] in order to bring movement in the garments, one could display on the picture the head of Zephyr, blowing through the clouds, thereby causing the garments to move." Springer adds that this pictorial device echoes the composition of Botticelli's *Birth of Venus*. Springer in Lützow, *Zeitschrift für bildende Kunst*, 14 (1879), 61.

63. WIA, III.38.1.2. "Botticelli, 1888–91. Introduction. Early Draft," 1.

64. Biese distinguishes between association and anthropomorphism in the following way: "With association we have something next to the other [*nebeneinander*], in anthropomorphic empathy we have something inside the other [*ineinander*]." But finally both association and anthropomorphism, Biese argues, act together in the aesthetic reception of images. Alfred Biese, *Das Associationsprinzip und der Anthropomorphismus in der Aesthetik*, 19–20. In his drafts, Warburg also associates anthropomorphic imagination with Vignoli's writings on the anthropomorphization of causality and with Robert Vischer on empathy. WIA, III.38.1.2, "Botticelli, 1888–91. Introduction. Early Draft," 8.

65. Biese, *Associationsprinzip*, 14. A later note by Warburg in his preparatory notes for his essay on Luther gives the following bibliographic note for Goethe's epigram: "J. W. von Goethe, *Maximen und Reflexionen* ed. [Max] Hecker (Weimar [Goethe-Gessellschaft] 1907) p. 36 'Nr. 203.'"

66. Baxandall, *Giotto and the Orators*, 134.

67. On Mercury as a wind-god, see Charles Dempsey, *The Portrayal of Love: Botticelli's Primavera and Humanist Culture at the Time of Lorenzo the Magnificent* (Princeton: Princeton University Press, 1992), 39–40.

68. On the role of demons as agents in allegorical accounts, see Angus Fletcher, "The Demonic Agent," in *Allegory: The Theory of a Symbolic Mode* (Ithaca: Cornell University Press, 1964), 25–69.

69. Warburg, *Renewal*, 134; and GS, 47.

70. Quoted in Gombrich, *Intellectual Biography*, 48. For the original, see WIA, ZK "Ae–Aphorismen," March 27, 1889. Similar general observations on "Drapery Motifs—*Gewandmotive*" in the Quattrocento appear among the discarded drafts of the dissertation. Warburg "Botticelli," WIA, III.39.1.1.

71. The fragment is dated 1895. WIA, III.40.1.1.2. "Botticelli, 1893. TS transcripts of some notes relating to the 4 Theses," 10.

72. This is explicitly stated in one of Warburg's unpublished dissertation drafts: "Die Idee das der [illegible] Bewegungsmanierismus des aufgehendes Quattrocento d. damaligen Vorstellungen von d. Antike herangezogen werden musste, kam d. Verfasser, als er im W.[inter] S.[emester] [18]88/89 unter d. Anleitung Prof. Schmarsows d. Flor. Kunst kennenlernt." WIA, III.38.1.1. "Botticelli, 1888-91. Introduction," 6. The note was apparently meant to be inserted at the end of the dissertation's introduction as a footnote or acknowledgement. In one of the preliminary sketches for the third and final section of the dissertation Warburg gives that section the preliminary title "The Importance of the Mannerism of Movement for the Development of Merely Pleasing Forms [*Die Bedeutung des Bewegungsmanierismus für die Entwicklung der schlechthin gefallenden Formen*]." WIA, III. 38.4, "Botticelli, 1888-1891. Conclusion, Including Notes on Leonardo and Attempt at Defining the Relation between Picture and 'Experience,'" 81.

73. Warburg, *Renewal*, 104–7.

74. Warburg, *Renewal*; and GS, 54. For the difficulty of translating the adjective "bewegt" into English and the relation of Warburg's term "bewegtes Beiwerk" to "bewegtes Leben"

(life in motion), see Gombrich, *Aby Warburg*, 16–17.

75. Michaud, *Aby Warburg and the Image in Motion*, and Georges Didi-Huberman, *L'image survivante: Histoire de l'art et temps des fantômes selon Aby Warburg* (Paris: Les Éditions de Minuit, 2002), 258–60.

76. Carus Sterne, "Darstellungen des bewegten Lebens," in *Natur und Kunst: Studien zur Entwicklungsgeschichte der Kunst*, 2nd ed. (Berlin: Allgemeiner Verein für Deutsche Litteratur, 1891), 310–20.

77. Ernst Brücke, "Die Darstellung der Bewegung durch die bildenden Künste," *Deutsche Rundschau* 26 (January–March 1881), 39–54. Brücke mostly examines rapid human movements, such as dancing or running, that are difficult to represent in painting, as opposed to slower movements that can be analyzed "step-by-step [*Schritt für Schritt*]." Brücke argues that in their representations of movement, painters should make use of a "clear memory image [*Erinnerungsbild*]" singled out from an action. Also see his *Bruchstücke aus der Theorie der bildenden Künste* (Leipzig: F. A. Brockhaus, 1877), a copy of which exists in the Warburg library.

78. Sterne, *Natur und Kunst*, 311–12; compare with Brücke, "Die Darstellung," 40–41. On Warburg's view of the iconography of the *Hilanderas*, see Karin Hellwig, "Aby Warburg und das "Weberinnenbild" von Diego Velázquez," *Zeitschrift für Kunstgeschichte* 69 (2006): 548–60.

79. Sterne, *Natur und Kunst*, 314–20. Brücke also uses similar material from Muybridge. See Brücke, "Die Darstellung," 47.

80. Immanuel Kant, *The Critique of Judgement*, ed. and trans. James Meredith (London: Oxford University Press, 1952), 68 (translation modified); German edition *Kritik der Urtheilskraft*, AAV, 226. For a critique of Kant's position on the parergon, see the well-known account by Jacques Derrida, "The Parergon," in *The Truth in Painting*, trans. Geoff Bennington and Ian McLeod (Chicago: University of Chicago Press, 1987), 37–83. Warburg had in fact studied Kant's *Third Critique* in a seminar he had taken in Strassburg in 1890, taught by Theobald Ziegler. WIA, III.34.8.2. "Kant, *Prolegomena*, and Ziegler, *Aesthetik*, Lecture Notes."

81. *Hegel's Lectures on Aesthetics: Lectures on Fine Art*, trans. T. M. Knox (Oxford: Oxford University Press, 1975), 2:615–16.

82. "Botticelli bahnt den 'Ornamentalen Verfall' der Hoch-Renaissance," WIA, III.38.4. "Botticelli, 1888–91. Conclusion," 62.

83. For Warburg's concern over the increasingly "ornamental" character of the art of his time, see the scholar's correspondence with his future wife, Mary Hertz: WIA, GC, Mary Hertz to Warburg, December 23, 1890; and Warburg to Mary Hertz December 15, 1890, and December 31, 1890. Excerpts are cited in Gombrich, *Intellectual Biography*, 80–81.

84. Sigmund Freud, "The Interpretation of Dreams," *The Standard Edition*, 4:306–8; and "Fragment of an Analysis of a Case of Hysteria" (1905 [1901]), *The Standard Edition*, 7:64–93.

85. Freud, "The Interpretation of Dreams," 282–84.

86. Stanza from an elegy by Poliziano on the death of Albiera degli Albizzi quoted by Warburg in his addenda (and partly earlier in the main text) of his dissertation, Warburg, *Renewal*, 414, 134f.

87. Ernst Gombrich, "Botticelli's Mythologies: A Study in the Neoplatonic Symbolism of his Circle," *Journal of the Warburg and the Courtauld Institutes* 8 (1945): 7–60, reprinted in *Symbolic Images: Studies in the Art of the Renaissance* (London: Phaidon, 1972), 31–81.

88. Warburg, *Renewal*, 122.

89. To be sure, Warburg also made similar references to other Florentine women who had died young. Gombrich criticizes the historiographic tradition associated with such "romantic interpretations" in "Botticelli's Mythologies," 10. For a defense of Warburg's interpretation, see Dempsey, *The Portrayal of Love*, 117–39.

90. In his text, Warburg in fact quotes Seneca's reference to Mercury twice. Warburg, *Renewal*, 115, 128. On Mercury's role in the *Primavera*, see Edgar Wind, *Pagan Mysteries in the Renaissance* (London: Faber and Faber, 1958), 106–10.

91. In his interpretation of Botticelli's paintings Gombrich also underlines the "interchangeable" character of mythological characters such as Venus in terms of their symbolic attributes in Renaissance philosophy. Gombrich, "Botticelli's Mythologies," 38.

92. Warburg's cosmological preoccupations in fact originate in his dissertation on Botticelli. In one of the drafts containing a table and other notes on the iconographic theme of the birth of Venus, Warburg inserts the phrase "Kosmogonische Allegorie" (WIA, III.38.2. *"Geburt der Venus,* Notes and Drafts," 10; see note 54 and fig. 12). Even if he did not elaborate in such associations in the published dissertation, Warburg would return to Botticelli's Venus in terms of its cosmological symbolism in a text written in April 1924 in Kreuzlingen. Aby Warburg, "Schicksalsmächte im Spiegel antikisierender Symbolik" (April 1924), in *Per Monstra ad Sphaeram: Sternglaube und Bilddeutung*, ed. Davide Stimilli and Claudia Wedepohl (Munich and Hamburg: Dölling and Galitz, 2008), 46.

Chapter Two

1. Paul Souriau, *L'Esthétique du Mouvement* (Paris: Alcan, 1889), 172. For the English edition: *The Aesthetics of Movement*, trans. and ed. Manon Souriau (Amherst: University of Massachusetts Press, 1981), 84. Souriau's book can be found in the Warburg Library and is mentioned more than once among Warburg's notes on aesthetics (WIA, ZK 41, "Aesthetik").

2. This is in fact how Manon Souriau abridges the original passage in the English translation. Souriau, *The Aesthetics of Movement*, 84.

3. WIA, ZK 6, "Ikonologie-Synthese," 006/002156–61.

4. The entire transcription by Warburg reads: "Baudissin Symbolik d[er] Schlange Semit[ische] Studien/Philo v[on] Byblos Phoenikische G[e]sch[ichte]/Fragm[enta] 9 übersch[rift]/Schl[ange]. Geschwindigkeit ohne Füsse u[nd] Hände/oder ein anderes Glied. . . . womit/d[ie] anderen Thiere sich fortbew[egen]/Agathodaemon Schlange." WIA, ZK 6, "Ikonologie-Synthese," 006/002160.

5. See the chapter "Die Symbolik der Schlange," *Studien zur Semitischen Religionsgeschichte*, Heft I, by Wolf Wilhelm Graf von Baudissin (Leipzig: F. W. Gunrow, 1876), 266–79; here, 268.

6. James Fergusson, *Tree and Serpent Worship; or, Images from Mythology and Art in India in the First and Fourth Centuries after Christ from the Sculptures of the Buddhist Topes at Sanchi and Amravati* (London: India Museum, 1868).

7. Fergusson, *Tree and Serpent Worship*, 62.

8. Fergusson, *Tree and Serpent Worship*, 72.

9. See Patrick Russell, M.D., *An Account of Indian Serpents, Collected on the Coast of Coromandel; Containing Descriptions and Drawings of Each Species Together with Experiments and Remarks on Their Several Poisons* (London: Bulmer, 1796); and Edward Nicholson (assistant surgeon in the Royal Artillery), *Indian Snakes. An Elementary Treatise on Ophiology with a Descriptive Catalogue of the Snakes Found in India and the Adjoining Countries* (Madras:

Higginborham, 1870).

10. J. Fayer, M.D. (Honorary Physician to the Queen), *The Thanatophidia of India Being a Description of the Venomous Snakes of the Indian Peninsula with an Account of the Influence of Their Poison on Life; and a Series of Experiments* (London: Churchill, 1872).

11. Fergusson, *Tree and Serpent Worship*, 2 (my emphasis).

12. Fergusson, *Tree and Serpent Worship*, 10. For a more accurate English translation of the same passage, see *Philo of Byblos: The Phoenician History*, trans. Harold W. Attridge and Robert A. Oden, Jr. (Washington, D.C.: Catholic Biblical Association of America, 1981), 63–65.

13. Fergusson's first note reads: "Sanchuniathon quoting Taatus ap Eusebium, Praep. Evangel. 40." In the second citation, Fergusson translates from the Greek and Latin editions of Eusebius's *Preparations*, by Thomas Gaisford (Oxford: Typographeo Academico, 1843) 1:66; and Carl Müller, *Fragmenta Historicorum Graecorum* (Paris: Firmin-Didot, 1849), 3:572.

14. Eusebius of Caesaria (c. 260–339 AD) was a prolific writer and scholar known mainly for his biblical commentaries. His works are valuable, in part, for their citations of ancient historians. Philo[n] of Byblos (c. 70–160 AD) is mostly known for his learned work on the history of Phoenician religion, extensive fragments of which are quoted by Eusebius. While Philo claims to have translated much of his material directly from the work of Sanchuniathon, his obvious indebtedness to Hellenistic culture makes this claim dubious. The existence of Sanchuniathon cannot be accurately dated: Philo refers to him as a pre–Trojan War writer, but according to other sources he lived as early as 1100–900 BC or as late as 700–500 BC. His work, written in Phoenician, was devoted to theology, cosmogony, and the origins of civilization. See *Oxford Classical Dictionary*, ed. S. Hornblower and A. Spawforth (Oxford: Oxford University Press, 1996), 1168; and A. I. Baumgarten, *The Phoenician History of Philo of Byblos* (London: E. J. Brill, 1981).

15. Baudissin, *Studien*, 1:41. The Phoenician Taautos is related to the Egyptian Thoth, the precursor of the Greek Hermes. Scholars point out that in texts of the archaic Phoenician tradition it is customary that statements about religious matters are attributed to a god.

16. Pneuma, a central element in Phoenician cosmogony, is different from air, wind, or breath. See Jürgen Ebach, *Weltentstehung und Kulturentwicklung bei Philo von Byblos* (Stuttgart: Kohlhammer, 1979), 36–38.

17. Phillip Roland Williams, "A Commentary to Philo Byblius' Phoenician History" (Ph.D. diss., University of Southern California, 1968), 30–52.

18. See Attridge and Oden, *Philo of Byblos*, 151; also see the editorial comments on this passage in the French edition of Eusebius: Eusèbe de Cèsarèe, *La Préparation Évangélique*, Livre 1, ed. Jean Sirinelli and Édouard des Places (Paris: Editions du Cerf, 1974).

19. Aristotle, "Progression of Animals," in *Parts of Animals—Movement of Animals, Progression of Animals*, trans. E. S. Forster (London: Heinemann, 1937), 505–7.

20. The hybrid figure is illustrated in the papyrus of Ani, early nineteenth dynasty, ca. 1300 BC. Balaji Mundkur, *The Cult of the Serpent: An Interdisciplinary Survey of its Manifestations and Origins* (Albany: State University of New York Press, 1983), 80, fig. 43.

21. Two lines from a German translation of Ovid's *Metamorphoses* (Book 15) offer the motto behind the book's title: "To be born or to become [*Werden*] is to begin to be what formerly we were not; and to perish [*Vergehen*] is to cease to appear what we seemed heretofore." Carus Sterne (Ernst Krause), *Werden und Vergehen. Eine Entwicklungsgeschichte des Naturganzen in gemeinverständlicher Fassung* (1876), 4th rev. ed. (Berlin: Gebrüder Borntraeger, 1900).

22. "Vom Vielfüssler zum Sechsfüssler," in Sterne, *Werden und Vergehen*, 1:378–420.

23. Sterne, *Werden und Vergehen*, 2:84–88.

24. Sterne, *Werden und Vergehen*, 2:83.

25. At the lowest scale of these genera is the American "glass snake," a lizard with no external limbs at all. See Raymond Lee Ditmars, *The Reptile Book: A Comprehensive, Popularized Work on the Structure and Habits of the Turtles, Tortoises, Crocodilians, Lizards and Snakes Which Inhabit the United States and Northern Mexico* (New York: Doubleday, 1907), 191–92.

26. Thomas Haining Gillespie, *The Way of a Serpent: A Popular Account of Its Habits* (New York: R. M. McBride and Company, 1938), 17–20.

27. Sterne, *Werden und Vergehen*, 2:88.

28. Sterne, *Werden und Vergehen*, 2:87.

29. Souriau, *The Aesthetics of Movement*, 55–57.

30. See the chapter "How They [Snakes] Move," in Gillespie, *The Way of a Serpent*, 28–32.

31. Jean Demoor, Jean Massart, and Émile Vandervelde, *L'évolution regressive en biologie et sociologie* (Paris: Alcan, 1897). For the English edition, see *Evolution by Atrophy in Biology and Sociology*, trans. Chalmers Mitchell (New York: D. Appleton and Company, 1899). In this edition, the term "regression" is also rendered as "degeneration."

32. Demoor, Massart, and Vandervelde, *Evolution by Atrophy*, 218.

33. "This 'évolution régressive' found in the person of Slevogt—within the framework of a technically tranquilized artistic configuration—a fertile soil and a vaccine against the agent that destroys romanticized terror, which the average educated person needs." Aby Warburg, "Memories of a Journey through the Pueblo Region," in Michaud, *Aby Warburg and the Image in Motion*," 308.

34. See "General Conclusions," in Demoor, Massart, and Vandervelde, *Evolution by Atrophy*, 320–22.

35. This was Küster's doctoral dissertation (University of Heidelberg, 1913) published later the same year as *Die Schlange in der griechischen Kunst und Religion* (Religionsgeschichtliche Versuche und Vorarbeiten 13.2) (Giessen: Töpelmann, 1913). An additional copy of the book in the Warburg Library has a handwritten dedication by Küster to Franz Böll, renowned professor of medieval cosmology and personal friend of Warburg.

36. Küster, *Die Schlange*, 147.

37. Küster in fact mentions Riegl's *Stilfragen* in his footnotes, in reference to the origin of spiral motifs in vegetal tendrils, even if the Viennese art historian tries to remove the development of ornament away from any naturalist origins. See Küster, *Die Schlange*, 14n.

38. Küster attributed the figurative form of these sculpted snakes to the funerary use of the vases on which they were attached. In ancient Greek religion, the serpent represented the soul of the deceased creeping up from the ground to take the nourishment provided inside the vase, and then returning back into the earth. Küster, *Die Schlange*, 41–42, 62–72.

39. Küster, *Die Schlange*, 7.

40. For Warburg's underlining and manuscript addition, see pages 143n and 161 in the copy of Küster's *Die Schlange* in the Warburg Library. Küster's footnote refers to the Moki snake dance, in particular the carrying of snakes in the dancers' mouth.

41. For the English edition of Warburg's Pueblo lecture, see Aby Warburg, *Images from the Region of Pueblo Indians of North America*, trans. Michael P. Steinberg (Ithaca: Cornell University Press, 1995); hereafter cited as Steinberg. For the German edition, Aby Warburg, *Schlangenritual. Ein Reisebericht*, ed. Ulrich Raulff (Berlin: Wagenbach, 1996); hereafter cited as Wagenbach. For three excellent albeit diverging commentaries on Warburg's essay,

see the afterword by Steinberg in the English edition, Steinberg, 59–114; Joseph Koerner's preface to the French edition of Warburg's lecture, *Le rituel du serpent. Récit d'un voyage en pays pueblo*, trans. Sibylle Muller and Philip Guiton (Paris: Macula, 2003), 9–54; and Ulrich Raulff, "The Seven Skins of the Snake—Oraibi, Kreuzlingen and Back: Stations on a Journey into Light," in *Photographs at the Frontier: Aby Warburg in America, 1895–1896*, ed. Benedetta Cestelli Guidi and Nicholas Mann (London: Merrell Holberton, in association with the Warburg Institute, London, 1998), 64–74. See also the anthology of critical essays on Warburg's lecture, *Schlangenritual. Der Transfer der Wissenformen vom Hopi Tsu' ti' kive zu Aby Warburgs Kreuzlinger Vortrag*, ed. Cora Bender, Thomas Hensel, and Erhard Schüttpelz (Berlin: Akademie Verlag, 2007), which includes an earlier version of this chapter.

42. Among Warburg's bibliographic notes there is a reference to the ophiological study by Leonhard Stejneger, *The Poisonous Snakes of North America* (Washington, D.C.: Reports of the Smithsonian Institution, 1895). WIA, ZK 40, "Americana," 040/020591.

43. Ethnographic and natural expeditions were funded by the same organizations, such as the Smithsonian Institution. See, for example, Alfred Kroeber, *Zuni Kin and Clan*, vol. 1, part 1, Anthropological Papers of the Museum of Natural History (Washington, D.C.: Smithsonian Institution, 1917).

44. For Warburg's collection of Pueblo artifacts, see Benedetta Cestelli Guidi, "Aby Warbug collezionista," in *Lo Sguardo di Giano*, ed. Claudia Cieri Via and Pietro Montani. (Turin: Nino Aragno, 2004), 523–68; and Benedetta Cestelli Guidi, "La Collection Pueblo d'Aby Warburg, 1895–1896. Culture matérielle et origins de l'image," in Warburg, *Le Rituel du serpent*, 162–92.

45. See sketches of such tools in Warburg's pocket books from his American trip, WIA, ZK 40, "Americana," 040/020435, 56 verso, 57 recto.

46. "Wodurch verliert der primitive Mensch das Gefühl der Einheit (Identität) zwischen seinem lebendigen Ich aus [und?] seinem jeweiligen thatsächlichen räumlichen körperlichen Umfang: durch das Geräth, den Schmuck, die Tracht (schmerzlose Körpertheile)—durch den Besitz (Eigenthum, Schenkung.)" WIA, III.43.1.1, "Grundlegende Bruchstücke," 133 (aphorism no. 328).

47. WIA, ZK 40, "Americana," 040/020434, 44.

48. Warburg's original typescript presents us with three different sections, all marked as "Conclusion" (*Schluss*). A handwritten manuscript note on the page of the typescript marked as "Uncle Sam, S[an] Fran[cisco]" states: "am 21. April nicht gezeigt; solte aber dazu gehören als ganz wesentlicher Stück," or "Not shown on April 21; but it should belong there as an absolutely essential piece." WIA, III.93.1, "Bilder aus dem Gebiet der Pueblo-Indianer in Nord Amerika. Vortrag gehalten am 21. April 1923. Kreuzlingen, Heilanstalt Belle-Vue. Von Prof. Dr. A. Warburg," 78. We should of course take into consideration the eyewitness accounts of the lecture offered by Saxl and by Warburg's son Max Adolf, who in their letters to Mary Warburg both declare that Warburg spoke freely, referring but cursorily to his written text. See the article by Dorothea McEwan, "Zur Entstehung des Vortrages über das Schlangenritual," in Schüttpelz, *Schlangenritual*, 267–83.

49. WIA, III.93.1, "Bilder aus dem Gebiet der Pueblo-Indianer," 107. A similar formulation on the transcendence of snake worship was inserted before the Uncle Sam finale in the published text. Steinberg, 52–53.

50. "Und dabei soll es bleiben. Der Mensch soll nicht im Gottesdienst vierfüssige Antilope sein müssen, soll nicht ein Tier sein müssen, wenn er sich dem Unendlichen nähern will. Er soll nur von seinen zwei Füssen Gebrauch machen, die Stufen hinangehen und den Kopf erheben zum Himmel." WIA, III.93.1, "Bilder aus dem Gebiet der Pueblo-Indianer," 107.

51. Indeed, a close reading of the lecture shows that almost every other phrase indicates a textual reference. The works by Schmidt, Fewkes, Harrison, and Lactantius acknowledged in the published footnotes are only the first layer of these citations (Steinberg, 55). The unpublished drafts present a second layer of references to Hans Vaihinger and his *Philosophie des Als-Ob* (also present in the published version), Tito Vignoli's *Myth and Science*, Goethe's *Faust*, as well as authors that would not appear in any other work by Warburg, such as Freud, Levy-Bruhl, and the physiognomist Heinz Werner. See, Aby Warburg, "Memories of a Journey through the Pueblo Region," in Michaud, *Aby Warburg and the Image in Motion*, 292–330.

52. Aby Warburg, "A Lecture on Snake Ritual," *Journal of the Warburg and the Courtauld Institutes* (hereafter cited as *JWI*) 2, no. 4 (April 1939): 277–92.

53. Warburg, "A Lecture on Snake Ritual," 289; also in Steinberg, 42. A similar reference to the immortality of the snake is mentioned in an extensive letter by Gertrud Bing, sent to Warburg in preparation for his lecture analyzing the religious symbolism of the snake in archaic cultures. See WIA, GC, Bing to Warburg, March 27, 1923.

54. The Warburg Archive contains three typescript copies of Warburg's lecture and each of them bears a different set of manuscript annotations by Warburg and/or Saxl (WIA, III.93.1–3). The first copy is annotated by Warburg himself and has a rather large number of references and addenda not included in the edited version published in the *JWI*. The typescript put together by Gertrud Bing and other editors (WIA, III.93.3.2), and on which F. W. Mainland based his English translation for the *JWI*, does not include any footnotes. Apparently, the five footnotes published in the *JWI* (collected from some of Warburg's annotations or from his earlier lecture drafts) were inserted after translation, thus explaining why the only footnote that is not a bibliographic reference remained in German. In Warburg's original typescript there is no sign of an addendum corresponding to this footnote.

55. Steinberg, 55, and Warburg, "A Lecture on Snake Ritual," 289. The text of that footnote comes from an earlier draft of the Kreuzlingen lecture, likely written between March 13 and March 29, 1923, in preparation for the final event. This draft seems to have been intended as a private memoir and differs greatly from the public presentation delivered one month later. The passage describing the snake's "five qualities" is dated March 26. WIA, III.93.4, "Bilder aus dem Gebiet der Pueblo-Indianer. Lecture draft, 1923, including autobiographical parts and additions," 95; for an English translation, Michaud, *Aby Warburg and the Image in Motion*, 324.

56. Among the publications recorded are Baudissin's *Esmun-Asklepios* (1904) and *Semitische Studien* (1876); Weinreich's *Antike Heilungswunder* (1909); August Marx's *Griechische–Marschen* (1889 edition); Salomon Reinach's *Cultes, mythes et religions*; Jacob Maehly's *Die Schlange im Mythus und Cultus der classischen Völker* (1867); J. L. Uhland's *Schriften zur Geschichte der Dichtung und Sage* (8 volumes, 1865–73), with a note on "Schlangen Weissagung"; Friedrich Leberecht Wilhelm Schwartz's *Die altgriechischen Schlangengottheiten* (Berlin: 1858, 1897).

57. Most of these notes seem to have been written at the same time; though the penmanship suggests an early moment in Warburg's career, these notes cannot be earlier than 1909, when Weinreich's *Antike Heilungswunder* (see note 56) was published.

58. Part of the research on antidotes was finally published by Gertrud Bing and the other editors of the 1932 edition of Warburg's collected works in the form of an extensive addendum to a synopsis of Warburg's three "Contributions to the Cultural History of the Florentine Quattrocento" of 1929—one of them referring to Gulio Romano's tondo painting of a snakebite-antidote vendor. See Warburg, *The Renewal of Pagan Antiquity*, 402–3,

547–48.

59. Darwin, *The Expression of the Emotions*, 272; Souriau, *The Aesthetics of Movement*, 3.

60. Entry in the clinical diary of Aby Warburg by Ludwig Binswanger, dated April 22, 1923. Ludwig Binswanger—Aby Warburg, *Die unendliche Heilung: Aby Warburg's Krankengeschichte*, ed. Chatal Marazia and Davide Stimilli (Zürich-Berlin: Diaphanes, 2007), 79 (my emphasis).

61. WIA, III.93.4, "Bilder aus dem Gebiet der Pueblo-Indianer. Lecture draft," 95.

62. Often during and after the Great War, Warburg would use terms from military discourse. For example, in "quality no 4" (from the same footnote of the *JWI* text), Warburg describes how the snake "shoots out from the secret holes in the earth" by using the verb "herausschnellen," which is complementary to the term "Schnellkraft," concerning the release of latent energy. Steinberg, 55.

63. In his lecture on stamps (*Briefmarkenvortrag*), Warburg employed the term "*automobil*" to designate the movement of words and images in modern printing devices. See Ulrich Raulff, *Wilde Energien; Vier Versuche zu Aby Warburg* (Göttingen: Wallstein Verlag 2003), 108.

64. Aby Warburg, "American Chapbooks," in *The Renewal of Pagan Antiquity*, 705.

65. Warburg "Memories from a Journey in the Pueblo Region," 310–11.

66. See the report by the U.S. pneumatic tube postal commission, *Development of the Pneumatic Tube and Automobile Mail-Service* (Washington, D.C.: Government Printing Office, 1917). For pneumatic telegraphy in France, see Charles Bontemps, *Les systèmes télégraphiques: aériens, électriques, pneumatiques* (Paris: Dunod, 1876). Warburg mentions "telegram and telephone" in the concluding paragraph of the edited lecture in its published version. Steinberg, 54.

67. This photograph was reprinted by László Moholy-Nagy from the popular illustrated journal *Weltspiegel*, with the caption: "massing (surface aspect) old motorcar tires" (*häufung [faktur] alte autoreifen*). See László Moholy-Nagy, *von material zu architektur* (GmbH Köthen, 1929), facsimile (Berlin: Gebr. Mann Verlag, 2001), 48, fig. 32.

68. See the photographs showing the ritual of "snake washing" in George A. Dorsey and H. R. Voth, *The Mishongnovi Ceremonies of the Snake and Antelope Fraternities* (Chicago: Field Columbian Museum, 1902), plates 126–29.

69. See, for example, Peter Lertes, *Die drahtlose Telegraphie und Telephonie*, 2nd ed., Wissenschaftliche Vorschungsberichte (Dresden: Steinkopff, 1923). For a discussion of telegraphy and wireless devices in Warburg's work, see Thomas Hensel, "Kupferschlangen, unendliche Wellen und telegraphierte Bilder. Aby Warburg und das technisches Bild" in Schüttpelz, in *Schlangenritual.*, 297–344.

70. Steinberg, 54.

71. WIA, III.93.1, "Bilder aus dem Gebiet der Publo-Indianer in Nord Amerika," 79. Warburg was not the only art historian of his time thinking about microphysics. Both Riegl, in the conclusion of his *Late Roman Art Industry* (1901), and later Panofsky, in his grand essay "Perspective as Symbolic Form" (1927; first presented as a lecture in the Warburg Library in Hamburg in 1924–25), had attributed changes between the ancient, medieval, and modern *Weltanschauung* to the corresponding conception of matter in contemporary physics, with a special reference to recent advances in atom and cellular theory.

72. Theoretical investigations of the microcosm and the macrocosm were prevalent in the early twentieth century, including Warburg's (and later Saxl's) researches in medieval cosmology and Renaissance philosophy. Among many other earlier studies, see Adolf Meyer, *Wesen und Geschichte der Theorie vom Mikro- und Makrokosmos* (Bern: C. Sturzeneg-

ger, 1900), which can be found in the Warburg Library.

73. WIA, GC, Warburg to Saxl, April 26, 1923. The content of the letter is well known since it was included in the first published version of the original text in German; Wagenbach, 58.

74. WIA, ZK 40, "Americana," 040/020443-4, no. 458 verso, 57.

75. See the letter written by his wife, Mary, which describes the children's activities in their holiday house in Fanö (WIA, GC, Mary to Aby Warburg, July 9, 1908), as well as the letters of Warburg's children to their mother reporting the frogs, including toads and tadpoles, in their terrarium (WIA, GC, Max Adolf and Marietta to Mary Warburg, April 8, 1914, and April, 9, 1914).

76. WIA, ZK 40, "Americana," 040/020723.

77. The drawing bears the inscription *gegenüber d.[er] Eingungswand* ("across from the entrance wall"). In his lecture Warburg comments on the earth-house symbol drawn on the entrance wall of a temple in Acoma. WIA, ZK 40, "Americana," 040/020742.

78. Adolph Bandelier, *A History of the Southwest: A Study of the Civilization and Conversion of the Indians in Southwestern United States and Northwestern Mexico from the Earliest Times to 1700*, ed. Ernest J. Burrus (Vatican City: Biblioteca Apostolica Vaticana, 1987).

79. See the color drawing dated 1885 in Bandelier, *A History of the Southwest*, vol. 1 supp., plate 2. For a description of the symbols, see 117 of the same volume.

80. Bandelier, *A History of the Southwest*, 2:189.

81. Bandelier, *A History of the Southwest*, 2:188.

82. The articles are cited in Küster, *Die Schlange*, 143n (see note 40). Konrad Theodor Preuss, "Der Ursprung der Religion und Kunst," part 1, *Globus* 86 (1904): 325; same reference also appears in Preuss, "Der Ursprung der Menschenopfer in Mexiko," *Globus* 86 (1904): 108–19; here 118.

83. "We are here in the realm of the perfect animistic and tree cult, which the work of Mannhardt has shown to belong to the universal religious patrimony of primitive peoples, and it has survived from European paganism down to the harvest customs of the present day." Steinberg, 30–31.

84. For a brief description of this ritual custom see Wilhelm Mannhardt, *Wald- und Feldkulte: Der Baumkultus der Germanen* (Berlin: Borntraeger, 1875), 1:354–55, 606. Mannhardt's account is based on a more extensive description (which is quoted here) in O. Frh. von Reinsberg-Düringsfeld, *Fest-Kalender aus Böhmen: ein Beitrag zur Kenntnis des Volkslebens und Volksglaubens in Böhmen* (Prague: J. L. Kober, 1861), 262. The original description is in an anthology of similar legends in Czech: Václav Krolmus, Staročeské pověsti, zpěvy, slavnosti, hry, obyčeje, a nápěvy : ohledem na bájesloví Českoslovanské. Čašt III, sešitek dvanáctý (V Praze: Jan Spurný, 1851), 3:139–40.

85. Gombrich, *Intellectual Biography*, 72.

86. Darwin, *The Expression of the Emotions*, 36. Dr. Henry Maudsley, *Body and Mind: An Inquiry into Their Connection and Mutual Influence, Specially in Reference to Mental Disorders Being the Gustonian Lectures for 1870 Delivered before the Royal College of Physicians* (New York: Appleton, 1871).

87. Maudsley, *Body and Mind*, 16–17.

88. Luigi Galvani, *De Viribus Electricitatis in Motu Musculari Commentarius* (Bologna, 1792). For a German edition, see Luigi Galvani, *Abhandlung über die Kräfte der Electricität bei der Muskelbewegung*, ed. A. J. von Oettingen (Leipzig: Engelmann, 1894).

89. Darwin, *The Expression of the Emotions*, 36.

90. WIA, ZK 1, "Ausdruckskunde," 001/000038-62. The same notes are mentioned in

the introduction.

91. Warburg's note from Drawin reads: "Reflex. Bew.[egungen] (ohne Bewusstsein). Enthaupteter Frosch der sich mit den Beinen säure—acid—tropfen abzuwaschen sucht—Pflüger." WIA, ZK 1, "Ausdruckskunde," 001/000050.

92. See Warburg's manuscript text titled "*Katharsis*" written April 28, 1923, in Kreuzlingen. WIA, III.93.6, "Pueblo Indians, 1923. 'Katharsis.'"

93. "Das Erinnerungsbild wird als Glied gefühlt," aphorism no. 87, dated September 22, 1890. WIA III.43.1.1, "Grundlegende Bruchstücke," 40.

94. WIA, ZK [12], "Antike Vorprägung," 066/039056, 61, 62. One of Warburg's notes reads "Bronzino, Flor[enz]. Pal.[azzo] V.[ecchio]" and includes the bibliographic reference "F. Goldschmidt Abb. IX." WIA, ZK [12], "Antike Vorprägung," 066/039061. Indeed, the Warburg Library copy of Fritz Goldschmidt, *Pontormo, Rosso und Bronzino. Ein Versuch zur Geschichte der Raumdarstellung* (Leipzig: Klinghardt, 1911), plate 9, bears an *X* underneath Bronzino's painting of "the brazen serpent."

95. The inscription reads: "J. Cats, *Alle de wercken*, Amsterdam 1700." WIA, ZK [12] 066/039056.

96. Part of this collaborative research culminated in Warburg's well-known, yet still unpublished 1926 lecture on Rembrandt. See Gombrich, *Intellectual Biography*, 229–38.

97. "Von Bronzino habe ich nun glücklich eine Aufrichtung der Schlange gefunden, die wirklich den jüngsten Sohn aus der Laokoongruppe enthält." Saxl's expression is subtle: the word *Aufrichtung* describes the "rising" of the serpent from the ground as described in the Bible, as well as its reemergence in Western iconography. After referring to Cornelis von Harlem and his "Pathos-Bildern" of the "Bethlehemitischen Kindermord," Saxl concludes: "Damit die Linie gegeben die zum jungen Rembrandt führt, wenn er auch die Probleme noch auf einer höheren Ebene der Spirale weiter führt." See letter, WIA, GC, Saxl to Warburg, June 15, 1925, published in Dorothea McEwan, *Wanderstrassen der Kultur: Die Aby Warburg—Fritz Saxl Korrespondenz 1920 bis 1929* (Hamburg: Dölling und Galitz Verlag, 2005), 157.

98. "Suggestion Bronzino—Laokoon interessiert mich sehr!" WIA, GC, Warburg to Saxl, June 19, 1925.

99. "Schlange in Geza gefunden, Benzinger, S. 328." See WIA ZK 6, "Ikonologie-Synthese," 006/002160.

100. Immanuel Benzinger, *Hebräische Archäologie*, (Leipzig: Mohr, 1894; Tübingen: Mohr, 1907; Leipzig: Pfeiffer, 1927). Both the second and the third edition include revisions by the author.

101. Benzinger, *Hebräische Archäologie* (1907), 328.

102. "Yidesch (Jargon: Aberglauben/Grossmutter W. ?)," WIA, ZK 6, "Ikonologie-Synthese," 006/002160.

Chapter Three

1. The photograph appeared as the frontispiece to a collection of essays marking the seventy-fifth birthday of the author in 1956. Wilhelm Worringer, *Fragen und Gegenfragen: Schriften zum Kunstproblem* (Munich: R. Piper, 1956).

2. For an image of the charcoal drawing *Worringer as Thinker*, c. 1942, see Helga Grebing, *Die Worringers: Bildungsbürgerlichkeit als Lebenssinn—Wilhelm und Marta Worringer (1881–1965)* (Berlin: Parthas Verlag, 2004), 186.

3. Gilles Deleuze and Félix Guattari, *A Thousand Plateaus: Capitalism and Schizophrenia*,

trans. Brian Masumi (Minneapolis: University of Minnesota Press, 1987), 168.

4. See Ann Stieglitz's interview with Worringer's assistant regarding the illustrations of the 1919 German edition of *Form Problems of the Gothic*. Ann Stieglitz, "The Reproduction of Agony: Toward a Reception-History of Grünewald's Isenheim Altar after the First World War," *Oxford Art Journal* 12, no. 2 (1989): 87–103.

5. Wilhelm Worringer, "Art Questions of the Day," *Monthly Criterion* (August 1927): 113–14; English translation of "Künstlerische Zeitfragen" (1921), reprinted in *Fragen und Gegenfragen*, 125.

6. Wilhelm Worringer, *Abstraction and Empathy: A Contribution to the Psychology of Style*, trans. Michael Bullock, (New York: International Universities Press, 1980), viii–ix; hereafter cited as *AE*. For the German: Wilhelm Worringer, *Abstraktion und Einfühlung: Ein Beitrag zur Stilpsychologie* (inaugural dissertation, Universität Bern, Neuwied, 1907). Among the many commentaries of *Abstraction and Empathy*, see Siegfried K. Lang, "Wilhelm Worringer's *Abstraktion und Einfühlung*. Entstehung und Bedeutung," in *Wilhelm Worringers Kunstgeschichte*, ed. Hannes Böhringer and Beate Söntgen (Munich: Fink, 2002), 81–118; Claudia Öhlschläger, *Abstraktionsdrang: Wilhelm Worringer und der Geist der Moderne* (Munich: Wilhelm Frank Verlag, 2005); and Yvonne Spielmann, "Redimensionierung einer Grundspannung," in Wilhelm Worringer, *Schriften*, ed. Hannes Böhringer, Helga Grebing, and Beate Söntgen, with the collaboration of Arne Zerbst (Munich: Wilhelm Frank Verlag, 2004), 2:1327–37.

7. "Der Centralbau ist der willenlosen Pflanze verwandt, und steht dem Krystallinismus der unorganischen Materie noch näher. Der Längsbau nimmt also auch hier Rücksicht auf das Geistige, wie es im Tiere schon sich äussert zum Unterschied von der Pflanze. Das christliche Culthaus soll vor allem Inne[n]raum sein." Alois Riegl, lecture notes (University of Vienna, summer of 1898), "Appendix," in *Late Roman Industry*, trans. Rolf Winkes (Rome: Giorgio Bretschneider, 1985), 241 (an. 14, ms. p. 61). For the original German edition but without these lecture notes, see Alois Riegl, *Die spätrömische Kunstindustrie nach den Funden in Österreich-Ungarn*, ed. Emil Reisch (Vienna: Österr. Staatsdruckerei, 1927; repr. facs., Darmstadt: Wissenschaftliche Buchgesellschaft, 1964). On another analysis of the Christian basilica by Riegl, see also his "Zur Entstehung der altchristlichen Basilika," in *Jahrbuch der K.K. Zentral-Kommission für Erforschung und Erhaltung der Kunst und Historischen Denkmale* (Vienna 1903), 196–216.

8. In his *Elements of Physiophilosophy* (1809–11), Lorenz Oken writes: "The inorganic is angular, the organic spherical." Quoted in Philip C. Ritterbush, "Aesthetics and Objectivity in the Study of Form in the Life Science," in *Organic Form: The Life of an Idea*, ed. G. S. Rousseau (London: Routledge, 1972), 43.

9. Riegl, *Late Roman Industry*, 20; and *Die spätrömische Kunstindustrie*, 24.

10. Gottfried Semper in the "Prolegomena" of his *Style* also referred to both animals and buildings such as the basilica in terms of the directional axis of movement. See Gottfried Semper, *Style in the Technical and Tectonic Arts or Practical Aesthetics*, trans. H. F. Mallgrave and Michael Robinson (Los Angeles: Getty Research Institute, 2004), 91, 96.

11. For Riegl's references to Saint Augustine, see the epilogue of his *Late Roman Industry*, 223–34. For reasons of "convenience," Riegl uses a contemporary anthology of excerpts from Augustine's later writings as a Christian, which have references to beauty and the fine arts by A. Berthaud, *Sancti Augustini doctrinam de pulchro ingenuisque artibus e variis illius operibus excerptam* (Poitier: Oudin, 1891).

12. On the necessity of a soul as the principle of growth in plants, see Thomas Aquinas, *A Commentary on Aristotle's De Anima*, trans. Robert Pasnau (New Haven: Yale University

Press, 1999), 138. For the "will" in plants, see Arthur Schopenhauer, *The World as Will and Representation*, trans. E. F. J. Payne (New York: Dover, 1958), 2:294–95. On the "soul of plants," Gustav Theodor Fechner, *Nanna oder Über das Seelenleben der Pflanzen* (c. 1848) (Leipzig: L. Voss, 1899).

13. In the conclusion of *Late Roman Industry*, Riegl refers again to late Roman building in terms of a tree, borrowing from his reading of Saint Augustine: "Thus a tree constitutes a unit with its completed individual shape (*de Ordine*, lib.II., c.XVIII, c.I, cl.1017) and no less its individual *anima vegetativa*, to whom it owes its development and movement (growth)." Riegl, *Late Roman Industry*, 227n119.

14. Alois Riegl, *Problems of Style: Foundations for a History of Ornament* (*Stilfragen*, c. 1893), trans. Evelyn Kain (Princeton: Princeton University Press, 1992).

15. Charles Darwin, *The Power of Movement in Plants* (London: John Murray, 1880), 1. See also Charles Darwin, *The Movements and Habits of Climbing Plants*, 2nd rev. ed. (New York: D. Appleton and Company, 1876).

16. Becquerel also used the term "suspended life." In addition to seeds, he made similar experiments in moss, bacteria, algae, and infusorians by dehydrating and freezing them and then reviving them by warming and rehydration. See Paul Becquerel, "Recherches expérimentales sur la vie latente des spores des *Mucorinées et des Ascomycétes* aux basses températures de I'hydrogène liquide," *Comptes rendus de I'Académie des sciences* 150 (1910): 1437–39; and "Action abiotique des rayons ultraviolets sur les spores sèches aux basses températures et l'origine cosmique de la vie," *Comptes rendus de I'Académie des sciences* 151 (1910): 86–88.

17. Excerpt from Fechner's *Nanna, the Soul of Plants*, translated into English in *The Religion of a Scientist: Selections from Gustav Th. Fechner*, ed. and trans. Walter Lowrie (New York: Pantheon Books, 1946), 196–97.

18. See Otto Lehmann, *Die scheinbar lebende kristalle; Anleitung zur Demonstration ihrer Eigenschaften sowie ihrer Beziehungen zu anderen flüssigen und zu den festen Kristallen in form eines Dreigesprächs* (Esslingen, München: J. F. Schreiber, 1907); and *Die neue Welt der flüssigen Kristalle und deren Bedeutung für Physik, Chemie, Technik und Biologie* (Leipzig: Akademische Verlagsgesellschaft, 1911). Lehmann's later books repeat much of the same material yet emphasize the connections between crystallography and biology, for example, Otto Lehmann, *Die Lehre von den flüssigen Krystallen und ihre Beziehung zu den Problemen der Biologie* (Wiesbaden: Bergmann, 1918).

19. Ernst Haeckel, *Kristallseelen; Studien über das anorganische Leben* (Leipzig: Kröner, 1917), 27 and frontispiece.

20. Lehmann, *Die neue Welt der flüssigen Kristalle*, 175; and Haeckel, *Kristallseelen*, 27–28.

21. Lehmann announced the last of his films in a new publication titled *Flüssige Kristalle und ihr scheinbares Leben. Forschungsergebnisse dargestellt in einem Kinofilm* (Leipzig: Voss, 1921). Lehmann mentions that his film would be available from the natural science section of a film society in Berlin and could be projected in any cinema theater.

22. This is a reference by Lehmann to the famous philosophical study of Hans Vaihinger, "The Philosophy of As If" (also mentioned in chapter 2). See Otto Lehmann, "Das 'Als ob' in Molekularphysik," in *Annalen der Philorsophie und Philosophischen Kritik* 1, no. 1 (1918): 203–30; cited in Lehmann, *Flüssige Kristalle und ihr scheinbares Leben*, 70n.

23. Lehmann, *Die Lehre von den flüssigen Krystallen*, 494.

24. Lehmann, *Die Lehre von den flüssigen Krystallen*, 496.

25. Lehmann, *Die neue Welt der flüssigen Kristalle*, 268–69.

26. See Lehmann's further references to "crystal worms," with additional photographs, in *Die Lehre von den flüssigen Kristallen*, 492–95.

27. Haeckel, *Kristallseelen; Studien über das anorganische Leben*, 27–28.

28. Lehmann, *Flüssige Kristalle und ihr scheinbares Leben*, 70.

29. Ernst Haeckel, *Die Radiolarien (Rhizopoda radiaria) Eine Monographie* (Berlin: Reimer 1862); and *Kunstformen der Natur* (Leipzig: Verlag des Bibliographischen Instituts, 1904).

30. Walter Hirt, *Das Leben der Anorganischen Welt: Eine Naturwissenschaftliche Skizze* (Munich: E. Reinhardt, 1914).

31. "Ich bethrachte den auf meinem Schreibtisch liegenden Briefbeschwerer. Er dehnt sich aus und zieht sich zusammen, je nachdem ich vor ihm sitze und mein warmer Atem ihm nahe ist, oder in der Stube herumgehe und mich entferne. Er reagiert auf das Öffnen der Türe und auf den Luftzug durch die Fensterritzen. Seine Bewegungen sind unmerklich und unmessbar, aber sie erfolgen und entsprechend den beständigen Zusammenziehungen und Ausdehnungen geht Luft in den Stein hinein und Luft wird wieder ausgepresst. Der Stein atmet." Hirt, *Das Leben der Anorganischen Welt*, 55.

32. Hirt, *Das Leben der Anorganischen Welt*, 112–15.

33. Hirt, *Das Leben der Anorganischen Welt*, 86–109.

34. In his next books, Hirt "unveiled" a new theory of the soul in which he described psychological functions based on physiological principles and with the use of illustrative diagrams. Alois Hirt, *Ein neuer Weg zur Erforschung der Seele: eine psychologische Skizze* (Munich: Ernst Reinhardt, 1917); and *Die Entschleierung der Seele: Eine neue Theorie* (Berlin: Hugo Bermühler Verlag, 1923).

35. Richard Semon, *Die Mneme als erhaltendes Prinzip im Wechsel des organischen Geschehens*, 2nd ed. (Leipzig: Engelmann,1908). For the English edition, see Richard Semon, *Mnemic Psychology*, trans. Bella Duffy (London: Allen & Unwin, 1923).

36. Haeckel, *Kristallseelen*, 99–100; and Hirt, *Das Leben der Anorganischen Welt*, 136–38.

37. Hirt, *Das Leben der Anorganischen Welt*, 147.

38. Translation modified. For the original, see *Abstraktion und Einfühlung*, 78–79.

39. "Es ist, als ob das Phänomen der flüssigen Kristalle sich in einer neuen Kristallisation unseres Denkens vollzöge." Wilhelm Worringer, "Künstlerische Zeitfragen" (1921), in *Fragen und Gegenfragen*, 126.

40. Giorgio Vasari, *The Lives of Artists*, trans. George Bull (London: Penguin Classics, 1988), 1:32; and Jacob Burckhardt, *The Age of Constantine the Great* (1852), trans. Moses Hadas (Berkeley: University of California Press, 1983), 220.

41. Riegl, *Late Roman Industry*, 54–55 (translation modified); and *Die spätrömische Kunstindustrie*, 90.

42. For the original text, see Worringer, *Abstraktion und Einfühlung*, 92.

43. For the German text, see Worringer, *Abstraktion und Einfühlung*, 74. Part of the same passage is repeated in a later section of the book (*AE* 109).

44. Worringer makes this claim in a passage in his next book while describing the "abstract yet empathetic" character of the Nordic strapwork ornament. Wilhelm Worringer, *Form in Gothic*, ed. Herbert Read (c. 1927) (New York: Schocken, 1957), 41; hereafter cited as *FG*. For the original edition: *Formprobleme der Gotik* (c. 1911) (Munich: R. Piper, 1930).

45. Deleuze and Guattari, *A Thousand Plateaus*, 498–99.

46. Juliet Koss, "On the Limits of Empathy," *Art Bulletin* 88, no. 1 (2006): 145. Koss, though, acknowledges that Worringer essentially "transposed" empathy to abstraction, and that "the two perceptual experiences were not always distinguishable." See also the critical

anthology *Einfühlung: Zur Geschichte und Gegenwart eines ästhetischen Konzepts,* ed. Robin Curtis and Gertrud Koch (Berlin: Fink Verlag, 2009).

47. Rudolf Arnheim, "Abstraction and Empathy in Retrospect," *Confinia Psychiatrica* 10, no. 1 (1967), mentioned in the introduction to this book.

48. See Worringer's references to marionettes in *AE* 107; and *FG* 157.

49. See Ernst Jentsch, "Zur Psychologie des Unheimlichen," in *Psychiatrisch-neurologische Wochenschrift* 8, no. 195 (1906): 219–21, 226–27; and Sigmund Freud, "The Uncanny" (1919), in *The Standard Edition,* 14:230.

50. For an extension of Freud's concept of psychological *anaclisis* as "propping" (*étayage*), see Jean Laplanche, *Life and Death in Psychoanalysis,* trans. Jeffrey Mehlman (Baltimore: Johns Hopkins University Press, 1976), 15–18.

51. Wilhelm Worringer, "Entstehung und Gestaltungsprinzipien in der Ornamentik," in *Kongress für Aesthetik und Allgemeine Kunstwissenschaft Berlin 7–9 October 1913,* ed. Max Dessoir (Stuttgart: Ferdinand Enke, 1914), 222–31.

52. For a history of the museum during the period of Worringer's visit (c. 1905), see Nélia Dias, *Le Musée d'Ethnographie du Trocadéro (1878–1908). Anthropologie et Muséologie en France* (Paris: Editions du CNRS, 1991).

53. Owen Jones, *The Grammar of Ornament* (London: Day, 1856), also in a German edition (*Grammatik der Ornamente*) by the same publisher and with the original plates.

54. In his 1913 lecture on ornamentation Worringer would identify Northern animal decoration with band ornament, yet argue that animal figuration is eclipsed by the abstraction of rhythm. Worringer, "Entstehung und Gestaltungsprinzipien der Ornamentik," 228.

55. Bernhard Salin, *Die altgermanische Thierornamentik. Typologische Studie über germanische Metallgegenstände aus dem IV. bis IX. Jahrhundert, nebst einer Studie über irische Ornamentik* (Stockholm: Beckman, 1904). Riegl's review of Salin's book was published in *Göttingische gelehrte Anzeigen* 167, no. 2 (1905): 228–36. Several of Salin's illustrations were also included by Piper in Worringer's *Formprobleme der Gotik.*

56. "Im VIII. Jahr. steigert sich die Unklarheit der neuen anaturalistischen Verbindungen in solchem Masse, dass dadurch das entgegengesetzte Exrem erreicht, die lebendige Thierornamentik in eine geometrische umgewandelt und dadurch im Grunde aufgehoben und vernichtet erscheint." Riegl, review of Salin's *Die altgermanische Thierornamentik,* 231.

57. Worringer cites Sophus Müller, *Die Thier-Ornamentik im Norden. Ursprung, Entwicklung und Verhältniss derselben zu gleichzeitigen Stilarten,* translated from the Danish (Hamburg: Meissner, 1881) (*AE* 61); and Woermann's *Geschichte der Kunst,* 2:87 (*AE* 110).

58. Lehmann, "Flüssige Kristalle und Magnetismus," in *Die neue Welt,* 343–67.

59. Riegl, *Late Roman Industry,* 15.

60. For a criticism of the role of race in Worringer's *Form in Gothic,* see Paul Frankl, "Gothic Man," in *The Gothic: Literary Sources and Interpretations through Eight Centuries* (Princeton: Princeton University Press, 1960), 669–80; and Carlo Ginzburg, "Style: Inclusion and Exclusion," in *Wooden Eyes: Nine Reflections on Distance,* trans. Martin Ryle and Kate Soper (New York: Columbia University Press, 2001), 130–31.

61. On associations between ornamental patterns, rhythmic dance movements, "comparative graphology," as well as "ethnic" and "race-psychological" factors, see Worringer, "Enstehung und Gestaltungsprinzipien der Ornamentik," 228.

62. For a comparative analysis of Worringer and Warburg, see Andrea Pinotti, "Chaos Phobos: arte e pericolo in Warburg, Worringer, Klee," in *Il paesaggio dell'estetica. Teorie e percorsi. Atti del 3 convegno nazionale Universitá di Siena maggio 1996* (Torino: Trauben, 1997). Warburg's Zettelkästen contain a bibliographic note on Worringer's *Abstraktion und Einfüh-*

lung, but with no further comments or notes. The Warburg archive also contains a few letters that indicate that Worringer was interested in lecturing at the Warburg Library in Hamburg (KBW) in 1924, yet the director, Fritz Saxl, diplomatically refused. See WIA, GC, Richard Hertz to Fritz Saxl, October 1, 1924.

63. Wilhelm Worringer, "Ars Una" (1954), in *Fragen und Gegenfragen*, 155–63.

64. "Die wechselvolle, schicksalreiche Auseinandersetzung von Mensch und Aussenwelt." Worringer, *Formprobleme*, 12; and *FG* 13.

65. Worringer quotes Laugier (cited erroneously as "Langier"), who, in his "Essay on Architecture" (1753), characterizes the Gothic as *"barbarie . . . informe, grotesque, excessif"* (quoted in French in Worringer's text) (*AE* 115).

66. On Worringer's abstraction and contemporary discourses of agoraphobia, see Anthony Vidler, *Warped Space* (Cambridge, MA · MIT Press, 2000), 44–45.

67. Georg Simmel, "The Metropolis and Mental Life," in *The Sociology of Georg Simmel*, ed. Kurt H. Wolff (New York: Free Press, 1950), 409–24. On the relationship between Worringer and Simmel, see Claudia Öhlschläger, *Abstraktionsdrang*, 16–23.

68. See Geoffrey Waite, "After Worringerian Virtual Reality: Videodromes and Cinema 3, MassCult and CyberWar," in Donahue, *Invisible Cathedrals*, 186.

69. See the afterword by Sebastian Weber in a recent German edition of *Abstraktion und Einfühlung* (Dresden: Verlag der Kunst, 1996).

70. For example, his critique of the ancient Egyptian's "Americanism" in Wilhelm Worringer, *Egyptian Art* (c. 1927), trans. Bernard Rackham (London: Putnam 1928). See also, Neil H. Donahue, "From Worringer to Baudrilliard and Back: Ancient Americans and (Post) Modern Culture in Weimar Germany," in *Invisible Cathedrals*, 135–55.

71. Ernst Haeckel, *The Riddle of the Universe at the Close of the Nineteenth Century*, trans. Joseph McCabe (New York and London: Harper & Brothers, 1900).

72. "Es ist nicht der Gegensatz, sondern die Mutterschoss, die Regel, welche mehr Sinn hat als die Ausnahme" (11.125). "Es ist ein *Fest*, aus dieser Welt in die 'tote Welt" überzugehen" (11.70; emphasis in the original). Friedrich Nietzsche, "Nachgelassene Fragmente Frühjar 1881 bis Sommer 1882," in *Nietzsche Werke Kritische Gesamtausgabe*, ed. Giorgio Colli und Mazzino Montinari (Berlin: Walter de Gruyter, 1973), 5.2:366, 384.

73. For the first publication of these aphorisms in German, see *Nietzsche's Werke* Zweite Abtheilung, Band 12, "Nachgelassene Werke Unveröffentlichtes aus der Zeit der Fröhlichen Wissenschaft und des Zarathustra (1881–1886)" (Leipzig: C. G. Naumann, 1901), 228–29 (aphorisms nos. 497–98).

74. Charles Andler, *Nietzsche, sa vie et sa pensée* (Paris: Bossard, 1920–31), 6:307.

75. See the special issue "Nietzsche et les fascists: Une Réparation," in *Acéphale* (Paris: January 21, 1937; fasc. repr., Paris: Jean Michel Place, 1995), 18. Some of these notes are included by Dennis Hollier in *The College of Sociology 1937–39*, trans. Betsy Wing (Minneapolis: University of Minnesota Press, 1988), 79, 406n.

76. See Herbert Read, "Introduction," in *Speculations: Essays on Humanism and the Philosophy of Art*, by T. E. Hulme, ed. Herbert Read (London: Routledge, 1924), x–xi.

77. See list of participants and auditors in *Kongress für Aesthetik 1913* (cited in note 51).

78. T. E. Hulme, "Humanism and the Religious Attitude," in Hulme, *Speculations*, 3–11. For Hulme's references to Worringer's polarity of *Abstraction and Empathy*, see the chapter on "Modern Art and its Philosophy," in Hulme, *Speculations*, 5–91.

79. Hulme, *Speculations*, 9.

80. Herbert Read, *The Green Child: A Romance* (New York: New Directions, 1948), 174.

81. Read, *The Green Child*, 194.

82. See Otto Rank, "Introduction," in *Art and Artist: Creative Urge and Personality Development* (1932) (New York: Norton, 1968), xlviii.

83. The caption reads: "The curve, the primary form of capitalism, is overcome. The new day dawns. Threateningly, the cubes march through the universe." *Simplicissimus* 24, no. 7 (May 13, 1919): 94. As Joan Weinstein notes, the cartoon was "a parody of the political implications of expressionist art." Joan Weinstein, *The End of Expressionism: Art and the November Revolution in Germany, 1918–19* (Chicago: Chicago University Press, 1990), 207.

84. See Romy Golan, "A Crisis of Confidence: From Machinism to the Organic," in *Modernity and Nostalgia: Art and Politics in France between the Wars* (New Haven: Yale University Press, 1995), 61–83; and Jeffrey Herf, *Reactionary Modernism: Technology, Culture, and Politics in Weimar and the Third Reich* (New York: Cambridge University Press, 1984).

85. Bloch reanimates an earlier attack by Lukács on the crystalline aesthetics (and ambivalent politics) of expressionism by juxtaposing the "Tree of Life" (*Lebensbaum*) in Gothic art to the "Crystal of Death" (*Todeskristall*) in Egyptian art and architecture. See Ernst Bloch, *The Principle of Hope*, trans. N. Plaice and P. Knight (Cambridge, MA: MIT Press, 1986), 2:720–22.

86. See Sedlmayr's centenary homage to Worringer, in which he praises the author of *Abstraction and Empathy* as a "great" man and one of the few "ingenious researchers" in art history. Hans Sedlmayr, "Wilhelm Worringer," *Pantheon* 32, no. 2 (April–June 1981): 182.

87. See Hans Sedlmayr, *Art in Crisis: The Lost Center*, trans. B. Battershaw (Chicago: H. Regnery Co., 1958), 161, 163.

88. For the application of liquid crystals in contemporary art, see Yves Charnay, "A New Medium for Expression: Painting with Liquid Crystals," and David Makow, "Liquid Crystals in Painting and Sculpture," in *Leonardo* 15, no. 4 (1982): 219–21, 257–61.

89. The anthology edited by Kepes also contained a small general article on crystallography by the chemistry professor Kathleen Lonsdale, "Art in Crystallography," in *The New Landscape in Art and Science*, ed. György Kepes (Chicago: Theobald & Co., 1956), 358–59. Lehmann's microphotographs were included in a section on magnification. See Kepes, *The New Landscape in Art and Science*, 146, figs. 134, 135.

90. See Ben Nicholson, with an introduction by Herbert Read, *Paintings, Reliefs, Drawings* (London: Lund, Humphries, 1948). Read's text was later republished in the collection of essays by the art historian dedicated to Worringer. Herbert Read, *The Philosophy of Modern Art* (c. 1952) (New York: Meridian, 1960), 244–54; here, 247.

91. For the pairing of Worringer with Tony Smith, see Joseph Masheck, "Crystalline Form, Worringer, and the Minimalism of Tony Smith," in *Building-Art: Modern Architecture under Cultural Construction* (Cambridge: Cambridge University Press, 1993), 143–61. For Worringer's aesthetic polarity vis-à-vis contemporary sculpture post-9/11, see Donald Kuspit, "Abstraction and Empathy, Once Again," in *Sculpture* 21, no. 7: 53–57.

92. These book covers are from Wilhelm Worringer, *Abstraktion und Einfühlung* (Munich: R. Piper, 1959); and Worringer, *Abstraction and Empathy* (New York: Meridian Books, 1967).

93. The article also includes the passage from T. E. Hulme's *Speculations* that synopsizes Worringer's argument in *Abstraction and Empathy*, and which Read had previously quoted in his introduction to the English translation of *Form in Gothic* of 1927 (x–xi). Read, *The Philosophy of Modern Art*, 248–49.

94. See David Thistlewood, "Herbert Read's Aesthetic Theorizing, 1914–1952: An Interpretation of *The Philosophy of Modern Art*," *Art History* 2, no. 3 (September 1979):

349–50; and James King, *The Last Modern: A Life of Herbert Read* (London: Weidenfeld and Nicolson, 1990).

95. Herbert Read, "Wilhelm Worringer," *Encounter* 25, no. 5 (November 1965): 58–60.

96. Read, "Wilhelm Worringer," 59.

97. On the character of Mr. Steiner, see Antonio Costa, *Federico Fellini: "La Dolce Vita"* (Torino: Lindau, 2010), 134–40.

98. For Worringer's appreciation of contemporary Italian painting, see Wilhelm Worringer, "Carlo Carrá's *Pinie am Meer*. Bemerkungen zu einem Bilde," in *Wisen und Leben* 18 (November 10, 1925): 1165–69. On Worringer's article, see Barbara Copeland Buenger, "Das Italien Max Beckmanns und Wilhelm Worringers," in Böhringer and Söntgen, *Wilhelm Worringers Kunstgeschichte*, 141–79.

99. In his recent analysis of the film, Antonio Costa also associates the role of Sylvia with Warburg's portrayal of the Renaissance nymph. Costa, *Federico Fellini*, 129–32.

100. For an analysis of the soundtrack of Fellini's *La Dolce Vita*, see M. Thomas Van Order, *Listening to Fellini: Music and Meaning in Black and White* (Madison: Fairleigh Dickinson University Press, 2009), 213–27.

Chapter Four

1. Letter dated September 6, 1919, in Fernand Léger, *Une correspondance d'affaires : Fernand Léger et Léonce Rosenberg, 1917–1937* (Paris: Éditions du Centre Pompidou, 1996), 58–59.

2. The original exhibition catalog from the spring 1911 Salon des Indépendants lists Léger's tableau as "6713: *Nu dans un paysage*," and together with two other works that are categorized as "drawings." Also, in Léger's written authorization of 1921 of Rosenberg's photography of some of the painter's works, the painting—then already in the collection of Kahnweiler—is mentioned again as *Nu dans un paysage*. See Léger, *Une correspondance d'affaires*, 88.

3. On painting as the "producer of models" apropos the historiography of Hubert Damisch, see Yve-Alain Bois, *Painting as Model* (Cambridge, MA: October/MIT Press, 1990), 245–57.

4. "*Fernand Léger* mesure le jour et la nuit, pèse des blocks, calcule des résistances. Sa composition *Nus dans un paysage*, est un corps vivant dont arbres et figures sont les organes. Peintre austère, Fernand Léger se passionne pour ce côté profond de la peinture qui touche aux sciences biologiques et que des Michel Ange et des Leonard presentirent. N'est pas là surtout que vous trouverons des matériaux qui voulons bâtir le monumnet de notre époque?" Jean Metzinger, "Cubisme et tradition," *Paris Journal* (August 16, 1911). A portion of the same text is quoted in Peter de Francia, *Fernand Léger* (New Haven: Yale University Press, 1983), 15.

5. On the relationship between Léger and the unanimist poet Jules Roman, see Judy Sund, "Fernand Léger and Unanimism: Where There's Smoke . . . ," *Oxford Art Journal* 7, no. 1 (1984): 49–56.

6. Dora Vallier, "La vie fait l'œuvre de Fernand Léger. Propos de l'artiste recueillis par Dora Vallier," *Cahiers d'Art* 29, no. 2 (1954) : 138.

7. Durkheim, *The Elementary Forms of Primitive Religion*, 315.

8. For the preparatory sketches for the *Dryad*, see Pablo Picasso, *Carnets, catalogue des dessins*, ed. Brigitte Léal (Paris: Musée Picasso, 1996), 1:200–217.

9. All exercises are featured in *Picasso Landscapes, 1890–1912: From the Academy to the*

Avant-garde, ed. by Maria Teresa Ocana (Boston: Bullfinch Press, 1995).

10. Hubert Damisch, *The Judgment of Paris,* trans. John Goodman (Chicago: Chicago University Press, 1996), 119–20. Dumézil discusses the Indo-European origin of that idea in Georges Dumézil, *Mythe et épopée,* vol. 1, *L'idéologie des trois fonctions dans les épopées des peuples indo-européens* (Paris: Gallimard, 1968).

11. Some of these drawings bear some similarities to another contemporary set of Picasso's drawings that are allegedly linked to Cézanne's treatment of the *Temptation of St. Anthony.* Ocana, *Picasso Landscapes,* fig. 196.

12. See Guillaume Apollinaire, *Apollinaire on Art: Essays and Reviews, 1902–1918,* ed. LeRoy C. Breunig, trans. Susan Suleiman (New York: Viking Press, 1972), 149–50, 153.

13. Apollinaire, *Apollinaire on Art,* 151–52 (translation modified). For the original text, see Guillaume Apollinaire, *Chroniques d'Art (1902–1918),* ed. L.-C. Breunig (Paris: Gallimard, 1960), 165.

14. In the École des Beaux-Arts, André Michelin was trained as an architect and Edouard as a painter under the direction of Bougereau. For a general history of the Michelin dynasty, see Alain Jemain, *Michelin, un siècle de secrets* (Paris: Calmann-Lévy, 1982).

15. For an analysis of the economic and social system of the Michelin company, see A. Dumond, C. Lamy, A. Gueslin, and P. Mazataud, *Michelin, les hommes du pneu. Les ouvriers Michelin, à Clermont-Ferrand, de 1889 à 1940* (Paris: Les Editions Ouvrières, 1993).

16. For an illustrated history of the Michelin advertising campaign, see René Bletterie, *Michelin, Clermont-Ferrand, capitale du pneu 1900/1920* (Avallon: Civry, 1981).

17. Michelin published its first motorist guide for France in 1900 and its first maps in 1908. Jemain, *Michelin,* 59.

18. These images were also imprinted on the ceramic tiles covering the colorful facade of the Michelin premises in London completed in 1911. See, Wendy Hitchmough, ed., *The Michelin Building* (London: Conran Octopus, 1987).

19. Hitchmough, *The Michelin Building,* 35.

20. Jemain, *Michelin,* 57; and Bletterie, *Capital du pneu,* 98.

21. On the illustration of old motorcar tires used by Moholy-Nagy, see chapter 2 on the movement of snakes.

22. Jemain, *Michelin,* 78–79.

23. Bletterie, *Capital du pneu,* 130–31.

24. Douglas Cooper, *Fernand Léger, dessins de guerre 1915–16* (Paris: Bergruen et Cie, 1956).

25. Fernand Léger, *Fernand Léger: Une correspondance de guerre à Louis Poughon, 1914–1918,* ed. Christian Derouet (Paris: Editions du Centre Pompidou, 1990), 66.

26. Vallier, "La vie fait l'œuvre de Fernand Léger," 148.

27. Georges Bataille, "The Structure and Function of the Army," in Hollier, *The College of Sociology,* 140.

28. Referring to the ingenious ordering of "quantities" by his superiors during the war, Léger would comment: "C'est l'abstraction pure, plus pure que la Peinture Cubist 'soi-même'. " Léger, *Une correspondance de guerre,* 36.

29. Léger, *Une correspondance de guerre,* 72.

30. For a parallel between the pictorial practices of cubism and camouflage techniques, see Roy Behrens, *Art, Design, and Modern Camouflage* (Dysart, IA: Bobolink Press, 2002), 58–81.

31. The statement is from a 1954 interview illustrated with a reproduction of *Nudes in the Forest:* "Peintres et sculpteurs vous racontent leur première exposition: la critique fut im-

pitoyable par Fernand Léger," *Les Lettres Françaises* (September 1954), reprinted in *Fernand Léger* (exhibition catalog), ed. Christian Derouet (Paris: Centre Pompidou, 1997), 297.

32. On the distinction between the three types of mimicry, see Roger Caillois, *The Mask of Medusa*, trans. George Ordish (New York: C. N. Potter, 1964).

33. Villier, "La vie fait l'œuvre de Fernand Léger," 149–50.

34. "Entretien de Fernand Léger avec Blaise Cendrars et Louis Carre sur le payssage dans l'oeuvre de Léger," in Blaise Cendrars, *Oeuvres Completes*, ed. Nino Frank (Paris: Editions Denoël, 1969), 14:288.

35. For the various wars fought by Léger, see Eric Michaud, "Art, War, Competition: The Three Battles of Fernand Léger," in Dorothy Kosinski, ed., *Fernand Léger: The Rhythm of Modern Life* (Munich: Prestel, 1994), 57–63.

36. On the colonial wars of that period, see *Bismarck, Europe and Africa: The Berlin Africa Conference, 1884–85 and the onset of partition*, ed. S. Förster, W. J. Mommsen, and R. Robinsom (London: Oxford University Press, 1988); and Thomas Pakenham, *The Scramble for Africa, 1876–1912* (New York: Random House, 1972). On the relation of the colonial wars and the work of Picasso, see Patricia Leighten, "The White Peril and *L'Art nègre*: Picasso, Primitivism, and Anticolonialism," *Art Bulletin* 72, no. 4 (December 1990): 609–30.

37. Pakenham, *The Scramble for Africa*, 585–602.

38. Jean Darcy, *France et Angleterre. Cent années de rivalité coloniale: l'affaire de Madagascar* (Paris: Perrin, 1908).

39. In a table of exports for the island and for the years 1906 to1911, rubber is in first place with an increase higher than 1,200 percent. *Encyclopaedia Britannica* (London, 1910), 10:275. For a history of the rubber industry, see Georges Le Fèvre, *L'épopée du caoutchouc* (Paris: Delamain et Boutelleau, 1927).

40. For a general history of the island, see Hubert Deschamps, *Histoire de Madagascar* (Paris: Berger-Levrault, 1960).

41. For the English point of view, see E. F. Knight, *Madagascar in War Time: The Times Special Correspondent's Experiences among the Hovas during the French Invasion of 1895* (London: Longsmans, Green, 1896).

42. Général Gallieni, *Neuf ans à Madagascar* (Paris: Hachette, 1908).

43. It is estimated that the whole "pacification" process cost the lives of one hundred thousand Malagasies. See Mervyn Brown, *Madagascar Rediscovered: A History from Early Times to Independence* (Hamden,CN: Archon, 1979), 252–55.

44. Léger, *Correspondance de guerre*, 20.

45. James Frazer, *The Golden Bough: A Study of Magic and Religion* (abridged edition) (London: Penguin, 1996), 131–32.

46. On the role of colonial ethnography of popular journals in Rousseau's paintings, *Le Douanier Rousseau* (Paris: Réunion des musées nationaux, 1985), 230–31, 246–47.

47. Villier, "La vie fait l'œuvre de Fernand Léger," 149.

48. Guillaume Apollinaire, *Les peintres cubistes. Méditations esthétiques* (Genève: P. Callier, 1950), 65.

49. See, for example, Descargues: "'une peinture de genre?' Car enfin 'les nus dans la forêt' sont purement et simplement des bûcherons au travail. . . . Le personage de gauche . . . s'inscrit dans une action générale: l'abattage d'une forêt." Pierre Descargues, *Fernand Léger* (Paris: Cercle d'Art, 1955), 26. Christopher Green points out Apollinaire's "mistake" but he attributes it to the poetry of Whitman, specifically a 1909 French translation of *Leaves of Grass*, which, according to Green, Apollinaire (and perhaps Léger, too) might have had in mind. Christopher Green, *Léger and the Avant-Garde*, (New Haven:

Yale University Press, 1976), 18–19.

50. Daniel Henry Kahnweiler, *Der Weg zum Kubismus* (Munich: Delphin, 1920), 47.

51. On the nudes' ambiguous gender, see Green, *Léger and the Avant-Garde*, 318n34.

52. Frazer, *The Golden Bough*, 9.

53. Frazer, *The Golden Bough*, 164–65.

54. "Even face to face with Gods, man is not always in such marked state of inferiority, for he often uses physical coercion on them to get what he wants. He beats the fetish when he is displeased, only to be reconciled with it if, in the end, it becomes more amenable to the wishes of its worshipper." Durkheim, *Elementary Forms*, 36–37.

55. Tylor, *Primitive Culture*, 1:456; and Frazer, *The Golden Bough*, 519.

56. Frazer, *The Golden Bough*, 521.

57. Frazer, *The Golden Bough*, 133.

58. For Léger's own responses to the "life of trees," see Vallier, "La vie fait l'oeuvre de Fernand Léger," 148.

59. Eadweard Muybridge, *Animal Locomotion: An Electro-Photographic Investigation of Consecutive Phases of Animal Movement, 1872–1885* (Philadelphia: University of Philadelphia, 1887).

60. Léger, interview by Vallier, "La vie fait l'œuvre de Fernand Léger, " 149.

61. J. E. Mansion, ed., *Harrap's Standard French and English Dictionary* (London, 1945), 1:226.

62. Caption in a drawing of four pairs of hands of machine workers titled *A la memoire de Majakowski* (1950, Musée Fernand Léger, Biot).

63. Karl Marx, *Capital*, ed. Frederick Engels, trans. S. Moore and E. Aveling (New York: International Publishers, 1967), 1:373–74.

64. Georges Bataille, "The Jesuve" (1930), in *Visions of Excess: Selected Writings, 1927–1939*, ed. and trans. Allan Stoekl (Minneapolis: Minnesota University Press, 1985), 73–78.

65. Bataille, "The Jesuve," 75–76.

66. Bataille, "The Jesuve," 77.

67. Léger, letter to Rosenberg, April 9, 1921, in Léger, *Une correspondance d'affaires*, 90.

68. Sigmund Freud, "Delusions and Dreams in Jensen's *Gradiva*," in Freud, *The Standard Edition*, 9:36.

69. The invention of rubber condoms follows the invention of the vulcanization of rubber by Goodyear in 1839; see Robert Jütte, *Contraception: A History* (Malden, MA: Polity, 2008), 201–2.

70. Bataille, "The Jesuve," 77.

71. On the development of the idea of the reflex, see Georges Canguilhem, "The Concept of Reflex," in F. Delaporte, ed., *A Vital Rationalist: Selected Writings from Georges Canguilhem*, trans. A. Goldhammer (New York: Zone, 1994), 179–216.

72. See the chapters "Head Tabooed" and "Hair Tabooed," in Frazer, *The Golden Bough*, 277–78.

73. Durkheim, *Elementary Forms*, 114–15.

74. Geza Roheim, *Animism, Magic, and the Divine King* (New York: International Universities Press, 1972), 253.

75. Frazer, *The Golden Bough*, 705.

76. See the chapter "The Killing of the Divine King," in Frazer, *The Golden Bough*, 319–35.

77. The headgear of this figure is reminiscent of the head of the "magic bird" (*l'oiseau magique*) that Léger created for the sets of *La creation du monde*, performed later by the

Swedish Ballet.

78. See, for example, Léger's drawing entitled *Study for the Dance: Three Women* of 1919 and his painting titled *The Dance* made ten years later in 1929 (see fig. 4.16).

79. See the lecture by Roger Caillois, "The Sociology of the Executioner," in Hollier, *The College of Sociology*, 233–47.

80. Frazer, *The Golden Bough*, 327.

81. Durkheim, *Elementary Forms*, 164.

82. Frazer, *The Golden Bough*, 356.

83. Durkheim, *Elementary Forms*, 390.

84. See Tito Vignoli, *Myth and Science: An Essay*, 99.

85. Aby Warburg, "Peasants at Work in Burgundian Tapestries" (1907), in Aby Warburg, *The Renewal of Pagan Antiquity*, 315–21.

86. Warburg, *The Renewal of Pagan Antiquity*, 485; and Warburg, *Gesammelte Schriften*, 1:383.

87. Durkheim quotes from Max Müller, *The Science of Thought* (London: Longmans, 1878), 272; and Durkheim, *Elementary Forms*, 74.

88. Frazer, *The Golden Bough*, 780–800.

89. Durkheim, *Elementary Forms*, 90–91. For a critique of Tylor, see the introduction in Lévy-Bruhl's *Les fonctions mentales dans les sociétés inférieures* (1909) in Lévy-Bruhl, *How Natives Think*, 23–27.

90. On the painter's comments on his "Nordic" identity, see Léger, *Une correspondance d'affaires*, 54–61, 161–62, 231–35. On the same subject, see also Maurice Raynal, *Fernand Léger* (Paris: Éditions de "L'effort moderne," 1920), text reprinted in Léger, *Une correspondance d'affaires*, 288–95; and Tériade, *Fernand Léger* (Paris: Editions Cahiers d'Art, 1928).

91. In a letter of 1931, Léger refers to the American city as "Barbarie moderne en ordre." Fernand Léger, *Une correspondance poste restante; lettres à Simone 1931–1941*, ed. Christian Derouet (Paris: Centre Georges Pompidou, 1997), 28.

92. A paraphrase on the poem by Constantine Cavafy, "Expecting the Barbarians," in C. P. Cavafy, *Collected Poems*, ed. George Savidis, trans. E. Keeley and P. Sherrard, rev. ed. (Princeton: Princeton University Press, 1992), 18–19. In his 1983 monograph on Léger, Peter de Francia quotes the same poem in the epilogue to his book, de Francia, *Fernand Léger*, 258.

93. I invoke here Freud's small paper "Great Is Diana of the Ephesians!" written between 1911 and 1912 during the same period that the psychoanalyst was writing *Totem and Taboo*. *The Standard Edition*, 12:342–44. The worship of Diana was also one of the main themes in Frazer's *Golden Bough*.

94. Frazer, *The Golden Bough*, 320–24.

95. On contagious and sympathetic magic, see Tylor, *Primitive Culture*, 1:116; and Freud, *Totem and Taboo*, 80–84.

96. For the group discussions between Le Fauconnier and Léger during the period that Léger was painting *Nudes in the Forest*, see Green, *Léger and the Avant-Garde*, 11; and David Cottington, *Cubism in the Shadow of War: The Avant-Garde and Politics in Paris, 1905–1914*, (New Haven: Yale University Press, 1998), 99.

97. For the Bergosnian theme of "organic regeneration" in Le Fauconnier's *L'Abondance*, see Mark Antliff, *Inventing Bergson. Cultural Politics and the Parisian Avant-Garde* (Princeton: Princeton University Press, 1993), 92–94.

98. Greene, *Léger and the Avant-Garde*, 31.

99. See John C. Burke, *Origins of the Science of Crystals* (Berkeley: University of Califor-

nia Press, 1966), 27. On the debates between Vulcanists and Neptunists, see C. C. Gillispie, *Genesis and Geology: A Study in the Relations between Scientific Thought, Natural Theology, and Social Opinion in Great Britain, 1790–1850* (Cambridge, MA: Harvard University Press, 1951).

100. Hélène Metzger, *La Genèse de la Science des Cristaux* (Paris: Blanchard, 1918), 95.

101. Paul Gaubert, "Cristaux liquides et liquides cristallins," *Revue Génerale de Science* 16, (1905): 983–93.

102. See F. Wallerant, *Cristallographie: Deformation des corps cristallisés, groupements, polymorphisme—isomorphisme* (Paris: Librairie polytechnique Ch.Beranger, 1909), 435.

103. See, for example, Alfred Lacroix, "Les minéraux des filons de pegmatite à tourmaline lithique de Madagascar," *Bulletin de la Société Française de Minéralogie* 5 (1908); 218–47; and, by the same author, *Minéralogie de la France et de ses colonies*, 5 vols. (Paris: Baudry, 1893–1913).

104. See Géza Róheim, *Animism, Magic, and the Divine King*, 77–80.

105. On Léger's praise of the merits of scientific microphotography as a new "pictorial possibility," see his lecture "The New Realism," in Fernand Léger, *Functions of Painting* (New York: Viking Press, 1973), 111.

106. Eadweard Muybridge, *Yosemite Photographs* (Chicago: Chicago Albumen Works, Inc., Yosemite Natural History Association, 1977).

107. Durkheim, *Elementary Forms*, 371.

108. On Nietzsche's aphorisms on the inorganic, see chapter 3.

109. According to his reminiscences to Dora Vallier, Léger started as an "élève architecte"—student or apprenticing architect—in Caen, and even if painting finally won him over, while he was studying painting under Gérôme in the Beaux-Arts in his first years in Paris he still had to work making "copies of architectural plans" and "retouching photographs" to make a living. Villier, "La vie fait l'œuvre de Fernand Léger," 135–36.

110. Cooper, *Fernand Léger*, figs. 10–14.

111. See the photograph from the exhibition "Ethnographie de Madagascar" organized in the Musée de l'Homme at Trocadéro in 1900. Related exhibits from Madagascar were later permanently exhibited in the Trocadéro. See Jacques Faublée, *L'ethnographie de Madagascar* (Paris: Éd. de France et d'Outre-Mer, 1946), 7.

112. Faublée, *L'ethnographie de Madagascar*, 103.

113. Frazer, *The Golden Bough*, 132–33.

114. Jurgis Baltrusăitis, "The Romance of Gothic Architecture," in *Aberrations: An Essay on the Legend of Forms* (Cambridge, MA: MIT Press, 1989), 107–35.

115. *La cathédrale engloutie*: prelude for piano from the first cahier of Claude Debussy's *Préludes*, first published in Paris in April 1910. The title was taken from the Breton legend of the drowned city of Ys.

116. See chapter 3.

117. See "Foundation Sacrifice," in Tylor, *Primitive Culture*, 1:105–8, and also Frazer, *The Golden Bough*, 230–31.

118. Tylor, *Primitive Culture*, 1:105.

119. Frazer, *The Golden Bough*, 230–31.

120. For the three interviews published between 1954 and 1955, see notes 6, 31, and 34.

121. I allude here to the title of the two ballets produced for the Swedish Ballet, the *Histoire naturelle* (with costumes by Larionov, 1914–15) and *La création du monde* (for which Léger did the stage set and costumes, with a libretto by Blaise Cendrars and music by

Darius Milhaud, 1919).

122. Erwin Panofsky, "Et in Arcadia Ego: Poussin and the elegiac tradition," in *Meaning in the Visual Arts* (New York: Penguin, 1993), 340–67; and Louis Marain, *To Destroy Painting*, trans. M. Hjort (Chicago: Chicago University Press, 1995), 79–90.

123. Parts of this imaginary "confession" emulate Lacan's soliloquy in the finale of his lecture, "The Dream of Irma's Injection," in which the French psychoanalyst impersonates Freud (or his unconscious): "I am he who wants not to be guilty for it (for having dared to begin to cure these patients)... I want to not be that. Instead of me there are all the others." Jacques Lacan, *The Seminar of Jacques Lacan. Book II: The Ego in Freud's Theory and in the Technique of Psychoanalysis, 1954–1955*, ed. Jacques Alain Miller, trans. Sylvana Tomaselli (New York: Norton, 1988), 170–71. For Durkheim's reference to the abuse of the divine fetish by the discontented members of the tribe, see note 54.

Chapter Five

1. Lotte Eisner, *The Haunted Screen: Expressionism in the Cinema and the Influence of Max Reinhardt* (*L'Ecran Demoniaque*, c. 1952, rev. 1965), trans. R. Greaves (Berkeley: University of California Press, 1994), 102.

2. "Scene 178 (Ellen's room): Nosferatu on his knees, supporting himself with one hand on the ground. He raises the other [hand] on the direction of the sun to shield himself from the light that brings him death." See Murnau's annotated copy of Henrik Galeen's original screenplay in Lotte H. Eisner, *Murnau* (Berkeley: University of California Press, 1973), 270.

3. The story is well known: Bram Stoker's widow, Florence, not only refused Murnau's producers the rights to her husband's novel, but also managed to have most of the copies of *Nosferatu* destroyed after its release. This was one of the more pragmatic reasons behind Count Orlok's transcendental "death by the light" rather than by stake, as in the original version of the story. However, Murnau's close shot of the window frame piercing the vampire's heart suggests the *window* taking its revenge on Stoker's *widow*. For *Nosferatu's* clandestine survival as *The Twelfth Hour* in France, see Eisner, *Murnau*, 108–19. On the film's various restoration projects, see Roy Ashbury, *Nosferatu* (London: York Press, 2001), 46–47.

4. Eric Rohmer, *L'organisation de l'espace dans le Faust de Murnau* (Paris: Union Générale d'Éditions, 1977).

5. The festive midnight affair that preceded the premiere screening of Murnau's *Nosferatu* on March 4, 1922, in Berlin started with "a spoken prologue inspired by Goethe's *Faust*." Ashbury, *Nosferatu*, 43–44.

6. Ashbury, *Nosferatu*, 42–43.

7. See Henry van de Velde, "Die Linie," in *Essays* (Leipzig: Insel Verlag, 1910); and August Schmarsow, *Zur Frage nach dem Malerischen, Beiträge zur Aesthetik der bildenden Künste*, vol. 1 (Leipzig: S. Hirzel, 1896).

8. E. T. A. Hoffmann, *Das öde Haus* (1817) (Berlin: Quetsche, 1991).

9. For contemporary folios of Lübeck architecture, including the salt warehouses, see Max Metzger, ed., *Die alte Profanarchitektur Lübecks* (Lübeck: Verlag von Charles Coleman, 1911); and G. Brandt, *Wohnräume und Dielen aus Alt-Schleswig-Holstein und Lübeck* (Berlin: Kunstwissenschaft, 1918).

10. For comparisons between Murnau's shots and art historical imagery, see Luciano Berriatúa, *Los Proverbios chinos de F. W. Murnau* (Madrid: Filmoteca Española, Instituto de la Cinematografía y de las Artes Audiovisuales, 1990); see 143 for the drawing of the Lübeck warehouses by Munch. Also see Eva M. J. Schmid, "Magie der Zeichen; Murnau und die

bildende Kunst," in Klaus Kreimeier, *Die Metaphysik des Dekors: Raum, Architektur und Licht im klassischen deutschen Stummfilm* (Marburg: F. W. Murnau Gesellschaft, 1994), 49–79.

11. Gustav Meyrink, *The Golem,* ed. E. F. Bleiber, trans. Madge Pemberton (c. 1928; repr., Dover: New York, 1986), 16. The novel was originally published serially in the periodical *Die Weissen Blätter* during 1913–14, and in book form in 1915 as *Der Golem* (Leipzig: Kurt Wolff Verlag).

12. Meyrink uses the terms *tückisches* and *feindseliges Leben.* In Meyrink, *Der Golem,* 19, and *The Golem,* 15 (translation altered).

13. See Ingrid Gloc, *Architektur der Jahrhundertwende in Prag: Zur Geschichte der Architektur zwischen Eklektizismus und Moderne im Spiegel der Sanierung der Prager Altstadt* (Nürnberg: VDG, 1994).

14. For a reading of the illustrations in Meyrink's *Golem* by Hugo Steiner Prag, Alfred Kubin, and later artists inspired by the novel, see Robert Karle, "Nicht ist phantastischer als die Wirklichkeit; Illustrationen zu Gustav Meyrink's *Der Golem,*" *Die Kunst* 8 (August 1988): 626–33.

15. Alfred Kubin, *Die andere Seite; Ein fantastischer Roman* (c. 1909) (Berlin: Georg Müller, 1920). Available in English as *The Other Side,* trans. Denver Lindley (New York: Crown Publishers, 1967).

16. Kubin, *The Other Side,* 24.

17. Paul Schultze-Naumburg, *Kulturarbeiten* (Munich: G. D. W. Callwey, 1904–17). Volume 4, *Staedtebau/herausgegeben vom Kunstwart* (1909), is dedicated to urban development: 37, 122, 123 (for images of buildings in Prague).

18. "Why such contempt [*Verachtung*] for simple and noble works, from which our restless and swanky times could learn the most?" See preface in André Lambert and Eduard Stahl, eds., *Architektur von 1750–1850* (Berlin: Wasmuth, 1903–12).

19. Paul Mebes, *Um 1800: Architektur und Handwerk im letzten Jahrhundert ihrer traditionellen Entwicklung,* 2nd ed., ed. Walter Curt Behrendt (Munich: F. Bruckmann, 1918), xi, 3. A third edition—an exact reprint of the second—was published in 1920.

20. In addition to Mebes, Lambert and Stahl also refer to historicist architecture as "the creations of our fathers and grandfathers, which stand next to us, both in time and spirit." See preface in Lambert and Stahl, *Architektur von 1750–1850.*

21. See, for example, photographs of monuments in Mebes, *Um 1800,* 182–89.

22. On filmic references to the pervading culture of sickness and mass death, see the masterful analysis of *Nosferatu* in Anton Kaes, *Shell Shock Cinema: Weimar Culture and the Wounds of War* (Princeton: Princeton University Press, 2009), 87–130.

23. Charles Darwin, *Insectivorous Plants* (New York: D. Appleton and Company, 1875).

24. Meyrink, *The Golem,* 15.

25. R. H. Francé, *Bios: Die Gesetze der Welt* (Stuttgart: Walter Seifert Verlag, 1923), 2:109.

26. Francé, *Bios,* 108.

27. Henrik Galeen, the scriptwriter of *Nosferatu,* had cowritten and directed the first film version of *The Golem* in 1913. When *Nosferatu* appeared, critics noted that Murnau's film "could have come out from Wegener's workshop." Ashbury, *Nosferatu,* 61.

28. Meyrink, *The Golem,* 15.

29. Alfred Kubin, "Aus Albanien," in *Fünfzig Zeichnungen* (Munich: Albert Langen, 1923). The book is a collection of Kubin's drawings for the review *Simplicissimus.*

30. Darwin, *The Expression of the Emotions in Man and Animals,* 122, 241–47.

31. Gina Lombroso, *Criminal Man: According to the Classifications of Cesare Lombroso*

(New York: G. P. Putnam, 1911), 14, fig. 4.

32. For a reevaluation of physiognomic discourses during the interwar period in Germany, see Frederick Schwartz, "Mimesis: Physiognomies of Art in Kracauer, Sedlmayr, Benjamin and Adorno," in *Blind Spots* (New Haven: Yale University Press, 2005), 137–242.

33. For Freud's references to the repression of smell, see *Civilization and its Discontents*, in *The Standard Edition*, 21:99–100f, 106f.

34. Kubin, *The Other Side*, 73–74.

35. Kubin, *The Other Side*, 100.

36. Kubin, *The Other Side*, 90–91.

37. See the introduction to this book.

38. Durkheim, *Elementary Forms*, 275.

39. Darwin, *The Expression of the Emotions*, 36.

40. For the problem of "evil" in the work of Meyrink, see Evelyn Konieczny, *Figuren und Funktionen des Bösen im Werk von Gustav Meyrink* (Wetzlar: Förderkreis Phantastik, 1996).

41. Meyrink, *The Golem*, 51.

42. Kubin, *The Other Side*, 212.

43. Meyrink, *The Golem*, 23.

44. Meyrink, *The Golem*, 29.

45. "At the end of these evolutionary developments, man as an individual ceases to exist; and there is no longer any need for him. This road leads to the stars." Kubin, *The Other Side*, 149. For the reference to theosophy: reportedly in Meyrink's room, during the period he was writing *The Golem*, there was "a picture of Madame Blavatsky next to a sculpture of a ghost disappearing into a wall." See E. F. Bleiber, "Introduction," in Meyrink, *The Golem*, iv.

46. Meyrink, *The Golem*, 25 (for the German text, *Der Golem*, 32).

47. Warburg is copying the following passage from the Gospel according to Saint John: "Ev. Joh. 3.8 der Wind blähet wo er will und du hörst sein Pausen wohl; aber du weisst nicht von woran er kommt, nur wohin er fährt." Warburg, file with manuscript notes titled "Wind/Athem/Seele?," WIA, ZK 19, "Religionskult," 019/010121.

48. Meyrink had undertaken the German translation of Dickens's complete works. See Bleiber, "Introduction," in Meyrink, *The Golem*, viii.

49. Charles Dickens, *Martin Chuzzlewit* (New York: Penguin, 1978), 59. See also Stephanie Meier, *Animation and Mechanization in the Novels of Charles Dickens* (Bern: Francke Verlag, 1982), 46; and Harold William Fawkner, *Animation and Reification in Dickens's Vision of the Life Denying Society* (Upsala: University of Stockholm, 1977).

50. For a discussion of the shop window in texts by early twentieth-century German critics, see Frederic J. Schwartz, *The Werkbund: Design Theory and Mass Culture before the First World War* (New Haven: Yale University Press, 1996), 102–4.

51. Lesley Brown, ed., *The New Shorter Oxford English Dictionary on Historical Principles* (Oxford: Clarendon Press, 1993), 80.

52. Emma Jung, *Animus and Anima: Two Essays* (Dallas: Spring Publications, 1957).

53. Brown, *The New Shorter Oxford English Dictionary*, 1676–77; and *The Oxford Latin Dictionary* (Oxford: Oxford University Press, 1982), 1066–68.

54. See, for example, *The Testimony of the Hartford Quakers for the Man Christ Jesus: Vindicated from the Malicious Slanders, Perversions, Confusions, Impertinencies and Idle Quibling of William Haworth an Independent-Preacher* (London: s.n., 1676).

55. Friedrich Theodor Vischer, *Auch einer: Eine Reisebekanntschaft* (Stuttgart: Deutsche Verlags-Anstalt, 1923). For the history of the book's reception, see Wendelin Haverkamp, *Aspekte der Modernität, Untersuchungen zur Geschichte des "Auch einer" von Friedrich Theodor*

Vischer (dissertation, T. H. Aachen, 1982).

56. See Friedrich Kluge et al., *Etymologisches Wörterbuch* (Berlin: De Gruyter, 1989).

57. Vischer, *Auch einer*, 17.

58. Vischer, *Auch einer*, 21–22. See the photograph of Vischer's study in the exhibition catalog *Auch einer: Friedrich Theodor Vischer zum 100. Totestag*, ed. Andrea Berger-Fix (Ludwigsburg: Städtliches Museum, 1987), 86–87.

59. Vischer, *Auch einer*, 11–12.

60. Vischer, *Auch einer*, 12.

61. Freud, *Totem and Taboo*, 61.

62. Kubin, *The Other Side*, 166.

63. Frazer, *The Golden Bough*, 654.

64. Freud, *Totem and Taboo*, 158; and Mebes, *Um 1800*, xi.

65. On the influence of the Heimatschutz movement on German architectural design see Christian Otto, "Modern Movement and Historical Continuity: The Heimatschutz Discourse in Germany," *Art Journal* 43, no. 2 (Summer 1983): 148–57.

66. See Sigmund Freud, "On Transience" (1915–16), in *The Standard Edition*, 14:307.

67. "[T]hat the phantom may attain to concrete form" (*die Gestalt des Phantoms plastisch werden könne*). Meyrink, *The Golem*, 29, and *Der Golem*, 37.

68. See Bruno Taut, ed., *Frühlicht* 1, no. 4 (1922): 122–24.

69. For a complete study of the competition, see Florian Zimmermann and Bruno Bruognolo, eds., *Der Schrei nach dem Turmhaus: Der Ideenwettbewerb Hochhaus am Bahnhof Friedrichstrasse Berlin 1921–1922* (Berlin: Bauhaus Archiv, 1988). For Mies's entry, 106–11.

70. Werner Graef, interview by Ludwig Glaeser, September 17, 1972, tape recording, in Canadian Centre for Architecture (CCA), Montreal, Ludwig Glaeser's research papers on Mies van der Rohe (1968–80) (hereafter referred to as "Glaeser Papers"), box 3, item 4. The transcript of this interview is in box 4, item 1, 31.

71. Graef made a similar claim in a letter to Ludwig Glaeser dated July 6, 1968. Wolf Tegethoff, "From Obscurity to Maturity: Mies van der Rohe's Breakthrough to Modernism," in *Mies van der Rohe: Critical Essays*, ed. Franz Schulze (Cambridge, MA: MIT Press, 1989), 45.

72. "Geschäftshaus- und Fabrik-Bauten. Ein Rundgang durch die Ausstellung des Geraer Kunstvereins im Städtischen Museum," newspaper review, in CCA, Glaeser Papers, box 6, item 1.

73. Arthur Drexler notices the same inconsistencies between the proposed second scheme and the Friedrichstrasse plan. See Arthur Drexler, ed., *The Mies van der Rohe Archive* (New York: Garland Publishers, 1986), 62. Wolf Tegethoff opines that Mies's drawings "point to an authentic site," although "attempts to locate the site in a 1920s map of the city [Berlin] have so far proved fruitless." See Tegethoff, "From Obscurity to Maturity," 44.

74. The three-page article contained photographs of the model and a text titled "Hochhäuser" by Carl Gotfrid. Carl Ernst Hinkefuss, ed., *Qualität (Internationale Propaganda-Zeitschrift für Qualitätserzeugnisse)* 3, no. 5/12 (August 1922–March 1923): 63–66. From Mies's business correspondence from that period, we learn that Mies had ordered 150 exemplars of this article, apparently to distribute as pamphlets. See Mies's correspondence in the Library of Congress, abstracts included in CCA, Glaeser Papers, box 1, item 4, 12.

75. See Drexler, *The Mies van der Rohe Archive*, 62; and Graef, interview.

76. Series of photographic prints, MoMA, Mies van der Rohe Archive, 16.571–16.578.

77. As Wolf Tegethoff has shown, the iron cupola projected in the background can be identified as the top of the Marine Panorama, which was close to the exhibition hall where

Mies's model was first displayed in the summer of 1922 in the annual *Grosse Berliner Kunstausstellung.* See Tegethoff, "From Obscurity to Maturity," 43.

78. From Mies's text on skyscrapers accompanying the 1922 *Frühlicht* article: English translation in Fritz Neumeyer, *The Artless World: Mies van der Rohe on the Building Art,* trans. Mark Jarzombek (Cambridge, MA: MIT Press, 1991), 240.

79. The drawing dates from between 1923 and 1926. It is reproduced in Dietrich Neumann, "Three Early Projects by Mies van der Rohe," *Perspecta* 27 (1992): 97; and in Detlef Mertins, "Architectures of Becoming: Mies van der Rohe and the Avant-Garde," in *Mies in Berlin,* ed. Terence Riley and Barry Bergdoll (New York: MoMA, 2001), 119.

80. For Mies's statements to the contrary, see "Mies Speaks: 'I Do Not Design Buildings, I Develop Buildings,'" *Architectural Review* 144 (December 1968): 451–52.

81. *Frühlicht* 1, no. 4: 123.

82. *Cahiers d'art,* 3, no. 1 (August 1928): 34. The original print used for this publication has recently resurfaced in the archives of the Centre George Pompidou, together with all other photographic materials from the archives of *Cahiers d'art* edited by Christian Zervos.

83. In the reconstruction of the model for Mies's centenary exhibition at MoMA in 1986, the low-rise houses were also presented as flat perforated surfaces.

84. See the correspondence between Mies and Walter Gropius between June 4 and July 27, 1923, in the Library of Congress, Mies's business correspondence, CCA, Glaeser Papers, box 1, item 4.

85. See Graef, interview. The photograph from the Weimar exhibition is reproduced in Tegethoff, "From Obscurity to Maturity," fig. 16; Neumann, "Three Early Projects," fig. 15; and Mertins, "Architectures of Becoming," fig. 16.

86. Mies van der Rohe to Walter Gropius, June 11, 1923, CCA, Glaeser Papers, box 1, item 4.

87. Graef, interview.

88. In a letter to Glaeser dated July 6, 1968, Graef had mentioned that Mies had the street façades molded by a sculptor, but Graef had not mentioned the artist's name. See Tegethoff, "From Obscurity to Maturity," 45.

89. See "Inventory and Transcription of Mies van der Rohe's Correspondence Including Special Files on Novembergruppe and BDA," in CCA, Glaeser Papers, box 1, item 6.

90. Oswald Herzog, "Der abstrakte Expressionismus in der bildenden Kunst," *Der Sturm* 10, no. 2 (April/May 1919): 29; and Oswald Herzog, "Abstraktion in der bildenden Kunst," *Der Kunsttopf* 1, no. 2 (1920): 22–25; as well as numerous covers and illustrations in *Der Sturm* and other journals.

91. The critic Stanley Casson, also a producer at the BBC, had apparently read T. E. Hulme or Herbert Read. See Stanley Casson, "Oswald Herzog and the German Artists of the Inorganic School," in *XXTH Century Sculptors* (London: Oxford University Press, 1930), 77–87.

92. For Herzog's collaboration with the Luckhardt brothers, see H. de Fries, ed., *Moderne Villen und Landhäuser* (Berlin: Wasmuth Verlag, 1925), 80–85. For Herzog's collaboration with Otto Bartning, including his *Sternkirche* (1922) and other projects, see the exhibition catalog *Haus Wylerberg: Ein Landhaus des Expressionismus von Otto Bartning; Architektur und Kulturelles Leben (1920–1926)* (Nijmegen, Holland: Nijmegen Museum, 1988), 84–96.

93. Contemporary criticism has neglected Herzog; for a brief exception, see Klara Drenker-Nagels, "Rhythmus und Dynamik; Oswald Herzog—Ein expressionistischer Bildhauer," *Weltkunst* 72, no. 3 (March 2002): 397–99.

94. Oswald Herzog, *Die stilistische Entwicklung der bildenden Künste: Eine Einführung in das Wesen der Kunst* (Berlin: Hause, 1912); Oswald Herzog, *Der Rythmus in Kunst und Natur: Das Wesen des Rhythmus und die Expression in der Natur und in der Kunst* (Berlin: Steglitz Verlag, 1914); Oswald Herzog, *Plastik: Sinfonie des Lebens* (Berlin: Twardy, 1921); and Oswald Herzog, *Zeit und Raum: Das Absolute in Kunst und Natur* (Berlin: Ottens Verlag 1928).

95. Herzog, *Der Rythmus,* 5.

96. Herzog, "Der abstrakte Expressionismus," 29.

97. Oswald Herzog, "Raum- und Körpererlebnis," *Frühlicht* 1, no, 4 (1922): 104–5.

98. Freud, *Totem and Taboo,* 142.

99. *G: Material zur elementaren Gestaltung* 3 (June 1924).

100. "It is in fact impossible to reproduce this building because it was never produced itself.... You can also say that Mies did do this building some thirty years later when he did the Seagram Building in New York." Thus Gene Summers stated his opposition to a proposal for the actual building of Mies's 1921 design in the still vacant Friedrichstrasse plot. See Fritz Neumeyer, ed., *Ludwig Mies van der Rohe: Hochhaus am Bahnhof Friedrichstrasse: Dokumentation des Mies-van-der-Rohe-Symposiums in der Neuen Nationalgalerie, Berlin* (Berlin: Wasmuth, 1993), 73.

101. See *Ludwig Mies van der Rohe,* 59; and Andres Lepik, "Mies and Photomontage, 1910–38," in Riley and Bergdoll, *Mies in Berlin,* 326.

102. Meyrink, *The Golem,* 16.

103. Eisner, *Murnau* (English edition), 116, 263.

104. Fritz Neumeyer reproduces Mies's notes with his requests to a book dealer for numerous of Francé's titles. Neumeyer, *The Artless World,* 102–6. On the relationship between Mies's architecture and Francé's writings, see Detlef Mertins, "Living in a Jungle: Mies, Organic Architecture and the Art of City Building," in *Mies in America,* ed. Phyllis Lambert (New York: CCA, Whitney, H. Abrams, 2001), 598–602.

105. In a collage by Kurt Schwitters, the worm's eye view of Mies's 1922 glass tower appears parallel to the photograph of a bone. Kurt Schwitters, ed., *Merz* 4 (July 1923).

106. Raoul H. Francé, *Plants as Inventors* (New York: A. and C. Boni, 1923), 26–27, originally published as *Die Pflanze als Erfinder* (Stuttgart: Kosmos, 1920).

107. Sigmund Freud, "On Narcissism: An Introduction," in *The Standard Edition,* 14:75.

108. Mies van der Rohe, "Wir stehen in der Wende der Zeit: Baukunst als Ausdruck geistiger Entscheidung," *Innendecoration* 39 (1928): 262; quoted in Neumeyer, *The Artless World,* xi.

Chapter Six

1. Georges Pudelko, "Paolo Uccello peintre lunaire" *Minotaure,* no. 7 (1935): 32–41; Brassaï photograph, *Minotaure,* no. 7 (1935): 26; André Breton, "La beauté sera convulsive" *Minotaure,* no. 5 (1934): 8–16; Paul Eluard, "Les Plus Belles Cartes Postales," *Minotaure,* nos. 3–4 (1933): 85–100.

2. On the myth of Daphne, see Yves F.-A. Giraud, *La Fable de Daphné: Essai sur un type de métamorphose végétale dans la littérature et dans les arts jusqu'a la fin du XVIIe siècle* (Geneva: Librarie Droz, 1969).

3. "[V]gl. alla Franzese Christine de Pisan," Aby Warburg, sketch of Apollo and Daphne and manuscript notes on the personal copy of his printed dissertation on Botticelli, WIA, III.40.1.1.1, "*Sandro Botticellis 'Geburt der Venus' und 'Frühling'* 1893. *Handexemplar,*" 27. For further notes on *Ovide moralisé* and other representations of Apollo and Daphne, see pages

28 and 32 in the same hand-exemplar.

4. Giraud, *La Fable de Daphné*, 21.

5. Ovid, *Metamophoses*, trans. A. D. Melville (Oxford: Oxford University Press, 1986), 14.

6. For representations of Daphne on the stage, see Giraud, *La Fable de Daphné*, 274–80.

7. *Minotaure*, nos. 1–2 (December 1933); these two advertisements also appeared on the same page in *Minotaure*, no. 5.

8. For a more extensive analysis of the rendering of Daphne's metamorphosis by nineteenth- and twentieth-century visual artists, see Christa Lichtenstern, *Metamorphose vom Mythos zum Prozessdenken: Ovid-Rezeption, surrealistische Ästhetik, Verwandlungsthematik der Nachkriegskunst* (Weinhein: VCH, 1992), 84–107. On a treatment of the same theme in a watercolor by Paul Klee, see Yvonne Scott, "Myth and Nature in Paul Klee's *Metamorphose*," *Burlington Magazine* 142, no. 1165 (April 2000): 226–28.

9. Salvador Dalí, *Hidden Faces*, trans. Haakon M. Chevalier (New York: Dial Press 1944).

10. Jacques Lacan, *The Seminar of Jacques Lacan, Book VII, The Ethics of Psychoanalysis, 1959–1960*, ed. Jacques-Alain Miller, trans. Dennis Porter (New York: W. W. Norton 1992), 60. For the original text, see Jacques Lacan, *Le Séminaire, Livre VII, L'éthique de la psychanalyse* (Paris: éditions du Seuil, 1998), 74.

11. Lacan, *The Ethics of Psychoanalysis*, 59.

12. See especially paragraphs 10 and 12 titled "The paths of conduction" and "The experience of pain," in Sigmund Freud, *The Origins of Psychoanalysis: Letters to Wilhelm Fliess, Drafts and Notes, 1887–1902*, ed. Marie Bonaparte and Ernst Kris, trans. James Strachey (New York: Basic Books, 1954), 376–83.

13. Lacan, *The Ethics of Psychoanalysis*, 58–59.

14. See the chapter "The Milky Way," in Kaja Silverman, *World Spectators* (Stanford: Stanford University Press, 2000), 111.

15. Ovid, *Metamophoses*, 17.

16. Sigmund Freud, *Beyond the Pleasure Principle*, in *The Standard Edition*, 20:27.

17. "By its death the outer layer has saved all the deeper ones from a similar fate." Freud, *Beyond the Pleasure Principle*, 27.

18. Ovid, *Metamorphoses*, 17.

19. Ovid, *Metamorphoses*, 17. On Bernini's *Apollo and Daphne* and seventeenth-century discourses of desire, see Andrea Bolland, "*Desiderio* and *Diletto*: Vision, Touch, and the Poetics of Bernini's *Apollo and Daphne*," *Art Bulletin* 82, no. 2 (June 2000): 309–30.

20. On the distinction between *douleur* and *suffrance*, see Klossowski's notes in his translation of Kierkegaard's *Antigone* (1938), partly reprinted in *The College of Sociology*, 173. The last part of Lacan's seventh seminar on ethics was dedicated to the figure of Antigone.

21. Anthony Vidler, "The Building in Pain," *AA Files*, no. 19 (Spring 1990): 3–11.

22. On the themes of "full speech" and "empty speech," see Jacques Lacan, *The Seminar of Jacques Lacan, Book I, Freud's Papers on Technique, 1953–1954*, ed. Jacques-Alain Miller, trans. John Forrester (New York: W. W. Norton 1988), 244.

23. See Wolfgang Stechow, *Apollo und Daphne*, Studien der Bibliothek Warburg (Berlin: Teubner, 1932), fig. 6.

24. On the custom of the ceremonial dressing of trees, see the chapter "Bekleidung des Baumes in Weise eines anthropomorphoschen Bildes" ("Dressing of the Tree in the Manner of an Anthropomorphic Image") in Carl Bötticher, *Der Baumkultus der Hellenen: nach den gottensdienstlichen Gebräuchen und den überlieferten Bildwerken* (Berlin: Weidmann, 1856),

101–7.

25. Adolf Loos, "The Principle of Cladding" (*Das Princip der Bekleidung*, 1908), in *Sämtliche Schriften*, ed. Franz Glück (Vienna: Verlag Herold, 1962), 105–12.

26. Carl Bötticher, *Der Baumkultus der Hellenen* (Berlin: Weidmann, 1856), 377–81. On the same theme, also see Giraud, *La fable de Daphné*, 68.

27. Ovid, *Metamorphoses*, 17.

28. This description is from the version of Daphne's myth by the medieval Spanish poet Garcilaso. See Mary E. Barnand, *The Myth of Apollo and Daphne from Ovid to Quevedo* (Durham: Duke University Press, 1987), 112.

29. See Kaja Silverman, "Freedom through Repetition," in Silverman, *World Spectators*, 62–67.

30. Lacan famously referred to Bernini's statue of Saint Theresa in his twentieth seminar. Jacques Lacan, *Encore: The Seminar of Jacques Lacan, Book XX, On Feminine Sexuality: The Limits of Love and Knowledge, 1972–1973*, ed. Jacques Alain-Miller, trans. Bruce Fink (New York: W. W. Norton & Co., 1998), 76.

31. For the dating of Bernini's *Daphne and Apollo*, see Rudolf Wittkower, *Bernini: The Sculptor of the Roman Baroque* (London: Phaidon, 1995), 240.

32. For the original placement of Bernini's statue, see Joy Kenseth, "Bernini's Borghese Sculptures: Another View," *Art Bulletin* 63, no. 2 (June 1981): 191–210. For a more complete history of the space in which Bernini's statue was installed, see Alvar Gonzalez-Palacios, "The Stanza di Apollo e Dafne in the villa Borghese," *Burlington Magazine* 137, no. 1109 (August 1995): 529–49. On the same subject, see Genevieve Warwick, "Speaking Statues: Bernini's *Apollo and Daphne* at the Villa Borghese," *Art History* 27, no. 3 (June 2004): 353–81.

33. See the contemporary description by Visconti in Gonzalez-Palacios, "The Stanza di Apollo e Dafne," 532.

34. The ceiling decoration was by Giovanni Battista Marchetti and the central painting by Pietro Angelleti. See Gonzalez-Palacios, "The Stanza di Apollo e Dafne," 533.

35. Gonzalez-Palacios, "The Stanza di Apollo e Dafne," 535.

36. Gonzalez-Palacios, "The Stanza di Apollo e Dafne," 533.

37. On the initial exchanges between Lacan and Dalí, see Elizabeth Roudinesco, *Jacques Lacan and Co.: A History of Psychoanalysis in France, 1925–1985*, trans. Jeffrey Mehlman (Chicago: Chicago University Press, 1990), 110–12. On Dali and Lacan's discussion on Borromean Islands, see Elizabeth Roudinesco, *Jacques Lacan* (New York: Columbia University Press, 1997), 377–78. For a comparative analysis of the texts by Dalí and Lacan, see José Ferreira, *Dalí-Lacan La Rencontre: ce que le psychanalyste doit au peintre* (Paris: L'Harmattan, 2003).

38. Salvador Dalí, *Daphne: La femme arbre*, in Robert Descharnes and Gilles Néret, *Salvador Dalí: The Paintings* (Köln: Taschen, 1997), 658 (fig. 1460).

39. For the two drawings, see Salvador Dalí, *50 Secrets of Magic Craftsmanship*, trans. Haakon Chevalier (New York: Dial Press, 1948), 166, 59.

40. Dalí, *Hidden Faces*, xii.

41. Dalí, *Hidden Faces*, 134–35.

42. Dalí, *Hidden Faces*, 207.

43. Dalí's treatise on magic included a drawing of the same anthropomorphic building in reverse; Dalí, *50 Secrets of Magic Craftsmanship*, 172.

44. *Apollo and Daphne*, attributed to Andrea Schiavone (Modena), illustrated in Stechow, *Apollo und Daphne*, plate 39.

45. See note 32.

46. Lacan, *The Ego in Freud's Theory and in the Technique of Psychoanalysis*, 166.

47. Jacques Lacan, *The Ethics of Psychoanalysis*, 60.

48. Heinrich von Kleist, "On the Marionette Theater" (*Über das Marionettentheater*), trans. Roman Paska, in *Fragments of the History of the Human Body*, ed. Michel Feher et al. (New York: Zone Books, 1989), 1:417.

49. Salvador Dalí, "De la beauté terrifiante et comestible de l'architecture modern style," *Minotaure*, nos. 3–4 (1933): 69–77. For an English translation of the text, see *The Collected Writings of Salvador Dalí*, ed. and trans. Haim Finkelstein (Cambridge, MA: Cambridge University Press, 1998), 193–200.

50. Louis Aragon and André Breton, "Le cincuantenaire de l'hysterie (1878–1928)," *La Révolution Surréaliste* 11 (March 1928): 20–22.

51. See Stechow, *Apollo und Daphne*, 14–15.

52. On the autopunitive character of modern architecture, see Tristan Tzara, "Concerning a Certain Automatism of Taste" (1936), in *The Surrealists Look at Art* (texts by Eluard, Aragon, Soupault, Breton, Tzara) (Venice, CA: Lapis Press, 1990), 193–213. For the original text: Tristan Tzara, "D'un certain Automatisme du Goùt," *Minotaure*, nos. 3–4 (1933): 81–84.

53. Salvador Dalí, "Apparitions aérodynamiques des 'Êtres-Objets,'" *Minotaure*, no. 6 (1935): 33–34; translated as "Aerodynamic Apparitions of 'Beings-Objects,'" in Dalí, *Collected Writings*, 209.

54. Descharnes and Néret, *Salvador Dalí: The Paintings*, 322 (fig. 718).

55. See the sculpture *The Tree of Life* by Lawrence Tenny Stevens installed on the west side of the Flushing River in Stanley Appelbaum, ed., *The New York World's Fair, 1939/1940*, photographs by Richard Wurts (New York: Dover, 1977), 101.

56. André Breton, *Mad Love*, trans. Mary Ann Caws (Lincoln: University of Nebraska Press, 1987), 10. The photograph was finally published in a 1937 issue of *Minotaure* in the article by Benjamin Péret, "La nature dévore le progress et le dépasse," *Minotaure*, no. 10 (1937): 20–21; for a commentary, see Hal Foster, *Compulsive Beauty* (Cambridge, MA: MIT Press, 1993), 27.

57. On Duchamp's "arbre-type," see Linda Dalrymple Henderson, *Duchamp in Context: Science and Technology in the Large Glass and Related Works* (Princeton: Princeton University Press, 1998).

58. André Breton, "La beauté sera convulsive," first published in *Minotaure*, no. 5 (1934): 8–15; and later as the first part of *L'amour fou* (Paris: Gallimard, 1937). See Breton, *Mad Love*, 10.

59. Breton describes the picture as "*L'image, telle qu'elle se produit dans l'écriture automatique*," *Minotaure*, no. 5 (1934): 10.

60. For the implications of gender in Renaissance depictions of Apollo and Daphne, see Yael Even, "Daphne (without Apollo) Reconsidered: Some Disregarded Images of Sexual Pursuit in Italian Renaissance and Baroque Art," *Studies in Iconography* 18 (1997): 143–59.

61. Claude Cahun, self-portrait *Je tends les bras* (1931); for a reproduction, see François Leperlier, *L'écart et la metamorphose* (Paris: Jean-Michel Place, 1992), 114.

62. Warburg's notes on Daphne in his Zettelkästen are in a file titled "Apoll u.[nd] Daphne" (before "Orpheus"): WIA, ZK 45 "Antike Mythologie: mythologisch—pragmatisch," 069/040898–918. A few more notes are in another file related to the representation of movement (*Beweglichkeit*) and the Nympha: WIA, ZK 7, "Ikonologie-Literatur," 007/002865–67.

63. On late Renaissance theatrical representations of Daphne (in relation to Rinuccini and others), see Warburg's notes on "*Aminta* and *Dafne*" WIA, III.41.12.1–2, "*Costumi Teatrali*, 1895." For the published version of these notes, see Warburg, "Theatrical intermezzi," in *Renewal*, 543–44.

64. For Warburg's notes on the exhibition on Ovid organized by the KBW in 1927, see WIA, III.97.1, "Ovid Exhibition, 1927."

65. For Ovid's description of Daphne's pursuit by Apollo as an iconographic origin for the depiction of accessories-in-motion, see Warburg, "Botticelli's *Birth of Venus* and *Spring*," in *Renewal*, 120. For Warburg's notes on Ovid in relation to his doctoral research, see Aby Warburg, "Botticelli; Ovid Notes," WIA, III.39.2.

66. See woodcut of Apollo and Daphne by a German master in Stechow, *Apollo und Daphne*, plate 10, image 22.

67. See Warburg's sketch and manuscript notes on the same woodcut (note 66) in his Zettelkästen. WIA. ZK [012] 061/035564.

68. On the iconographic problem of Daphne's clothing, see Isabelle Lecocq and Serge Alexandre, "La 'lignification' de Daphné: L'interprétation magistrale du Bernini," *Art & Fact* 17 (1998): 25–26.

69. Alberti, *On Painting and On Sculpture*, 86–87.

70. The two statuettes of Daphne made of silver and coral by the Nuremberg master Wenzel Jamnitzer date from 1570 to 1575. See Michèle Bimbenet-Privat and Alexis Kugel, "La Daphné d'argent et de corail par Wenzel Jamnitzer au musée national de la Renaissance," *La Revue des Musées de France, Revue du Louvre* 57, no. 4 (October 2007): 62–74.

71. On the qualities of coral, see Charles Darwin, *The Structure and Distribution of Coral Reefs* (London: Smith, Elder, 1889); and for a commentary of the same essay, Horst Bredekamp, *Darwin's Korallen. Die Frühen Evolutionsdiagramme und die Tradition der Naturgeschichte* (Berlin: Wagenbach, 2005).

72. Aristotle, *De Anima* (*On the Soul*), trans. Hugh Lawson-Tancred (London: Penguin Classics, 1986), 162.

73. Ovid, *Metamorphoses*, 17.

74. George Bataille, ed., "Architecture", in *Encyclopaedia Acephalica*, trans. Iain White (London: Atlas Press, 1995), 35–36.

75. WIA, GC, Fritz Saxl to Valentin Müller, September 29, 1928.

76. WIA, GC, Fritz Saxl to Wolfgang Stechow, October 16, 1928, and Stechow to Saxl, October 18, 1928. The archive also contains a number of letters by Saxl, Warburg, and Stechow mentioning several representations of Daphne, which shows that both Warburg and Saxl had an active interest in Stechow's project.

77. Stechow eventually criticized Müller's approach, and Saxl agreed with the criticisms. WIA, GC, Stechow to Saxl, February 8, 1929, and Saxl to Stechow, February 9, 1929.

78. Valentin Müller, "Die Typen der Daphne-Darstellung," in *Mitteilungen des Deutschen Archäologischen Instituts* 44, no. 2 (1929); and Wolfgang Stechow, *Apollo und Daphne* (Studien der Biliothek Warburg, 23) (Berlin: Teubner, 1932). For another iconographic study of Daphne from the same period, see B. Pace, "Metamorfosi figurate," *Bollettino d'Arte* 27 (1934): 487–507.

79. For the description of the four Daphne types, see Müller, "Die Typen der Daphne-Darstellung," 59–68.

80. For the ethnic origins of the four types, see Müller, "Die Typen der Daphne-Darstellung," 69–82.

81. Müller, "Die Typen der Daphne-Darstellung," 83.

82. Erwin Panofsky, "A. Dürer's rythmische Kunst," *Jahrbuch fur Kunstwissenshaft* (1926): 136–92; a review of Albrecht Kauffmann, *Albrecht Dürer's rhythmische Kunst* (Leipzig: E. A. Seemann, 1924). On the same subject, see Horst Bredekamp, "A Neglected Tradition? Art History as Bildwissenschaft," *Critical Inquiry* 29, no. 3 (Spring 2003): 418–28.

83. Stechow, *Apollo und Daphne*, 19–26.

84. Deleuze and Guattari, *A Thousand Plateaus*, 498.

85. See Bernd Roeck, *Florence 1900: The Quest for Arcadia*, trans. Stewart Spencer (New Haven: Yale University Press, 2009), 70–71.

86. In his article, D'Annunzio refers to the painting of *Apollo and Daphne* by Antonio del Pollauiolo that he had recently seen in the National Gallery in London. Gabriele D'Annunzio, "Del cinematografo come strumento di liberazione e come arte di trasfigurazione," *Corriere della Sera* (November 28, 1914); reprinted in Valentina Valentini, *La tragedia moderna e mediterranea. Sul teatro di Gabriele D'Annunzio* (Milano: F. Angeli, 1992), 100–105 (here, 102). For a critical analysis of the same passage, see Carla Marengo Vaglio, "Joyce, il cinema, il viaggio. La pratica dell' invenzione," in Giorgetta Revelli, *Da Ulysses a 2001: Odissea nello Spazio* (Pisa: ETS, 2002), 27–49. I am grateful to Professor Marengo Vaglio for pointing me to d'Annunzio's passage on Daphne.

87. Carla Marengo Vaglio, "Joyce, il cinema," 47.

88. Ovid, *Metamorphoses*, 17.

89. See "Wandel der Peneios Auffassung," in Stechow, *Apollo und Daphne*, 31.

90. Aby Warburg, *Journal*, April 3, 1929. Cited in Gombrich, *Aby Warburg*, 303.

91. For Warburg's study of Manet's sources from Hellenistic antiquity to the nineteenth century, see Aby Warburg, "Manet" (1929), WIA, III.116.1–6. For a commentary of Warburg's iconographic analysis of the same theme, see Damisch, *The Judgment of Paris*, 73–74; 217–27.

92. See the lecture "De l'anal à l'idéal" (June 19, 1963), in Jacques Lacan, *Le Seminaire, Livre X, L'Angoisse, 1962–1963* (Paris: Seuil, 2004), 356.

93. Beham's engraving dates ca. 1523. Stechow, *Apollo und Daphne*, fig. 25.

94. See, Warburg, *The Renewal of Pagan Antiquity*, 428–29.

95. Stechow, *Apollo und Daphne*, fig. 2. On the historiographic legacy of the figure of Laura, see J. B. Trapp, "Petrarch's Laura: The Portraiture of an Imaginary Beloved," *Journal of the Warburg and the Courtauld Institutes* 64 (2001): 55–192.

96. Stechow connects (with reservation) the picture by Luini to a poem by Lorenzo de' Medici about Daphne and Peneus. See Stechow, *Apollo und Daphne*, 68. More recently scholars have argued that the female figure depicted is not Daphne, but another mythological personage.

97. Stechow, *Apollo und Daphne*, 68–69.

98. "Dosso: Apoll sitzt . . . begeistert, im Hgr. [Hintergrund], Daphne die verwandelt wird." WIA, ZK 45, "Antike Nachleben mythologisch pragmatisch," 069/040899. In his notes on the same painting of Apollo, Warburg mentions the study of Henriette Mendelsohn, *Das Werk der Dossi* (Munich: Müller & Rentsch, 1914).

99. Only certain fragments from Peri's opera remain. See Stechow, *Apollo und Daphne*, 53–56.

100. See Giraud, *La Fable de Daphné*, 448–58.

101. On a recent retelling of the myth of Orpheus and Eurydice, see Kaja Silverman, "Orpheus Rex," in *Flesh of My Flesh* (Stanford: Stanford University Press, 2009), 37–58.

102. The metamorphosis from woman to talking tree occurs in the German opera by

Schütz (1627) and several other theatrical intermezzi. See Giraud, *La Fable de Daphné*, 443.

103. Richard Strauss, *Daphne: Eine bukolische tragödie*, opus 82 (London: Schott, 1939). The libretto was written by Joseph Gregor and was based on the story of Daphne by Parthenios, not the abridged version of the myth in Ovid. In the opera's 1938 premiere in Dresden, the soprano Margarete Teschemacher, in the role of Daphne, was wearing a costume inspired by the dress worn by Pomona in Botticelli's *Primavera*. See Bryan Randolph Gilliam, *Richard Strauss's Daphne Opera: Metamorphosis and Symphonic Continuity* (Ph.D. diss., University of California, San Diego, 1983).

104. "Der Baum allein singt!" See *Grove Dictionary of Opera*, 1:1072–73. For the various phases of Strauss's composition of the opera, see Kenneth Birkin, *Friedenstag and Daphne: An Interpretative Study of the Literary and Dramatic Sources of Two Operas by Richard Strauss* (New York: Garland, 1989).

105. Roger Caillois, "Mimétisme et psychasthénie légendaire," *Minotaure*, no. 7 (1935): 4–10.

106. Jacques Chenevière, *Daphné* (Paris: Aus Éditions du Sagittaire, 1926).

107. André Breton, *Nadja* (Paris: Gallimard, 1962).

108. On Daphne as a cosmogonic myth, see Sabine Zaalene, "Les éléments, présentation du monde et représentation poétique dans les frontispices des *Métamorphoses* d'Ovide aux XVIIe et XVIIIe siècles," in *Les Éléments et les métamorphoses de la nature: Imaginaire et symbolique des arts dans la culture Européenne du XVIe au XVIIIe siècle*, ed. Hervé Brunon (Bordeaux: William Blake & Co., 2004), 265–76.

109. "Aussi n'est-ce pas là un point de vue qui soit jamais complètement abstrait de notre pensée, à une époque où les doigts en haillons de l'arbre de Daphné, quand ils se profileront sur le champ calciné par le champignon géant de notre toute-puissance - toujours présent à l'heure actuelle à l'horizon de notre imagination - sont là pour nous rappeler l'au-delà d'où peut se peser le point de vue de la vérité." See lecture dated November 29, 1961, in Jacques Lacan, *Le Seminaire IX: L'Identification 1961–1962* (typescript available online: http://www.ecole-lacanienne.net/stenos/seminaireIX/1961.11.29.pdf/page 3).

Index

de Pisan, Christine (*Letter of Othea*), 37, 272, 278, 293, 355n3; figs. 1.4, 6.4, 6.25

Der Golem, wie er in die Welt kam (Wegener, sets by Poelzig), 224–26; figs. 5.10–5.12

Der Sturm, 252, 354n90

devolution, 80, 84, 223, 298. *See also* evolution

di Duccio, Agostino, 50, 52, 57, 326n44, 326n45, 326n46

Diana (goddess), 62, 66–67

Diana of the Ephesians (Freud), 194, 348n93

Dickens, Charles, 236–38, 352n48–49

dogs, 9–20, 45, 228, 320n17. *See also* Darwin, Charles: dog of

Domenichino, 62

Dora (Freud), 65

Dorians, 193

Doric style, 85

Dossi, Dosso, 307–8, 360n98; fig. 6.30

drapery, 45, 48, 59

 in Alberti, 56

 in Riegl, 129–30

 in Vignoli, 47–48

 in Vischer, Friedrich Theodor, 46–47, 52. *See also* Vischer, Friedrich Theodor

 in Vischer, Robert, 45–46. *See also* Vischer, Robert

 in Warburg, 52, 56, 59, 84, 328n70. *See also* Warburg, Aby

 in Worringer, 38, 135–36. *See also* Worringer, Wilhelm

Dream of Venus, The (pavilion). *See* Dalí, Salvador

Druids, 193, 205

Duchamp, Marcel, 164, 287, 358n57

Dürer, Albrecht, 182, 290, 359n82

Durkheim, Émile, ix, xiii, 17, 19–21, 26

 Elementary Forms of the Religious Life, The, 24, 165, 167, 190–94, 200, 202, 322n48

 Saint-Simon, and, 25, 323n60

 social animation, xiii–xiv, 25–26

 soul, on the, 25, 234

dynamogram, 88

ego, viii, 208, 259, 281, 350n123

Egypt, Egyptians, 77–79, 113, 342n70

 architecture, 130, 197

 art, 300, 342n70, 343n85

 headdress, 136, 225

ornament, 118, 135; fig. 3.2

 religion, 93, 301, 331n15

Eluard, Paul, 263, 288, 355n1, 358n52

Eleonora of Toledo, Chapel of, (Palazzo Vecchio, Florence), 105; fig. 2.20

empathy, xiii, 3, 48, 94, 97, 161, 268, 306

 abstraction and, xi, 132–34, 153–54, 271, 319n6, 340n46

 aesthetic theory of, vii, ix, 45–47, 240, 328n64

 animation and, vii, 4–7, 47, 71, 126, 144

 negative, 71

 Vischer, Friedrich Theodor, 22, 47, 239–40. *See also* Vischer, Friedrich Theodor

 Vischer, Robert, 22, 45–46, 328n64. *See also* Vischer, Robert

 Warburg, Aby, 23, 32, 47, 98, 322n58, 322n34

 Worringer, Wilhelm, 131–32, 135, 143, 338n6. *See also* Worringer, Wilhelm

engram (Richard Semon), 15, 79, 103, 128, 148

Entfernung ("distancing") (Aby Warburg), 23

ethnography, xiii, 25, 66, 88, 99–102, 125, 164, 179, 181, 187, 194, 199–200, 207, 333n43, 346n46

 on animism, 10, 16–17, 25, 47, 68, 321n34

Europa, 55

Eurydice, 310, 360n101

Eusebius of Caesaria (*Evangelical Preparations*), 78, 85, 95, 331n13–14, 331n18

evolution, 79–81, 83, 90–91, 109, 128, 134, 138, 184–85, 197, 270–71, 298, 313, 352n45

 regressive evolution, 83–85, 88, 184, 332n31

 See also devolution; regressive evolution (*évolution régressive*)

evolutionism, 11, 15, 18, 45, 62, 74, 79, 104, 137, 146, 359n71

excitation (*Erregung*), 4, 15, 47–48, 190, 195, 269–70, 272, 282, 292, 312

execution (of the divine king) (anthropological account), 102, 188, 190–91, 255, 348n79

expressionism, 115, 151, 219, 251–52, 343n83, 350n1, 354n90

Expression of the Emotions in Men and Animals, The. See Darwin, Charles

extensional animation. *See* animation

Hume, David, 16
hysteresis (inorganic memory), 128, 149. *See also* inorganic: memory

immobility, xi, 117–18, 121, 129. *See also* inertia
inanimate, ix–x, xvii, 5, 10–11, 61, 68, 89, 129, 132, 161, 183, 225, 312
 objects, viii, xi–xii, 12, 17–20, 56–58, 64, 66, 133, 223, 234–37
inanimation, process of, 234–35. *See also* animation; deanimation; paralysis
India, Indians, 76, 126, 154,
 temples, 74–76
Indian rubber. *See* rubber
industrial production, viii, 26, 170, 207
industrial standardization (*Typisierung*), 88
inertia, 12, 23, 118, 175, 202, 296, 311–12.
 See also immobility
inhuman, xi, 146, 216
inorganic, vii–xiii, 64–65, 125, 164, 290, 296, 307
 abstraction, 116, 132, 271
 accessories, xiii, 31, 45–47, 57, 64, 89, 135–36
 agency in, viii, 133
 animation of, vii, xi, xvii, 116, 131–34, 143, 145, 154, 156, 198, 315, 317
 art, 23, 118–19, 128–30, 143, 149, 164–65, 253, 354n91
 artifacts, viii, 89, 149
 Bataille, xiii, 146, 342n75
 behavior, 126–28, 162,
 biology, 200
 collectivity, 147
 Deleuze, xiii, 132, 303 (*see also* Deleuze, Gilles)
 Hulme, 146–47 (*see also* Hulme, T. E.)
 impulse, 133
 Léger, in, 165, 167, 172, 175, 183–84, 186, 194, 197, 313
 life, vii, 24, 123, 125–28, 146, 149, 198–99
 maternal bosom as, 146, 202
 matter, viii, 117, 121, 125, 128, 140, 146, 161, 281, 294
 memory, 128, 147–50
 morphology, 117, 338n8
 mimicry, 200–202, 222–26
 mode of organization, 25, 136, 272
 natural objects, 58

Nietzsche, 146, 342n72, 342n73. *See also* Nietzsche, Friedrich
ornament, 131–33, 145
pathology, 126–28, 149; fig. 3.8
progeny, 145–48
politics, 147
shield, 271
vestiges, 81, 150
Worringer, xiii, 116–17, 131–34, 143, 151, 303. *See also* Worringer, Wilhelm
inorganicism, 23, 123, 135, 143
Institute of Sociology at Brussels, 84
International Architecture exhibition (Gropius) 249
International Style (architecture), 151
Interpretation of Dreams, The. See Freud, Sigmund
invertebrate organisms, 79
Italy, Italians, 154–57, 169, 228
 art, 38–39, 44, 58, 60, 69, 324n11
 language, 58, 154, 156, 290, 320n23, 327n55
 literature, 55–57, 303
 opera and theatrical intermezzi, 290, 309
 Renaissance, x, 108, 191,
 war, 223

Jaina temples, 75
Jamnitzer, Wenzel, 296–98, 359n70. *See also* coral; Daphne
Janitschek, Hubert, 327n56, 328n62
Japan, 2–3, 169, 319n1
Jentsch, Emil, 133, 341n49
Jones, Owen (*Grammar of Ornament*), 137, 341n53
Jünger, Ernst, 147
Jupiter, 67

Kahnweiler, Daniel Henry, 180, 186, 344n2, 347n50
Kant, Immanuel, 64, 68, 329n80
Kepes, György, 150, 343n89; fig. 3.15
Kracauer, Siegfried, 144, 352n32; fig. 5.2
Krampf, Gunther, (*Nosferatu*) 217
Krause, Ernst, (pseud. Carus Sterne)
 Natur und Kunst (Nature and Art), 62–64, 329n76; fig. 1.14
 Werden und Vergehen (Becoming and Passing Away), 79–82, 84, 91, 331n21; figs. 2.5–2.7

Francé, Raoul H.)

See also Caillois, Roger; camouflage

mineral, viii, x–xi, xvii, 26, 118, 121, 126–27, 138, 140, 171–72, 175, 177–78, 195, 197

 origins, 146, 197–200, 202, 206, 208, 223, 281–82, 296, 317

mineralogy, 126, 130, 164–65, 198–99, 349n103

Minotaure (journal), 263, 266, 276, 282–83, 287, 311, 355n1; figs. 6.9, 6.13, 6.14

Mnemosyne Atlas (*Memory Atlas*) (Warburg), 50, 290, 326n46; figs. 1.11, 6.17. *See also* Warburg, Aby

mobility, xiii, 60–61, 66, 68, 135, 221, 303, 307. *See also* movement

Moeschke, Marianne, 224

Moholy-Nagy, Laszlo (*von material zu architektur*), 95, 172, 335n67; fig. 2.13

Moki, 88–89, 102, 194, 111, 332n40

Monadology. See Leibniz, Gottfried Wilhelm

Mondrian, Piet, 153, 268

monism, viii, 68, 119, 125, 128–29, 132, 143, 150, 157, 164–65, 200, 224

Monistic Psychology of Art (Warburg), 22, 89, 322n51, 326n40. *See also* Warburg, Aby

Monteverdi, Claudio, 310

Moore, Henry, 153

Morandi, Giorgio, 156

Moses, 91, 108, 110

movement, 17, 25, 31, 37, 52–66, 69, 118, 226, 253, 266, 269, 300–301, 358n62

 of accessories. *See* accessories

 agency of, 9–11, 98

 of air (wind), 46, 50, 58. *See also* air

 of animals, 81, 102, 118, 331n19, 338n10

 anorganic, 78, 92–94, 102–4

 of drapery. *See* drapery

 of human bodies, 8, 56, 59, 64, 182, 184, 189–90, 216, 292, 341n61

 inorganic, 131, 133

 internal, 7, 117, 303

 latent, 116–19, 123, 126, 136

 life-in-movement (*Bewegtes Leben*), 62–66

 mannerism of, 59–62

 of objects, 12, 17, 25, 56–57, 126, 133, 237–38

 in plants, 118, 222, 249, 339n13, 339n15

 pneumatic, 78, 134

 psychological, 45, 269–70, 275, 322n54

reflex, 102–3

representation in painting, 38, 62, 301–2, 329n77

simulation of (*Beweglichkeit*), vii, x–xi, xiii, 135, 303, 358n62

of snakes, 57, 71–85, 88, 91–93, 104; fig. 2.8

 See also mobility; snakes (serpents)

Müller, Max, 193, 348n87

Müller, Valentin (study on Daphne) 298; fig. 6.23

Munch, Edward (drawing of buildings in Lübeck), 217, 350n10

Murnau, Friendrich Wilhelm, 314–15

 Faust, 215–16, 350n4; figs. 5.4, 5.5

 See also *Faust* (Murnau, Friedrich Wilhelm)

 Nosferatu, 211–32, 235, 238, 241, 244, 257–61, 350n2, 350n3, 351n27. See also *Nosferatu* (Murnau)

mustache, 42; fig. 1.6

Muybridge, Eadweard, 53, 62–64, 164, 183–84, 329n79, 347n59, 349n106

Myth and Science (*Mito e Scienzia*). *See* Vignoli, Tito

Nagas (India), 74–75

Nash, John, 153

Native Americans, 88, 102

natural history, xiii, 66, 79, 82, 88–89, 109, 150, 222

Navicella mosaic, Saint Peter's Cathedral, Rome, 4, 6–9, 319n9; figs. 01, 02

Nebensachen (accessories), 64. *See also* accessories

Neptunists, 198, 348n99

New Mexico, 88, 97

Nicholson, Ben, 151–53, 343n90

Nietzsche, Friedrich, xiii, 146, 202, 207, 238, 342n72, 342n73, 342n74, 342n75

North America, 80, 88–91, 169, 194, 333n42. *See also* America, Americans: Southwest

Northerners, 132–33, 140–45, 152–53, 156, 194

 Northern ornament, 131, 133, 137, 138, 140, 341n54, 341n55, 341n57

 Northern painting, 108, 278

Nosferatu (Murnau), 211–32, 235, 238, 257–61, 315, 350n1, 350n3, 350n5, 351n22, 351n27; figs. 5.1–5.3, 5.8,

5.14, 5.16–5.18, 5.32
and animation, x, 222–23
gestures, xiii, 211–17, 235, 255, 260–61,
315, 350n2
houses, 211–12, 217–19, 228–32,
257–58
publicity images, 218, 232; fig. 5.19
See also Murnau, Friedrich Wilhelm
Novembergruppe, 251–52, 354n89
Nudes in the Forest (*Nus dans la forêt*) (Lé-
ger), ix, xi–xii, xv, xvii, 95, 162–209,
265–66, 271, 312–13; figs. 4.1, 4.11,
4.14, 4.15, 4.20, 4.23, 4.27, 4.29;
plates 5–7
and architecture, 203, 208
comments by Apollinaire, 168, 170
earlier titles, 163, 344n2
iconography, 165–67, 178, 183
landscape, 163, 176, 195–202
reviews, 168, 170
See also Apollinaire, Guillaume; Léger,
Fernand
nymph (*nimfa* or *ninfa* [Warburg]), xi–xii,
35, 67, 100, 157, 263, 265–76,
281–82, 285,288–90, 294, 296–99,
301–2–311, 314–17, 344n99,
358n62
running, 53, 67, 263, 266, 268, 302–3
See also Daphne; Warburg, Aby

O'Gallop, Marius Rossillon (affichist, *Biben-
dum*), 170
objectivity, ix, 338n8
Oceania, 85
olfactory perception, 232–34
Ophites, 75
optically stimulated epilepsy (*Pokémon*), 2,
319n2
Oraibi, 93, 333n41
organic, 25, 55, 64–65, 74, 78–85, 121, 129,
142, 145–47, 154, 202, 205–6, 240,
269, 271, 300–301, 343n83, 348n97,
355n104
bodily extensions, 64, 183–84, 190–91,
304
form, 22, 117, 145, 147, 197, 300–301,
338n8
ideology, 25, 147, 207, 255
and the inorganic, ix–x, 25, 45, 89, 125,
131–34 , 157, 164, 175, 222, 224,
288, 294

life, 22, 89, 131, 198–99, 225
memory, 12, 144, 147
organicism, xi, 147, 207. *See also* anorganic:
anorganicism; inorganicism
ornament, viii, xi, 39–44, 49, 55, 65, 84–85,
116–19, 130–46, 187, 275, 284, 308
animal, 137–40, 142, 341n55, 341n57
architectural, 74, 187, 197, 225, 240, 275,
279–80
bodily, 61, 69, 89
crystalline, x, 119, 140
geometric, 87, 135
ornamental motifs and patterns, ix,
39–42, 62, 87, 98, 118, 131–40, 142,
150, 310, 341n51
Northern, 131–33, 137–40
rhetorical, 115
spiral, 8, 41–42, 62, 85, 118, 225, 320n11,
332n37; fig. 2.9
vegetal, x, 55, 116, 118–19, 136, 225,
276, 332n37
See also Germany, Germans; Greece,
Greeks; Northerners; Pueblos (North
America)
ornamentalism, 62, 64, 329n82, 329n83
Orpheus, 104, 182, 290, 304, 306, 310,
358n62, 360n101
Other Side, The (*Die Andere Seite*), 219–21,
223, 229, 232–35, 241, 257, 259,
351n14, 351n15, 351n29; figs. 5.7,
5.16. *See also* Kubin, Alfred
Ovid, 53, 55, 278, 288, 290, 361n103
Metamorphoses, xi, 55, 67, 263–66,
270–72, 275, 295, 298, 301, 303–4,
306, 310, 313, 331n21, 355n3, 356n5,
356n8, 357n28, 359n64, 359n65,
361n108; figs. 6.1, 6.10, 6.16. *See also*
metamorphosis

pain, 39, 89, 173, 238, 241
actualization of pain in architecture
(Lacan), 268–75, 279, 281, 284, 290,
314, 317
and animation, 12, 21, 93
building in, 272, 275, 356n21
limit of, 269, 282, 314
produced by or projected on objects, 12,
15, 18–19, 241
stimuli, 21, 104, 269–71, 356n12
Palazzo Vecchio, 105; fig. 2.20
panic attacks, 220, 234

Panofsky, Erwin, 301, 335n71, 350n122, 359n82

paralysis, xi, 1, 4–5, 26, 35, 168, 26, 232, 234–35, 265–66, 312–13. *See also* petrification

parasol, 9–12, 14–15, 20, 23, 26–27, 47, 236, 314

Pathosformel (pathos formula), 13, 104, 182, 216, 304. *See also* Warburg, Aby

Pauli, Gustav, 34

Peneus, 296, 304, 307, 360

Peri, Jacomo (*Dafne* opera), 360n99

Perle (Kubin, *The Other Side*), 219, 233–35, 256, 259

Peter, Saint, 8, 44

Petrarch, 306–7, 312, 360n95

petrification, 26, 268–69, 271–72, 314–15. *See also* Daphne

Pflüger, Eduard, 102–3, 337n91

phantom limb, 104

pharmakopoieia, Warburg Library section on, 92

Philo of Byblos (*Phoenician History*), 72–74, 77–79, 85, 91–94, 98–99, 104, 109–11, 236, 330n4, 331n12, 331n14, 331n17, 331n18; fig. 2.2

phobic animation. *See* animation: phobic

Phoebus, 62. *See also* Apollo

Phoenicians, 74, 77–78, 104

Phoenician History. *See* Philo of Byblos (*Phoenician History*)

physiognomy, vii, ix, 225–34, 238, 240, 281, 352n32

 depictions of anger, 228

Picasso, Pablo, 165–67, 176, 189, 194–95, 208, 266, 344n8, 344n9, 345n11, 346n36; figs. 4.2, 4.3, 4.18

Piper, Reinhard, 137, 140

Pliny, 273

Pluto, 67

pneuma, 78, 104, 168, 236

pneumatic, 226, 266

 agency, 104, 126, 134

 movement, 78–79, 95

 "Representation of the Spheres" (Warburg), 50, 326n46

 technology, ix, 98, 207

pneumatics, 95, 168–67, 171–72, 177, 193, 200, 202, 208

pneumatism, vii

Poelzig, Hans (set designs for *Der Golem* by Wegener), 224–26, 240, 244, 257, 260; figs. 5.10–5.12

Pokémon (animated television series), 2–5, 8, 21, 23, 26, 319n1, 319n2, 319n3, 319n4

polarity, 57, 68, 89, 97, 129, 143, 153, 253, 314, 323n57, 342n78, 343n91. *See also* analogy; Warburg, Aby

Poliziano, Angelo, 53, 55, 66, 329n86

Pollaiulo (*Apollo and Daphne*), 290, 303

polyp, 222, 258

postimpressionism, 167

Poussin, Nicolas, 208, 350n122

Prague, 219–20, 259, 336n84, 351n17

preanimistic stage, 17, 20, 322n42. *See also* animatism (preanimistic stage)

Pre-Raphaelites, 64

Preuss, Konrad, 102, 336n82

Primavera (Botticelli). *See* Botticelli, Sandro

Primitive Culture. *See* Tylor, Edward (*Primitive Culture*)

projection

 cinematic, 121, 230, 256, 284

 as formal protrusion, 185, 228, 285

 geometric, 296

 as psychological process, 5, 21, 59, 65, 240, 259–61

Proserpina, 55, 67

prosthesis, 89, 98, 104, 172, 184

Proust, Marcel, xv

psychology, 5, 7, 140, 219, 265, 269, 340n34

 aesthetics (psychological), vii, 22, 45, 71, 89, 132, 146, 153, 304, 319n6, 322n51, 338n6

 animal, 11–12, 47

 empathetic, 45–48, 133, 239

 experience (psychological), 5, 8, 45, 117

 of expression, x, 45, 144, 304,

 and race, 142–43, 322n42, 341n61

 responses (psychological), x, 12, 15, 128, 228, 269, 275, 292, 307, 311

psychoanalysis, ix, xiii, 21, 315, 321n31, 341n50

 Freudian, 65, 149, 240–41, 269, 348n93. *See also* Freud, Sigmund

 Lacanian, 268–77, 282, 313, 350n123. *See also* Lacan, Jacques

Pueblos (North America), 69, 89–91, 95, 98, 100, 102, 321n30

 costume (*Tracht*), 89–90

 dance rituals, 15, 84, 109, 172, 190

pythons, 80–81; fig. 2.6